WOMEN ARTISTS:

An Historical, Contemporary and Feminist Bibliography

by

DONNA G. BACHMANN

and

SHERRY PILAND

The Scarecrow Press, Inc.
Metuchen, N.J. & London
1978

Library of Congress Cataloging in Publication Data

Bachmann, Donna G 1948-
 Women artists.

 1. Women artists--Bibliography. I. Piland, Sherry, joint
author. II. Title.
Z7963. A75B32 [N8354] 016. 709'2'2 78-19182
ISBN 0-8108-1149-9

CONTENTS

iii

51026

iv

v

ILLUSTRATIONS

vii

viii

Fine Arts Museums of San Francisco, California Palace of the Legion of Honor, Mr. and Mrs. Louis Benoist Fund. 135

ACKNOWLEDGMENTS

Many people and things have contributed to this project. The most crucial was Sherry Piland's enthusiastic collaboration that transformed my original manuscript on seventy-three artists into the present book covering one hundred sixty-one women. Ours has been an ideal association.

The original project was encouraged by Dr. Burton Dunbar's permission to pursue it in lieu of more traditional art history credits.

That first version of the bibliography was the 1976 recipient of the Jane Berry Award for Women's Studies, chosen each year at the University of Missouri, Kansas City.

Sherry and I received the art historical training that has enabled us to write this book from the faculty of the Art and Art History Department at the University of Missouri. Lee Anne Miller, chair of the department, and Joan Bassin, art historian at the Kansas City Art Institute, kindly read and critiqued our introductory essay.

Both Adele Simon, formerly a librarian at the General Library of U. M. K. C. , and Anne Tompkins, past librarian of the Nelson Gallery-Atkins Museum Reference Library, have given us useful counsel on the form and organization this bibliography has taken. Their respective libraries have made our research possible.

The National Women's Caucus for Art and our local Kansas City chapter have given us much moral support and the kind of continuing interest that sustains a project as long and drawn out as this one has been.

One cannot begin to enumerate the many people that make the writing of a particular book possible, without first acknowledging the family, friends and lovers who patiently endure the writing and the writers in their midst. This is especially true in our case --you know who you are!

And finally we wish to offer our sincere thanks to a few women whose mistressful and diverse contributions to the field of women's art history have inspired us: Judy Chicago, Anne Sutherland Harris, Lucy Lippard, Cindy Nemser, Linda Nochlin, Karen Petersen, Miriam Schapiro, Eleanor Tufts, and J. J. Wilson. Sisters ... Homage!

INTRODUCTION

Art history texts are incomplete because the contributions of
women artists have not been included. This gap in the literature
and our own pressing need to know about our heritage as women in
art have compelled us, an artist and an art historian, to write this
book. The bibliography originated from a small, personal project
to fill in that blank in our own educations, to find some answers
for ourselves that we very badly needed. This work has grown far
beyond our first expectations. We are gratified to share it. We
hope it will help to rectify the false but widely held notion among
art history students that because no women artists are presented in
classes, none existed, or that those who did exist produced nothing
worth viewing. We suspect that many people teaching and writing
art history also hold that view. It is to them that we particularly
direct this effort.

Many standard surveys of art history fail to mention a single
woman artist (Gombrich, Janson, Gardner). Through the use of the
generic term "man," even chapters covering anonymous art of pre-
historic, ancient and medieval eras imply that the artists were all
male.

Museums and galleries perpetuate the idea that women have
not been artists. For some years the only work by a woman on
prominent display in our local museum, the Nelson Gallery-Atkins
Museum, was a Grace Hartigan painting. We were relieved to find
even one representative of our sex there. Years later we were
both pleased and horrified to find in the basement reference library,
far from public view, works by Suzanne Valadon, Isabel Bishop,
Florine Stettheimer, and over the card catalogue, a Marie Lauren-
cin! We were glad to see them ourselves and to find them acces-
sible at all (thanks, significantly, to then librarian Anne Tompkins and
her all-female staff), but dismayed that so few people could enjoy
them.[1] Feminists in other cities can describe situations of a sim-
ilar nature in their own local art institutions.

Art schools take an active role in discouraging women stu-
dents. While the student population is approximately half female
and half male, studio faculties remain overwhelmingly male. The
attitude of male instructors toward their female students is subtly
different. It is poisoned by the belief that women students are not
as serious as men and that art educations will be "wasted" on them
if marriage and children come along. I (Donna) learned these things

firsthand as a painting student at the Kansas City Art Institute in the late sixties. I found a studio faculty of twenty-nine, of whom only one was a woman (painter Shirley Luke Schnell), teaching untenured in the freshman program. For some 250 women students she was the only example we had of what it might mean to be a woman and an artist. Now, ten years later, the studio faculty is larger and Shirley has her much deserved tenure. A tiny handful of untenured women faculty has been hired, though none in my old painting department. The Kansas City Art Institute merely illustrates the pattern that persists among art schools throughout the country.

As students eager to know about women artists of the past, we got little response to our questions since our teachers did not know either. As our educations and our involvement in feminist activism continued, we decided to answer the questions for ourselves. Have there been any women artists? (B.C., Before Cassatt?) If so--who, and where, and when? If not--why not?

The amount of material we found surprised us. Undoubtedly, more time and effort would result in still more information, but the bibliography presented here covers basic information that needs immediate circulation. We were hungry for this information and know that other women in art feel the same need. We hope this work will be useful in women's studies, as a guide for independent reading, and as a starting place for the Amazonian task of filling in the vast gaps in the literature of women's art history. We have striven for completeness; that is why we have included many references that may seem minute and out-of-date. We have included many minor artists, not in the hope of elevating their status, but of presenting a more complete picture. A few artists have even been presented for whom no extant work has yet been found. Though we have tried to be thorough, we were doomed from the onset. The 161 women artists covered by our text must be viewed as a small island--actually the peak of a mountain mostly buried far beneath the sea, yet to be explored.

We learned through our bibliographic sleuthing that in spite of many obstacles there have always been women artists, sometimes working in obscurity, but often recognized as professionals. We found that there was just as much reason to suppose that individual, anonymous artists might be women as men. While this was made clear, a new question arose--why were we never told? Why has this aspect of everyone's cultural heritage been lost, hidden, or ignored?

A basic tenet of liberal education is that we all need our cultural heritage. But even now, people who are not white and male have very little chance of learning about anything but the cultural contributions of that very special minority. This cultural bias has not always been so strong. Though they did not discuss a large number of women artists, both Pliny and Vasari wrote of art and artists in a matter of fact way without resorting to sexual stereotyping. Really negative writing about women artists seems to have

begun in the middle of the nineteenth century. This coincided with
the beginnings of the suffragist movement and was probably a reflec-
tion of the need felt by men to preserve art as their realm.[2] One
writer of this period, Walter Sparrow, presented much valuable in-
formation in his book, Women Painters of the World, but he illus-
trated his sexual bias eloquently in his description of women artists
--they have a "nursery nature"![3] A recurring pattern in early
writing about women artists is a pronounced lack of discussion about
the actual work they produced. Instead we hear of their beauty,
charm, morals, or the lack of them; of their ability as musicians,
housekeepers, and conversationalists--attributes that many of us
will recognize as survival skills. A lack of media response to
women's work continues today.[4] Although early writers did revive
some interest in women artists, they ultimately hurt more than they
helped; for their prejudices were passed on and eventually became
accepted as "fact": "women artists are only second rate."

It is awesomely difficult for anyone to be an artist. But the
young man in art school, if he is white, has the advantage of seeing
all around him uncounted examples of male artists, all manner of
"role models" in galleries, museums, the art press, books, art
history classes, and especially in the persons of his teachers. The
young woman does not have this encouragement. She is told in doz-
ens of ways that she has no heritage, that there have not been sig-
nificant women artists in the past and that their numbers today are
insignificant. Language is inadequate to convey how profoundly crip-
pling this is. We have found it difficult as women to identify genu-
inely with the great art of the past as it is offered in traditional
art history classes and museum holdings. As Miriam Schapiro
says, "I knew if I had lived back then, I couldn't have been Rem-
brandt, only Mrs. Rembrandt!" While facetious, this remark sums
up the essentials of the situation. It is a vast relief, on a purely
emotional level, to learn that we could have been Judith Leyster!

The elitism, racism, and sexism that have infected the his-
tory of art are a direct reflection of the same ills plaguing our
larger society. Patriarchal values have for so long comprised the
status quo, dominating our legal systems, social customs, language,
and even religious beliefs, that it is difficult even to perceive the
pervasive sexist bias, let alone imagine alternatives. Arlene Raven
speaks of that bias and of one of its effects:

> She [woman] has not participated in the mainstream of the
> [male] culture, and the culture does not operate from her
> perspective. Her contribution has neither spoken to nor
> been understood by that system, and the content of her
> art has been bypassed by interpretations which could not
> reveal it.[5]

Raven's statement also hints at the challenge and potential for a
feminist art history, at things yet unlearned about ourselves and our
foremothers. For too long the distorted mirror of traditional art

history has obscured the cultural contributions of women. Though the injustices of the past cannot be changed, they need not be perpetuated. And while cataloging past discrimination will not alter the rigid economic structure of the present art market nor change the status of contemporary women artists, documenting our past oppressions is a necessary part of claiming our history and of validating our own experience as women. The contemporary feminist movement is working on several fronts: the theoretical, the historical, and the practical, and though in existence only a few years, it has had an impact in all these areas.

The first phase of the feminist art movement was a period of consciousness-raising; women learned from one another that sexism is an issue in art just as in other fields. This beginning, women artists simply meeting together, was revolutionary in itself. In the past women artists have more often than not worked in isolation, without the sense of community and mutual support that male artists have frequently given one another. In an effort to be taken seriously, many women artists in the past have actively denied their connection to other women. Some continue to do so today. The woman's art movement makes the pathetic attempts to be accepted as "one of the fellows" no longer necessary.

The next step was to begin to affect some changes in the art market system. The discrimination there included only token numbers of women in gallery stables (an unfortunate but apt term), in important exhibitions, and in public collections. Other aspects of this discrimination were inadequate sale prices and a general lack of critical response to women's work. Women artists were nearly absent altogether from the ranks of college art teachers, in spite of large numbers of qualified women.

In 1969 the Art Workers Coalition was formed in New York to protest exhibition policies at the Museum of Modern Art. This was a radical but male-dominated group. Later that year W.A.R. (Women Artists in Revolution) was formed in reaction to the failure of the Art Workers Coalition to consider seriously the issue of sexism in the art world. In an early W.A.R. project equal representation for women was sought in the Whitney Annual Exhibitions. Demands were also made to the Museum of Modern Art and other New York institutions for more one-woman shows, for fifty per cent inclusion of women in museum shows, and for continuous non-juried exhibits of women's work. The protests at the Whitney took several forms, some quite innovative, and lasted over several weeks.[6] Although the Whitney still did not include fifty per cent women, the percentage did double.

In addition to confrontations with establishment institutions, women began creating their own alternative institutions. A collective organization was most often used in opposition to traditional hierarchical structures. Some of the alternative forms explored included organizing their own exhibitions, cooperating in ventures in rented spaces, and later opening co-op galleries. Members

tended to be compatible politically without the necessity for stylis-
tic uniformity in their work. Slide registries formed across the
nation, enabling women to become familiar with each other's work
and to dispel the myth among curators, dealers, and art depart-
ment chairs that there were no working women artists. New
publications such as The Feminist Art Journal and the Women
Artist's Newsletter became forums for discussion and forged new
lines of communication.

Without question, the most exciting alternative institution
the women's art movement has yet mothered is the Feminist Studio
Workshop in Los Angeles. It is a women's art school completely
removed from male values and culture, where female experience is
explored and affirmed. [7] The Feminist Studio Workshop grew out
of short-term experimental programs produced by Judy Chicago at
Fresno State College in 1970. She was joined by Miriam Schapiro
at the California Institute of the Arts in 1971. The landmark col-
laborative environmental project Womanhouse grew out of that joint
effort. The F.S.W. is located in the Woman's Building, [8] a center
for women's culture; it houses a feminist bookstore, a feminist
therapist, the Women's Graphic Center, a cooperative women's
recording company, a restaurant, several galleries and classrooms,
and a public performance area.

Judy Chicago is currently working on a monumental environ-
mental project, "The Dinner Party," that will reinterpret the last
supper theme from the point of view of "those who have prepared
the meals and set the table throughout history." It will celebrate
and reclaim women's heritage in myth and history. Vast amounts
of research, design, and traditional female crafts such as china
painting and embroidery are required for the project. To accom-
plish all this, Chicago has recruited women from across the coun-
try to join her as what seem to be apprentice-collaborators, thus
creating and exploring another format for artists. The consensus
among feminists, in and out of the art world, is that the process
is surely as important as the product.

Another aspect of the women's art movement is represented
by the Women's Caucus for Art. The W.C.A. is a national femi-
nist organization of professional gallery and museum women, art
historians, and practicing artists. It originally grew out of the
College Art Association in 1972, and continues to hold its national
meetings in conjunction with the C.A.A., although it is an inde-
pendent organization. Nationally the W.C.A. has directed its en-
ergies toward women's studies in art history and hiring practices
in college and university art departments, with a corresponding
emphasis on affirmative action projects. A job placement bureau
for members, a lively newsletter, and national juried exhibits are
other W.C.A. projects. Scattered throughout the nation, local
W.C.A. chapters originate their own programs. In April of 1977
our local Kansas City chapter produced Women Artists '77, an ex-
hibit of area women artists juried by Miriam Schapiro that in-
cluded a day-long symposium. [9] Our keynote speaker, New York

critic Lucy Lippard, placed the work of local women artists in a
national context. In addition to exhibits of contemporary women,
women artists of the past are at last beginning to receive some at-
tention in group and retrospective exhibits by major museums. Ex-
hibits of the work of Romaine Brooks, Lilly Martin Spencer and
Cecilia Beaux are particularly good examples. [10] Previous group
shows of historical women artists have just been climaxed by
Women Artists: 1550-1950, [11] co-curated by Ann Sutherland Harris
and Linda Nochlin.

Due to the rising consciousness of women everywhere and
the context thus created, women's art has not been transformed in
a vacuum. The audience for women's art is large and is increas-
ing. While the women's art movement is affecting the art women
make, it is having an even greater impact on the lives of individual
women artists. We are no longer hoping our femaleness will go
unnoticed or signing our work with initials instead of a first name.
Women are trying to make art with the totality of their experience,
celebrating rather than deleting that part of themselves which is
female. As an undergraduate I have personally experienced the hos-
tility of a traditional painting department toward woman-identified
imagery (which I did not then understand I was doing). Not only
was I isolated from the emerging feminist art movement of the
east and west coasts, I was alienated from the women art students
around me. We perceived one another as competitors for the ap-
proval of our male teachers and classmates. The sense of per-
sonal relief, of community, of context, and of permission that the
women's art movement gives is immense. Thus conscious feminine
identification is becoming a dominant factor in both the form and
the content of the work of many women.

The concept of the ownership of ideas has been strong in
traditional art history; sources and ideas are jealously guarded for
fear someone will publish before you do. The woman's movement
generally has a rich communal-socialist aspect which is in direct
opposition to that attitude. The guarding of research, it is hoped,
will be opened up with the women's art movement and the sense of
sharing for a common goal. An excellent case in point is an arti-
cle on Emily Carr by Gila Yelin Hirsch, published in The Feminist
Art Journal, in which the author generously offers to share her ex-
tensive studies with anyone interested. [12]

The women's art movement is not without its controversies.
A major issue has been the question of female sensibility: whether
the art women make is different in some fundamental way from art
made by men. Such differences, in turn, imply intrinsic differ-
ences between the sexes. This is a dangerous concept considering
that historically the proclamation "women are different" has, in
practice, been interpreted to mean "women are inferior." In this
instance, however, some feminists are saying "women are super-
ior!" It is clear that women and men, as groups, have very dif-
ferent life experiences; that those differences might account for

differences in art produced by the two groups is plausible. Though some feminists claim to perceive basic differences between art produced by women and art produced by men, to date no systematic study of any kind has been done to document such differences. If and when concrete statistics are obtained, we will still be faced with the necessity of differentiating between inborn and learned characteristics, something social scientists have yet to accomplish.

To what differences does a female sensibility refer in contemporary art?[13] Centralized imagery is the most often cited characteristic. Concave, organic, and centered forms are seen as relating to body image and sexuality. The central focus in a work thus serves as a metaphor for a woman's body--or more bluntly, for her vagina or uterus. Understandably, many women artists object to this idea, seeing it as the ultimate sexual stereotype. Some other traits associated with contemporary female sensibility, which might appear somewhat more frequently in the work of women than in men, are the layering of space, the use of "veils," decorative motifs, patterning, grids, symmetry, ritualistic or compulsive techniques, autobiographical content, repetition, ambiguity, and a general preference for the organic over the inorganic. Whether or not femininity results in unconscious symbolism, it is clear that many women today are consciously choosing to work with components of that visual vocabulary to achieve works rich in personal content that can be "read" by a larger and larger audience. This phenomenon is related to a general reaction against empty, contentless art.

Historically, many of the obvious differences between the art work men and women have done can be attributable to environmental factors--violently contrasting societal roles and expectations and harsh restrictions on female education and aspirations. For example, women were long barred from studying the nude. This readily explains a preponderance of portraiture and still life in art produced by women (as compared to men), and the near absence of women from the field of history painting. Whether a layer of other, more subtle differences will be discovered, beyond the obvious ones, is a fascinating question--addressing the basic problem of where imagery comes from and the processes by which artists are influenced by their societies.

We of the feminist art movement must try to avoid dogmatism and resist the urge to define ourselves into categories that are too confining. We can rejoice in the work of Georgia O'Keeffe, even though she rejects feminism and denies any sexual content in her work. And we can affirm the work of the many productive women artists whose work does not seem to reflect a "female sensibility." Such women are certainly valuable role models. The women's movement has always been about increasing the choices and widening the circle. The old dichotomies, the positions of either/ or, of black/white, or of male/female, are too simplistic and do not truly reflect the range of possibilities open to us. We can embrace, absorb, and transcend arbitrary categories that could divide

us. However doctrinaire some factions may be, the women's movement has always resisted coordination from a central committee. It can justly be called fragmented. This is equally true of the feminist art movement. The organizations, projects, and publications briefly outlined earlier describe part of an ever-shifting and evolving multiplicity that make up the feminist art movement. Like the larger movement of which it is a part, the feminist art movement exists on many levels. It is so rich and diverse that no one woman can know it in its totality.

Another debate in progress that also refers to the female sensibility issue is the question of crafts, principally ceramics and fiber. In the majority of cultures women have traditionally been the potters, spinners, weavers, and pliers of needles. By ranking arts as high and low, or as major and minor (with many subdivisions, history painting beats genre much as a full house beats a flush), those areas where men have predominated were ascribed more importance, and those where women participated were correspondingly devalued. There is more at work here than mere coincidence. [14] A benefit of this "benign neglect" is that craftwork, especially needlework, is one of the few areas where the educational process and criteria for quality have been controlled by women. Artistic expression has gone largely unhampered because the rich content of needlework was not simply unintelligible to men but actually invisible to them. [15] It is for these reasons that a special section on needlework has been included in this bibliography.

In the nineteenth century, when women were inundating the field of art, a great many were channeled into minor arts considered more suitable to ladies, such as porcelain painting, jewelry making, glass cutting, and engraving copies of paintings. [16] Most girls' educations were marked by the production of samplers, intricate examples of crewel and embroidery, usually framed for display. [17] For the young women whose educations included "finishing school," some instruction in music and art was also included. Dilettantism was the highest aim of that training. Thus women were taught to be artistic rather than to be artists. George Eliot dismissed the results as "small tinkling and smearing...." [18] Domestic training remained at the core of all women's educations, though some upper class women were allowed a thin veneer of "artistic accomplishments."

Today the tradition of needlework continues. My mother taught me to sew, embroider, and crochet. Needlework's association with domesticity and "woman's proper sphere" has also continued--in home economics classes and in state fairs where patchwork quilts and crocheted tablecloths are displayed next to the canning and baked goods. The contrast between my mother's teaching and my art school training could not have been greater, and represents a profound gulf between male and female institutions. I continue to derive great satisfaction from the skills my mother taught me--ones she learned from her mother. They are a positive part

of my heritage as a woman. The feminist art movement is making possible, at last, the integration of our craft heritage into women's art. Miriam Schapiro's collage work, utilizing fabric, ribbons, and lace, gives us all permission to do likewise. She has described her own joyful discovery that her domestic self and her artistic self need not be alienated from one another. Wholeness is possible. [19]

I was quite impressed when I read of Judy Chicago's struggles to obtain traditionally male skills by going to pyrotechnique school and to auto body painting school. [20] But even as a feminist, I was incredulous when I heard her later speak of her apprenticeship with a woman china painter! A "little-old-lady-hobby" like that, I thought, could not be a medium for legitimate art! My arrogant response was shattered when, a few months later, I actually experienced some of the resulting work. [21] I am now a penitent convert.

Thus many women artists today are consciously choosing to work with materials and techniques that are associated with crafts and with their own heritage as women. This is something no female artists who wished to be taken seriously a few years ago would have dared to do. That this tendency might also indicate unconscious kinship with female ancestors has been suggested but cannot yet be determined. The training most of us receive as girls growing up and the pride in things "womanly" fostered by the women's movement can account for the phenomenon. Increasingly men are using craft materials and processes, but their work is not so often devalued with the label of craft as is that of women. [22] This seems to be one of the chief utilities in continuing to differentiate between art and craft. The old guide line, that art is nonfunctional while craft is functional, ignores the many cultures in which the most vigorous artistic statements have been expressed in functional crafts, such as African masks, oriental carpets, and Navajo blankets.

In the early stages of compiling this book we had the naive hope of presenting an assessment of some women artists. We have found this task to be very premature and certainly beyond our expertise. Many women artists were written off by art historians in the nineteenth century, and their work has remained relatively inaccessible ever since. Many of the women included in this bibliography have not had monographic studies done about them. Catalogues raisonné are available for only a few. The oeuvres of some have not even been roughly established. Much archival work with original source material has yet to be done. Until basic scholarship on many women artists is done by art historians who find the concept of a woman artist plausible rather than ridiculous, a truly even-handed evaluation is impossible. The Brooks, Spencer, and Beaux retrospectives and Women Artists: 1550-1950, mentioned earlier, together with forthcoming dissertations on Angelica Kauffman and Judith Leyster (cited in their individual bibliographies), exemplify the sort of definitive literature that is so badly needed.

The necessity for a firsthand experience with art work, giv-
ing it a chance to "speak for itself," was demonstrated to me by
the work of Elizabeth Vigée-LeBrun a couple of years ago. I had
read some nineteenth century "criticism" of her, consisting mostly
of gossip concerning a coquette life-style. I had heard of her huge
output of portraiture, and seen a few old and very poor reproduc-
tions. I was thus predisposed to think of her as a hack. In the
National Gallery of Art, and later in the Metropolitan Museum, I
had the extraordinary luck to encounter her on her own terms. I
was won over. I found her work exuberant, lush, lyrical, and
marvelously composed. But no catalogue raisonné has yet sorted
out her immense oeuvre.

A truism of art history is that artists influence one another.
But for a woman artist, the discovery of her teacher or principal
influence has often resulted in her summary dismissal as a sort of
artistic camp follower. Judith Leyster has long been dismissed as
a Frans Hals imitator. Elisabetta Sirani is shrugged off as a mi-
nor follower of Guido Reni. Some simple stylistic comparisons in
the recent catalogue by Anne Sutherland Harris and Linda Nochlin
demonstrate how shallow and cursory such judgments have been.

In order to begin to evaluate the contributions of women
artists of the past, it is imperative that the attitudes toward women
and the options open to them in a particular society be understood.
The field of women's studies, which addresses such questions, is
new and only beginning to receive academic legitimacy. Too often
even male artists are viewed as entities unto themselves, immune
to the social, political, and economic conditions of their day.
Linda Nochlin urges us to begin asking which social classes have
produced artists and why. [23] She points out that the ranks of the
aristocracy have produced no artists. She suggests that the expec-
tations and attitudes held by and for that particular group precluded
the development of whatever artistic potential was present. A
similar societal mechanism functioned to limit severely the number
of historical women artists prior to the nineteenth century. Those
women who did compete professionally did so by overcoming odds
more staggering than any their male colleagues could have en-
countered. First of all, women were born into a society convinced
that women were, by definition, lesser human beings. Their occu-
pational choices were limited to wife, nun, and whore. A woman
who aspired for something more had to have the permission and
encouragement of the men in her life. Almost a prerequisite was
the good fortune to be born the daughter of an artist. For with
regular apprenticeship, and later academies, closed to her, only
training available within her family was open.

Some other harsh realities that directly impinged upon the
development of individual women artists were an inability to travel,
the restriction against studying the nude, and the lack of contra-
ception. Even when a professional career was established a woman
still had to contend with a society that considered her an oddity or
a freak of nature. That some women artists prevailed against the

position of their sex is a testimony to the human spirit. That one
cannot point to a female Michelangelo or Dürer should not discredit
the genuine accomplishments of women artists. We believe that
artistic genius, though rare and fragile, is an evenly distributed
human attribute. The conditions necessary for fostering it or for
killing it have yet to be given serious study.

Too often great artists are perceived as miraculous beings
who follow their preordained destinies, oblivious of the hardships
that would have felled an ordinary mortal. This attitude is silly
as well as dehumanizing. It also implies that a potential female
Cézanne certainly would have manifested herself, if in fact, she
were ever born. Virginia Woolf, in A Room of One's Own, elo-
quently dispatched that particular red herring in her description of
what would probably have happened had Shakespeare been born a
woman in sixteenth-century England. [24] Women artists do not need
to be awarded a handicap in evaluating their artistic contributions
--only, like their male confrères--to be studied objectively in the
full context of their lives and milieux.

Art history often reads like an Old Testament chronicle
(Millet begat Courbet, who begat Manet, who begat Degas...).
While imposing a simplistic order upon the staggering mass of
past art, the linear approach ignores all the art produced outside
its narrow path. The work of one generation functions to keep the
work of the next generation relevant (or at least useful) art his-
torically. This implies that the work of one generation

> ... is distinguishable only in the light of an immediately
> preceding generation. This criticism subtly denies a
> whole generation's creative intensity or original intent on
> the basis that the 'look' (in terms of style or technique)
> borrows from or belongs to another generation. [25]

Women artists have certainly suffered from this art-historical ap-
proach because they have so often worked outside of the mainstream.
If art history is approached only in terms of a few pre-selected in-
dividuals passing in review, are we not missing most of the fabric
of art and the vast majority of our visual heritage? It would be-
hoove us to examine occasionally the work kept in museum store
rooms to see if we agree with those who put it there out of sight.

In reexamining women artists many questions need to be re-
solved. The reattribution of a "great" work from a man to a wo-
man has often had the ironic consequence of lessening the work's
importance rather than elevating the status of the woman artist.
Can we accept the attitude that while women have created great
works of art, they have not been great artists? In establishing
the oeuvres of many women artists, much reattribution will be
necessary.

While it is clear that women artists have been influenced
by the art world around them (male), little thought has been given

to the possibility of their influence upon it. This investigation could be especially fruitful among artists married to one another. Surely the relationships of Sonia and Robert Delaunay, of Lee Krasner and Jackson Pollack, or of Judith Leyster and Jan Miense Molenaer were to some extent reciprocal.

The separatism of women's studies programs, of institutions such as the Feminist Studio Workshop, and of projects like this bibliography have been criticized for taking women out of participation in the mainstream just at the point when equality, at last, seems possible. This separatism is made necessary by the bitter fact that the humanities as they exist today refer only to the endeavors and experience of men. The rediscovery, reclamation, and resurrection of women's heritage cannot take place in the midst of unsympathetic male institutions.

Ultimately, integration is necessary. There is a danger of women's art history being cut off from "real" art history. Perhaps in the future it will be possible to combine the male and female halves of experience, to produce a fully human history of art.

NOTES

1. The Hartigan painting has been joined since the introduction was written by a large Nevelson wall piece and more recently by an extraordinary Cassatt pastel. Grandma Moses and Kay Sage are listed in the catalogue as are a few other lesser known women artists. A large part of the anonymous art, especially in the "ethnic" collection, can be safely assumed to be by women. The current construction of a new library at the Nelson Gallery has caused the small women's collection to be returned to storage.

2. Schwartz, Therese. "They Built Women a Bad Art History," Feminist Art Journal, II, no. 3 (Fall 1973): 10-11, 22.

3. Sparrow, Walter Shaw. Women Painters of the World, from the Time of Caterina Vigri, 1413-1463, to Rosa Bonheur and the Present Day (London: Hodder and Stoughton, 1905; New York, 1909; reprint, New York: Hacker Art Books, 1976), p. 11.

4. Sex Differentials in Art Exhibition Reviews--A Statistical Study, and Selected Press Reaction (Los Angeles: Tamarind Lithography Workshop, March 1972). Prepared by Betty Fiske, Rosalie Braeutgam and June Wayne.

5. Raven, Arlene. "Women's Art: The Development of a Theoretical Perspective," Womenspace Journal, I, no. 1 (February-March 1973): 14-20. Parentheses are mine.

6. Skiles, Jacqueline and McDevitt, Janet, eds. A Documentary

Herstory of Women Artists in Revolution (Pittsburgh:
Know, Inc., 1971; 2nd ed. 1973).

7. Chicago, Judy. Through the Flower, My Struggle as a Wo-
man Artist (Garden City: Doubleday & Co., Inc., 1975).
Wilding, Faith. By Our Own Hands, The Woman Artist's
Movement in Southern California, 1970-1976 (Santa Monica:
Double X, 1976). Chapter, "The Feminist Studio Work-
shop," pp. 82-87.

8. The address of the Woman's Building is 1727 North Spring
Street, Los Angeles, California 90012. The telephone
number is (212) 221-6161.

9. Kansas City, Women's Caucus for Art. Women Artists '77,
Kansas City Regional Juried Art Exhibition (April 1977).

10. Breeskin, Adelyn Dohme. Romaine Brooks, "Thief of Souls"
(Washington, D.C.: National Collection of Fine Arts,
Smithsonian Institute Press, March 1971).
Goodyear, Frank and Bailey, Elizabeth. Cecilia Beaux, Por-
trait of an Artist (Philadelphia: Pennsylvania Academy of
Fine Arts, 1974-1975).
Bolton-Smith, Robin and Trettner, William H. Lilly Martin
Spencer, 1822-1902, The Joys of Sentiment (Washington,
D.C.: The National Collection of Fine Arts, June 15-
September 13, 1973).

11. Harris, Ann Sutherland and Nochlin, Linda. Women Artists:
1550-1950 (New York: Alfred A. Knopf, 1976).

12. Hirsch, Gila Yelin. "Emily Carr," Feminist Art Journal, 5
(Summer 1976): 28-31.

13. Brumer, Miriam. "Organic Image = Women's Image?"
Feminist Art Journal, 2 (Spring 1973): 12-13.
Iskin, Ruth. "Sexual Image in Art--Male and Female,"
Womanspace Journal, I, no. 1 (Summer 1973).
Mainardi, Patricia. "A Feminine Sensibility?--Two Views,"
Feminist Art Journal, I (April 1972): 4, 25.
"What Is Female Imagery?" Ms. 3, no. 11 (May 1975): 62-
65, 80-83.

14. This phenomenon is true in other fields. Medicine is more
highly rewarded and regarded than is nursing. College
professors have more status than do public school teachers.

15. Mainardi, Patricia. "Quilts: The Great American Art,"
Feminist Art Journal, II (Winter 1973): 1, 18-23.
Maines, Rachel. "Fanceywork: The Archaeology of Lives,"
Feminist Art Journal, 3 (Winter 1974/75): 1, 3.

16. Baldwin, Carl. "The Predestined Delicate Hand, Some

Second Empire Definitions of Women's Role in Art and Industry," Feminist Art Journal, II, no. 4 (Winter 1973/74): 14-15.

17. Fratto, Toni Flores. "Samplers: One of the Lesser American Arts," Feminist Art Journal, 5, no. 4 (Winter 1976/77): 11-15.

18. Eliot, George (Marian Evans). The Works of George Eliot, vol. VI: Middlemarch, vol. I (New York: The Century Co., 1911), pp. 90-91.

19. She described this personal discovery as a panelist at the Mid-America College Art Association meeting in Kansas City in the fall of 1975. The panel was on content in abstract art.

20. Chicago. Through the Flower..., pp. 36, 58-59.

21. I saw a solo exhibit of Chicago's china painting pieces in Los Angeles, January 1977. Included were The Tender Buttons Series, The Broken Butterfly series, and Did You Know Your Mother had a Sacred Heart? altarpiece.

22. Letter to the editor, from Brenda Miller. Artforum, 11 (April 1973): 9.

23. Nochlin, Linda. "Why Have There Been No Great Women Artists?" Art News, 69, no. 9 (January 1971): 22-39, 67-71.

24. Woolf, Virginia. A Room of One's Own (New York: Harcourt, Brace and World, 1929), pp. 48-50.

25. Harithas, James. "Weather Paint," Art News, 71 (May 1972): 40-43, 63.

A NOTE ON FORM

We have tried to provide complete citations in standard form throughout this bibliography. But there are a number of entries for which this has not been possible. For example, sometimes the publisher or the page numbers will not be given. Rather than delete such entries, we included them in the belief that they were still useful.

References to exhibition catalogues present a special problem to the bibliographer. We have arbitrarily chosen the following form: City. Institution (gallery or museum). <u>Title</u>. Dates. However, when a catalogue contains an important essay, it is still listed in the catalogue section, but under the author's name--as though it were a book.

SECTION I

GENERAL WORKS
CONCERNING WOMEN ARTISTS

This section is composed of a large variety of works, all relating to the general subject of women artists. Surveys, biographical dictionaries, criticism, theory, catalogues, bibliographies, microfilm collections, slide sets, and dissertations are included. In addition there are a few works supplying cultural and social background, and thus the attitudes toward women and their work. While historical women artists are emphasized in this bibliography, works about the contemporary women's art movement are also included. A range of points of view are represented, from misogyny to feminism.

This section is divided into three groups: books, periodicals, and catalogues. Microfilm collections, slide sets, and dissertations are included with the books. Papers delivered before societies are grouped with the periodicals. Full citations are given for works which are listed several times in Section II in shortened form.

BOOKS

Adair, Virginia and Lee. Eighteenth Century Pastel Portraits. London, 1971.

Alcott, Abigail May (Mme. Nieriker). Studying Art Abroad and How to Do It Cheaply. Boston: Roberts Brothers, 1879.
 Louisa May Alcott's sister was considered, prior to her early death, to have had a quite promising art career ahead of her. She was one of the many adventurous American women who journeyed to Paris to study, much like Cassatt. In this volume she offers practical advice concerning such things as the most fatherly ship captains and which ateliers had life classes segregated by sex so that one might properly study the nude. Its usefulness today is its ability to convey the problems and options of women art students in nineteenth century Paris. (See Jeanne Stump in the periodical section for more information about Alcott.)

Alesson, Jean. Les femmes artistes au salon de 1878 et l'exposition universelle. Paris: Au bureau de la gazette des femmes, 1878.
 The success of women artists at this world's fair and their special pavilion had much to do with the inclusion of a Woman's Building at the Chicago World's Columbian Exposition in 1893.

Alpha Kappa Alpha Society. Afro-American Women in Art: Their Achievements in Sculpture and Painting. Greensboro, N.C., 1969.

Anton, Ferdinand. Women in Pre-Columbian America. New York: Abner Schram Enterprises Ltd., 1976.

Armstrong, Tom and others. 200 Years of American Sculpture. New York: Whitney Museum of American Art, 1876.
 Contains excellent section of short "Artists Biographies and Bibliographies" completed by Libby Seaberg and Cherene Holland, which includes a number of women. Photographs of most of the sculptors are included.

Azar, Amie. Femmes peintres d'Egypte. Cairo, 1953.
 This book concerns nine Egyptian women artists.

Barnard College Women's Center. Women's Work and Women's
 Studies 1972. Distributed by Know, Inc. (P.O. Box 86031,
 Pittsburgh, Pa. 15221).

_____. Women's Work and Women's Studies, 1973-74, A Bibli-
 ography. Old Westbury, N.Y.: The Feminist Press, 1975.
 A 370-page bibliography. The Feminist Press' address
 is Box 334, Old Westbury, N.Y. 11568.

Beaton, Cecil and Nicolson, Gail Buckland. The Magic Image:
 The Genius of Photography from 1839 to the Present Day.
 London: Weidenfeld, 1975.
 Several women photographers are discussed.

Bell, Susan G., ed. Women: From the Greeks to the French
 Revolution. Belmont, Calif.: Wadsworth Publishing Co.,
 1973.

Bellier de la Chavignerie, Emile and Auvray, Louis. Dictionnaire
 général des arts du dessin jusqu'à nos jours. 2 vols.
 Paris, 1882-85.

Bénézit, Emmanuel. Dictionnaire critique et documentair des
 peintres, sculpteurs, dessinateurs et graveurs. 8 vols.
 1948-55.
 Bénézit includes many women in his set. Though entries
are short they can often supply a starting place for research.

Benjamin, S. G. W. Contemporary Art in Europe. New York:
 Harper and Brothers, 1877.
 Mentions a few women artists very briefly.

Benoust, Madeleine. Quelques femmes peintres. Paris: Librairie
 Stock, 1936.
 Photographs, reproductions and biographies are included.

Benton, Suzanne. The Art of Welded Sculpture. New York: Van
 Nostrand Reinhold, 1975.
 A truly feminist book that covers not only technique in a
field often considered "masculine," but personal commentary on
the problems of women in the art world and how those problems en-
croach on one's personal life. Includes an extremely beneficial sec-
tion on the presentation and promotion of one's work. Her book is
also distinguished by the use of female pronouns throughout.

Biographical Sketches of American Artists. Lansing: Michigan
 State Library, 1924.
 Includes numerous short accounts of women artists.

Boccaccio, Giovanni. De Claris mulieribus. c.1370. trans. and
 ed. Guarino, G. A. Concerning Famous Women. New
 Brunswick, 1973.

Boccaccio elaborates Pliny's short paragraph on women artists.

Bowlt, John E., ed. and trans. Russian Art of the Avant-Garde: Theory and Criticism, 1902-1936. New York: Viking Press, 1976.
A number of women were in the forefront of the Russian avant-garde, particularly Alexandra Exter, Liubov Popova and Olga Rozanova.

Bryan, Michael. Dictionary of Painters and Engravers, 5 vols. Editor, George Williams. New York: MacMillan Co., 1903.
Many women are discussed in this work.

Bulliet, C. J. The Courtezan Olympia, an Intimate Survey of Artists and Their Mistress Models. New York: Covici, Friede Publishers, 1930.
Chapter 12 is of particular interest: "How the Model Olympia Stepped Down from the Dias and Picked Up a Paint Brush."

Castiglione, Baldassare. Il cortegiano. Urbano, 1528. trans. Singleton, C. S. The Book of the Courtier. New York, 1959.
Ann Sutherland Harris cites the original edition and the some thirty that followed throughout Europe, as popularizing and legitimizing education for upper class women, including art education. This idea had an important impact on the development of women artists.

Cavé, Marie-Elizabeth. La femme aujourd'hui, la femme d'autrefois. Paris, 1863.
See Cavé's bibliography in Section II, the nineteenth century.

Chicago, Judy. Through the Flower, My Struggle as a Woman Artist. New York: Doubleday & Co., 1975.
A personal and passionate autobiography; the first I have seen in which a "successful" woman artist acknowledges the price she paid and shares this experience with her sisters. This is unusual in that most women in her position have chosen to not identify with other women.

Chicago World's Columbian Exposition, Official Catalogue, Part XIV, Woman's Building. Chicago: W. B. Conkey Co., 1893.
The catalogue of the historic Woman's Building merely lists displays by country, artist (all of whom were women), title of the work and catalogue number. It also contains a floor plan of the building. All of which conveys a sense of the magnitude of the entire project. The exhibits are staggering in their number and variety and in the degree to which all nationalities are included.

Clark, Alice. The Working Life of Women in the Seventeenth Century. London, 1919.

Clayton, Elen C. English Female Artists. 2 vols. London: Tinsley Brothers, 1876.
Volume one concerns historical women artists. Volume two deals with then contemporary women, most of whom are obscure or unknown today. In addition to the artists cited in Section II many others are discussed as well. Clayton gives only a vague general list of her sources.

Clement, Clara Erskine. Women in the Fine Arts: From the Seventh Century B. C. to the Twentieth Century A. D. Cambridge, Mass.: Houghton Mifflin & Co., The Riverside Press, 1904; reprint edn., New York: Hacker Art Books, 1974.
This small biographical dictionary provides a rich source on historical women artists. Entries consist of short biographies and descriptions of major works. They range in length from a few lines to several pages. Particular emphasis is placed on nineteenth-century women. Thirty-three black and white reproductions of inferior quality are included that would have better been left out. Clement lists approximately 500 artists. This book suffers a flaw common to most of its era--sources are quoted in only a general way.

Coerr, DeRenne. Art by Women, An Index of Works in Public Collections.
A publication currently being compiled. It will provide "a comprehensive index of all works known to be by women artists regardless of fame or art historical prominence ... a 'what is where' guide useful in the planning of exhibitions, research, publication, and additional collection of women's art." Volunteers are being sought to coordinate the effort across the country. Ms. Coerr can be contacted at 479 34th Ave., San Francisco, CA 94121.

Colding, Torben Holch. Aspects of Miniature Painting: Its Origins and Development. Copenhagen, 1953.
Many women have worked in this format.

Cole, Doris. From Tipi to Skyscraper, A History of Women in Architecture. Boston: I Press Inc., 1973.
A chronological overview. While not an in-depth study, it does include an important chapter on the first serious architectural school for women in the United States, the Cambridge School. Unfortunately it has no index, but it does have a small bibliography.

Collins, J. L. Women Artists in America: Eighteenth Century to the Present. Chattanooga: University of Tennessee, Art Department, Vol. I, 1973; Vol. II, 1975.
This reference index has been reviewed by the ARLIS Newsletter as needing an index and a major re-editing, and thus of being of negligible value.

Crespi, Luigi. Vite de'Pittori Bolognesi. Rome, 1769.
 Records twenty-three women painters as active in Bologna in the sixteenth and seventeenth centuries.

Daniel, Sadie Iola. Women Builders. Washington, D.C.: Associated Publishers, 1931.
 Illustrates the work of seven women architects.

Daniels, Arlene Kaplan. A Survey of Research Concerns on Women's Issues. Washington, D.C.: The Project on the Status and Education of Women of the Association of American Colleges, 1976.
 An overview and bibliography. The address is 1818 R. Street, N.W., Washington, D.C. 20009.

Daubié, J. V. La femme pauvre au XIXe siècle. Paris, 1866.

Dawson, Bonnie. Women's Films in Print, An Annotated Guide to 800 Films by Women. San Francisco: Booklegger Press. Address is 555 29th St., 94131.

Doty, Robert. Human Concern/Personal Torment: The Grotesque in American Art. New York: Whitney Museum, 1969.
 "A fair sampling of contemporary female artists.... "

Duhet, P.-M., ed. Les femmes et la révolution, 1789-1794. Paris, 1971.

Ebert, Lee R.; Heath, Mary; and Baskin, Lisa, eds. Women: An Issue. Boston, Toronto: Little, Brown & Co., 1972.
 The chapter, "Art's Looking Glass," will be cited for a number of women in Section II. "A brilliantly diverse exploration into just what it means to be a woman and a human being." Self-portraits of fifteen women artists are included.

Eckenstein, Lina. Women Under Monasticism. Cambridge: University Press, 1896.

Edwards, Lee R., et al., Woman: An Issue: see Addenda.

Ellet, Elizabeth Fries Lummis. Women Artists in All Ages and Countries. New York: Harper & Brothers, 1859.
 This book has unfortunately not yet been reprinted; it can only be read today in the rare and fragile original edition. Ellet's book serves as a principle source for Clement's Women in the Fine Arts..., which she acknowledged. This one is the more readable of the two. It is organized by century and geographic area. A substantial amount of Ellet's text was translated from Ernst Guhl's Die Frauen in die Kunstgeschichte, cited later.

Elliot, Maude Howe, ed. Art and Handicraft in the Woman's Building of the World's Columbian Exposition of 1893.
 Elliot's is the best contemporary source about the Wo-

man's Building, razed after the fair. The only reproductions of the specially commissioned murals are to be found there; the most important one being Modern Woman, by Mary Cassatt. Elliot was a member of the Board of Lady Managers, and thus this is in some respects an "official" version.

Encyclopedia of World Art. 15 vols. 1959.
 Only rarely is a substantiative account given of a women artist. Usually the women listed in the index are mentioned in a sentence that begins something like, "Also painting in this time period were...."

Fidiere, Octave. Les femmes artistes a l'Académie Royale. Paris: Charavey Frères, 1885.

Fierro, Sister Nancy. Premiere: Keyboard Works by Women Composers. Hollywood: Avant Records, 1974.
 The history of women in music is beginning to be re-claimed.

Films by Women. Toronto: Canadian Film Maker's Distribution Center, 1976.
 Lists feature-length and short films by Canadian women. The address is 406 Jarris St., Toronto, Ontario.

Fowler, Carol. Contributions of Women--Art. Minneapolis: Dillon Press, 1976.
 This is a part of a series. It consists of six brief bi-ographies written for ages ten to fourteen. An appendix includes thirteen sketches of other artists and one patron/collector.

Frost, Henry Atherton and Sears, William. Women in Architec-ture and Landscape Architecture. Northampton, Mass.: Smith College, 1928.

Furniss, Harry. Some Victorian Women, Good, Bad and Indif-ferent. London, 1923.
 Furniss was a raconteur and caricaturist. His book contains a chapter on women artists. Also included are stories about models, whom he thought to be a curious and simple breed. "Period sexism."

Garrard, Mary. Slides of Works by Women Artists: A Source Book. Women's Caucus for Art, 1974.
 Syllabi for women's studies in studio and art history have long decried the difficulty of obtaining slides of work by women, whe-ther contemporary or historical. This work lists 666 women artists and directs the reader to over 1600 specific slides of their work. An updated edition is being prepared. The book is available from Garrard at 4907 Upton Street, N.W., Washington, D.C. 20016.

Gautier, Xavière. Surréalisme et sexualité. Paris, 1971.
 Many women artists have been and continue to be active in Surrealism.

Gerdts, William H. American Neo-Classic Sculpture, the Marble
 Resurrection. New York: The Viking Press, 1973.
 An excellent and profusely illustrated volume. Edmonia
Lewis, Harriet Hosmer and Vinnie Ream Hoxie are some of the
American women sculptors dealt with in the book. He presents an
enormous amount of bibliography on each artist, which we have taken
liberal advantage of in the sections dealing with the individual wo-
men. The book does suffer from not being better indexed--it is
quite difficult to find all the illustrations and information on indi-
vidual artists.

Gernsheim, Helmut and Gernsheim, Alison. History of Photogra-
 phy from the Camera Obscura to the Beginning of the
 Modern Era. New York: McGraw-Hill, 1969.

The Gerritsen Collection of Women's History. Glen Rock, N. J. :
 Microfilming Corporation of America.
 Over 4, 000 volumes of books, periodicals and pamphlets,
covering the social, political and intellectual history of women on
microfilm. The address is 21 Harristown Road, Glen Rock, N. J.
07452.

Graham, Mayo. Some Canadian Women Artists. Ottawa: National
 Gallery of Canada, 1975.

Gray, Camilla. The Great Experiment: Russian Art, 1863-1922.
 New York: Harry N. Abrams, Inc. , 1962.

Guhl, Ernst von. Die Frauen in die Kunstgeschichte. Berlin:
 Guttentag, 1858.
 Ellet, cited previously, took much--with acknowledgment
--from this book. See "Women Artists," a review, cited in the
periodical section.

Guicciardini, Ludovico. Descrittione dei Paesi Bassi. Antwerp,
 1567.
 Ann Sutherland Harris cites from Guicciardini's Account
of the Ancient Flemish School of Painting. London, 1795. She
says he records seven women as active artists in 1567. Susan
Horenbout (see Susannah Hourbout in Section II, the sixteenth cen-
tury), Clara Skeyers, Lavina (Teerlinc), and Ann Smiter; four of
them are miniaturists.

Hale, Nancy. The Life in the Studio. Boston: Little, Brown and
 Co. , 1969.
 Beautifully written reminiscences by the daughter of the
painter Lilian Wescott Hale (1881-1963). Illustrates how life in the
studio was integrated into the totality of the artist's life and family.

Halle, F. W. Women in Soviet Russia. New York, 1933.

Hanaford, Phebe A. Daughters of America. Augusta, Maine:
 True & Co. , 1883.

Chapter ten is entitled "Women Artists," pp. 271-304.
She briefly discusses a large number of women. Much of her material has been derived from Ellet's book.

Harksen, Sibylle. Women in the Middle Ages. New York: Abner
Schram Enterprises Ltd., 1976.

Harris, Ann Sutherland and Nochlin, Linda. Women Artists:
1550-1950. New York: Alfred A. Knopf, 1976.
The landmark catalogue accompanying the exhibit of historical women artists that opened in January of 1977; the show is
traveling throughout the country. The catalogue contains definitive
essays, bibliographies, and numerous reproductions, some of them
in color. It is without doubt the most thorough and scholarly work
on women artists available. This work is so rich and important a
source of bibliographical wealth that in trying to incorporate all its
nuances, we considerably delayed the release of our manuscript for
this bibliography. Slides are available from Rosenthal listed in
the Addenda. See the catalogue section under Los Angeles for
additional annotation.

Hart, Charles Henry. Some Lessons of Encouragement from the
Lives of American Women Artists. Philadelphia, 1906.
This was an address delivered before the Philadelphia
School of Design for Women at the Annual Commencement, on May
31, 1906. Hart discusses Patience Wright and Harriet Hosmer.
Wright was a Quaker who was active as a sculptor in wax in the
late seventeenth century. See Clement's entry on her and Sellers'
book later in this section. In addition to Hosmer, Hart mentions
some of the other female neo-classical sculptors.

Hartley, M. Adventures in the Arts. New York, 1921.
See chapter, "Some Women Artists," 112ff.

Hayes, Danielle B. Women Photograph Men. New York: William
Morrow, 1977.
A humanistic collection of images of men, as seen by
women. It is a relief to see that there is no reverse sexism.
The introduction is by Molly Haskell; see the periodical section for
a reprinted adaptation of that essay.

Hess, Thomas B. and Baker, Elizabeth C. Art and Sexual Poli-
tics, Women's Liberation, Women Artists, and Art History.
New York: Art News Service, Collier Books, 1973.
Essentially a reprint of the special issue of Art News
devoted to the issue of women in art, 69, no. 9 (January 1971).
Most of the important articles have been cited individually.

Hess, Thomas B. and Nochlin, Linda, eds. Woman as Sex Object,
Studies in Erotic Art, 1730-1970. Art News Annual XXXVIII.
Newsweek, Inc., 1972.
A lavish, scholarly, entertaining and even feminist treat-
ment.

Hildebrandt, Hans. Die Frau als Kunsterin. Berlin, 1928.

Hirsch, Anton. Die Frauen in der bildenden Kunst. Stuttgart, 1905.

History of Women. Woodbridge, Conn.: Research Publications, Inc. (Microfilm.)
Described as comprehensive and "the world's most important holdings of women's history resources have been brought together ... interdisciplinary...." The address is 12 Lunar Drive, Woodbridge, Conn. 06525.

Howitt, Anna Mary. An Art Student in Munich. Boston: Ticknor, Reed, and Fields, 1854.

Hsu, Chung-p'ei. The Position of Women in Free China: Chinese Women Show Their Mettle in the Arts. Taipei, Taiwan: Culture Publishing Foundation, 1953.

Interviews with Women in the Arts. Part 2. New York: Tower Press, 1976.
Project of class taught by Janet Kozloff at School for Visual Arts in 1973-74. Each student interviewed a woman artist. Includes reproduction of each artist's work. Part I appeared in Spring 1975. A limited number of copies are available from: Women in the Arts Publication, c/o School for Visual Arts, 209 East 23rd Street, New York, N.Y. 10010.

Kampen, Natalie. Images and Status of Roman Working Women: Second and Third Century Sculpture from Ostia. (Ph.D. dissertation, Brown University, 1976.)

Karas, Maria. The Woman's Building, Chicago 1893, The Woman's Building, Los Angeles 1973- . Los Angeles: Woman's Graphic Center, May 1975.

Kelso, Ruth. Doctrine for the Lady of the Renaissance. Urbana, Ill., 1956.

Kirkland, Winifred. Girls Who Became Artists. New York, 1934; reprinted Freeport, N.Y.: Books for Libraries Press, 1967.
This is for juvenile readers.

Kowalski, Rosemary Ribich. Women and Film: A Bibliography. Metuchen, N.J.: The Scarecrow Press, 1976.

Lexikon der Frau. 2 Vols. Zurich, 1953.

Lippard, Lucy. From the Center. Feminist Essays on Women's Art. New York: E. P. Dutton and Co., 1976.
Essays written by Lippard since 1971, plus a section of fiction.

Macksey, Joan and Macksey, Kenneth. The Book of Women's
Achievements. New York: Stein and Day, 1976. pp. 194-
209.
Contains chapter entitled "As Artists" that provides a
biographical survey of seventy-two women artists.

Malvasia, Carlo Cesare. Felsina Pittrice vite de pittori bolognesi.
2 vols. Bologna, 1678.
These are two beautifully set and bound volumes (if you
have the good fortune to see the first editions). Vol. I contains
the biography of Lauinia (Lavinia) Fontana, pp. 219-224; and Vol.
II that of Elisabetta Sirani, pp. 453-482. Both are faced with en-
graved portraits of the artists. Citing from an 1841 edition,
Harris notes mention of Anguissola, Fontana and Galizia in Vol. II,
p. 92, in the life of Baldassare Galanino.

Mann, Marjory and Noggle, Ann. Women in Photography, An His-
torical Survey. San Francisco: Museum of Art, 1975.
The introduction is by John Humphrey.

Marrow, Deborah. The Art Patronage of Maria de Medici. (Ph.D.
dissertation in progress, University of Pennsylvania.)

Mathey, François. Six femmes peintres. Paris, 1951.
Mathey discusses Berthe Morisot, Eva Gonzales, Sera-
phine Louis, Suzanne Valadon, Maria Blanchard and Marie Lauren-
cin. In her excellent bibliography Krasilovsky (see the periodical
section) praises the color reproductions but condemns the text as
"incredibly sexist."

Mazerod, L. Les femmes célèbres. 2 vols. Paris, 1960-61.

Miner, Dorothy. Anastaise and Her Sisters. Baltimore: Walters
Art Gallery, 1974.
A pamphlet summarizing the current information available
on medieval women illuminators. Christine de Pisan, writing in
her Cité des dames, c. 1405 says, "With regard to painting at the
present time I know of a woman called Anastaise who is so skill-
ful and experienced in painting the borders of manuscripts and the
backgrounds of stories that no one can cite a craftsman in the city
of Paris, the center of the best illuminators on earth, who in these
endeavors surpasses her in any way."

Mitchell, Peter. Great Flower Painters: Four Centuries of Flor-
al Art. London, 1973.

Moore, Julia Gordon. History of the Detroit Society of Women
Painters and Sculptors 1903-1953. Detroit, 1953.

Munsterberg, Hugo. A History of Women Artists. New York:
Clarkson N. Potter, Inc., 1975.
This is a survey covering from the prehistoric era to
the present day. Pottery, weaving, painting, graphics, sculpture

and photography are included. Although the book has 110 adequate illustrations, it is sorely lacking in bibliography and footnoting. Munsterberg takes a patronizing, condescending attitude in his treatment of women artists and is frequently contradictory in his assessment of their historical status.

Neilson, Winthrop and Francis. Seven Women: Great Painters. Philadelphia: Chilton Book Company, 1969.
　　　　The Neilsons provide chapters and reproductions on Angelica Kauffman, Elizabeth Vigée-leBrun, Berthe Morisot, Mary Cassatt, Cecilia Beaux, Marie Laurencin and Georgia O'Keeffe. One of the most valuable features of this book is an extensive list of the works of each woman on public display and its location. But otherwise the book is quite weak. The information is essentially correct and therefore valuable. But it too often lapses into the maudlin and into apologies which none of these women needs. However, we must admit that if we had encountered this book as young women, it would have gone a long way toward encouraging us. Its mere existence is helpful. The bibliography is inferior. The readers to whom this book is apparently aimed (children and people with no art history background) deserve better.

Nemser, Cindy. Art Talk. New York: Charles Scribner's Sons, 1975.
　　　　Nemser was the editor of the New York-based Feminist Art Journal. Here she publishes interviews with Barbara Hepworth, Sonia Delaunay, Louise Nevelson, Lee Krasner, Alice Neel, Grace Hartigan, Marisol, Eva Hesse, Lila Katzen, Eleanor Antin, Audry Flack and Nancy Grossman. Good black and white reproductions and selected bibliography are included for each artist. Nemser's interviews are out of the ordinary in that she explores the lives and attitudes of her subjects as women, in addition to the usual information yielded in this format. How successful women artists have coped with the problems of a society that considered them housewives with hobbies, of child rearing, of basic economic survival is crucial information. It has been hitherto ignored by the art press. We must here acknowledge the use of much of the bibliographic data she provided in Section II.

Newhall, Beaumont. The History of Photography from 1839 to the Present Day. New York: Museum of Modern Art, 1964.

Oulmont, Pierre. Les femmes peintres du dix-huitième siècle. Paris, 1928.

Parada Y Santin, Jose. Las Pintaras Espanolas, boceto historico-biographico y artistico. Madrid: Imprint de Asilo de Huerfanos des S. C. de Jesus, 1902.

Pavière, Sydney Herbert. A Dictionary of Flower, Fruit and Still Life Painters. 3 vols. Leigh-on-Sea, 1962-64.

Petersen, Karen and Wilson, J. J. Women Artists: Recognition

and Reappraisal, from the Early Middle Ages to the Twentieth Century. New York: Harper and Row (Colophon paperback), June 1976.
 This work discusses over 250 women and includes many reproductions. Rather than a strictly scholarly work, it is conceived as a badly needed supplement to traditional art survey textbooks, a niche it fits admirably. Petersen and Wilson have also produced four slide sets--also sorely needed. 1. Women Artists, an Historical Survey. (Early Middle Ages to 1900). 120 slides with notes. 2. Women Artists: The Twentieth Century. 3. Women Artists: Third World. 4. Women Artists: Images--Themes and Dreams. The last three sets each contain eighty slides and include notes. The text and the four slide sets form a unique educational "first-aid kit"--invaluable alike to feminists launching women's studies programs and to traditionally trained art historians attempting to redress the old imbalances.

Pevsner, Nikolaus. Academies of Art, Past and Present. Cambridge, 1940.

Pilkington, Matthew. A General Dictionary of Painters. London: Thomas McLean, 1824. 2 vols.
 Brief biographical entries that include a number of women artists.

Pliny the Elder. The Elder Pliny's Chapters on the History of Art. Chicago: Argonaut Publishers, Inc., 1968.
 The translation is by K. Jex-Blake. Commentary and introduction are by E. Sellers. The preface and bibliography are by Raymond V. Schoder. Guhl, Clement, and Ellet all offer rehashings of the slim data regarding women artists of classical times. Their common source is Pliny who begins the brief paragraphs allotted to them (pp. 105, 171) with, "women too have been painters." He mentions Timarete, Eirene, Kalypso, Aristarete, Iaia and Olympias.

Poisson, Georges. La femme dans la peinture française moderne. Paris: Plon.
 Black and white reproductions of Lydis, Laurencin, Valadon, Morisot, Luks, Fini, Cassatt and Abbema.

Pomeroy, S. B. Goddesses, Whores, Wives and Slaves: Women in Classical Antiquity. New York: Schocken, 1975.

Power, Eileen. Medieval Women. Cambridge, 1975.
 Edited by M. M. Postan. See especially Chapter Three, "The Working Woman in Town and Country."

Ragg, Laura M. The Women Artists of Bologna. London: Methuen & Co., 1907.

Rodriguez-Prampolini, Ida. El surrealismo y el arte fantastico de Mexico. Mexico City: Universidad Nacional Autonoma de Mexico, 1969.

Rogers, Katherine. The Troublesome Helpmate, A History of
Misogyny in Literature. Seattle: University of Washington
Press, 1966.
Rogers' work is indirectly related to the topic at hand.
But it provides an engrossingly readable and impeccably documented
survey of the attitudes toward women and their abilities, as re-
flected in English and American literature and in its Biblical and
classical forebears.

Ruddick, Sarah, and Daniels, Pamela, eds. Working It Out, 23
Women Writers, Artists, Scientists and Scholars Talk about
Their Lives and Work. New York: Pantheon, 1977.
Forward by Adrienne Rich. See especially Miriam Scha-
piro's "Notes from a Conversation of Art, Feminism and Work. "

Sachs, Hannelore. The Renaissance Woman. New York: McGraw-
Hill Book Co., 1971.
This book was translated from German by Marianne
Herzfeld and revised by D. Talbot Rice. The chapter entitled
"The Practice of Art, " pp. 36-40, outlines the status of women in
the Renaissance related to art, including literature. She mentions
the often noted phenomenon of women artists learning from their
fathers. Large reproductions are included of work by Sofonisba
Anguissola, Catharina van Hemessen and Properzia de'Rossi. It
is an excellent cultural and sociological survey of the status of wo-
men in Renaissance society. It is beautifully illustrated throughout
with reproductions of the contemporary art of the era.

Schapiro, Miriam, ed. Anonymous Was a Woman, Documentation
of the Women's Art Festival and a Collection of Letters to
Young Women Artists. Valencia, Ca.: Feminist Art Pro-
gram, California Institute of the Arts, 1974.
The title is derived from Virginia Woolf's famous lines
in her book, A Room of One's Own, cited in this section. This is
a product of the Feminist Art Program, now functioning independ-
ently as the Feminist Studio Workshop. More can be learned about
it in Chicago's Through the Flower and Spear's Women's Studies,
also cited in this section. A basic premise is the necessity of
separatism from male teachers and students because feminine ex-
perience is devalued rather than affirmed in traditional settings.
In this it is similar to consciousness-raising. The section of
letters to young women artists (by older women artists) is inspired
by a general lack of role models for female art students.

_____, ed. Art: A Woman's Sensibility. La Jolla, Ca.:
Laurence McGilbery, 1975.
Seventy-six contemporary women artists are depicted to-
gether with their own statements. At the request of the Feminist
Art Program, California Institute of the Arts, each woman sub-
mitted one photograph of her work, one photograph of herself and
a statement about the intentions of her art.

Seibert, Ilse. Women in the Ancient Near East. New York:
Abner Schram Enterprises, Ltd., 1976.

Sellers, Charles Coleman. Patience Wright, American Artist and
Spy in George III's London. Middleton, Conn. : Wesleyan
University Press, 1976.
In Wright was a sculptor who worked in wax. Harris and
Nochlin mention her on page 29 of their catalogue, as do Hart and
Clement, cited earlier in this section.

Sex Differentials in Art Exhibition Reviews--A Statistical Study and
Selected Press Reaction. Los Angeles: Tamarind Lithog-
raphy Workshop, March 1972.
In Prepared by Betty Fiske, Rosalie Braeutigam and June
Wayne. This is a landmark study documenting the vast discrimi-
nation against women artists in the reviews of their shows by the
art press and other media.

Short, Ernest. The Painter in History. London: Hollis and Car-
ter, 1948.
In this lengthy review of painting history, two brief pages
summarize the entire contribution of women. The women men-
tioned by Short tend to be forgotten, minor English artists.

Singer, C. et al., eds. A History of Technology. Oxford, 1957.
Ann Sutherland Harris cites plate 16, which depicts a
woman painting decoration on a Grecian vase in a pottery workshop,
as probably being the oldest image of a woman artist at work.

Skiles, Jacqueline. The Women Artists Movement. Pittsburgh,
Pa. : Know, Inc.
This was originally a paper delivered before the Ameri-
can Sociological Association Annual Meeting on August 28, 1972.
It can be ordered from Know, Inc. at P.O. Box 86013, 15221.

_____ and McDevitt, Janet, eds. A Documentary Herstory of
Women Artists in Revolution. Pittsburgh, Pa. : Know, Inc.,
1973.
The early 1970s have seen increasing activism on the
part of women artists. A focal point for that activity has been
W.A.R.'s (Women Artists in Revolution) confrontation with New
York galleries and museums. A Documentary Herstory ... is a
fascinating compilation of position papers, posters, correspondence
and magazine and newspaper articles that graphically outline that
struggle.

Sonnenfeld, Amanda. Deutsche Frauengestalten: Zehn Lebenbe-
schreibungen nervorrangender Frauen für die Mädchenwelt.
Stuttgart, 1910.

Sparrow, Walter Shaw. Women Painters of the World, from the
Time of Caterina Vigri, 1413-1463 to Rosa Bonheur and the
Present Day. London: Hodder and Stoughton, 1905; New
York 1909; reprint, New York: Hacker Art Books, 1976.
This book presents much important and obscure informa-
tion about historical women artists. The entire index is reprinted

in the Women's History Research Center's publication, Female
Artists Past and Present, listed later in this section. However,
Sparrow damns women from the onset with a "nursery nature."
Schwartz (see the periodical section) cites Sparrow's book as one
of a species that arose after 1850 in which women artists were
revived in order to be attacked and "listed as second rate, unim-
portant and amateurs who should be directed and advised." Never-
theless, it includes the following essays by Sparrow: "Women
Painters in Italy Since the Fourteenth Century"; "Early British
Women Painters"; "Women Painters in the United States." Other
essays are: "Modern British Women Painters," by Ralph Peacock;
"Women Painters in Belgium and Holland," by N. Jany; "Women
Painters in Germany, Austria, Russia, Switzerland and Spain," by
Wilhelm Scholerman; and "Some Finnish Women Painters," by
Helena Westermarck.

Spear, Athena Tacha and Gellman, Lola B. Women's Studies in
 Art and Art History, Description of Current Courses with
 Other Related Information. New York: Women's Caucus
 for Art, College Art Association, January 1975.
 The second edition. This work consists chiefly of forty
course syllabi, many of which include valuable bibliography on
women artists. It is available from Dr. Lola B. Gellman at 14
Lakeside Dr., New Rochelle, N.Y. 10801. See also Fine's up-
dated 3rd edition listed in the Addenda.

Stein, Judith E. The Iconography of Sappho: 1775-1875. (Ph.D.
 dissertation in progress, University of Pennsylvania.)

Sterling, Charles. Still Life Painting from Antiquity to the Present
 Time. Paris, 1959.

Sullerot, E. Histoire et sociologie du travail féminin. Paris, 1968.

Taft, Lorado. The History of American Sculpture. New York:
 MacMillan Co., 1930.
 Includes a chapter on women sculptors.

Thieme, Ulrich and Becker, Felix, eds. Allgemeines Lexikon der
 bildenden Kunstler von der Antike bis zur Gegenwart. 37
 vols. 1907-1950. Six supplementary volumes on twentieth-
 century art are by Vollmer.
 A surprising number of women artists are included. The
short entries often include some bibliography.

Thorpe, Margaret Farrand. The Literary Sculptors. Durham,
 N.C.: Duke University Press, 1965.

Thurston, Rev. R. B. Eminent Women of the Age. 1869.

Torelli, Vieri. Pitricci e scultrici Italiane d'Oggi. Rome:
 Flammenghi, 1953.
 Krasilovsky (see periodical section) says, regarding the
selections on Italian women painters and sculptors, that it is a

tasteful publishing product but essentially useless.

Torre, Susanna, ed. Women in American Architecture: A His-
toric and Contemporary Perspective. New York: Whitney
Library of Design, and Watson-Guptill Publications, 1977.
Foreword by Marita O'Hare, Architectural League of
New York. Documents the exhibition held at the Brooklyn Museum
from February 23 to April 15, 1977. 250 black and white illus-
trations. There are five sections: Part I, "Women's Place":
The Design of Domestic Space; Part II, describes the careers of
women architects from the mid-nineteenth century through the
1960's; Part III, women as architectural critics; Part IV, the con-
temporary status of women architects; and Part V, a discussion of
spatial symbolism, Lucy Lippard and others.

Trapp, Kenneth R. The Cincinnati Ceramic Movement and Rockwood
Pottery 1876-1916. (Ph.D. dissertation in progress, Illinois,
Urbana.)
See also Macht, Carol, The Ladies, God Bless 'Em, in
the catalogue section.

Tucker, Anne, ed. The Woman's Eye. New York: Knopf, 1973.
A survey of important women photographers, including
Kasebier, Johnston, Bourke-White, Lange, Abbott, Morgan, Arbus,
Wells, Dater and Nettles. Large, clear black and white reproductions.

Tuckerman, Henry T. Book of the Artists. 1st published 1867.
Facsimile edition, 1966, James F. Carr Publisher.
Mentions several women sculptors.

Tufts, Eleanor. Our Hidden Heritage: Five Centuries of Women
Artists. New York: Paddington Press Ltd., Two Conti-
nents Publishing Group, 1974; paperback reprint 1977.
This is one of the most exciting, beautiful, scholarly and
useful books to date on women artists. There are chapters on:
Sofonisba Anguissola, Lavinia Fontana, Levina Teerling, Catharina
van Hemessen, Artemisia Gentileschi, Judith Leyster, Elisabetta
Sirani, Maria Sibylla Merian, Rachel Ruysch, Rosalba Carriera,
Angelica Kauffmann, Elisabeth Vigée-LeBrun, Sara Peale, Rosa
Bonheur, Edmonia Lewis, Suzanne Valadon, Käthe Kollwitz, Paula
Modersohn-Becker, Gwendolyn John, Natalia Goncharova, Germaine
Richier, and I. Rice Pereira. Each chapter includes a portrait,
several good black and white reproductions and extensive bibliogra-
phy. It was that bibliography which formed the nucleus of this one.

Urquidi, Jose Macedonio. Bolivianas ilustres: heroinas escri-
toras, artistas, estudios, blograficos y criticos. Las Pax:
Escuela Tipografica Salesiana, 1918.

Vachon, Marius. La femme dans l'art, les protectrices des arts,
les femmes artistes. 2 vols. Paris, 1893.

Vasari, Georgio. Lives of Italian Painters. Edited and prefaced
by Havelock Ellis. Vol. 4. London: Walter Scott, Ltd., p. 186.

_____ . Lives of the Most Eminent Painters, Sculptors and
Architects. Translated by Guston Devere. Vol. 10. Lon-
don: Phillip Lee Warm, 1912-15.

Viallet, Bice. Gli autoritratti femminili delle R. R. Galleria degli
Uffizi. Rome, c. 1924.

Vicinus, Martha, ed. Suffer and Be Still, Women in the Victorian
Age. Bloomington and London: Indiana University Press, 1972.
Chapter Four is of particular interest. It is "Marriage,
Redundancy or Sin: The Painter's View of Women in the First
Twenty-five Years of Victoria's Reign" (pp. 45-76). Other chap-
ters outline women's status in other areas of Victorian society.

Wald, Carol. Myth America: Picturing Women, 1865-1945. New
York: Pantheon Books, 1975.

Walpole, Horace. Anecdotes of Painting in England. Vol. 3.
London: Henry G. Bohn, 1849.
In this chronological examination, with emphasis on royal
patronage, several women who worked in England are discussed.

Weese, Maria and Wild, Doris. Die schweizer Frau in Kunstge-
werbe und bildender Kunst. Zurich, 1928.

Wiesenfeld, Cheryl et al., eds. Women See Women. New York:
Thomas Y. Crowell Co., 1975.
Photographic anthology and short biographies of over
eighty women photographers. Introductory essay by Annie Gottlieb.

Wilding, Faith. By Our Hands. Santa Monica, Calif.: Double X,
1977.
A documentation of the women artist's movement in
Southern California from 1970-1976.

Williams, Ora. American Black Women in the Arts and Social
Sciences: A Bibliographic Survey. Metuchen, N. J.: Scare-
crow Press, 1973.

Wolff-Arndt, Phillippine. Wir Frauen von einst; Erinnerungen
einer Malerin. Munich, 1929.

Women and Film: A Resource Handbook. Washington, D. C.:
Project on the Status and Education of Women, Association
of American Colleges (1818 R. St., N. W., 20009).

Women Artists 18th to 19th Century. Stamford, Conn.: Sandak,
Inc., 1976.
A set of 120 glass mounted slides. A smaller selection
of 60 is also available. While the availability of any slides of
work by women artists must be viewed as a positive improvement,
this collection is obviously a quickly compiled effort of slides al-
ready on hand. It appears to be designed to exploit the current

interest in women artists, without meeting the genuine needs of
that market. It can in no way be viewed as comprehensive. Of
120 slides, only eight are from the nineteenth century, and only
two "represent" the eighteenth century. The balance of the set,
approximately half painting and half sculpture, provides uneven
coverage of more contemporary women artists.

Women's Films in Print. San Francisco: Booklegger Press,
1976.
Annotated guide to 800 16mm films by women. The ad-
dress is 555 29th Street, San Francisco, California 94131.

Women's History Research Center, Inc. Female Artists, Past and
Present. Berkeley, April 1974.
In addition to a large bibliography on historical women
artists (one of our sources), directories of women in the visual
arts are listed by media with an emphasis on contemporary women.
W. H. R. C. is at 2325 Oak St., Berkeley CA 94708.

_____. Female Artists--1975 Supplement. Berkeley, October
1975.
A supplement to the above.

_____. Directory of Films by and about Women. Berkeley,
1972.

Women's Work: American Art 1974. Stamford, Conn.: Sandak,
Inc., 1974.
A slide set of 76 glass mounted slides from the exhibi-
tion of the same name held at the Philadelphia Civic Center Mu-
seum, Spring, 1974. The show was organized by "Philadelphia
Focuses on Women in the Visual Arts." Judith Stein provides the
commentary that accompanies the set. From the listing it appears
to be a fairly good cross section of contemporary women artists
of both painting and sculpture.

Woolf, Virginia. A Room of One's Own. New York: Harcourt,
Brace and World, 1929; reprinted many times.
This is actually a long essay in which the famous quote
is found, 'Indeed, I would venture to guess that anon, who wrote
so many poems without signing them, was often a woman." She
explores the nature of the creative process and the peculiar his-
torical position of women in relationship to it. Though she uses
literature as her example of creativity, her analysis applies equal-
ly well to other creative fields.

Zinserling, Vera. Women in Greece and Rome. New York:
Schram, 1973.
The limited and circumscribed sphere of ancient women
is described. Their small numbers are plainly the result of pover-
ty of opportunity. The lines of a poem whose author I do not know,
recur to me, 'Our heroes died in childbirth, our geniuses were
never taught to read or write."

PERIODICALS

Alf, Martha. "My Interest in Women Artists of the Past." Wo-
manspace Journal. I, no. 2 (April-May):15-16.
Alf is interested in the lifestyles and conditions of his-
torical women artists. She observes the prevalence of daughters
of artists and their variety of marital experience.

Alloway, Lawrence. "Women's Art in the 70's." Art in America.
64 (May-June 1976):64-72.
An examination of the history, results, and problems of
the women artists movement.

Art Education. (November 1975).
Issue edited by Bette Acuff. Scholarly articles on wo-
men in art and art education, and sexual stereotyping. Available
from the National Art Education Association, 1916 Association
Drive, Reston, Virginia.

Art Journal. XXXV, no. 4 (Summer 1976).
An issue on women in art. Articles by Garrard, With-
ers, Lippard, White, Schlossman, Muto, Brodsky and Vogel are
cited individually in this section. The cover is especially delight-
ful, featuring a sepia reproduction of an old photograph of neoclass-
ical sculptor Harriet Hosmer, surrounded by some twenty-four of
her male assistants, circa 1860!

Art Magazine. 5 (Fall 1973).
Published in Toronto. A special issue devoted to women
in art. Included are: "What Is It Like to Be a Woman in Art?,"
and Fleisher's "Love or Art," cited later in this section, and
Chalmers F. Graeme's "The Woman as an Art Viewer."

Art News. 69, no. 9 (January 1971).
The bulk of this issue is devoted to the question of wo-
men in the arts. Important articles by Linda Nochlin, Elizabeth
C. Baker and Thomas B. Hess are cited individually in this sec-
tion. Good color plates and other reproductions of women's art
are included. A number of contemporary women artists contribute
their response to Nochlin's question, "Why Have There Been No
Great Women Artists?" Most of the text is reprinted in: Hess,
Thomas B. and Baker, Elizabeth C., eds. Art and Sexual Poli-
tics, Women's Liberation, Women Artists and Art History. New

York: Art News Service, Collier Books, 1973.

Artes Visuales. (January-March 1976).
 The periodical published by the Museo de Arte Moderno
(Bosque de Chapultepec, Reform y Ghandi, Mexico 5, D.F. Mexi-
co.) Articles on women, art and femininity by contemporary Mexi-
can women artists. Also included are articles by Charlotte Moser,
Lippard, Chicago, and Raven.

Baker, Elizabeth C. "Sexual Art-Politics." Art News. 69, no.
 9 (January 1971):47-48, 60-62.
 It is reprinted in Hess & Baker, Art and Sexual Poli-
tics ..., cited above, on pages 108-146. Baker deals with the
discrimination against women artists, both as students and as fac-
ulty, in the university setting.

Baldwin, Carl. "The Predestined Delicate Hand, Some Second Em-
 pire Definitions of Women's Role in Art and Industry."
 Feminist Art Journal. II, no. 4 (Winter 1973-1974):14-15.
 Baldwin considers French society between the years 1860
and 1863. He states that women were considered to possess only
those talents of patience and dexterity. He speaks of women being
"gently persuaded or violently hounded" out of the profession of art.
He cites sources that only praise women in terms of their skill at
reproduction, visually or biologically.

Beatts, Anne and Hymovitch, Lowena. "Paintings you Never
 Studied in Art 101." Ms. IV, no. 4 (October 1975):80.
 An eloquent reply to those who do not understand why
some women today are less than happy with the ways women, es-
pecially the female nude, have been treated by western painters.
It is a color reproduction of what, at first glance appears to be,
Manet's Le dejeuner sur l'herbe captioned with a brief commentary
on its significance to modern art. The second glance reveals it
as a superb parody--the sexes have been reversed! Two fashion-
ably clad young women hold a conversation in the company of two
quite unidealized male nudes. The commentary continues the par-
ody.

Berkeley, Ellen. "Women in Architecture." Architectural Forum.
 137 (Sept. 1972):46-53.
 Statistic review of the discrimination women in architec-
ture have faced. Reviews women's organizations, legal action un-
dertaken, and the response of the A.I.A. to pressure by women.

Berliner, David. "Women Artists Today." Cosmopolitan. 175
 (October 1973):216-219, 226-227.

Berlo, Janet. "The Cambridge School: Women in Architecture."
 Feminist Art Journal. V, no. 1 (Spring 1976).
 An account of a women's architectural school, now de-
funct.

Boyers, Robert and Bernstein, Maxine. "Women, The Arts, and
the Politics of Culture: An Interview with Susan Sontag."
Salmagundi. no. 31-32 (Fall 1975-Winter 1976):29-48.

Braden, S. "Politics in Art." Studio. 187 (June 1974):272-274.

Braderman, Joan. "Report, The First Festival of Women's Films."
Artforum. (September 1972).

deBretteville, Sheila Levrant. "A Reexamination of Some Aspects
of the Design Arts from the Perspective of a Woman Design-
er." Arts in Society. XI, no. 1 (Spring-Summer 1974):
115-123.
Describes common depictions of women and men in ad-
vertising art as a continuation of their stereotyped roles and be-
haviors and shows how this is capitalized upon. Discusses ways
to develop images of alternative values, drawing on her own ex-
periences as a designer for examples. Speculates on the possibili-
ties of design in disseminating feminism.

Broderick, Herbert. "Solomon and Sheba Revisited." Gesta.
XVI, no. 1 (1977):45-48.

Brodsky, Judith K. "Some Notes on Women Printmakers." Art
Journal. 35 (Summer 1976):374-377.
Excellent historical survey of women printmakers, a sub-
ject on which little has been written.

_____. "The Women's Caucus for Art." Women's Studies
Newsletter. V, nos. 1&2 (Winter-Spring 1977):13-15.
Brodsky is a past president of the Women's Caucus for
Art.

Brooks, Valerie. "The Wives of the Artists." Print. 29 (March/
April 1975):44-49 and 86.
Three women painters and illustrators discuss the diffi-
culties in defining their own professional identities while being
overshadowed by their husband's careers.

Broude, Norma. "Degas' 'Misogyny.'" Art Bulletin. LIX, no.
1 (March 1977):95-107.

Brumer, Miriam. "Organic Image = Women's Image?" Feminist
Art Journal. 2 (Spring 1973):12-13.
An interesting argument against curved organic shapes
being seen as "inner-core imagery" of women related to the womb
and sexuality.

Burnham, Jack. "Patriarchal Tendencies within the Feminist Art
Movement." The New Art Examiner. Vol. 4, no. 10
(Summer 1977):1, 8-9, 11.

Bye, Arthur E. "Women and the World of Art." Arts and Deco-
ration. 10 (1918):86-87.

Carpenter, Edward. "Statement: Designing Women. " Industrial
 Design. 11 (June 1964):72-74.
 An informal survey on women in design which begins by
referring to "girls" who graduate from industrial design courses.
Discusses the lack of awareness of the field among students and
the fear of women students about technical aspects. Mentions the
large number of women working for General Motors, but stresses
their main concern is car interiors, where they feel "more com-
fortable. "

Carr, Annmarie Weyl. "Women Artists in the Middle Ages. "
 Feminist Art Journal. 5 (Spring 1976), pp. 5-9.
 Excellent summary of state of research on women artists
from around 800 to the 15th century, with extensive bibliography
and several reproductions.

Chadwick, W. "Eros or Thanatos--The Surrealist Cult of Love
 Reexamined. " Artforum. (November 1975):45-56.

Chicago, Judy and Schapiro, Miriam. "A Feminist Art Program. "
 Art Journal. 31 (Fall 1971):48-49.
 A brief explanation of the California Institute of Arts
feminist program. Includes quotations by both authors from Every-
woman magazine.

Chrysalis, A Magazine of Women's Culture. I, nos. 1 & 2 (1977).
 A new quarterly, published by a California Corp. , 1727
North Spring St. (The Woman's Building), Los Angeles, Ca. 90012.
The first issue included articles by Ruth Iskin, "Joan Snyder:
Toward a Feminist Imperative, " and Dolores Hayden, "Redesigning
the Domestic Workplace. " The second had Lucy Lippard's 'Quite
Contrary: Body, Nature and Ritual in Women's Art, " and a cata-
logue of feminist publishers.

Cliff, Ursula. "Gallery 4: Florence Knoll. " Industrial Design.
 8 (April 1961):66-71.
 Review of work by woman designer Knoll, head of firm
Knoll Associates.

Cohodas, Marvin. 'Dat so la Lee's Basketry Design. " American
 Indian Art. I, no. 4 (Autumn 1976):22-31.

Corning, Leonard J. 'Women Artists of the Olden Times. " The
 Manhattan Magazine. IV (1884):215.

Dijkstra, Bram. 'The Androgyne in Nineteenth-Century Art and
 Literature. " Comparative Literature. 26 (Winter 1974):62-73.

Duncan, Carol. "Virility and Domination in Early Twentieth Cen-
 tury Vanguard Painting. " Artforum. 12 (December 1973):
 30-39.
 This is a good example of how a feminist analysis can
offer valuable new insights and interpretations of art. Illustrations

and bibliography are included. The degree to which "gentlemen wilt protest too much" is seen in a reply (and a rejoiner) in the letter column of the following Issue: 12 (March 1974):9. Explores primarily the aggressive male sexuality, in both imagery and style, of the Fauves and the Brucke artists. Briefly discusses how this imagery of women was an especially pernicious obstacle for women artists.

Edgerton, Giles. "Is There A Sex Distinction in Art? The Attitude of the Critic Toward Women's Exhibits." The Craftsman. XIV (1908):238-251.

Elderkin, Kate McK. "The Contribution of Women to Ornament in Antiquity." Classical Studies Presented to Edward Capps. Princeton, 1936.

Eva. "Women Artists: What History Has Done with Them." Liberation News Service. (December 2, 1972).

Everywoman. (May 7, 1971).
 A special issue devoted to feminist art, edited by Judy Chicago. The address of the periodical is 10438 W. Washington Blvd., Venice, Ca. 90291.

Farnsworth, Paul. "The Effects of Role-Taking on Artistic Achievement." Journal of Aesthetics and Art Criticism. 18 (March 1960):345-349.
 Results of a 1957 study seeking data on sex roles in the area of the arts, that shows the general thinking that creativity is a masculine trait and passive artistic activities are feminine in nature. Women who picture creativity as a masculine role therefore find it difficult to sustain creative effort.

Feminist Art Journal.
 A quarterly begun in the spring of 1972 that ceased publication with Vol. 6, no. 2, Summer 1977. Some back issues of this high quality journal, a true pioneer, should be available from its editor Cindy Nemser, 41 Montgomery Place, Brooklyn, N.Y. 11215. Many of its historical articles are cited specifically in this bibliography. The F.A.J. consistently combined controversy with scholarship and thus provided many of us across the country with a "subscription to a support system."

Film Library Quarterly. (Winter 1971-72).
 A special issue on women and film.

Fleisher, Pat. "Love or Art." Arts Magazine. (Fall 1973).
 This deals with the conflict that most women artists are faced with, unresolvable claims upon their energies and time by their art and their loved ones. This is a dilemma which society does not generally impose upon male artists.

Frankenstein, Alfred. "Toward a Complete History of Art: 'Women Artists, 1550-1950.'" Art in America. (March-April

1977):66-69.
A review of the Harris and Nochlin show. Three glorious color reproductions are included.

"French Women Painters: Exhibition." Cahiers d'art. VII (January 1926):18.

Friedman, Joan. "Every Lady Her Own Drawing Master." Apollo. Vol. CV, no. 182 (April 1977):262-67.

Gabhart, Ann and Broun, Elizabeth. "Old Mistresses, Women Artists of the Past." The Walters Art Gallery Bulletin. 24, no. 7 (April 1972): n. p. (1-8).
This article concerns an exhibition of women artists that ran concurrently that month. Romaine Brooks, Artemisia Gentileschi, Adelaide Labille-Guiard, Jane Stuart, Lily Martin Spencer and Mary Cassatt are discussed. It is an excellent introduction to the entire topic of historical women artists and their problems. Even the title touches on the sexism of our culture as expressed in our language. Gabhart and Broun demonstrate that however great the social obstacles and the personal price, numbers of women have successfully dealt with them to produce "works of real merit." They also touch upon the irony of misattributions and the profound conflicts involved in assuming the male role of artist.

Gallichan, Mrs. C. G. (Hartley). "The Paris Club of International Women Artists." Art Journal. (1900):282-284.

Gardner, Albert Ten Eyck. "A Century of Women." Metropolitan Museum of Art Bulletin. n. s. 7 (December 1948):110-118.
Gardner writes on the centennial anniversary of the Seneca Falls Convention of 1848 which marked the beginning of organized feminism in the United States. He provides an excellent survey account of the struggle of women artists to compete in the mainstream of American art. He discusses Cassatt and the mural projects for the Chicago Worlds Fair Woman's Building of 1893. But even he ends on a note of sexism in asserting that a woman's greatest contribution to the world of art is to be the mother of a genius (presumably male).

Garrard, Mary. "'Of Men, Women and Art': Some Historical Reflections." Art Journal. 35 (Summer 1976):324-329.
An analysis of the art world as suffering from the same stereotypical feminity that women have been subjected to.

Glueck, Grace. "Making Cultural Institutions More Responsive to Social Needs." Arts in Society. XI, no. 1 (Spring-Summer 1974):49-54.
One of several articles in the special issue called "Women and the Arts." Summarizes innovations being tried by museums (often under pressure) to make their programs more relevant to the community through outreach branches, ethnic and women's exhibitions. Discusses the possibilities of alternative

institutions and change coming from within existing institutions
through pressure from employees.

Goldin, Amy. "American Art History Has Been Called Elitist,
Racist, and Sexist. The Charges Stick." Art News.
(April 1975):48-51.
　　　　Goldin launches wholesale and across-the-board charges
against American art history in a short editorial-style essay that
is unfortunately more witty than soundly substantiated. The timely
heresy she speaks deserves more documentation.

Goulinat, J. G. "Les femmes peintres au XVIIIe siècle." L'art
et les artistes. n. s. 13 (June 1926):289-294.
　　　　A review of an important exhibit which mentions a Mlle.
Loir, Labille-Guiard, Vigée-LeBrun, Vallayer-Coster, Constance
Mayer, Marguerite Gerard, and Françoise Duparc. See the arti-
cle by Linzeler later in this section for another treatment of this
exhibit.

Greene, Alice. "The Girl-Student in Paris." Magazine of Art.
6 (1883):286-287.

Grier, Barbara and Reid, Coletta, eds. The Lavender Herring.
Lesbian Essays from the Ladder. Baltimore: Diana Press,
1976, pp. 284-357.
　　　　This includes a section entitled "The Lesbian Image in
Art," consisting of eight essays written by Sarah Whitworth.

Hackney, L. W. "Chinese Women Painters." International Studio.
78 (1923):74-77.

Hagen, Luise. "Lady Artists in Germany." International Studio.
4 (1898):91-99.
　　　　Hagen discusses the work of two women, Bertha Weg-
mann and Jeanna Bauck, with good black and white reproductions
to illustrate. Hagen unfortunately begins this quite complimentary
discussion of their work with a great load of vituperation for the
work of other, unnamed, German women artists.

Hardenburgh, Linn and Duchon, Susan. "In Retrospect--The Mid-
west Women's Artists' Conference." Art Journal. XXXV,
no. 4 (Summer 1976):386-88.

Harper, Paula. "Suffrage Posters." Spare Rib. no. 41 (Novem-
ber 1975):9-13.
　　　　The English Suffrage movement was far more militant
and flamboyant generally than its American counterpart; this Eng-
lish periodical would probably reflect that.

Harris, Anne Sutherland. "The Second Sex in Academe (Fine Arts
Division)." Art In America. 60 (May 1972):18-19.
　　　　A review with statistics of the status of women in studio
and art history departments in four year colleges, in universities,
and in museums.

Harris, Anne Sutherland. "Women in College Art Departments and
Museums. " Art Journal. 32, no. 4 (Summer 1973):417-19.
This contains bibliography and statistics.

Haskell, Molly. "As the Lens Turns: Women Photograph Men. "
Ms. VI, no. 3 (September 1977):31-34.
An adaptation of the introduction she worte for Danielle
Hayes' book, Women Photograph Men, listed in the book section.
She discusses the fundamentally different views the sexes have
taken of one another.

Helson, Ravenna. "Inner Reality of Women. " Arts in Society.
XI, no. 1 (Spring-Summer 1974):25-36.
Another of the articles in the special "Women and the
Arts" issue.

Henrotin, Ellen. "An Outsider's View of the Woman's Exhibit. "
Cosmopolitan. 15 (Sept. 1893):560-566.
Inventory of the art contained in the Woman's Building of
the Columbian Exposition with several reproductions. Also men-
tions other aspects of the building such as the scientific depart-
ment, nursing section and model kitchen.

Henshaw, Richard. "Women Directors, 160 Filmographies. " Film
Comment. (November-December 1972).

Heresies I. A Feminist Publication on Art and Politics. (Janu-
ary 1977).
The first issue of a new quarterly produced by the Here-
sies Collective, Inc. at the Fine Arts Building, 105 Hudson Street,
New York, N.Y. 10013 (P.O. Box 766, Canal Street Station).
Some articles: Eva Cockcroft, "Women in the Community Mural
Movement"; Harmony Hammond, "Feminist Abstract Art--A Politi-
cal Viewpoint"; and Lucy Lippard, "The Pink Glass Swan: Upward
and Downward Mobility in the Art World. " A selected bibliography
on feminism, art and politics closes the issue.

Hess, Thomas B. "Editorial, Is Women's Lib Medieval?" Art
News. 69, no. 9 (January 1971):49; reprinted in Hess,
Thomas B. and Baker, Elizabeth C. Art and Sexual Poli-
tics, Women's Liberation, Women Artists and Art History,
under the new title, "Great Women Artists. " New York:
Art News Service, Collier Books, 1973. pp. 44-48.
Here he chivalrously declares in rebuttal to Linda Noch-
lin that there have been great women artists.

Hillman, James. "First Adam, Then Eve, Fantasies of Female
Inferiority in Changing Consciousness. " Art International.
14 (September 1970):30-43.
Hillman deals with great erudition with one of the most
difficult and crucial issues relating to the status of women, that of
their "unreal" status as reflected in myth, literature, the imagi-
nation and even science. This may seem rather far afield for this

bibliography, but unconscious attitudes about the nature of women, held by both sexes, have a profound effect on the images a society produces. More simply, it is very hard to take yourself serious- ly when nobody else does.

Holder, Maryse. "Another Cuntree: At Last, A Mainstream Fe-
 male Art Movement." Off Our Backs, XI, no. 10 (Septem-
 ber 1973):11-17.
 A good survey article focusing on female imagery and
erotic content.

Holland, Clife. "Lady Art Student's Life in Paris." International
 Studio. 21 (1904):225-233.
 Holland covers much the same ground as Alcott's Study-
ing Art Abroad, cited in the book section.

Holmes, C. J. "Women as Painters." The Dome. 3 (April,
 June, July 1899).
 Lists twenty-six historical women artists but observes
"...the true genius (?) of the sex is observant, tasteful, and teach-
able, but not creative." The Dome was a London periodical.

Hudnut, Joseph. "The Architectress." Journal of American Insti-
 tute of Architects. Part I, 15 (March 1951):111-116 and
 Part II, 15 (April 1951):181-184 and 187-188.
 Condescending attempt to explain away the prejudices
against women architects, calling women "... that uncertain, coy
and useful branch of the human race." While he sees no way a
woman can combine a successful architectural career with mar-
riage, he does add that they are useful after graduation because
they can be hired cheaper.

In Praise of Women Artists.
 This is a beautiful annual calendar, illustrated with large,
full color reproductions of paintings by women artists. It is in
its third year of production. It is available from Bo-Tree Pro-
ductions, 2 Casa Way, San Francisco, Ca. 94123.

Iskin, Ruth. "Sexual Imagery in Art--Male and Female." Woman-
 space Journal. I, no. 1 (Summer 1973).

Janeway, Elizabeth. "Images of Women." Arts in Society. XI,
 no. 1 (Spring-Summer 1974):9-18.
 Another of the articles in the special "Women and the
Arts" issue.

John, Augustus. "The Woman Artist." Vogue. 72 (October 27,
 1928):76-77, 112, 116.
 This is a truly classic example of the standard slander
regarding women artists. He begins typically enough by asserting
his position as an ally. Angelica Kauffman and Rosa Bonheur he
calls "energetic but empty," blaming this on their painting like
men and rejecting their "natural feminine grace." He does allow

that when a woman paints avowedly as a woman the case is different. But of the several women he cites as examples, the only one known today is Marie Laurencin, whom he does not consider successful. The delicious irony of Augustus John's position is that he was then a very successful artist and president of the Royal Academy; while his own sister, artist Gwendolyn John--with at least equal talent, the same parents and a shared and equal education--lived in obscurity in a shack on the outskirts of Paris with a large collection of cats! He makes no connection between the lot of his sister and what he calls "the realm of art, which is free to every comer."

Jouin, Henry. "L'exposition des artistes femmes." Journal des beaux-arts et de la littérature. Brussels. XXIV (1882):66.

Kamerick, Maureen. "The Woman Artist and the Art Academy: A Case Study in Institutional Prejudice." New Research on Women at the University of Michigan, 1974, pp. 249-260.

Kampen, Marjorie. "Women's Art: Beginning of a Methodology." The Feminist Art Journal. I, no. 2 (Fall 1972):10, 19.

Kampen, Natlie. "Hellenistic Artists: Female." Archeologie Classica. XXVII, Fasc. 1 (1975):9-17.

Karsilovsky, Alexis Rafael. "Feminism in the Arts: An Interim Bibliography." Artforum. (June 1972):72-76.
　　An excellent annotated bibliography that touches upon historical women artists as well as the contemporary feminist art movement. It has been one of our principle sources.

Kershaw, J. D. "Philadelphia School of Design for Women." The Sketch Book. IV, no. 6 (April 1905).
　　Another women's art school.

Kozloff, Joyce and Zucker, Barbara. "The Women's Movement: Still a 'Source of Strength' or 'One Big Bore'?" Art News. 75, no. 4 (April 1976):48-50.

Kuzmany, K. 'Die Kunst der Frau." Die Kunste für Alle. XXVI (1910):193ff.

LeGrange, Leon. 'De rang des femmes dans les arts." Gazette des beaux arts. (October 1, 1960):30-43; reprinted in English a few months later in The Crayon, a New York art magazine.
　　LeGrange begins, deceptively enough, by praising important women artists of the past, Margaretha van Eyck and Rachel Ruysch in particular. But he quickly lapses into the most shocking condescension toward contemporary women artists, whose proper sphere he kindly outlines. They are good for decorating vases, for coloring prints and for reproducing engravings of paintings by men, "... and those painstaking arts which correspond so well to the role of abnegation and devotion which the honest woman

happily fills here on earth and which is her religion." (!)

Leris, G. de. "Les femmes à l'Academie de Peinture." L'art.
XLV (1888):122-33.

Likos, Patt. "The Ladies of the Red Rose." Feminist Art Jour-
nal. 5 (Fall 1976):11-15 and 43.
Good discussion of the state of education for women
artists in Philadelphia at the turn of the century. Focuses on the
fascinating cooperative lives and careers of three women artists,
Violet Oakley, Elizabeth Shippen Green, and Jessie Wilcox Smith.

Lippard, Lucy. "Household Images in Art." Ms. 1 (March
1973):22-25.
A look at the use of domestic imagery by contemporary
women artists. Well illustrated.

_____. "Projecting a Feminist Criticism." Art Journal. 35
(Summer 1976):337-339.

_____. "The Pains and Pleasures of Rebirth: Women's Body
Art." Art in America. 64 (May/June 1976):73-81.
Discussion of art in which the primary image or medium
is the artist's own body, and examination of male and female dif-
ferences in this genre.

_____. "Sexual Politics, Arts Style." Art in America. 59
(September 1971):19-20.
Short, but concise summary of the state of discrimina-
tion against women artists by dealers, educators, and journalists.

_____. "Why Separate Women's Art?" Art and Artists. 8
(October 1973):8-9.
This short essay is an adaptation from the catalogue
Ten Artists (Who Also Happen to be Women), at the Kenan Art
Center in Lockport, N.Y. and at the Michael C. Rockefeller Arts
Center in Fredonia, N.Y. during January of 1973. It is an excel-
lent summary of why women's art should, on occasion, be sepa-
rated.

Lyons, Lisa. "Sugar and Vice: Images of Women in Late Medie-
val Art." Feminist Art Journal. (Winter 1974-75):8-10.

Mainardi, Pat. "A Feminine Sensibility?--Two Views." Feminist
Art Journal. 1 (April 1972):4 and 25.
An argument against the "female aesthetic," stating that
the only artistic freedom women should pursue is the same free-
dom that men have--the freedom to make every kind of art that
is known.

Maison, Margaret. "Insignificant Objects of Desire." The Listen-
er. (July 22, 1971):105-107.
Brief survey of the first women's movement that includes
an account of status of women artists.

Marcou, P. F. "Une exposition rétrospective d'art féminin. Gazette des beaux-arts. (1908):297ff.

Marling, Karal Ann. "A New Deal for Women: Edris Eckhardt and the Federal Art Project." Abstract of a paper delivered to the College Art Association in January 1975.
 A look at the effect of the WPA's Federal Art Project on opportunities for women and the image of women as professional artists.

Marmer, Nancy. "Womanspace, a Creative Battle for Equality in the Art World." Art News. 72 (Summer 1973):38-39.

Marter, Joan M. "Interaction or Compromise: The Creative Production of Three Women Married to Early Modernists, Sonia Delaunay-Terk, Marguerite Thompson Zorach, Sophie Taeuber-Arp." Abstract of paper delivered to the College Art Association in January 1975.
 Marter is at Sweet Briar College, Virginia.

Merritt, A. L. "A Letter to Artists: Especially Women Artists." Lippincott's Magazine. LXV (1900):463-69.

Meyer, Annie Nathan. "The Woman's Section at the World's Fair." International Studio. 59, no. 234 (August 1916):XXIX-XXXII (pages).
 There was no woman's building at the World's Fair in 1916; only a room where, among others, Morisot and Cassatt were shown. Meyer described the tenor of the room's display as "masculine," meaning "clear, capable, vigorous." Which unfortunately leaves one with the impression that to be feminine must mean to be unclear, incompetent and weak.

"More on Women's Art: An Exchange." Art in America. (November-December 1976).
 Diane Burko, Mary Beth Edelson, Harmony Hammond, Miriam Schapiro, et al.

Ms. (April 1977).
 While Ms. often reviews women artists, this issue is particularly rich. Articles by Lucy Lippard, "New Landscape Art," and especially Margot Williams and Paul Elliott's "Maria Martin: The Brush Behind Audobon's Birds," etc.

Muto, Laverne. "A Feminist Art--The American Memorial Picture." Art Journal. 35 (Summer 1976):352-358.
 A form of folk-art widely practiced in the 18th and 19th centuries.

The National Carvers Museum Review. IV, no. 3.
 An issue devoted to women wood carvers.

Nemser, Cindy. "Art Criticism and the Gender Prejudice."

Arts Magazine. 46 (March 1972):44-46.
Deals with the question of whether there are recogniz-
able feminine characteristics in art created by women. Confronts
the critical vocabulary that is rife with sexual connotations.

_____. "Stereotypes and Women Artists." The Feminist Art
Journal. I, no. 1 (April 1972):1, 22, 23.
An extremely well done article which explores the char-
acteristics of "phallic criticism" from the nineteenth century to
present day in reviews of women artists. One of her best points
is that one may be fairly sure that some discrimination is afoot
when the word "feminine" appears in art criticism.

_____. "Towards a Feminist Sensibility: Contemporary Trends
in Women's Art." Feminist Art Journal. 5 (Summer
1976):19-23.
Discusses the wide diversity of women's art as well as
some of the commonalities, such as frequent autobiographical con-
tent, documentation of the immediate experiences of a woman, art
with political statements, and art with sexual imagery.

_____. "The Women's Conference at the Corcoran." Art in
America. (January-February 1973):86-90.

Neuls-Bates, Carol. "Five Women Composers, 1587-1875."
Feminist Art Journal. V, no. 2 (Summer 1976).
A slight digression here from the topic at hand, but we
think a meaningful one.

Nochlin, Linda. "By a Woman Painted, Eight Who Made Art in
the Nineteenth Century." Ms. III, no. 1 (July 1974):68-75,
103.
Nochlin briefly discusses Rosa Bonheur, Sophie Anderson,
Berthe Morisot, Margaretta and Sarah Peale, Elizabeth Siddal,
Emily Mary Osborn and Mary Cassatt. There are several good
color reproductions included.

_____. "Eroticism and Female Imagery in Nineteenth Century
Art." Woman as Sex Object, Studies in Erotic Art, 1730-
1970. Edited by Thomas B. Hess and Nochiln. New York:
Art News Annual XXXVIII, Newsweek, Inc., p. 8-15.
One of the most hilarious and eloquent commentaries on
the ludicrousness and inhumanity of a standard "woman as sex
object" motif, that of "breasts as fruit." Nochlin places side by
side two photographs. The first is French, from the nineteenth
century; a nude, vacuous damsel, clad only in black stockings,
holds a fruit laden tray beneath her breasts. Next to it Nochlin
places a photograph of her own. A nude and equally vacuous
young fellow--sporting knee socks--holds a tray of bananas some-
what lower, beneath his penis.

_____. "How Feminism in the Arts Can Implement Cultural
Change." Arts in Society. XI, no. 1 (Spring-Summer
1974):81-89.

_____ . "Some Women Realists. " <u>Arts.</u> 48 (Fall 1974):46-51.
Discussion and reproductions of Sylvia Mangold, Yvonne
Jacquette and Janet Fish, with a valuable aside about an artistic
foremother of theirs, Emily Mary Osborn.

_____ . "Some Women Realists: Painters of the Figure. "
<u>Arts.</u> 48 (May 1974):29-33.
Here Nochlin has reference to Alice Neel and Sylvia
Sleigh among others.

_____ . "Why Have There Been No Great Women Artists?"
<u>Art News.</u> 69, no. 9 (January 1971):22-39, 67-71; re-
printed in Hess, Thomas B. and Baker, Elizabeth C. , eds.
<u>Art and Sexual Politics....</u> New York: Art News Service,
Collier Books, 1973, pp. 1-39; and in Gornick, Vivian and
Moran, Barbara K. <u>Women in Sexist Society, Studies in
Power and Powerlessness.</u> New York: Basic Books, Inc.,
Chapter 3, pp. 344-366. This last version is without the
very important illustrations.
Nochlin does begin her long essay by pointing out the
prejudice and assumptions of the question posed in her title. But
she unfortunately ends by concluding that there have been no great
women artists; for which she is severely taken to task by Pat
Mainardi in a book review in the <u>Feminist Art Journal,</u> II, no. 4
(Winter 1973-1974):18. This judgment takes at face value accumu-
lated art history regarding women without considering the centuries
of bias against women both in art history and in western civiliza-
tion in general. Far more valuable is the main body of her essay
in which she discusses "the golden nugget theory of art history,"
the denial of art education to women (especially study of the nude),
and the importance of beginning to ask "where artists come from. "

Orenstein, Gloria Feman. "Art History. " <u>Signs: A Journal of
Women in Culture and Society.</u> I, no. 2 (Winter 1975):505-
525.

_____ . "Art History and the Case for the Women of Surreal-
ism. " <u>The Journal of General Education.</u> XXVII, no. 1
(Spring 1975):31-54.

_____ . "Women of Surrealism. " <u>Feminist Art Journal.</u> II,
no. 22 (Spring 1973):1, 15-21.
This is a shorter version of the above. Orenstein dis-
cusses Remedios Varo, Leonor Fini, Leonora Carrington, Meret
Oppenheim, Toyen, Elena Garro, Dorothea Tanning, et al. Seve-
ral black and white reproductions and a bibliography are included.

Pacchioni, A. "Mostra nazionale d'arte femminile Torino. "
<u>Emporium.</u> CV (June 1947):271-272.

Pagels, Elaine H. "Whatever Became of God the Mother? Con-
flicting Images of God in Early Christianity. " <u>Signs: Jour-
nal of Women in Culture and Society.</u> II, no. 2 (Winter
1976):193-303.

Paine, Judith. "The Women's Pavilion of 1876." Feminist Art
 Journal. 4 (Winter, 1975/76):5-12.
 An account of the organization, contents of, and reac-
tions to the Women's Pavilion at the Centennial Exposition in Phila-
delphia.

Payne, Frank Owen. "The Work of Some American Women in
 Plastic Art." Art and Archeology. 6 (December 1917):311-
 322.
 Well illustrated survey of women sculptors working in
the early 1900's.

Postlethwaite, H. L. "More Noted Women Painters." Magazine
 of Art. 22 (1898):480-484.

_____. "Some Noted Women Painters." Magazine of Art. 18
 (1895):17-22.

Print. 10 (September 1955):16-67.
 An all-women's issue.

Proctor, Ida. "Some Early Women Painters." Country Life.
 107 (April 14, 1950):1040-1042.

Proske, Beatrice. "Part I: American Women Sculptors." Na-
 tional Sculpture Review. 24 (Summer/Fall 1975):8-15. and
 28.
 Excellent summary of the position of American women
sculptors from 1725 to contemporary times. Beautifully illus-
trated with black and white reproductions.

Reiss, Margot. "Self Portraits of Women." Der Kunstwanderer.
 9 (April 1927):321-323.

Richardson, Margaret. "Women Theorists." Architectural Design.
 XLV (August 1975):466-467.

Roberts, Helene. "The Inside, the Surface, the Mass: Some Re-
 curring Images of Women." Women's Studies. II, no. 3
 (1974):289-307.

Rorem, Ned. "Women: Artist or Artist-ess." Vogue. 155
 (April 1, 1971):172-173.

Russell, Margarita. "The Women Painters in Arnold Houbraken's
 De Groote Schouburgh der nederlandsche konstschilders en
 schilderessen." Abstract to a paper delivered before the
 College Art Association in January 1975.
 Houbraken published his work between 1718 and 1721.
The title is translated "The Grand Theatre of Netherland's Painters
and Women-Painters." Russell is from Georgetown University.

Sandell, Renee. "Female Clique!" The Report. Women's Caucus

of the National Art Education Association (Autumn 1975).

Saunier, Charles. "Exposition retrospective feminine au lyceum-
france. " Les arts. VII (April 1908):1-7.

Sauzeau-Boetti, Anne-Marie. "Negative Capability as Practice in
Women's Art. " Studio International. (January-February
1976):24-30.

Schapiro, Miriam. "The Education of Women as Artists: Project
Womanhouse. " Art Journal. XXXI, no. 3 (Spring 1972):
268-270.
 See the catalogue to this exhibition under Valencia, Ca.
in the next section. Discusses the methods of teaching, the con-
ception and creation of Womanhouse.

Schlossman, Betty and York, Hildreth. "Women in Ancient Art. "
Art Journal. 35, no. 4 (Summer 1976).

Schulze, Franz. "Women's Art: Beyond Chauvinism. " Art News.
(March 1975):70-72.
 A highly favorable review of the success of two new
feminist galleries in Chicago, "Artemisia" and "ARC. "

Schwartz, Therese. "If De Kooning Is an Old Master, What Is
Georgia O'Keeffe?" Feminist Art Journal. I, no. 2 (Fall
1972):12-13, 20.
 A review of the "Old Mistresses" show in Baltimore at
the Walters Art Gallery in the spring of 1972. (See also Gabhart
and Broun earlier in this section.) Fair black and white reproduc-
tions are included.

_____. "They Built Women a Bad Art History. " Feminist Art
Journal. II, no. 3 (Fall 1973):10-11, 22.
 Schwartz reviews several writers in the late nineteenth
century for their extreme misogyny toward women artists. She
believes them instrumental in the near eradication of women from
art history. Some of the men she discusses are Corning, Holmes,
LaGrange (listed in this section) and Sparrow, in the book section.
She has been an important source for us.

Siblik, E. "Exposition de peinture feminine française à Prague. "
Beaux Arts. (June 4, 1937):8.

Sims, Lowery S. "Black Americans in the Visual Arts: A Survey
of Bibliographic Materials and Research Sources. " Artforum.
(April 1973):66-70.

Sloan, Patricia. "Statement on the Status of Women in the Arts. "
Art Journal. 31 (Summer 1972):425-427.
 Scathing analysis by an artist on the good and bad effects
of the women's movement on the art world.

Smith, Barbara Herrnstein. "Women Artists: Some Muted Notes. "
Journal of Communication. 24, no. 2 (Spring 1974):146-149.

Smith, David Loeffler. "Observations on a Few Celebrated Wo-
men Artists. " American Artist. 26 (Jan. 1962):52-55 and
78-81.
Sympathetic survey of a number of historical women
artists from Vigée-LeBrun to Cassatt. Several good illustrations.

Smith, Sharon. "Women Who Make Movies. " Women and Film.
1, nos. 3 & 4: 77-92.
An international filmmakers list arranged by country.
This is a tri-annual magazine. The address is P. O. Box 4501,
Berkeley, Ca. 94704.

Snyder-Ott, Joelyn. "Woman's Place in the Home (That She
Built). " Feminist Art Journal. III, no. 3 (Fall 1974):7-8,
18.
This is a survey article about the Woman's Building of
the Chicago World's Columbian Exposition of 1893. It touches upon
the political climate that helped bring it about but does not men-
tion Susan B. Anthony as the originator of the idea. See "letters,"
Feminist Art Journal, IV, no. 1 (Spring 1975):46-47, for addition-
al comments on this article.

Somerville, E. "An 'Atelier des Dames'. " Magazine of Art. 9
(1886):152-157.
Humorous account of women art students in Paris.

Strong, Sarah. "A Man's World, A Woman's Place. " Architec-
tural Design. XLV (August 1975):463-465.

Studies in Art Education. (Winter 1976).
Edited by Sandra Packard and Enid Zimmerman. It con-
tains articles about research on sexual stereotyping, and on women
in art and in art education. It is available from the National Art
Education Association, 1916 Association Drive, Reston, Virginia.

Stump, Jeanne. "May Alcott: Problems of the Woman Artist in
the Nineteenth Century. " Abstract of a paper delivered
before the College Art Association in January 1975.
This paper deals with Louisa May Alcott's sister, an
artist. Note Alcott's book (listed in the book section of this bibli-
ography). Stump is located at the University of Kansas.

"Surveying the Role of Women in the Profession. " American Insti-
tute of Architects Journal. 61 (June 1974):9.
Result of a survey of women architects that reveals they
comprise only 1. 2% of the total registered architects and receive
substantially lower salaries for the same work than men.

Sutton, D. "A Londres: exposition de femmes peintres. " Arts.
(November 1946):3.

Take One. III, no. 2 (February 1972).
 A special issue on women and film.

Thompson, Jane. "World of the Double Win: Male and Female
 Principles in Design." Feminist Art Journal. 5 (Fall
 1976):16-20.

"A Thousand Women in Architecture." Architectural Record.
 Part I, 103 (March 1948):105-113 and Part II, 103 (June
 1948):108-115.
 A survey of women architects and their works with brief
biographical sketches.

Tourneux, M. "Une exposition rétrospective d'art féminin." Ga-
 zette des beaux-arts. XXXIX (1908):290-300.

The Velvet Light Trap. (Fall 1972).
 Issue devoted to women and film.

Visual Dialog. I, no. 2 (Winter 1975-76), and II, no. 3 (Winter
 1976-77).
 Two issues devoted to women in the visual arts. The
address is 138 Country Club Drive, P.O. Box 1438, Los Altos,
California 94022. The second issue includes: Judith Brodsky,
"Some Comments on the Women's Art Movement"; Sandra Packard,
"Uphill Struggle: Women in Art Academe"; Judy Loeb, "Educating
Women in the Visual Arts: An Overview"; Mary Fifield, "Affirma-
tive Action in Academia: An Unfulfilled Promise"; and Susan Be-
chaud, "The Woman's Building, L.A."; etc.

Vogel, Lise. "Erotica, The Academy, and Art Publishing: A Re-
 view of Woman as Sex Object, Studies in Erotic Art, 1730-
 1970." New York, 1972. Art Journal 35 (Summer 1976):
 378-385.

_____. "Fine Arts and Feminism: The Awakening Conscious-
 ness." Feminist Studies. 11, no. 1 (1974):3-37.
 "Thoughtful discussion of feminist art criticism." The
address is 417 Riverside Drive, New York, N.Y. 10025.

Wayne, Jane. "The Male Artist as a Stereotypical Female, or Pi-
 casso as Scarlet O'Hara to Hirshhorn's Rhett Butler."
 Art News. 72 (December 1973):41-42; reprinted in Arts
 and Society. XI, no. 1 (Spring-Summer 1974):107-113.
 She relates the powerless position of artists to the stere-
otypical view of them as inept, unable to cope, and needing help--
a view that is almost identical to the stereotypical concepts of wo-
men. Wayne calls for the organization of artists into a powerblock
to seize control of the art world from dealers, curators, et al.;
and thus to look out for their own interests.

Weeks, Charlotte J. "Lady Art-Students in Munich." Magazine
 of Art. 4 (1881):343-347.

_____ . "Women at Work: The Slade Girls. " Magazine of Art.
6 (1883):324-329.
Description of women art students at the Slade School in
England.

Weltenkampt, Frank. "Some Women Etchers. " Scribner's. XLVI
(December 1909):731-739.

"What Is Female Imagery?" Ms. III, no. 11 (May 1975):62-65,
80-83.
Conversations exploring the controversial question of
whether or not the art of women is, in some intrinsic way, diffe-
rent from that of men. In Chicago the participants were Johnnie
Johnson, Celia Marriott, Joy Poe and Royanne Rosenberg; in Los
Angeles, Eleanor Antin, Sheila de Bretteville, Judy Chicago, Ruth
Iskin and Arlene Raven; and in New York, Susan Hall, Lucy Lip-
pard, Linda Nochlin, Joan Snyder and Susan Torre.

White, Barbara Ehrlich. "A 1974 Perspective: Why Women's
Studies in Art and Art History?" Art Journal. 35 (Summer
1976):340-343.
Excellent analysis of the value of women's studies.

White, B. E. and L. S. "Survey on the Status of Women in Col-
lege Art Departments. " Art Journal. 32, no. 4 (Summer
1973):420-421.
Statistical analysis of results of a questionnaire sponsored
by the College Art Association Committee on the status of women.

Whitesel, Lita. "Women as Art Students, Teachers and Artists. "
Art Education Journal of the National Art Education Asso-
ciation. 28, no. 3 (March 1975):22-26.
A statistical review of the extent to which women, as
compared to men, undertake training in art and participate at pro-
fessional levels as teachers and artists.

Withers, Josephine. "Artistic Women and Women Artists. " Art
Journal. 35 (Summer 1976):330-336.
A look at the 19th century view of women as "naturally
artistic" and the artistic training provided for young women of the
period.

Womanart Magazine. I, no. 1 (1976); ', no. 2 (Fall 1976); I, no.
3 (Winter-Spring 1977).
A quarterly edited by Ellen Lubell, P. O. Box 3358,
Grand Central Station, New York, N. Y. 10017. The first is-
sue has articles on Edmonia Lewis and sexism at the Museum
of Modern Art. The second includes articles on Gertrude
Stein, Laura Knight and Artemesia Gentileschi. The third is-
sue reviews Women Artists: 1550-1950 and discusses the
Sister Chapel at length.

"Woman as Photographer. " Camera. XLVI (September 1967):3-

46.

Womansphere.
 The Journal of The Washington Women's Art Center.
This is a bi-monthly publication that began in April 1975. The
address is 1821 Q Street, N.W., Washington, D.C. 20009.

Women and Art. (Winter 1971).
 The predecessor of the Feminist Art Journal. It was
edited by Pat Mainardi, Marjorie Kramer and Irene Peslikis. The
issue contained articles about Alice Neel and Rosa Bonheur, among
others.

Women Artists Newsletter.
 A publication edited by Cynthia Naveretta. There
are ten issues per year. It began in the spring of 1975. The
address is P.O. Box 3304, Grand Central Station, New York, N.Y.
10017.

"Women Artists." Southern Review. 5 (April 1869):299-322.
 A classical sexual put-down of women artists. Points
out that as women increase their power, their morals decline.
States that the only true function of women is to bring happiness to
the world and that it is "... only the disappointed woman who turns
to Art...."

"Women Artists." The Westminster Review. 70 (July 1858):91-
 104.
 This is an anonymous review of Ernst Guhl's book Die
Frauen in der Kunstgeschichte, which was listed in the book sec-
tion of this bibliography. This is a lengthy article which summa-
rizes large segments of Guhl's book, providing a useful synopsis
of a work difficult to locate today. The following are a few of the
women discussed in the article: Sabina von Steinbach, Margriete
van Eyck, Caterina Vigri, Maria Robusti, Irene de Spilimberg,
Lavinia Fontana, Artemisia Gentileschi, Elizabetta Sirani, Rachel
Ruysch, Elizabeth Cheron, Angelica Kauffmann, Vigée-LeBrun,
Rosalba Carriera and Maria Cosway.

"Women in Architecture." Progressive Architecture. LVII
 (March 1977):37-55.

"Women Painters Exhibition." Chicago Art Institute Scrapbook.
 XIV (March-December 1901):22, 24, 27.

Women's Caucus for Art Newsletter. 1971-
 The quarterly newsletter of the Women's Caucus for Art,
a national organization of feminist artists, art historians, and mu-
seum and gallery women. It originally grew out of the College
Art Association. The newsletter contains synopses of programs and
panels relating to women in the arts, updates on affirmative action,
regional reports, an occasional personal testimony, and an excel-
lent on-going bibliography which we have made liberal use of in

this bibliography. Subscription is by membership in the WCA ($10.00 annually, $5.00 for student, part-time, and unemployed; membership secretary is Nancy Russell, 6604 North Bosworth, Chicago, Illinois 60626).

"X Salon Femenino de Arte Actual." Goya. CV (November 1971): 197.

CATALOGUES

Amsterdam. Exposition des dessins exécutés par des femmes. 1884.

Brooklyn Museum. Works on Paper--Women Artists. September 24-November 9, 1975.

Brussels. Bibliothèque Royale. Femmes graveuses belges, 1870-1970. January 30-February 28, 1971.

Chadds Ford, Pennsylvania. Brandywine River Museum. Women Artists in the Howard Pyle Tradition. September 6-November 23, 1975.
 An illustrated catalogue introduced by Anne E. Mayer. Howard Pyle was an important teacher and sponsor of women artists.

Gaud, Roger. Les femmes peintres au XVIIIe siècle. Castres: Musée Goya, 1973.

Gerdts, William H. The White Marmorean Flock, Nineteenth Century American Women Neoclassical Sculptors. Poughkeepsie, N.Y.: Vassar College Art Gallery, April 4-April 30, 1972.
 Gerdts is probably the foremost scholar on American neoclassical sculpture. See also his book listed previously in Section I. His long introduction discusses the phenomenon of the relatively large number of American women who studied in Rome, of which the exhibit is composed. Bibliography and good black and white reproductions are included.

_____. Women Artists of America, 1707-1964. Newark, New Jersey: The Newark Museum, 1965.

Hill, Ms. M. Brawley. Women. A Historical Survey of Works by Women Artists. Winston-Salem and Raleigh, N.C.: Salem Fine Arts Center and North Carolina Museum of Art, February 27-April 20, 1972.
 Hill presents a thorough and coherent listing of women artists, from the middle ages to the present day. The catalogue itself consists of eighty-five sharp black and white reproductions with extremely complete captions that in many instances include

references to other reproductions and bibliography.

Huber, Christine Jones. The Pennsylvania Academy and Its Wo-
 men, 1850-1920. Philadelphia: Peal House Galleries,
 May 3-June 16, 1973.
 Huber's long essay is excellent. Reproductions are in
black and white. A wealth of bibliography is also included. The
catalogue's entry on each woman is augmented with a short bio-
graphical paragraph. Artists included are: Ann Sophia Towne
Darrah, Lily Martin Spencer, Anna Sellers, Mary Jane Peale,
Rosa M. Towne, Virginia Granbery, Juliet Lavinia Tanner, Fidelia
Bridges, Ida Waugh, Emily Sartain, Mary Smith, Mary Nimmo
Moran, Mrs. E. V. Duffey, Mary Stevenson Cassatt, Anna Lea
Merritt, Maria Oakey Dewing, Lilla Cabot Perry, Susan Mac-
Dowell Eakins, Mary Franklin, Cecilia Beaux, Claude Raguet Hirst,
Anna Elizabeth Klumpke, Margaret Lesley Bush-Brown, Alice Bar-
ber Stephens, Elisabeth Fearn Bonsall, Jessie Willcox Smith, Alice
Schille, Anna Mary Richards, Florine Stettheimer, Bessie Potter
Vonnoh, Nancy Maybin Ferguson, Violet Oakley, Marianna Sloan,
Anna Hyatt Huntington, Martha Walter, Lilian Westcott Hale, Mar-
garet Foster Richardson, Helen Kiner McCarthy, Annie Traquair
Lang, Alice Kent Stoddard, Edith Emerson, Catherine Morris
Wright. Huber also discusses the art training available to women
in the nineteenth century.

Huntington, N.Y. Heckscher Museum. Artists of Suffolk County.
 Part IX. Twenty Women Artists. July 20-August 31, 1975.
 There is a short introduction by Ruth Solomon indicating
that the emphasis is on young, emerging artists. There are black
and white reproductions. Artists are: Arneli Arms, Sandra Ben-
ney, Nicole Bigar, Priscilla Bowden, Margery Caggiano, Janet
Culbertson, Natalie Edgar, Coco Gordon, Zena Kaplan, Li-Lan,
Susanne Yardley Mason, Joyce Stillman Myers, Pat Ralph, Dorothy
Ruddick, Patricia Stevens, Mary Stubelek, Jeanette Styborski, Syl-
via Pauloo-Taylor, E. Sterina Velardi, and Graziella Zebilsky.

Kansas City, Missouri. Women's Caucus for Art. Women Artists
 '77, Kansas City Regional Juried Art Exhibition. April
 1977.
 An illustrated catalogue of the show juried by Miriam
Schapiro, held in the University of Missouri, Kansas City Fine
Arts Gallery. It contains an essay by Jeanne Stump, "In the Tra-
dition of Women Artists." It is available from Donna Bachmann,
4140 McGee, Kansas City, Mo. 64111.

Kovinick, Phil. The Woman Artist in the American West, 1860-1960.
 Fullerton, Calif.: Muckenthaler Cultural Center, April 2-
 May 31, 1976.
 The WCA Newsletter describes it thus: "Will probably
NOT 'bring about the complete dissipation of the long-held view that
the virile West can be effectively portrayed only by male delinea-
tors' and includes a pallid selection of works by 56 artists." Ad-
dress is 1201 West Malvern, Fullerton, Ca. 92633.

Kohlmeyer, Ida. American Women: Twentieth Century. Peoria,
Ill. : Lakeview Center for the Arts and Sciences, Septem-
ber 15-October 29, 1972.
Kohlmeyer's introduction discusses the premise of an all-
woman show.

Long Beach, Calif. Museum of Art. Women Architects Today.
October 4-November 20, 1975.
This exhibition was held under the auspices of the New
York City Chapter of the American Institute of Architects. The
poster listed 58 women architects and reported that women com-
prised one per cent of all American architects.

Los Angeles. The American Personality, The Artist-Illustrator of
Life in the United States, 1860-1930.
Prepared by the Grunwald Center for the Graphic Arts,
UCLA, by graduate students under the direction of E. Maurice
Bloch. It has a section on "American Women and the Woman Il-
lustrator. "

Los Angeles. L. A. County Museum of Art. Women Artists, 1550-
1950. December 21, 1976-March 13, 1977.
This immense exhibit traveled to the University Art Mu-
seum in Austin, Texas; the Museum of Art, Carnegie Institute in
Pittsburgh; and The Brooklyn Museum, throughout the balance of
1977. See the book section under Harris and Nochlin, the co-cur-
ators of the exhibit, for additonal annotation.

Los Angeles. The Women's Caucus for Art and the Woman's Build-
ing. Contemporary Issues: Works on Paper by Women.
February 3-March 1, 1977.
Nearly 200 artists from thirty states were chosen by
thirty-seven curators, each of whom selected fewer than six artists.

Macht, Carol. The Ladies, God Bless 'Em, The Woman's Art
Movement in Cincinnati in the Nineteenth Century. Cincin-
nati Art Museum, February 19-April 18, 1976.
An unfortunate title. Macht's introduction includes a bib-
liography. This show emphasized ceramics and furniture.

Mann, Margery and Noggle, Anne. Women of Photography, An
Historical Survey. San Francisco Museum of Modern Art,
Civic Center, April 18-June 15, 1975.
Catalogue includes bibliography. Chronological survey of
large number of women photographers.

Minault, D. Denise. Women as Heroine. Worcester, Mass. :
Worcester Art Museum, September 15-October 22, 1973.
"The first exhibition to examine the role of women in
seventeenth century Italian baroque painting. "

New York. Finch College Museum of Art. Galaxy of Ladies--
American Paintings from the Paul Magriel Collection. 1966.

The exhibition catalogue was prepared by Elayne H. Varian, the text by Barbara Novak O'Doherty.

New York. Museum of Modern Art. Extraordinary Women--Drawings. July 22-September 29, 1977.
Sonia Gechtoff, Natalia Gontcharova, Hannah Höch, Lee Krasner, Sophie Taeuber-Arp, Suzanne Valadon, et al. (!)

New York. Whitney Museum of American Art, Downtown branch. Nineteenth Century American Women Artists. January 14-February 25, 1976. (Pamphlet.)

New York Cultural Center. Women Choose Women. January 12-February 18, 1973.
The catalogue lists 109 contemporary artists.

Paris. Galerie J. Charpentier. Exposition des femmes peintres du XVIIIᵉ siècle. 1926.

Paris. Grand Palais. La femme peintre et sculpteur du XVIIᵉ siècle. 1975.

Paris. Hôtel de Lyceum-France. Exposition des femmes peintres. 1908.
Organized by Mme. A. Besnard. See Saunier, C. and Tourneux, M. in the periodical section for reviews.

Paris. Hôtel de Lyceum-France. Exposition des femmes peintres. 1913.

Paris. Hôtel des Négociants en Objets d'Art. Explication des peintres, graveurs, miniatures et autres ouvrages des femmes peintres du XVIIIᵉ siècle. 1926.

Paris. Musée des Ecoles Etrangères Contemporaines, du Jeu de Paume des Tuileries. Les femmes artistes d'Europe exposent au Musée de Paume. February 1937.

Paris. Petit Palais. Women Painters Exhibition. May, 1937.
Artists included were Suzanne Valadon, Elizabeth Vigée-LeBrun, Berthe Morisot, Seraphine Louis, Marie Laurencin, Marie Blanchard, Eva Gonzales, and Sonia Terk (Delaunay).

Philadelphia. FOCUS. A Document of Philadelphia Focuses on Women in the Visual Arts. April-May 1974.
This outlines the development of several exhibits and events coordinated for the spring of 1974 to honor women in the visual arts.

Philadelphia. Historical Society of Pennsylvania and Library Company of Philadelphia. Women: 1500-1900. April 25-July 5, 1974.
This is one of the events of Focus above.

Philadelphia. Samuel S. Fleisher Art Memorial. In Her Own
Image. April 1974.
One of the events of Focus with the exhibition organized
by Cindy Nemser.

Philadelphia. Temple University. The Tyler School: Working
Women Artists from Tyler School of Art. April 1974.
One of the events of Focus. Introductory essay by Bur-
rows Dunham. Twenty-five selected artists are illustrated with
short biographies and statements by each artist.

Poughkeepsie. Vassar College Art Gallery. Seven American Wo-
men: The Depression Decade. January 19-March 5, 1976.
Exhibition sponsored by AIR, a women's cooperative
gallery, 97 Wooster St., New York, N.Y. 10012. The show was
guest curated by Karal Ann Marling and Helen A. Harrison. The
catalogue is illustrated.

Saint Louis. City Art Museum. Collection of Paintings by Women
Artists of Boston. December 7, 1913.

Saint Louis. City Art Museum. Special Exhibit Catalogue--Paint-
ings by Six American Women. April 5, 1918.

San Antonio. Marion Koogler McNay Art Institute. American
Artists '76: A Celebration. 1976.
An exhibition of living American women artists.

South Hadley, Mass. Mount Holyoke College of Art Museum.
Fourteen American Women Printmakers of the Thirties and
Forties. April 5-19, 1973.
While there are no reproductions there is a short para-
graph on each woman and a selected bibliography. Included are
Peggy Bacon, Isabel Bishop, Mabel Dwight, Anga Enters, Wanda
Gag, Marion Greenwood, Doris Lee, Clare Leighton, Ethel Myers,
Andree Ruellan, Margery Ryerson, Helen Farr Sloan, Beulah
Stevenson, Agnes Tait.

Stony Brook, Long Island. Suffolk Museum. Unmanly Art. Octo-
ber 14-November 24, 1972.
June Blum writes the short introduction. Some of the
artists represented in the show are Rosalyn Drexler, Alice Neel,
Marisol, Lee Bontecou, Marjorie Strider, Linda Benglis, Elaine
de Kooning, Louise Nevelson, Miriam Schapiro, Lee Krasner,
Louise Bourgeois, Janet Fish, Sylvia Sleigh, Pat Mainardi, May
Stevens, Judy Chicago and Ellen Lanyon.

Stryker, Catherine Connell. Studios at Cogslea. Wilmington, Del.:
The Delaware Art Museum, February 20-March 28, 1976.
An illustrated catalogue of seventy-three pages of works
by Violet Oakley, Elizabeth Shippen Green and Jessie Willcox
Smith.

Valencia, Calif. Feminist Art Program of the California Institute
of the Arts. Womanhouse. February 1972.
An all woman environment created by twenty-six women.
The co-directors of the Feminist Art Program were Judy Chicago
and Miriam Schapiro. Some of the rooms were a Dollhouse, a
Bridal Staircase, a Menstruation Bathroom, a Garden Jungle, a
Nightmare Bathroom, Leah's room from Colette's Chérie, and a
breasts-to-eggs kitchen.

Washington, D. C. Washington Gallery. Paper Works. A Juried
Exhibition of Works by Women on, of, or about Paper.
May 3-26, 1974.
The catalogue lists sixty women plus a chronology of the
exhibit's development.

Weitenkampt, Frank. Catalogue of a Collection of Engravings,
Etchings and Lithographs by Women. New York: The
Grolier Club, April 12-27, 1901.

Women as Artists and Women in the Arts, A Bibliography of Art
Exhibition Catalogues. Boston: World Wide Books Inc.,
1978.
An extraordinary bibliography of exhibition catalogues of
women's shows both contemporary and historical, which sorely
tempted this bibliographer to greatly enlarge this particular section
of the book! Request a copy from World Wide Books, Inc., 37-39
Antwerp Street, Boston, Mass. 02135, (615) 787-9100. They also
supply a price list of the individual catalogues in stock. Offerings
are genuinely "world wide." Descriptions and reviews are avail-
able in the quarterly bulletin published by the same company.

Zurich. Kunsthaus. Die Frau als Künstlerin. 1958.

INDIVIDUAL ARTISTS

This section is divided into centuries, with each artist's bibliography listed alphabetically under her respective century. Each artist is introduced by a short biographical paragraph. References to books, periodicals, and catalogues are grouped together in alphabetical order. Many citations will be in shortened form; full citations for these references are to be found in Section I.

Due to the far greater numbers of women artists in the twentieth century, and to the even greater amount of literature available on all contemporary artists, the final portion of this section of the bibliography makes even less pretense toward completion than do earlier sections. Also, we chose a cut-off birth year of 1930 to impose some limitation upon the scope of the twentieth-century section.

For many of the 161 artists included in this section, a short --and by no means complete--"Collections" list has been included at the end of their respective bibliographies. We hope the short collection lists will be of some help to people seeking to experience these artists first hand.

FIFTEENTH CENTURY AND EARLIER

ENDE. c. 975. Spanish.

Little is known about the life of this manuscript illuminator, who may have been a nun. The Beatus Apocalypse, called "one of the most splendid examples of Mozarabic book ornamentation and illustration known," by Miner (below), is partially illustrated and signed by her.

Apocalypse of Gerona. facsimile edition. Commentary by J. M. Casanovas, Cesar Dubles and Wilhelm Neuss. Olten-Lausanne-Freiburg: Urs Graf, n. d.

Carr, Annemarie Weyl. "Women Artists in the Middle Ages." p. 6.
Discusses her participation in the Gerona Apocalypse.

Harris and Nochlin. Women Artists, 1550-1950. p. 17.
Harris gives the signature of the Beatus Apocalypse, located in the Cathedral Treasury in Gerona: "En Depintrix et Dei Aiutrix Frater Emeterius et Presbiter." She translates: "En (Ende) paintress and helper of God and Brother Emeterius Presbiter." She says it is significant that her name precedes his. She points out that another manuscript, signed by Emeterius alone, has made it possible to isolate their individual contributions--giving the majority to Ende.

Hirmer, Max and Palol, Pedro de. Early Medieval Art in Spain. New York: Harry Abrams, n. d.
The Gerona manuscript was based on the commentary by Beatus of Liebana of 786. These authors believe the Visigothic script was by a senior priest and the illuminations by Ende.

Miner, Dorothy. Anastaise and Her Sisters.

Munsterberg. A History of Women Artists. pp. 12, 14.

Petersen and Wilson. Women Artists. pp. 13-14.

MARGARETHA VAN EYCK. c. 1406. Bruges.

The sister of Jan and Hubert. She was honored as an artist

in her own lifetime. A miniaturist and manuscript illuminator. The extent to which she was involved in the work of her brothers has yet to be determined.

Aulanier, Christiane. "Marguerite Van Eyck et L'homme au Turban Rouge." Gazette des Beaux Arts. 56, s6, pp. 57-58.
This discussion of the similarities in a portrait of Marguerite and The Man with a Red Turban includes some mention of Marguerite's dates.

Bénézit. Dictionnaire. Vol. 3. p. 633.

Clement. Women in the Fine Arts. pp. 119-120.

Crowe, J. A. and Cavalcaselle, G. B. The Early Flemish Painters: Notices of Their Lives and Works. London: John Murray, 1872, 2nd edition, pp. 129-132.
Includes a lengthy description of the missal of the Duke of Bedford which they attribute to her.

Ellet. Women Artists in All Ages. p. 34.

Heresies, a new publication of a collective of feminists, devoted to examining art and politics from a feminist perspective published a reproduction attributed to Van Eyck (Jan. 1977, p. 45). Unfortunately, the source of the reproduction was not given.

van Mander, Carel. Dutch and Flemish Masters. trans. from the Schilderboeck by Constant van de Wall. New York, 1936. p. 4.
"Their sister, Margriete van Eyck, became famous for her painting, too. Like Minerva, Margriete shunned Hymen and Lucina and remained in maiden state to the end of her life."

Schwartz. "They Built Women a Bad Art History."

Thieme and Becker. Allgemeines Lexikon. Vol. 11, p. 134.

HILDEGARDE VON BINGEN. 1098-1179. German.

Although she was never canonized, she is known as Saint Hildegarde. She was a Benedictine and became an abbess in 1136. In 1147 she moved her community to Rupertsberg, near Bingen on the Rhine, and built a large convent. She was one of the most influential women of the middle ages, acting as an advisor to rulers of both Church and state. At the age of forty-three she started having visions and other unusual spiritual experiences. She was called the "sybil of the Rhine." Her chief work, Scivias, c. 1165, describes and illustrates thirty-five of her visions regarding the future history of the world. Circular and mandala forms dominate her work. The earliest manuscript of Scivias, perhaps not the original, has been lost from the Stadtsbibliothek in Wiesbaden since

World War II. While Hildegarde probably did not illuminate the original manuscript herself, she surely worked closely with the artist, and the imagery must be credited to her imagination.

Attwater, Donald. The Penguin Dictionary of Saints. Middlesex: Penguin Books, 1965, pp. 170-171.
 Good biographical summary.

Baillet, Dom L. "Les miniatures du Scivias de Sainte Hildegarde conservé à la Bibliothèque de Wiesbaden." Foundation E. Piot, Monuments et mémoires. XIX (1911): 49-149.

Buckeler, M. Hildegard von Bingen, Wisse die Wege. Salzburg, 1954.

Carr, Annemarie Weyl. "Women Artists in the Middle Ages." Feminist Art Journal. 5(Spring 1976):7.
 While Saint Hildegard may not have personally illustrated her manuscripts, the unique images should be credited to her imagination.

Harris and Nochlin. Women Artists, 1550-1950. p. 18.

Heer, F. The Medieval World. London: Mentor paperback edition, 1961. pp. 283 & 320ff.

Hildegard von Bingen. Wisse die Wege (Scivias). Salzburg: Otto Muller, 1954.

Hill. Women, An Historical Survey.... Catalogue, p. viii.
 Notes that she was also a composer.

Holweck, Rev. F. G. A Biographical Dictionary of the Saints. St. Louis: B. Herdes Book Co., 1924; reprint edition, Gale Research Company, Detroit, 1969. p. 485.

Kessler, Clemencia H. "A Problematic Illumination of the Heidelberg Liber Scivias." Marsyas. 8 (1957-1959):7-21.
 Compares two manuscripts of Liber Scivias, a book of revelations by Hildegard, and discusses the different illuminations of the same text. Although questioning her degree of involvement, she does believe Hildegard helped in the preparation of the manuscripts since she was interested in every phase of cloister life. Several illustrations are included.

Miner. Anastaise and Her Sisters....

Munsterberg. A History of Women Artists. p. 12.

Petersen and Wilson. Women Artists. pp. 14-15.
 They report that she also invented a secret language of 920 words.

Theodoric and Goafried. Vie de Saint Hildegarde. Paris, 1907.

HERRADE VON LANDSBERG. Active 1160-1170. German.

She was the Abbess of Hohenburg in Alsace. In order to help educate her nuns, she produced the encyclopedia Hortus deliciarum (garden of delights), a compendium of medieval learning. The original manuscript was destroyed by fire during the Franco-German war of 1870. It can be studied today only through the line drawings traced by scholars prior to its destruction. That manuscript is thought by some to be from a generation after Herrade's death, and to have been produced in Strasbourg. The earliest manuscript was probably produced in her own convent by the nuns.

Cames, G. Allegories et symboles dans l'Hortus Deliciarum. Leyden, 1971.

Carr. "Women Artists in the Middle Ages."
"The greatest of the medieval pictorial encyclopedias."

Harris and Nochlin. Women Artists, 1550-1950. p. 18.

Katzenellenbogen, A. Allegories of the Virtues and Vices in Medieval Art. London, 1939.

Munsterberg. A History of Women Artists. pp. 12, 15.

Petersen and Wilson. Women Artists... pp. 15-16, 17, 18, 19.

Straub, A. and Keller, G. Herrade de Landsberg, Hortus Deliciarum. Strasbourg, 1879-99; reprint: Caratzas Brothers, 1977. This new edition is translated by A. D. Caratzas. It is a limited edition of 750 copies. 113 illustrations, and 251 pages.

SABINA VON STEINBACH. Active 1225-1240. German.

Sabina is the one woman in this bibliography whose existence is not certain. There is a long tradition that she was the daughter of sculptor Erwin von Steinbach and completed his work on the Strasbourg Cathedral upon his death. The allegorical figures, The Synagogue and The Christian Church, from the south portal, are traditionally attributed to her. The following translated Latin inscription is found on one of the scrolls held by her statue of the Apostle John, "May the grace of God fall to thy share, Sabina, whose hands have formed my image out of this hard stone." Harris reports that Sabina is a legend inspired by a mistaken reading of that inscription. She believes that Sabina was the donor of the statue.

Ellet. Women Artists in All Ages. p. 30.

Eva. "Women Artists...."

Guhl. Die Frauen....

Harris and Nochlin. Women Artists, 1550-1950. p. 25.
Harris cites Reinhardt (below) as her source.

Hess. "Is Women's Lib Medieval?"
Hess says that Sabina's work surpassed her father's.

Munsterberg. History of Women Artists. pp. 84-85.

Reinhardt, H. La cathédrale de Strasbourg. Paris, 1907. p. 101.

Tufts. Our Hidden Heritage. p. xvi.

"Women Artists." (review of Guhl)

SAINTE CATERINA DEI VIGRI. 1413-1463. Italian.

She was born of a noble family in Bologna. She was a
Franciscan nun who founded the Convent of Corpus Domini in Bo-
logna. As the only artist to be canonized (1712) she is considered
a special patron of the fine arts. She did small religious works
and decorated missals with miniatures and illumination. Harris
describes her work as "naive, provincial and archaic," which
would seem to demonstrate the limitations a cloistered life could
impose upon an artist's development. Some of her works as well
as her relics are preserved at the convent she founded.

Bénézit. Dictionnaire. Vol. 8. p. 568.

Bryan. Dictionary of Painters. Vol. 5, p. 301.

Clement. Women in the Fine Arts. pp. 350-352.

Ellet. Women Artists in All Ages. p. 35.

Guhl. Die Frauen....

Harris and Nochlin. Women Artists, 1550-1950. p. 20.

Ragg. Women Artists of Bologna. pp. 11ff, 150-157.

Sparrow. Women Painters of the World. p. 23.

Tufts. Our Hidden Heritage. p. 244.

"Women Artists." (review of Guhl)

SIXTEENTH CENTURY

SOFONISBA ANGUISSOLA. 1532/35-1625. Italian.

Sofonisba is unusual in that she was not the daughter of an artist. She was born in Cremona, the eldest of six talented daughters of a minor nobleman. Her sisters also painted and were gifted in music and literature. Sofonisba studied painting under Bernardino Campi in Cremona, and later under Bernardino Gatti. She was primarily a portraitist but also did small historical subjects. She did a great many self portraits, perhaps reflecting a demand for images of the phenomena she presented--a woman artist! In 1560 she went to Spain to serve as court painter and as a lady in waiting at the court of Phillip II. She spent at least ten years there, possibly twenty. She was twice married, the second time for love. She was known by Vasari, Michelangelo, and in her old age, Van Dyck. Over fifty paintings are attributed to her today, but only one is currently known from her mature and productive Spanish years.

Adriani, Gert. Anton Van Dyck italienisches Skizzenbuch. Vienna, 1940. pp. 72-73.
 This concerns Van Dyck's visit to Sofonisba in Palermo in 1624, shortly before her death.

Alf. "My interest in Women Artists of the Past."

Baldinucci, Filippo. Notizie de'professori del disegno da Cimabue in qua. Florence, 1681.
 Harris cites: Opere di Filippo Baldinucci, Milan, 1808-12. She describes his as the best early biography of Anguissola since it utilizes sixteenth-century sources.

Berenson, Bernard. Italian Painters of the Renaissance: Central Italian and Northern Italian Schools. London: Phaidon; revised edition 1968, Vol. I, pp. 13-14.
 Berenson provides a list of her work.

Bonetti, C. Sofonisba Anguissola. Cremona, 1932.

Borea, Evalina. "Caravaggio e La Spagna: osservazioni su una mostra a Siviglia," Bollettino d'Arte. 59 (Jan. -June 1974):47-48.

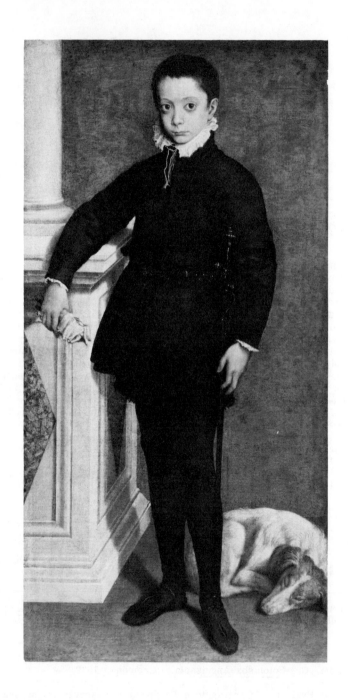

Sofonisba Anguissola. Portrait of a Boy with Sword, Gloves and a
Dog. Oil. Walters Art Gallery, Baltimore, Md.

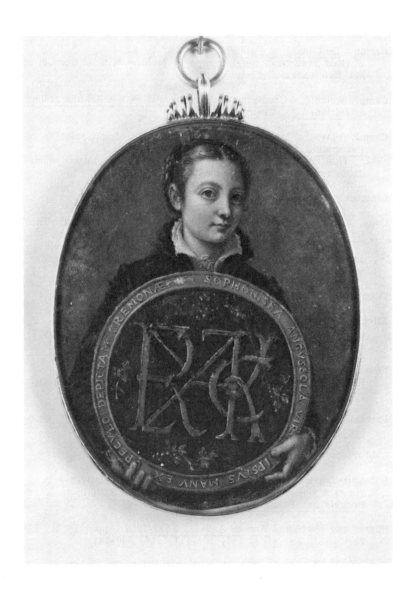

Sofonisba Anguissola. Self Portrait. ca. 1552. Oil on copper.
3 1/4" x 2 1/2". Museum of Fine Arts, Boston, Mass. Emma
F. Monroe Fund.

Illustrated with Ritratto di Vecchio.

Bryan. Dictionary of Painters. Vol. 1, p. 41.
 Good résumé of her biography. Includes a brief account of
 her five sisters. Lists her works.

Campi, Antonio. Cremona fedelissima città et nobilissima colonia
 di Romani.... Cremona, 1585.

Caroli, Flavio. "Antologia di artist; per Lucia Anguissola."
 Paragone. 277 (1973):69-73.
 This concerns a younger sister of Sofonisba, Lucia; whose
 dates are quite tentative--c. 1540-c.1565.

Clement. Women in the Fine Arts. pp. 11-16.

Cook, Herbert. "More Portraits by Sofonisba Anguissola." The
 Burlington Magazine. XXVI (1915):228-236.
 Attempts to clear up confusion over her birth and death
 dates. Accompanied by 5 good illustrations of her portrait
 work.

Edwards. Women: An Issue.

Ellet. Women Artists in All Ages. pp. 48-55.
 Chapter IV is entitled, "The Six Wonderful Sisters Anguis-
 sola."

Fournier-Soclovèze, M. "Sofonisba Anguissola et ses soeurs."
 Revue de l'art ancien et moderne. V, no. 25 (1899):Part I,
 pp. 313-324; V, no. 26 (1899):Part II, pp. 379-392.

Frizzoni, G. "La pietra tombale di Sofonisba Anguissola." Ras-
 segna bibliografica dell'arte. XII (1909):53-55.

Gabhart and Brown. "Old Mistresses."

Haraszti-Takacs, Marianne. "Nouvelles données relatives à la
 vie et à l'oeuvre de Sofonisba Anguissola." Bulletin du Musée
 Hongris des Beaux-Arts. XXXI (1968):53-67.

Harris and Nochlin. Women Artists, 1550-1950. pp. 13, 21, 23-
 29, 30-31, 34, 41-42, 44, 106-111, 116, 340-341.

Holmes, C. J. "S. Anguissola and Philip II." The Burlington
 Magazine. XXVI (1915):181-187.
 Discusses the reasoning for a new attribution to Anguissola.

Kuhnel-Kunze, Irene. "Zur Bildniskunst der Sofonisba und Lucia
 Anguissola." Pantheon. XX (1962):83-96.

Longhi, R. "Indicazioni per Sofonisba Anguissola." Paragone.
 No. 157 (1963):50-52.

Munsterberg. History of Women Artists. p. 19.

Nicodemi, G. "Commemorazione di artisti minor: Sofonisba Anguissola." Emporium. (1927):222-223.

Pilkington, Matthew. A General Dictionary of Painters. London: Thomas McLean, 1824. Vol. I, pp. 21-22.

Prinz, W. Die Sammlung der Selbstbildnisse in den Uffizien I., Geschichte der Sammlung. Berlin, 1971.

Sachs. The Renaissance Woman. pp. 39, 88. Illustrations.

"The Samuel H. Kress Study Collection--Sofonisba Anguissola." Oberlin College Bulletin. 19 No. 1 (Fall 1961):34.

Schwartz. "If De Kooning...."

Soprani, Raffaele. Le vite de'pittori, scultori, et architetti genovesi.... Genoa, 1674.
 Harris cites from the 1768-1769 edition with notes by G. Ratti, pp. 411-16. She describes it as the first published biography of Sofonisba Anguissola.

Sparrow. Women Painters of the World. p. 24-28.

de Tolnay, Charles. "Sofonisba Anguissola and Her Relations with Michelangelo." Journal of the Walters Art Gallery. IV (1941): 116-117.
 An account of letters sent by Anguissola's father to Michelangelo, indicating the strong possibility that Michelangelo gave her general advice and criticism of her work.

Tufts. Our Hidden Heritage. pp. 21-29.

_____. "Sofonisba Anguissola, Renaissance Woman." Art News. LXXI (October 1972):50-53.

Vasari, Giorgio. Lives of the Most Eminent Painters, Sculptors and Architects. Translated by Guston Devere. London: Philip Lee Warner, 1912-15. Vol. 8, pp. 45-48, and Vol. 5, pp. 127-128.
 Vasari recounts visiting the Anguissola family and mentions the talents of each sister, describing portraits by Minerva and Lucia. He also records an exchange of letters between Sofonisba and Pope Pius IV.

Zaist, Giovanni Battista. Notizie istoriche de' pittori, scultori et architetti cremonesi, opera postuma di Giambattista Zaist data in Luce da Anton Maria Panni. 2 vols. Cremona, 1774.

Collections:

> Baltimore, Walters Art Gallery.
> Boston, Museum of Fine Arts.
> Corsham Court, Methuen Collection.
> Madrid, Museo 'del Prado.
> Naples, Gallerie Nazionali di Capodimonte.
> Nivaagard, Hague Collection.
> Poznán, Muzeum Narodowe.
> Siena, Pinacotheca.
> Southampton, City of Southampton Art Gallery.
> Vienna, Kunsthistorisches Museum.

LAVINIA FONTANA. 1552-1614. Italian.

The daughter of an artist, Prospero Fontana (1512-1597), who was also her teacher. She is said to have felt the influence of Ludovico Carracci, another student of her father. In 1579 she married another of her father's students, G. P. Zappi. Theirs was a liberated relationship in that he supported her career, perhaps even painting the drapery in her paintings. They had eleven children, only three of whom survived their mother. She worked in Rome from 1600 until her death, under the patronage of Pope Clement VIII. She was elected to the Rome Academy. Her portraits of the Roman nobility were done in a conservative "maniera" style. She also did group portraits, religious scenes, and altar pieces. One hundred thirty-five documented works, of which less than sixty are known today. In 1611 a portrait medal was cast in her honor.

Alf. "My Interest in Women Artists of the Past. "

Art News. 69 (January 1971):26.
 Her Self Portrait is reproduced.

Baglione, Giovanni Battista. Le vite de'pittori, scultori et architetti dal pontificato di Georgio XII del 1572, in fino a'tempi di Papa Urbano VIII nel 1642. Rome, 1642. p. 143; facsimile edition with marginal notes by Bellori, edited by V. Mariani, Rome, 1935.

Bénézit, Dictionnaire. Vol. 3, p. 804.
 Lists her paintings.

Borenius, Tancred. "A Portrait by Lavinia Fontana. " Burlington Magazine. 41 (July 1922):41-42.
 Mentions 17th C. Italian manuscripts concerning her life.

Bryan. Dictionary of Painters. Vol. 2, p. 177.
 Lists 22 of her most important paintings and recounts the facts of her life.

Burlington Magazine. 110 (November 1968):598.

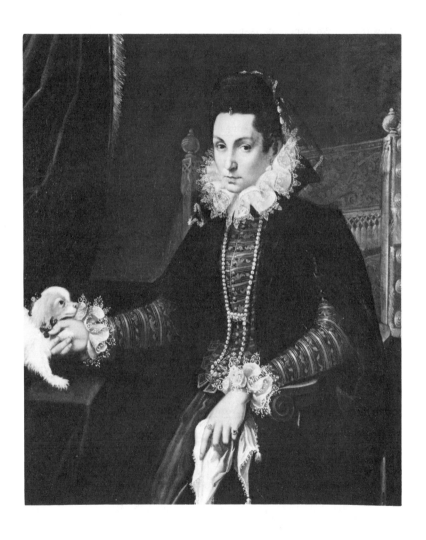

Lavinia Fontana. Portrait of a Noblewoman with a Lap Dog. Oil.
Walters Art Gallery, Baltimore, Md.

Fontana's Visit of the Queen of Sheba is reproduced.

Clement. Women in the Fine Arts. pp. 128-130.

Edwards. Women: An Issue.

Ellet. Women Artists in All Ages. pp. 61-64.

Freedberg, Sydney. Painting in Italy, 1500-1600. Harmondsworth, Middlesex and Baltimore: Penguin, 1971. p. 394.
Harris says Friedberg "dismisses her as without interest."

Galli, Romeo. Lavinia Fontana, pittrice, 1552-1614. Imola, 1940.

Gristina, Mary Campbell. Lavinia Fontana. (Ph.D. dissertation in progress).

Guhl. Die Frauen....

Harris and Nochlin. Women Artists, 1550-1950. pp. 21, 24-31, 42-43, 69, 106, 111-14, 141, 147, 341.

"Lavinia Fontana: A Further Contribution." Burlington Magazine. 85 (Oct. 1944):258.
Lists her works in England.

Malvasia, Carlo Cesare. Felsina pittrice. Bologna, 1678. Vol. I, pp. 219-224.
The chapter on Fontana is faced with a portrait engraving of her.

Mancini, Giulio. Considerazioni sulla pittura. 2 vols. Rome, 1956-57.
Edited by A. Marucchi and L. Salerno.

Munsterberg. A History of Women Artists, p. 22.

Pachero, Francisco. Arte de la pintura. 1956. Vol. I, p. 148.

Sachs. The Renaissance Woman. p. 39.

de los Santos, F. Francisco. Descripción de San Lorenzo del Escorial. 1657 and 1698, as quoted in F. J. Sanchez Canton, Fuentes literarias para la Historia del Arte Español. Madrid, 1933. Vol. II, p. 249.

Schwartz. "If De Kooning...."

_____. "They Built Women a Bad Art History."

Sparrow. Women Painters of the World. pp. 28-29.

Thieme and Becker. Allgemeines Lexikon. Vol. 12, pp. 182-183.

Trevor-Roper, Hugh. The Plunder of the Arts. London, 1970.
 p. 32.

Tufts, Eleanor. "Ms. Lavinia Fontana from Bologna: A Success-
 ful Sixteenth Century Portraitist." Art News. LXXIII (Febru-
 ary 1974):60-64.

_____. Our Hidden Heritage. pp. 31-43.

Collections:

 Baltimore, Walters Art Gallery.
 Bologna, Pinacoteca.
 Bordeux, Musée des Beaux-Arts.
 Dublin, National Gallery of Ireland.
 Florence, Galleria degli Uffizi.
 Imola, Bibliotèca.
 Naples, Museo di Capodimonte.
 New York, Rojtman Foundation, Inc.
 Rome, Galleria Nazionale (Corsini).

CATERINA VAN HEMESSEN. 1528-after 1587. Flemish.

 She was born in Antwerp, the daughter of artist Jan Sanders
van Hemessen. She is thought to have perhaps worked on the back-
grounds of some of her father's paintings. She painted half-length
portraits and small religious works in a style far simpler and sub-
dued than her father's lively mannerism. She and her husband, a
musician, spent some years in Spain at the court of Queen Mary
of Hungary. Ten signed and dated works survive today--all pre-
vious to her marriage. This suggests that she either stopped
painting or that her later production has yet to be found.

Bénézit. Dictionnaire. Vol. 4, p. 651.
 She married her husband, a musician, in 1554.

Bergmans, Simone. "Note complementaire a l'étude des De
 Hemessen, de van Amstel et du monogrammiste de Brunswick."
 Revue Belge d'Archeologie et d'Histoire de l'Art. XXVII
 (1958):77-83.

_____. "Le problème du Monogrammiste de Brunswick." Bul-
 letin, Musées Royaux des Beaux-Arts de Belgique. XIV (1965):
 143-162.
 Bergmans believes that Catharina might have been the
 Brunswick Monogrammist.

_____. "Le problème Jan van Hemessen, monogrammiste de
 Brunswick." Revue belge d'archéologie et d'histoire de l'art.
 XXIII (1955, II):133-157.

Edwards. Women: An Issue.

Ellet. <u>Women Artists in All Ages.</u> p. 57.

Guicciardini. <u>Descrittione dei Paesi Bassi.</u>
In 1567 he mentioned Hemessen as one of the women artists then alive.

Harris and Nochlin. <u>Women Artists, 1550-1950.</u> pp. 12, 13, 24-26, 28-29, 41, 105, 340.

Sachs. <u>The Renaissance Woman.</u> pp. 38-39.

Sparrow. <u>Women Painters of the World.</u>

Thieme and Becker. <u>Allgemeines Lexikon.</u> Vol. 16, p. 367.

Tufts. <u>Our Hidden Heritage.</u> pp. 51-57.

Vasari. <u>Lives of the Most Eminent Painters.</u> trans. by Devere. Vol. 9, pp. 268-269.
Mentions her in his discussion of miniaturists.

<u>Collections</u>:

 Amsterdam, Rijksmuseum.
 Basle, Öffentliche Kunstsammlung.
 Brussels, Museum of Fine Arts.
 Cambridge, England, Fitzwilliam Museum.
 Cologne, Wallraf-Richartz Museum.
 London, National Gallery.
 Rhode Island, Museum of the Rhode Island School of Design.

SUSANNAH HOURBOUT. 1503-after 1550. Flemish.

 Only one scrap of documentation survives about this woman, recorded by Dürer himself. In the end of May in 1521, while in Antwerp, he makes the following entry in his diary: "Master Gerhard, the illuminator, has a daughter about eighteen years old named Susannah. She has illuminated a 'Salvator' on a little sheet, for which I gave her one florin. It is wonderful that a woman can do so much." Gerhard, with his entire family, afterwards departed to England to enter the service of Henry VIII, to satisfy the demand for miniatures. There Susannah married one of the king's archers and died with honors in her adopted country.

Clayton. <u>English Female Artists.</u> Vol. I, pp. 5-7.
Clayton spells her name "Hornebolt."

Conway, William Martin, trans. and ed. <u>The Writings of Albrecht Dürer.</u> New York: Philosophical Library, 1958. p. 120.

Ellet. <u>Women Artists in All Ages.</u> p. 57.
Here Dürer is quoted as buying a little illuminated book

from her.

Guicciardini. Descrittione dei Paesi Bassi.
He cites "Susan Horenbout" as one of seven Flemish women artists active in 1567. Another alternate spelling of her name is Hornebolt.

Harris and Nochlin. Women Artists, 1550-1950. p. 26, 30, 41, 102.

Munsterberg. A History of Women Artists. p. 22.

Paget, H. "Gerard and Lucas Hornebolt in England. " Burlington Magazine. (1959):396-402.
An article about her father and brother. Susannah represents the many women artists who worked in family workshops and whose names and production are lost to us today.

Sachs. The Renaissance Woman. p. 38.

Sparrow. Women Painters of the World. p. 253.

Tufts. Our Hidden Heritage. pp. 43, 243.

Vasari. Lives of the Most Eminent Painters. trans. by Devere. Vol. 9, pp. 268-269.
Says she's the sister of Lucas, an artist, and is from Ghent. Mentions she was invited into the service of Henry the 8th.

BARBARA LONGHI. 1552-1638. Italian.

Born in Ravenna, the daughter of mannerist painter Luca Longhi. She followed his style but simplified it. She did portraits and religious works.

Bénézit. Dictionnaire. Vol. 5, p. 621.
Gives her date of death as around 1638.

Bryan. Dictionary of Painters. Vol. 3, p. 243.
Lists her paintings.

Clement. Women in the Fine Arts. p. 215.

Ellet. Women Artists In All Ages. p. 47.

Harris and Nochlin. Women Artists, 1550-1950. p. 28, 106.
Harris says that no serious research has been done on Longhi. She reproduces her Madonna and Child with St. John the Baptist.

Sparrow. Women Painters of the World. p. 24.

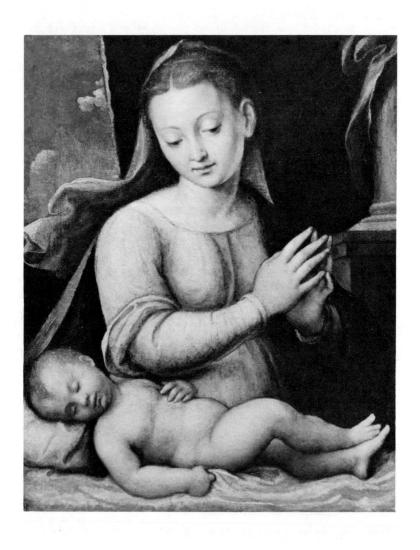

Barbara Longhi. <u>Madonna and Child.</u> Walters Art Gallery, Balti-
more, Md.

Thieme and Becker. Allgemeines Lexicon. Vol. 23, p. 356.

Vasari. Lives of the Most Eminent Painters. trans. by Devere.
 Vol. 9, p. 155.
 Mentions Longhi as "... a little girl, draws well and has
 begun to do some work in color."

Collections:

 Dresden, Gemäldegalerie.

MARIETTA ROBUSTI. 1560-1590. Venice.

 The daughter of Tintoretto and his student. She was also
accomplished in music. She was a highly acclaimed portraitist.
She was invited to paint for the courts of the Emperor Maximilian
in Germany and Phillip II of Spain. Whether she remained in
Venice because of her father's insistence or because of his poor
health is not clear. She was married to a jeweler. The bulk of
her oeuvre has probably been misattributed to her father.
 One of the remarkable "oversights" of art history is that
although there has been a long awareness of Robusti as an artist,
little interest in discovering her works has surfaced.

Alf. "My Interest in Women Artists of the Past."

Bénézit. Dictionnaire. Vol. 8, p. 317.

Bryan. Dictionary of Painters. Vol. 4, p. 262.

"Buried in False Signatures: Women in Art." The Ladder.
 (April-May 1972).

Clement. Women in the Fine Arts. pp. 290-292.

Edwards. Women: An Issue.

Ellet. Women Artists in All Ages. pp. 45-46.

Eva. "Women Artists...."

Guhl. Die Frauen....

Harris and Nochlin. Women Artists, 1550-1950. p. 28.
 Harris states that only her self portrait in the Uffizi can
 be securely attributed to her, though several others are asso-
 ciated with her.

Hess. "Is Women's Lib Medieval?"
 Hess relates that in 1920 Venturi changed the attribution of
 the portrait of Marco del Vescovi in the Vienna Museum from
 Tintoretto to his daughter.

Newton, Eric. Tintoretto. Westport, Conn.: Greenwood Press, 1952, p. 62.

Osler, W. Roscoe. Tintoretto. New York: Scribner and Welford, 1879, pp. 33-34.
 Anecdotal account of Tintoretto's relationship to his daughter. Until age 15 she assisted him, dressed as a boy, with strangers not realizing it was his daughter.

Petersen and Wilson. Women Artists. p. 28.

Rossi, P. Iacopo Tintoretto, I Ritratti. Venice, 1974. pp. 138-139.

Schwartz. "They Built Us a Bad Art History."

Sparrow. Women Painters of the World.

Theime and Becker. Allgemeines Lexikon. Vol. 33, pp. 198-199.

Tietze-Conrat, E. "Marietta, fille du Tintoret: peintre de portraits." Gazette des Beaux-Arts. 12 (Dec. 1934):258-262.
 Discussion of the reattribution of a work from her father to her, based on the discovery of her signature. Illustrates two works by her as well as her portrait done by her father.

"Women Artists." (review of Guhl)

Collections:

 Bordeaux, Bordeaux Museum.
 Florence, Uffizi.
 Vienna, Kunsthistorisches Museum.

PROPERZIA DE'ROSSI. 1490-1530. Italian.

 De'Rossi is the only woman sculptor to emerge from the Italian Renaissance. She was a pupil of Raimondi and was influenced by Tribolo. She also did engravings and etchings, was an accomplished musician and was educated in the sciences. Her first work was reportedly a crucifixion scene carved on a peach stone. When she received a commission for part of the facade decorations of San Petronio, the male artists in competition with her became jealous and waged a campaign to discredit her. As a result her bas-relief of Joseph and Potiphar's Wife was interpreted as revealing her unrequited love for a young noble man. This was a work that had earned praise from Vasari. The superintendents of the church elected not to put the relief in place. Through grief and mortification at this discrimination she died at age forty. Her work can be seen today at the Church of San Petronio and in the Museum of San Petronio in Bologna.

Benezit. Dictionnaire. Vol. 7, p. 367.

Clement. Women in the Fine Arts. pp. 299-301.

Ellet. Women Artists in All Ages. Chapter III is devoted to her,
pp. 39ff.

Guhl. Die Frauen....

Harris and Nochlin. Women Artists, 1550-1950. p. 23, 25, 27,
30, 147.

Munsterberg. A History of Women Artists. p. 85.

Petersen and Wilson. Women Artists. p. 27.

Ragg. Women Artists of Bologne. p. 4.

Sachs. The Renaissance Woman. Text on p. 39; reproduction of
a bas relief on p. 82.

Thieme and Becker. Allgemeines Lexikon. Vol. 29, pp. 71, 72.

Tufts. Our Hidden Heritage. pp. xvi, 244.

Vasari, Georgio. Lives of Italian Painters. Edited and prefaced
by Havelock Ellis. London: Walter Scott, Ltd. Vol. IV,
pp. 181-186.

"Women Artists" (review of Guhl).

DIANA GHISI SCULTORE. 1530-1590. Italian.

 She was born in Mantua and was the student of her father
and brother. She painted and engraved religious subjects. Circa
1579 she married architect and sculptor Francesco Ricciarelli.
Forty-six engravings have been catalogued as hers. She is also
known as Sculptori or Mantovana. She died in Rome.

von Bartsch, Adam Ritter. Le peintre graveur italian. Milan:
U. Hoepli, 1906.
 He has catalogued Ghisi's prints.

Bénézit. Dictionnaire. Vol. 4, p. 232.

Brodsky, Judith. "Some Notes on Women Printmakers." Art
Journal. 35 (Summer 1976):28-30.

Bryan. Dictionary of Painters. Vol. 5, p. 60.

Feinberg, Alice M. "Diana Ghisi--Italian Printmaker, 1530-1590."
Feminist Art Journal. IV, no. 3 (Fall 1975):28-30.

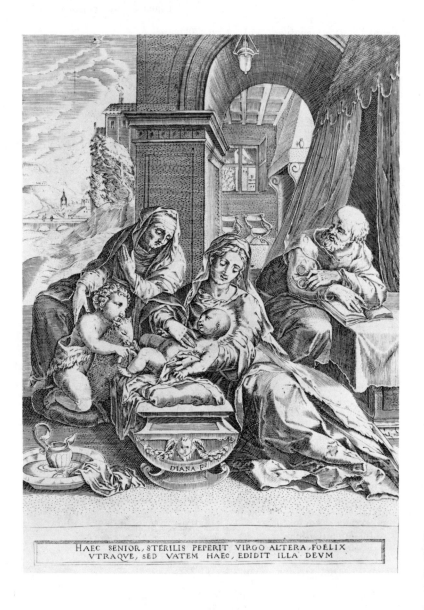

HAEC SENIOR, STERILIS PEPERIT VIRGO ALTERA, FOELIX
VTRAQVE, SED VATEM HAEC, EDIDIT ILLA DEVM

Diana Ghisi Scultore. The Holy Family. Engraving. Fogg Art
Museum, Harvard University, Cambridge, Mass.

Feinberg has supplied much of the bibliography on Ghisi here.. The article is illustrated with good black and white reproductions of Ghisi's prints.

Harris and Nochlin. Women Artists, 1550-1950. p. 29.

Munsterberg. History of Women Artists. p. 105.
Cites different birth and death dates and gives a different name for her husband.

Vasari. Lives of the Most Eminent Painters. trans. by Devere. Vol. 8, p. 42.

Weitenkampt, Frank. Catalogue of a Collection of Engravings, Etchings and Lithographs by Women. New York: The Grolier Club, April 12-27, 1901. p. 38.

Collections:

Cambridge, Fogg Museum, Harvard University.

IRENE DI SPILIMBERG. 1540-1560. Italian.

She was born in Udina, Italy to a noble family that originated in Germany. She was educated in Venice, where for two years she was the student of Titian. Not only skilled in painting, she was also proficient in letters, music and design. She died at the age of twenty, her first promise unrealized. No work is attributed to her today.

Bryan. Dictionary of Painters. Vol. 5, p. 109.
Spells the name "Spilembergo" and says she painted for her amusement only.

Clement. Women in the Fine Arts. pp. 320-321.

Ellet. Women Artists in All Ages. pp. 44-45.

Guhl. Die Frauen....

Harris and Nochlin. Women Artists, 1550-1950. p. 28.
Harris relates that she was inspired to try painting after seeing a self portrait of Sofonisba Anguissola. This incident points out the crucial necessity for role models, both historical and contemporary, for young women artists.

Minghetti, Marco. "Le donne italiane nelle belle arti al secolo xv et xvi." Nuova antologia. XXXV (1877):308-330.
Mention is made of Spilimberg on 319ff.

Sachs, Hannelore. Renaissance Woman. p. 39.

Vasari. Lives of the Most Eminent Painters. trans. by Devere.
Vol. 9, p. 175.

LEVINA TEERLINC. Circa 1520-1576. Flemish.

The daughter of miniaturist Alexander Bening, or Benninck
(1483/84-1561). She too was a miniaturist. She was invited to
England by Henry VIII, who paid her a higher salary than he did
Holbein! She continued to serve under Edward VI, Mary I, and
Elizabeth I. With her husband and son, she became an English
citizen. While Teerlinc's life and career are quite well documented
from contemporary records--enabling Harris to describe her as
"the most important miniaturist active in England between Holbein
and Hilliard"--the complete lack of signed works by her and the
lack of a dedicated scholar to reassemble her oeuvre leave her
with only a few tentative attributions. Her name is alternately
spelled Teerling.

Auerbach, Erna. Nicolas Hilliard. London, 1961; Boston, 1964.

Bénézit. Dictionnaire. Vol. I, p. 554.
Gives her father's name as Simon Bening.

Bergmans, Simone. "The Miniatures of Levina Teerlinc." The
Burlington Magazine. LXIV (1934):232-236.
Illustrated article attempting to attribute several miniatures
to her, based on the previous attribution of a work in the
Victoria and Albert Museum.

Clayton. English Female Artists. pp. 7-12.

Durrieu, Paul. Alexandre Bening et les peintres du Breviare
Grimani. Paris, 1891.

Ellet. Women Artists in All Ages. pp. 57-58.

Gucciardini. Descrittione dei Paesi Bassi.
Harris cites her brief mention (1567) as the only one in
print prior to the nineteenth century.

Harris and Nochlin. Women Artists, 1550-1950. pp. 19, 25-26,
42, 102-104, 105, 340.
Harris questions most of the attributions given in Tufts
chapter (below).

Nichols, John Gough. "Notices of the Contemporaries and Suc-
cessors of Holbein." Archaeologia. XXX (1863):39-40.

Petersen and Wilson. Women Artists. p. 27.

Reynolds, G. The Connoisseur Period Guides: The Tudor Period,
1500-1603. London, 1956.

See "Portrait Miniatures," p. 131.

Sachs. The Renaissance Woman. pp. 38, 83.
A full-page black and white reproduction of her self por-
trait.

Strong, Roy C. The English Icon: Elizabethan and Jacobean Por-
traiture. London, 1969.

Tufts. Our Hidden Heritage. pp. 43-49.

Vasari. Lives of the Most Eminent Painters. trans. by Devere.
Vol. 9, pp. 268-269.
Is only mentioned in his discussion of miniaturists.

Walpole. Anecdotes of Painting. Vol. I, p. 108.

Collections:

London, Victoria and Albert Museum.
Windsor Castle, Collection of Her Majesty, the Queen.

MAYKEN VERHULST. 1520-1560. Flemish.

She was born in Malines. She was the wife of Pieter Coeck
van Aelst, whom she married in 1537, and the mother-in-law of
Pieter Bruegel. She was the grandmother and first teacher of Jan
"Velvet" Brueghel. She was also known as Marie Bessemer. She
was known as a watercolorist and miniaturist. There are no works
currently attributed to her.

Bénézit. Dictionnaire. Vol. I, p. 629.

Bergmans, Simone. "Le problème Jan van Hemessen, monogram-
miste de Brunswick." Revue Belge d'Archéologie et d'Histoire
de l'Art. 23 (1955, II):133-157.
Bergmans also considers Mayken Verhulst as possibly being
the Brunswick Monogrammist.

Foote, Timothy. The World of Bruegel, c. 1525-1569. New York:
Time-Life Books, 1968. pp. 70, 71, 170.

Harris and Nochlin. Women Artists, 1550-1950. p. 105.

Sachs. The Renaissance Woman. p. 38.

Tufts. Our Hidden Heritage. pp. 52, 243.

SEVENTEENTH CENTURY

MARY BEALE (née CRADOCK). 1632-1699. English.

Beale was the daughter of a clergyman. She is considered by some authorities to be the first English woman to have made her living painting. Although she married an artist in 1651, Charles Beale, he took over the domestic role of managing the household, grinding her colors and preparing her canvas, while she became the breadwinner. She was the friend of Sir Peter Lely and probably studied with Thomas Flatman. Beale had two sons. One of her children, Charles, became a miniaturist and portrait painter and assisted his mother with her practice in London. She was primarily a portraitist.

Bénézit. Dictionnaire. Vol. I, pp. 487-488.

Bryan. Dictionary of Painters. Vol. I, p. 100.

Clayton. English Female Artists. Vol. I, pp. 40-53.

Clement. Women in the Fine Arts. pp. 34-35.

Cullum, George. Mary Beale. Ipswich: W. S. Harrison, 1918.

Daniels, Jeffery. "The Excellent Ms. Mary Beale." Art News. 74, no. 8 (October 1975):100-101.
 Good summary of her life and work. Illustrated with a good black and white self portrait.

Ellet. Women Artists in All Ages. p. 110, 123.

Flower, Sibylla J. "The Excellent Mrs. Mary Beale." Connoisseur. 190 (Dec. 1975):302.

Harris and Nochlin. Women Artists, 1550-1950. p. 363.

John. "The Woman Artist."

London. Geffrye Museum. The Excellent Mrs. Mary Beale. 1975.
 Catalogue by Elizabeth Walsh and Richard Jeffree.

Petersen and Wilson. Women Artists.... pp. 34-35.

Pilkington, Matthew. A General Dictionary of Painters. London: Thomas McLean, 1824, Vol. I, p. 58.
"She was amiable in her conduct, assiduous in her profession, and had the happiness to live in universal esteem, and to receive every encouragement."

Reitlinger, Henry S. "The Beale Drawings in the British Museum." Burlington Magazine. 41 (Sept. 1922):143-147.
Describes generally the 176 drawings, 165 of which are attributed to Mary Beale. Discusses early documents related to the drawings and proposes that the bulk of the collection might instead be by Charles, her son. Several good black and white illustrations.

Sparrow. Women Painters of the World. pp. 57-58.

Thieme and Becker. Allgemeines Lexicon. Vol. 3, p. 110.

Tufts. Our Hidden Heritage. pp. xv, 101.

Vertue, George. The Note-Books of G. Vertue Relating to Artists and Collections in England. 6 vols. Oxford, 1930-42. Prepared by Katherine Esdaile, S.H.F. Strangways and Sir Henry Hake.

Walpole. Anecdotes of Painting. Vol. II, pp. 537-544.
Quotes at length from the pocket-book journals kept by her husband, the most valuable source of information on Beale. According to Walpole, most of the thirty-odd volumes were lost, but one volume of the journals is located at Oxford University's Bodleian Library. Walpole's quotes are taken from Vertue's extractions of the journals.

Walsh, Elizabeth. "Mrs. Mary Beale, Paintress." Connoisseur. 131 (April 1953):3-8.
Discusses the heavy influence of Lely on her work between 1672 and 1681. Mentions that her reputation as a portraitist was first established in ecclesiastical circles. Records details of her life by drawing from contemporary letters and diaries. Establishes her death date as 1699 (not 1697 as Walpole asserts).

Collections:

London, National Portrait Gallery.

ELIZABETH SOPHIE CHERON. 1648-1711. French.

Chéron was born in Paris, the daughter of the painter Henri Chéron. She learned miniature and enamel painting from her

father. Originally a protestant, she converted to Catholicism.
She was admitted to the French Academy in 1672 and was later
pensioned by Louis XIV. In 1699 she became a member of the
Padua Academy. She married for the first time at the age of
sixty. Her husband, Jacques Le Hay, was an engineer for the
king. She was also accomplished as a printmaker, musician, and
poet.

Bénézit. Dictionnaire. Vol. 2, p. 476.

Bryan. Dictionary of Painters. Vol. 1, p. 288.

Clement. Women in the Fine Arts. pp. 81-83.

Ellet. Women Artists in All Ages. p. 90.

Guhl. Die Frauen....

de Mirimonde, A. P. "Portraits de musiciens et concerts de
 L'école Française. " Revue du Louvre. 15 (1965):217-219.
 Discusses her use of self-portraits to point out her talents
 as a musician. Two illustrations.

Harris and Nochlin. Women Artists, 1550-1950. pp. 29, 36.

Petersen and Wilson. Women Artists. p. 34.
 Illustrates with self portrait.

Thieme and Becker. Allgemeines Lexikon. Vol. 6, pp. 30-31.

"Women Artists" (review of Guhl).

SUZANNE DE COURT. Active circa 1600. French.

 The daughter and student of enamelist Jean de Court. She
did elaborate Limoges enamels in colors rather than grisaille.

Bénézit. Dictionnaire. Vol. 2, p. 685.

Gabhart and Broun. "Old Mistresses.... "

Harris and Nochlin. Women Artists, 1550-1950. p. 20.

Petersen and Wilson. Women Artists. p. 33.

Thieme and Becker. Allgemeines Lexikon. Vol. 7, p. 585.

Collections:

 Baltimore, Walters Art Gallery.
 Dijon Museum.
 Lyon Museum.

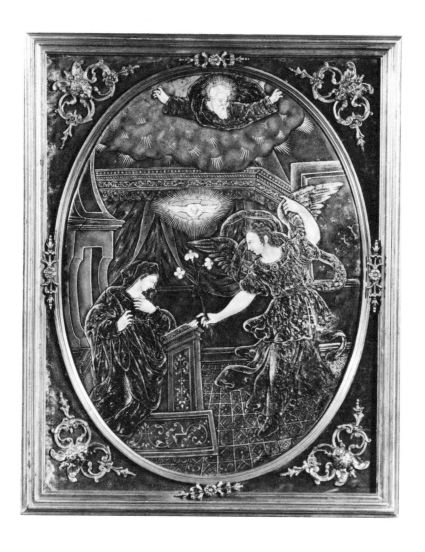

Suzanne de Court. The Annunciation. ca. 1600. Limoges enamel plaque. 7 7/16" x 5 5/8". Walters Art Gallery. Baltimore, Md.

New York, Frick Collection.
New York, Metropolitan Museum, Lehman Collection.
Paris, Louvre.

FEDE GALIZIA. 1578-1630. Italian.

She was the daughter of miniaturist Nunzio Galizia, and a
child prodigy. Her talents were noted in print at age twelve; she
had an established portrait career at sixteen. She did public com-
missions for churches. Harris says her still lifes are her most
important works, and calls them among the earliest true still
lifes.

Bottari, Stefano. "Fede Galizia. " Arte antica e moderna. No.
 24 (1963):309-360.

_____. Fede Galizia pittrice (1578-1630). Trento: Collana
 Artisti Trentini, 1965.
 Provides a catalogue of her works. This is an enlarged
 version of his 1963 article, it contains more illustrations.

Harris and Nochlin. Women Artists, 1550-1950. pp. 28, 31-33,
 41-43, 106, 115-117, 341.
 We are indebted to Harris for all the information and bibli-
 ography presented here on Galizia.

Lomazzo, G. P. Idea del tempio della pittura. Milan, 1690.
 p. 163.

Collections:

 Milan, Pinacoteca Ambrosiana.
 Sarasota, Florida, Ringling Museums.

GIOVANNA GARZONI. 1600-1670. Italian.

Giovanna Garzoni did small studies of plants and animals
using a delicate and characteristic stipple technique, in tempera
and watercolor on vellum. Her compositions were simple and ele-
gant. Harris calls her works, "among the finest ... botanical
studies made in the seventeenth century. " She was probably pa-
tronized by the Medici. Portraits and religious works are also
mentioned for her. She is thought to have been born in Ascoli
Picento. She lived in Venice, Rome and Naples. Nothing is
known of her training.

Blunt, W. The Art of Botanical Illustration. New York, 1951.
 p. 81.

Bottari, Giovanni Gaetano. Raccolta di lettere sulla pittura, scul-
 tore, ed architettura. Milan, 1754; Milan, 1822-25 ed. , Vol.

Attributed to Giovanna Garzoni. Still Life with Birds and Fruit. ca. 1640. Watercolor over pencil on parchment. 10 1/8" x 16 3/8". Cleveland Museum of Art, bequest of Mrs. Elma M. Schniewind in memory of her parents Mr. and Mrs. Frank Geib.

I, pp. 238-42.
 Latter edition enlarged by Stefano Ticozzi.

Carboni, Giacinto. Cantalamessa. Memorie intorno i letterati e gli artisti della città di Ascoli nel Picento. Ascoli Picento, 1830.

Colding, Torben Holch. Aspects of Miniature Painting: Its Origins and Development. Copenhagen, 1953.

Harris and Nochlin. Women Artists, 1550-1950. pp. 17, 27, 29, 32, 41, 73, 135-136, 153, 342.
 Harris cites many mentions of Garzoni in the archives of the Accademia di San Luca, of which she was a member. We are indebted to Harris for most of the bibliography on Garzoni.

Mitchell, Peter. Great Flower Painters: Four Centuries of Floral Art. London, 1973. Plate 161.

Naples. Palazzo Reale. La natura morta italiana. 1964.
 An exhibit organized by Stefano Bottari, catalogue by Raffaelo Causa, Italo Faldi, Mina Gregori, Anna Ottani, et al. Harris credits Mina Gregori with the reconstruction of Garzoni's artistic personality.

Pascoli, Lione. Vite de' pittori, scultori, ed architetti moderni.
2 vols. Rome, 1730-1736.

Petersen and Wilson. Women Artists.... p. 131, a reproduction.

Collections:

Cleveland, Museum of Art.
Florence, Palazzo Pitti.
Florence, Uffizi.
Holland, Collection of the Queen.
Madrid, Biblioteca Nacional.
Rome, Accademia di San Luca.

ARTEMISIA GENTILESCHI. 1593-circa 1652. Italian.

She was the daughter and student of Orazio Gentileschi
(1563-1639), whose name she kept rather than that of her husband.
She was born in Rome and worked in Florence, Genoa, Naples and
London. In 1612 her father charged Agostini Tassi with raping
her. Tassi had been hired to teach Artemisia perspective. After
the trial, Artemisia was married off to a respectable Florentine.
Though they had at least one daughter, theirs does not seem to
have been a successful marriage because in 1615 she left her hus-
band and moved to Rome. Stylistically she is classed as a follow-
er of Caravaggio. She was one of the first women artists to
choose women as subject matter, depicting strong, powerful hero-
ines, as in her several paintings of Judith decapitating Holofernes.

Baldinucci, Filippo. Notizie dei professori del disegno da Cima-
bue in qua. Vol. 3. Florence, 1681.
 Harris cites Opere di Filippo Baldinucci. Milan, 1808-12.
She says he merely adds a short biography of her to the one
on her father.

Bénézit. Dictionnaire. Vol. 4, p. 207.

Bissell, R. Ward. "Artemisia Gentileschi--A New Documented
Chronology." Art Bulletin. L (June 1968):153-168.
 This article presents the hard data and includes a large
number of clear black and white reproductions. Of particular
interest are the records of the rape trial which her father ini-
tiated against Agostino Tassi. She was reportedly tortured for
evidence in the trial, which shows that jurisprudence regarding
rape victims has not changed substantially in the last 300
years. Curiously, no studies have been done to link her
imagery with this experience in her life. Instead, the assump-
tion is made that her work reflects a hostility to men--in fact,
it could well be a reflection of empathy with women. She con-
sistently chose strong female personalities as subjects--such
as Queen Esther and Bathsheba.

Artemisia Gentileschi. Judith and Maidservant with the Head of Holofernes. ca. 1625. Oil on canvas. 72 1/2" x 55 3/4". Detroit Institute of Arts, gift of Leslie H. Green.

Borea, Evelina. Caravaggio e Caravaggeschi nelle Galleria di Firenze. Florence: Palazzo Pitti, 1970.
A catalogue.

Bryan. Dictionary of Painters. Vol. 2, p. 229.

de Campos, R. Redig. "Una giuditta opera sconosciuta del Gentileschi Nella Pinocoteca Vaticana." Revista d'Arte. 11 (July 1939):311-323.

Cavaliere, Barbara. "Artemisia Gentileschi: Her Life in Art." Womanart. Vol. I, no. 2 (Fall 1976).

Clayton. English Female Artists. pp. 21-30.

Clement. Women in the Fine Arts. pp. 140-141.

Crino, Anna Maria. "More Letters from Orazio and Artemisia Gentileschi." Burlington Magazine. 102 (July 1960):264-265.
Reprints four letters from Artemisia to her patron Andrea Cioli. Mentions that she had a daughter who was taught painting by her mother, but gave it up after marriage.

Ellet. Women Artists in All Ages. p. 66.

Farina, Ruth E. S. Artemisia Gentileschi, Italian Artist of the Seicento. A completed Master's thesis. Reproduces Artemisia's letters in Italian. Contact R. Farina, 319 N. Hobart Pl., L.A., Calif. 90004.

Fröhlich-Bume, L. "Rediscovered Picture by Artemisia Gentileschi: Fame." Burlington Magazine. 77 (Nov. 1940):169.

Gabhart and Broun. "Old Mistresses."

Guhl. Die Frauen....

Harris and Nochlin. Women Artists, 1550-1950. pp. 15, 27-28, 32, 42-43, 70-71, 112, 118-123, 149, 166, 341-342.

Levey, Michael. "Notes on the Royal Collection II, Artemisia Gentileschi's 'Self Portrait' at Hampton Court." Burlington Magazine. 104 (February 1962):79-80.
Compares this work to other portraits by Gentileschi.

Longhi, Roberto. "Gentileschi padre e figlia." L'arte. XIX (1916):245-314.
Reprinted in Scritti giovannili 1912-1922. Florence, 1961. I, tome 1, pp. 219-283.

"Notes on the Royal Collection II, Artemisia Gentileschi's 'Self Portrait' at Hampton Court." The Burlington Magazine. 104 (Feb. 1962):79-80.

Compares this work to other portraits by Gentileschi.

Mori, Alfred. The Italian Followers of Caravaggio. Cambridge, Mass., 1967.

Munsterberg. A History of Women Artists. p. 23-26.

Richardson, E. P. "Masterpiece of Baroque Drama: Gentileschi's Judith and Holofernes." Art Quarterly. 16 (Summer 1953): 90-92.
 Contends that the servant depicted is a self-portrait.

Ruffo, Vincenzo. "Galleria Ruffo nel secolo XVII in Messina con lettere di pittori ed altri documenti inediti." Bollettino d'arte. (1916):21ff.

von Sandrart, Joachim. Academie der Bau-, Bild- und Mahlery-Künste von 1675. Munich, 1925.

Schwartz. "They Built Women a Bad Art History."

_____. "If De Kooning...."

Sparrow. Women Painters of the World.

Spear, Richard. Caravaggio and His Followers. Cleveland Museum of Art, 1971.

_____. "Caravaggisti at the Palazzo Pitti." Art Quarterly. 34 (1971):108-110.
 A couple of attributions to Gentileschi are briefly mentioned.

Thieme and Becker. Allgemeines Lexicon. Vol. 13, pp. 408-409.

Toesca, Maria. "Versi in lode di Artemisia Gentileschi." Paragone. 251 (1971):89-92.

Tufts. Our Hidden Heritage. pp. 59-69.

Voss, Hermann. Die Malerei des Barock in Rom. Berlin, 1924. p. 463.

Walpole. Anecdotes of Painting. Vol. 2, p. 361.
 "... as famous for her loves as for her painting, but not inferior to her father."

Wittkower, Rudolf. Art and Architecture in Italy, 1600-1750. Baltimore. p. 357ff.

_____ and Wittkower, Margot. Born Under Saturn. London: Weidenfeld and Nicolson, 1963, pp. 162-164.
 A section of Chapter 7, entitled "Agostino Tassi--The Seducer of Artemisia Gentileschi," recounts the highlights of the

rape trial but in a rather flippant, anecdotal manner.

''Women's Art'' (review of Guhl).

Young, Mahonri Sharp. ''Three Baroque Masterpieces for Colum-
bus.'' Apollo. 86 (July 1967):78-81.
Briefly describes and illustrates in color, her David and
Bathsheba.

Collections:

Bologna, Palazzo Comunale.
Cambridge, Fogg Art Museum, Harvard University.
Columbus, Ohio, The Columbus Gallery of Fine Arts.
Detroit, Institute of Arts.
Florence, Galleria Pitti.
Florence, Galleria Uffizi.
London, Hampton Court, Collection of Her Majesty the Queen.
Madrid, Museo del Prado.
New York, Metropolitan Museum.

JUDITH LEYSTER. 1609-1660. Dutch.

Leyster was the daughter of a brewer, not an artist. She
was born in Haarlem and spent part of her life in Amsterdam.
She specialized in small genre pictures and also did portraits and
still life. Her relationship to Frans Hals is unclear. She witnessed
the baptism of one of his children, but later sued him when he
lured one of her students into his studio without compensating her.
She won the case. She has long been dismissed as an imitator of
Hals--some of her work has been misattributed to him--but her
compositions are more complex, she places a greater emphasis on
the play of light and her brush stroke is more controlled. She
entered the Haarlem Guild of St. Luke in 1633. In 1636 she mar-
ried painter Jan Meinse Molenaer (1610-1668), they had three chil-
dren. Unfortunately her output seems to have declined after her
marriage. Perhaps she collaborated with him. Her magnificent
self portrait in the act of painting can be seen today at the Nation-
al Gallery, in Washington, D.C.

Ampzing, Samuel. Beschrijvinge ende lof der stadt Haerlem.
Haarlem, 1628.
First mention of her name in print.

Bénézit. Dictionnaire. Vol. 5, pp. 562-563.

Bredius, A. ''Een conflect tusschen Frans Hals en Judith Leyster.''
Oud-Holland. 35 (1917):71-77.

Clement. Women in the Fine Arts. pp. 382-383.

Connoisseur, 92 (1933):323.

Judith Leyster. Self Portrait. ca. 1635. Oil on canvas. 29 3/8"
x 25 5/8". (1050), National Gallery of Art, Washington, D.C.,
gift of Mr. and Mrs. Robert Woods Bliss.

A full page black and white reproduction of her painting, Boy Playing Flute, now located in the National Museum of Stockholm.

Crimm, Von Claus. "Frans Hals und seine 'Schule'. " Müchner Jahrbuch der Bildenden Kunst. 22 (1971):146-150.

Harms, Juliane. "Judith Leyster, ihr Leben und ihr Werk. " Oud-Holland. 44 (1929):88-96, 112-126, 145-154, 221-242, 275-279.
No book or monograph has yet been done on Leyster; this is the principal source today. Summarizes the known biographical data, stylistically reviews her oeuvre, pointing out similarities to the work of Hals and Honthorst, discusses Leyster's collaboration with Molenaer, gives a detailed chronology of her work, and makes a number of attributions.

Harris and Nochlin. Women Artists, 1550-1950. pp. 29, 35, 41-42, 74, 137-139, 140, 342-343.

Hess. "Is Women's Lib Medieval?"
Hess relates how The Jolly Topper in the Rijksmuseum, Amsterdam, long considered a Frans Hals, revealed Leyster's characteristic "J*" upon being cleaned. The uncovered date, 1629, established the painting as the earliest attributed to her, done at the age of nineteen.

Hofrichter, Frima Fox. Judith Leyster: A Preliminary Catalogue. M.A. Thesis, Hunter College.
Hofrichter's dissertation topic is to be a catalogue raisonné of Leyster.

_____. "Judith Leyster's Proposition--Between Virtue and Vice." Feminist Art Journal. 4, no. 3 (Fall 1975):22-26.
Good black and white reproductions and footnotes. This was originally offered as a paper before the College Art Association in January 1975. Hofrichter is from Rutgers University.

Hofstede de Groot, Cornelis. "Judith Leyster. " Jahrbuch der Koniglich Preussischen Kunstsammlungen. 14 (1893):190-198, 232.
A "Frans Hals" had just been purchased by the Louvre that revealed Leyster's characteristic "J*" signature upon being cleaned.

_____. "Schilderijen door Judith Leyster. " Oud-Holland. 46 (1929):25-26.
Presents arguments against a number of attributions made by Juliane Harms.

Iskin, Ruth. "Sexual and Self Imagery in Art: Male and Female. " Womanspace Journal. I, no. 1 (Summer 1973).

de Mirimonde, A. P. "La musique dans des oeuvres hollandaises du Louvre." Revue du Louvre. 12 (1962):126.

Neurdenburg, Elisabeth. "Judith Leyster." Oud-Holland. 46 (1929):27-30.
 Recounts known biographical facts. Attempts to clarify date of birth.

Petersen and Wilson. Women Artists. p. 38.

Schneider, A. von. "Gerard Honthorst und Judith Leyster." Oud-Holland. XXXX (1922):173.

Slatkes, Leonard. "The Age of Rembrandt." Art Quarterly. 31 (Spring 1968):88.
 Briefly discusses the effect of Honthorst and Terbrugghen on Leyster's work. Mentions she was probably a pupil of Frans Hals. Includes reproduction of Boy with a Skull.

Sparrow. Women Painters of the World. p. 260.
 Says she had a pupil in 1635, Guillaume Wauters, who later studied with Hals.

Thieme and Becker. Allgemeines Lexikon. Vol. 23, pp. 176-177.

Tufts. Our Hidden Heritage. pp. 71-79.

Wilenski, R. H. Introduction to Dutch Art. London: Faber and Gwyer Limited, 1929. pp. 93-98.
 Includes several reproductions. Lists several works attributed to her. Sexual bias again raises its ugly head--"Women painters, as everyone knows, always imitate the work of some man...." Wilenski sees her as an imitator of her husband and of Hals. He recounts the fantastic theory of Robert Dangers (Die Rembrandt-Fälschungen. Hanover: Goedel, 1928) that Molenaer was frequently unfaithful and that Leyster sought and found consolation with Rembrandt. Dangers also believed that Leyster helped Rembrandt with his pictures and was the mother of his child. Included is a list of works he attributes to her in collaboration with Rembrandt, Hals, and Vermeer. No evidence is offered to substantiate this far-fetched theory.

Willigen, A. van der. Les artistes de Harlem. Haarlem, 1927. p. 140.

Winjnman, H. F. "Het Geboortejaar van Judith Leyster." Oud-Holland. 49 (1932):62-65.
 Documents her baptism and summarizes her early life. Speculates that she was probably an apprentice of Hendrik Ter Brugghen at Utrech in 1628. Discounts the theory that she died in childbirth.

Collections:

 Amsterdam, Rijksmuseum.
 Dublin, National Gallery of Ireland.
 Haarlem, Frans Halsmuseum.
 The Hague, The Mauritshuis.
 London, National Gallery.
 Karlsruhe, Staatliche Kunsthalle.
 Stockholm, National Museum.
 Washington, D.C., National Gallery of Art.

MARIA SIBYLLA MERIAN. 1647-1717. German.

She was born into a German family of engravers and publishers and received her art education from her stepfather. Merian was a scientist-artist who illustrated her own entomological, zoological and botanical works. She usually painted in watercolor on vellum. Her first set of engravings was published when she was twenty-two. In 1668 she married Johann Graff, a flower painter. Two daughters were born of this reportedly unhappy marriage which was dissolved in 1685. With her two daughters she joined a religious sect, the Labadists. At the age of fifty-five, accompanied by one daughter, she departed for Surinam, South America to do field work. In 1701 she returned to Hamburg and presented the city with her collection of specimens.

Bénézit. Dictionnaire. Vol. 6, p. 70.

Blunt, Wilfred. The Art of Botanical Illustration. London, 1950; New York, 1951. pp. 127-129.

Bryan. Dictionary of Painters. Vol. 3, p. 324.

Clement. Women in the Fine Arts. pp. 238-240.
 Says her teacher was Abraham Mignon and her husband was an architect. Mentions that she knew and admired Rachael Ruysch.

Duncan, James. The Naturalist's Library. Edinburgh, 1843. Vol. XL, pp. 39-40.

Ellet. Women Artists of All Ages. pp. 116-120.

Flower, Sibylla. "Prints by Maria Sibylla Merian." Connoisseur. 176 (March 1971):227.
 Review of an exhibition with an illustration.

Gelder, Jan Gerrit van. Dutch Drawings and Prints. New York, 1959.

Harris and Nochlin. Women Artists, 1550-1950. pp. 17, 27, 32, 35, 43, 65, 135, 153-155, 344.

Maria Sibylla Merian. Metamorphosis of a Frog. Watercolor.
15 5/16" x 11 3/8". The Minneapolis Institute of Arts, the Min-
nich Collection.

Lendorff, Gertrude. <u>Maria Sibylla Merian 1647-1717, ihr Leben und ihr Werk.</u> Basel, 1955.

Merian, Maria Sibylla. <u>Erucarum ortus alimentum et paradoxa metamorphosis, in qua origo, pabulum, transformatio, nec non tempus, locus et proprietater erucarum vermium, papilionum, phaelaenarum, muscarum, aliorumque, hujusmodi exsanguinium animal- culorum exhibentur.</u>... Amsterdam, 1717.

_____. <u>Der Raupen wunderbare Verwandelung und sonderbare Blumennahrung.</u> 1679.
Second and third volumes on European insects were published in 1683 and 1717 respectively.

_____. <u>Leningrad Watercolors.</u> New York: Harcourt, Braće, Jovanovich, Inc., 1975 (?).
This two-volume set is a limited edition. The first volume contains fifty facsimiles with captions and descriptions in German, English, French and Russian. The second volume contains the text and an illustrated catalogue with seventeen fold-out sheets. All together there are 196 reproductions of her paintings. This annotation is based on a prospectus. We do not know if this set has actually been published.

_____. <u>Metamorphosis Insectorum Surinamensium.</u> Amsterdam, 1705.
The text is in both Latin and Dutch. There are sixty plates.

_____. <u>Neues Blumenbuch.</u> 3 vols. Nuremberg, 1680.
Extremely rare. The first volume was issued in 1675 as Florum fasciculi tres; a second volume in 1677; both were reissued with the third volume in 1680.

Mitchell, Peter. <u>European Flower Painters.</u> London: Adam and Charles Black, 1973, p. 169.
Includes black and white reproduction of her work.

Munsterberg. <u>History of Women Artists.</u> p. 30.

Petersen and Wilson. <u>Women Artists.</u> p. 30.
Mentions her acquaintance with the artist Anna Schurman, also a Labadist. In discussing her marital problems, notes that she declared herself a widow somewhat prematurely.

Pfeiffer, M. A. <u>Die Werke der Maria Sibylla Merian.</u> Meissen, 1931.

Quednau, Werner. <u>Maria Sibylla Merian: der Lebensweg einer grossen Künstlerin und Forcherin.</u> Gütersloh, 1966.

Rücker, Elizabeth. <u>Maria Sibylla Merian, 1647-1717.</u> Nuremberg: Germanisches Nationalmuseum, 1967. A catalogue.

Sandrart, Joachim von. Deutsche Akademie der Edlen Bau- Bild-
 und Mahlerey-Künste. Nuremberg, 1675-79. 2 vols.
 Harris cites an edition by A. Pelzer, Munich, 1925, p. 339.

Schnack, Frederich. Das kleine Buch der Tropenwunder: kolori-
 erte Stiche.... Leipzig, 1954.

Stuldreher-Nienhuis, J. Verborgen paradijzen, het leven en de
 werken van Maria Sibylla Merian, 1647-1717. Arnheim, 1944;
 2nd edition 1945.

"A Surinam Portfolio." Natural History. (December 1962):30.

Thieme and Becker. Allgemeines Lexikon. Vol. 24, p. 413.

Tufts. Our Hidden Heritage. pp. 89-97.

Collections:

 Basel, Oeffentlichen Kunstsammlung.
 Berlin, Dahlem Museum, Kupferstichkabinett.
 Darmstadt, Hessisches Landesmuseum.
 London, British Museum.
 Minneapolis Institute of Arts.
 New York, Metropolitan Museum of Art.
 New York, Pierpont Morgan Library.
 Nuremberg, Germanisches Nationalmuseum.
 Vienna, Albertina.
 Windsor Castle, Royal Library.
 Yale University, Beinecke Rare Book & Manuscript Library.

LOUISE MOILLON. 1610-1696. French.

 Moillon was born in Paris, the daughter of landscape and
portrait painter Nicolas Moillon. Her brothers also painted. She
served an apprenticeship in the studio of her stepfather, François
Garnier. On the strength of the talent she had exhibited by age
ten or eleven, a contract was signed with Garnier regarding her
future production. She specialized in still life, basing her style
on Dutch and Flemish prototypes, interpreting the genre in a quiet,
restrained manner. Twenty-five paintings from 1629-1682 are ex-
tant. Harris calls her "one of the finest still life painters of the
first half of the seventeenth century in France." Because of the
Protestant beliefs of the family, they were persecuted when the
Edict of Nantes was revoked in 1685.

Bénézit. Dictionnaire. Vol. 6, p. 154.

Brookner, Anita. "France, Country of a Thousand Museums, and
 the Age of Louis XIV." Connoisseur. 141 (March 1958):38.
 Notes Moillon's dependence on Zurburan, from whom she
 borrows her austerities of color and composition and her

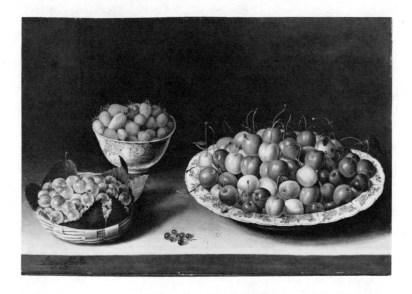

Louise Moillon. Still Life with Cherries, Strawberries and Gooseberries. 1630. Oil on panel. 12 3/4" x 9 1/4". The Norton Simon Foundation, Los Angeles.

religious quality.

Douen, O. "Les Girardot à l'époque de la Révocation." Bulletin historique et littéraire de la Société de l'Histoire du Protestantisme Francaise. 3rd Series, ix, Vol. 39 (1890):449-464.

Faré, Michel. La nature morte en France; son histoire et son evolution du XVIIe au XXe siècle. 2 vols. Geneva, 1962. pp. 41-43, 98-100.

_____. Le grand siècle de la nature morte en France, le XVIIe siècle. Paris, 1974. p. 48ff.

Faré, M. and F. "Trois peintures de fruits du temps de Louis XIII." Connaissance des Arts. 272 (Oct. 1974):88-95.
 Good color reproductions.

Harris and Nochlin. Women Artists, 1550-1950. pp. 29, 32, 34-35, 41-43, 75, 116, 132, 141-143, 184, 343.

Munsterberg. History of Women Artists. p. 31.

Petersen and Wilson. Women Artists. pp. 33-34.

Thieme and Becker. Allgemeines Lexikon. Vol. 25, p. 22.

Wilhelm, Jacques. "Louise Moillon." L'oeil. (September 6-12, 1956).

Collections:

Chicago, Art Institute.
Paris, Musée National du Louvre.
San Francisco, Norton Simon Foundation.

MARIA VAN OOSTERWYCK. 1630-1693. Dutch.

Oosterwyck was a flower painter who did at least one elaborate vanitas painting. She was born near Delft, the daughter of a protestant clergyman. She is said to have studied with Jan Davidsz de Heem in Utrecht. She was reportedly courted by painter Willem van Aelst, but turned him down in order to devote herself to her career. About two dozen works are known today. She was patronized by the King of Poland, Louis XIV, and the Emperor Leopold.

Bénézit. Dictionnaire. Vol. 6, p. 431.

Bredius, A. "Archiefsprokkelingen: een en ander over Marie von Oosterwyck varmaert Konstschilderesse." Oud-Holland. 52 (1935):180-182.

Bryan. Dictionary of Painters. Vol. 4, p. 41.

Bury, A. "Say It with Flowers." Connoisseur. 151 (Dec. 1962): 254.

Clement. Women in the Fine Arts. pp. 260-261.

Ellet. Women Artists. p. 104.

Harris and Nochlin. Women Artist, 1550-1950. pp. 29, 32, 34-35, 44, 76, 145-146, 152, 158, 343.

Houbraken, Arnold. De groote shouburgh der Nederlantsche Konstschilders en Schilderessen. 3 vols. Amsterdam, 1718-1720.
Harris notes that it is the first compilation of artist's biographies to mention women artists (Schilderessen) in its title. (See also Russell in the periodical section.)

Mitchell, Peter. European Flower Painters. pp. 190-191.

Petersen and Wilson. Women Artists. p. 41.
Notes that in keeping with her reputation for nonconformity,

she gave painting lessons to her servants.

Thieme and Becker. Allgemeines Lexikon. Vol. 26, p. 25.

Collections:

> Atlanta, E. Okarna Gallery.
> Augsburg, Städtische Kunstsammlungen.
> Copenhagen, Royal Museum.
> Dresden, Staatliche Kunstsammlung.
> Florence, Uffizi.
> The Hague, Mauritshuis.
> Prague, Národní Galerie.
> Vienna, Kunsthistorisches Museum.

CLARA PEETERS. 1594-after 1657 (?). Flemish.

Peeters was a phenomenally precocious painter whose first signed work, a fully realized still life, dates from her fourteenth year. She was born in Antwerp and worked in Amsterdam and The Hague. She did a great variety of still lifes--flowers, food stuffs, and precious objects. She was especially interested in the fall of light and resulting reflections on metal. Harris says "Her first works predate almost all known examples of Flemish still life painting of the type she made.... Thus she would appear to be one of the originators of the genre."

Benedict, Curt. "Osias Beert, un peintre oublié de natures mortes." L'amour de l'art. XIX (1938):307-314.
 Harris suggests that Beert might have been Peeter's teacher, but notes that since none of his paintings are dated their relationship will be hard to determine.

Bénézit. Dictionnaire. Vol. 6, p. 570.

Bryan. Dictionary of Painters. Vol. 4, p. 86.

Connaissance des Arts. 225-173 (1970):87.
 A detail of a still life is reproduced in color.

Edwards. Women: An Issue.

Gerson, H. and Ter Kuile, E. H. Art and Architecture in Belgium, 1600-1800. Baltimore, 1960.

Greindl, E. Les peintres flamands de nature morte au XVIIe siècle. Brussels, 1956.

Hairs, Marie Louise. "Osias Beert, l'ancien peintre de fleurs." Revue belge d'archéologie et d'histoire de l'art. XX (1951): 237-51.

_____. 1965 ed. pp. 241-44 and 398.
 Harris gives the above cryptic citation for Peeters which,
she says, catalogues and discusses Peeter's flower paintings.

Harris and Nochlin. Women Artists, 1550-1950. pp. 28, 32-35,
 41-43, 72, 105, 116, 131-33, 146, 342.

Hill. Women, An Historical Survey.... Catalogue. p. ix.

Mitchell. European Flower Painters. pp. 196 and 199.
 Discusses the documents concerning her disputed dates,
which he believes are 1589 to after 1657. Discusses her style
and gives us two black and white reproductions.

Petersen and Wilson. Women Artists. pp. 36-37.

Tufts. Our Hidden Heritage. pp. xxviii, 72, 100.

Collections:

 Amsterdam, Rijksmuseum.
 Karlsruhe, Staatliche Kunsthalle.
 London, Hallsborough Gallery.
 Madrid, The Prado.
 Oxford, Ashmolean Museum.

LUISA ROLDAN. 1656-1704. Spanish.

 Roldán is the first woman sculptor recorded in Spain. She
was born in Seville, the daughter of a sculptor. She worked in
the family workshop with two brothers and a sister. Another
sister was trained as a sculpture painter. Luisa married a sculp-
tor in 1671. Her first independent work was in 1687, a commis-
sion for Holy Week monument figures. In 1696 she went to Ma-
drid and the following year was appointed sculptor for the Royal
Court of Charles II--without salary. After his death she contin-
ued as sculptor for Philip V. Her work consists mainly of wood
and clay figures, frequently polychromed, and often approaching a
trompe l'oeil realism.

Bénézit. Dictionnaire. Vol. 7, p. 321.

Ellet. Women Artists in All Ages. pp. 87-88.

Harris and Nochlin. Women Artists, 1550-1950. pp. 29, 163.
 Harris notes that in a letter from Cole describing Rosalba
Carriera's admission to the Academy, "a great Spanish virtuo-
so sculptress" was also so honored ("grande virtuosa scultrice
che sta a Madrid et ha inviato un bozzo bellissimo"). Harris
concludes that he could only have been referring to Luisa
Roldán.

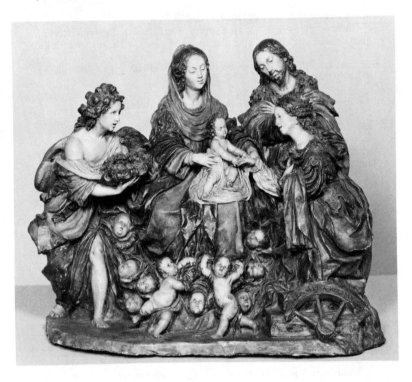

Luisa Roldán. The Mystical Marriage of St. Catherine. Hispanic
Society of America, New York.

Martin, Domingo Sánches-Mesa. "Nuevas obras de Luisa Roldán
 y Jose Risueño en Londres y Granada." Archivo español de
 arte. 40 (Oct. 1967):325-331.

Munsterberg. A History of Women Artists. p. 86.

Nemser. Art Talk. pp. 312-313, 321.
 Audry Flack's 1971 painting, Macerena Esperanza, is of a
 statue by Luisa Roldán. It is located in Seville and is life
 size, of polychromed wood.

Petersen and Wilson. Women Artists. pp. 31-32.

Proske, Beatrice Gilman. "Luisa Roldán at Madrid." Connoisseur.
 155 (Feb.-April 1964):128-132, 199-203 and 269-273.
 This three-part article is an excellent survey of Roldán's

life and work. It includes good color reproductions, as well
as black and white. Part I summarizes her biography and de-
tails her financial difficulties. Parts II and III describe her
work, especially her small terra cotta groups. Proske notes
that her knowledge of color harmony was from Valdés Leal,
who often collaborated with her father.

Sanchez-Mesa Martín, Domingo. "Nuevas obras de Luisa Roldán
y Jose Risueño en Londres y Granada." Archivo español de
arte. CLVII (October 1967):325-331.

Thieme and Becker. Allgemeines Lexikon. Vol. 28, p. 523.
Lists her works.

Tufts. Our Hidden Heritage. pp. xvi, 101.

Collections:

London, Victoria and Albert Museum.
New York, Hispanic Society.

ANNA MARIA VAN SCHURMAN. 1607-1678. Flemish.

Schurman was born in Cologne to Dutch parents who had
emigrated because of religious persecution. She moved with her
parents to Utrecht in 1615, and in 1620 to Francker. There she
became orphaned and returned to Utrecht. She was a precocious
child, learning to read at age three. By age seven she was profi-
cient in Latin. She became proficient in several languages, was
skilled as a musician, drew, painted, carved in wood and ivory,
modeled in wax, and made copper engravings. Later in her life
she became a follower of Johann de Labadie and devoted herself
to theological studies. In 1677 she was visited by William Penn
and was acquainted with Maria Sibylla Merian.

Bénézit. Dictionnaire. Vol. 7, p. 662.

Brodsky, Judith. "Some Notes on Women Printmakers." College
Art Journal. 35 (Summer 1976):375.

Bryan. Dictionary of Painters. Vol. 5, p. 52.

Guhl. Die Frauen....

Munsterberg. History of Women Artists. pp. 28-29.

Pelliot, Marianne. "Verres gravés au diamant." Gazette des
Beaux Arts. 3 (1930):319.
Says two glasses, etched and signed by her, are in the
Rijksmuseum, Amsterdam.

Penn, William. Journal of William Penn While Visiting Holland

and Germany in 1677. Philadelphia: Friends' Book Store, 1878, pp. 116-126.
 Account of his visit to Wieward, where the Labadist group was residing, and his interview with Schurman. She was sixty years old at the time, "... an ancient maiden...." She explained that she joined the group when she saw that her learning was vanity. She resolved to give up her former way of life and acquaintances and retire from the world.

Petersen and Wilson. Women Artists. p. 38.

Sparrow. Women Painters of the World. p. 285.

Thieme and Becker. Allgemeines Lexikon. Vol. 30, p. 343.

Collections:

 Utrecht University Museum.

ELISABETTA SIRANI. 1638-1665. Italian.

 Sirani was born to a poor Bolognese family; her father and teacher, Giovanni Andrea Sirani (1610-1670), was a minor painter. She was encouraged to paint by Malvasia, who ultimately became her biographer. She met with immediate success, executing her first commission at seventeen. According to her own records she completed at least 190 works before her early death at twenty-seven. She painted and engraved portraits, religious, allegorical and mythological works, and received public commissions. Her work is related to that of Guido Reni; and she has been dismissed as only a minor imitator. Harris points out that that is a superficial evaluation. She says that Sirani's achievements have yet to be the object of serious scholarship. A servant was accused of poisoning her when Sirani died suddenly at the age of twenty-seven. An autopsy revealed holes in her stomach, which would probably be diagnosed today as ulcers. The pace at which she must have worked and the pressures on her to produce might well have resulted in such a condition.

Alf. "My Interest in Women Artists of the Past."

Bénézit. Dictionnaire. Vol. 7, p. 785.

Bologna. La pittura del Seicento Emiliano. 1959. pp. 139f.
 Exhibition catalogue. Includes bibliography.

Bryan. Dictionary of Painters. Vol. 5, p. 87.

Clements. Women in the Fine Arts. pp. 317-319.

Edwards, Evelyn Foster. "Elisabetta Sirani." Art in America.
 5 (Aug. 1929):242-246.

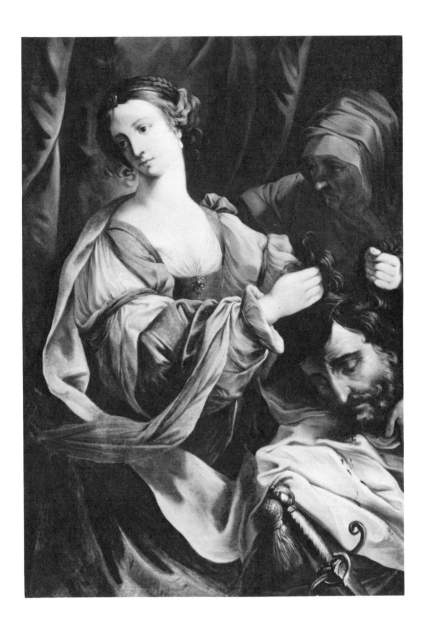

Elisabetta Sirani. Judith with the Head of Holofernes. Oil on
canvas. 46 3/4" x 37 1/2". Walters Art Gallery. Baltimore,
Md.

Describes her art as naive, without the sophistication that comes with a wider experience. Sirani never left her birthplace, Bologne.

Ellet. Women Artists in All Ages. p. 67.

Emiliani, Andrea. "Giovan Andrea ed Elisabetta Sirani." In Maestri della pittura del seicento emiliano, pp. 140-45. Catalogue by F. Arcangeli, et al. Bologna: Palazzo dell'Archiginnasio, 1959.

Faxon, Alicia. "Elisabetta Sirani: Bolognese Jewel." Boston Globe. (July 13, 1972).

Gabhart and Broun. "Old Mistresses."

Guhl. Die Frauen....

Harris and Nochlin. Women Artists, 1550-1950. pp. 25, 29, 41-43, 77, 147-149, 150, 152, 343-344.

Kurz, Otto. Bolognese Drawings ... at Windsor Castle. London, 1955. pp. 133-36.

Malvasia, Carlo Cesare. Felsina pittrice. Bologna, 1678. Vol. II, pp. 453-563.
Count Malvasia was a friend of the Sirani family and Elisabetta's biographer. The chapter devoted to her is illustrated by a portrait engraving and the design of the elaborate catafalque for her lavish funeral.

Manaresi, Antonio. Elisabetta Sirani. Bologna, 1898.

Munsterberg. A History of Women Artists. p. 105.

Petersen and Wilson. Women Artists. pp. 27-28.

Ragg. Women Artists of Bologna. p. 287.

Schwartz. "They Built Women a Bad Art History."

Sparrow. Women Painters of the World. pp. 28-30.
He attributes her death to a stomach disease.

Thieme and Becker. Allgemeines Lexikon. Vol. 31, pp. 99-100.
Includes an extensive listing of her works and a lengthy bibliography.

Tufts. Our Hidden Heritage. pp. 81-87.

"Women Artists" (review of Guhl).

Collections:

 Baltimore, Walters Art Gallery.
 Bologna, Pinacoteca Nazionale.
 Cambridge, Mass., Fogg Museum, Harvard University.
 New York, Metropolitan Museum of Art.
 Windsor Castle.
 Zagreb, Strossmeyer Gallery.

ANNA WASSER. 1676-1713. Swiss.

 Wasser was the daughter of an artist and was born in
Zurich. She was also a precocious linguist. At age twelve she
began a three-year period of study with Joseph Werner in Bern.
She gained a wide reputation as a miniaturist and received nume-
rous commissions from the courts of Europe. Her father, seeing
her monetary value, rushed and overworked her, which eventually
resulted in her failing health. When the chance came she accepted
a commission at the court of Solms Braunfels and traveled there
in the accompaniment of a brother. There she was able to per-
fect her paintings and her health improved. However, her father
summoned her home and in the haste of her return she fell and
suffered an injury that brought her death at age thirty-four. She
especially liked to do pastoral and rural scenes, as well as por-
traits.

Bénézit. Dictionnaire. Vol. 8, p. 670.
 Gives her dates as 1678-1714.

Bryan. Dictionary of Painters. Vol. 5, p. 336.

Clement. Women in the Fine Arts. pp. 355-356.

Ellet. Women Artists. pp. 129-131.

Munsterberg. A History of Women Artists. pp. 31, 33.
 Munsterberg spells her name "Waser. " He provides a re-
production in black and white of a self portrait done at age
fifteen.

Thieme and Becker. Allgemeines Lexikon. Vol. 35, p. 170.

Collections:

 Zurich, Kunsthaus.

EIGHTEENTH CENTURY

HESTER BATEMAN. c. 1740-1790. English.

Although Bateman was not the only woman silversmith of
her age, she certainly was the most prolific. A considerable
quantity of her work survives and includes virtually every kind of
silver utensil. She was active in London from 1774, when she
entered the Goldsmith's Hall, until 1789. Her husband was a chain
maker, a branch of silversmithing. She had at least five children,
who became her apprentices and carried on the family business.
A number of American museums possess collections of her work,
including the Chicago Art Institute and the Springfield, Massachu-
setts, Museum of Fine Arts.

Gillingham, Harrold E. "Concerning Hester Bateman." Antiques.
 39 (Feb. 1941):76-77.
 Summarizes biographical facts. Includes many illustrations
 of her work and her mark.

Jackson, Sir Charles. English Goldsmiths and their Marks. Lon-
 don, 1921.
 Lists close to fifty women silversmiths working during the
 18th century.

Keys, Homer Eaton. "Hester Bateman, Silversmith." Antiques.
 20 (Dec. 1931):367-368.
 Sees the wide variety of her surviving work as evidence of
 her large patronage. Believes she had only four children.

Shure, David. Hester Bateman: Queen of English Silversmiths.
 Garden City, N.Y.: Doubleday and Co., Inc., 1959.
 Monograph of her work. Contains short, but comprehensive
 biographical summary, a helpful family tree schematization,
 and 86 plates of her work.

Walter, William. "New Light on Hester Bateman." Antiques. 63
 (Jan. 1953):36-39.
 Discusses new information sources--her registration at
 Goldsmith's Hall, her will, and that of her husband. Dis-
 cusses the evolution of the business and compares her work to
 that of her children.

Wenham, Edward. "Women Silversmiths." Antiques. 46 (Oct. 1944):200-202.

LADY DIANA BEAUCLERK. 1734-1808. English.

Lady Beauclerk was the elder daughter of the third Duke of Marlborough and was celebrated as an amateur artist. In 1757 she married the second Lord Bolingbroke. In 1761 she was named Lady-in-Waiting to Queen Charlotte. In 1768 she divorced her husband and two days later married Topham Beauclerk. During her youth she especially admired the work of Rubens and spent much time copying his work and that of other great masters. Her subjects were cupids, children and rustic genre--done in a rather rococo style, often only lightly touched with color. Josiah Wedgwood commissioned designs from her and she did some interior decorating. She was a friend of Horace Walpole's and illustrated his The Mysterious Mother. She also illustrated, in 1796, Burger's Leonora and in 1797 Dryden's Fables.

Bryan. Dictionary of Painters. Vol. 1, p. 102.

Ellet. Women Artists in All Ages. p. 187.

Erskine, Beatrice Caroline Strong (Mrs. Stuart). Lady Diana Beauclerk: Her Life and Work. London: T. F. Unwin, 1903. Includes color plates.

_____. "Lady Di's Scrapbook." Connoisseur. 7 (1903):32-37. Discusses one of her sketchbooks. Includes several good black and white reproductions and a watercolor sketch in color.

Petersen and Wilson. Women Artists. pp. 46-47.

Sparrow. Women Painters of the World. p. 58.

Thieme and Becker. Allgemeines Lexikon. Vol. 3, p. 115.

Walpole. Anecdotes of Painting. Vol. 1, p. xx.

ROSALBA CARRIERA. 1675-1757. Italian.

Carriera was one of the originators of the rococo style in Italy and France. She introduced the pastel portrait into France. Her brilliant and innovative pastel technique influenced Maurice Quentin de la Tour. In addition to her pastel production she did oil portraits and miniatures. She was the granddaughter of an artist but probably first showed her artistic abilities in lace making, her mother's profession. Next she decorated ivory snuff boxes for Venetian tourists. She is said to have been the student of Antonio Lazari, Guiseppe Diamantini and Antonio Balestra; but her work resembles none of them. She was selling miniatures by

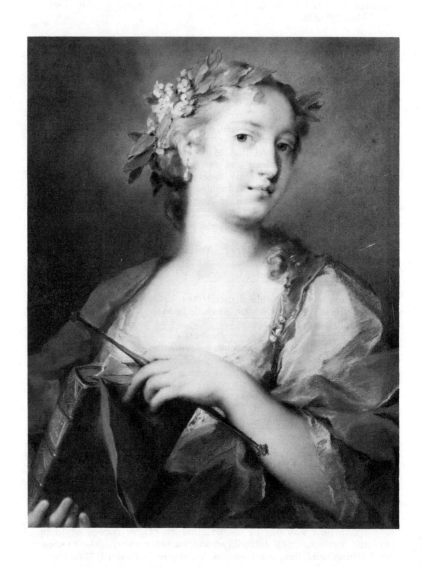

Rosalba Carriera. Portrait of a Lady with a Laurel Leaf. Pastel
on paper. Museum of Fine Arts, Boston, Mass., gift of Mrs.
Albert J. Beveridge.

1700. In 1705 she was elected to the Academy of Rome. Ultimately she was admitted to the Academies of Bologna, Florence and Paris. Her international career was greater than any of the women who had preceded her. She received commissions from the courts of France and Austria. Throughout her life she was assisted by her sister Giovanna. She never married. The last ten years of her life were spent in blindness.

Bénézit. Dictionnaire. Vol. 2, pp. 343-344.

Blashfield, Evangeline Wilbur. Portraits and Backgrounds, Hrotsvitha, Aphra Behn, Alissé, Rosalba Carriera. New York: Charles Scribner's Sons, 1917; reprint edition Freeport, N.Y.: Books for Libraries Press, 1971.

Bryan. Dictionary of Painters. Vol. 1, pp. 260-261.
 Lists several people with whom she studied; includes listing of 143 of her works in the Dresden Gallery.

Cessi, F. Rosalba Carriera. Milan: I Maestri di Colore, No. 97, 1967.

Clement. Women in the Fine Arts. pp. 74-76.

Colding, Torben Holch. Aspects of Miniature Painting: Its Origins and Development. Copenhagen, 1953.

Dobson, Austin. Rosalba's Journal and Other Papers. London: Oxford University Press, 1926; reprint edition Freeport, N.Y.: Books for Libraries Press, 1970.
 This essay concerns the journal Carriera kept during her sojourn in Paris, 1720-1721.

La donna ideale. Milano: Editore Rizzoli, 1966.

Edwards. Women: An Issue.

Ellet. Women Artists in All Ages. pp. 226-232.

Gatto, Gabrielle. "Per la cronologia di Rosalba Carriera." Arte veneta. XXV (1971):182-193.

Guhl. Die Frauen....

Hoerschlemann, Emilie von. Rosalba Carriera, Die Meisterin der Pastellmalerie, und Bilder aus der Kunst und Kulturgeschichte des 18 Jahrhunderts. Leipzig, 1908.

Harris and Nochlin. Women Artists, 1550-1950. pp. 17, 30, 36, 38-39, 40, 42-44, 161-164, 345.

Jeannerat, C. "Le origini del ritratto a miniatura in avario." Dedalo. II (1931):767-80.

Levey, Michael. Painting in XVIII Century Venice. London, 1959.
pp. 135-146.

Longhi, Roberto. Viatice per cinque secoli di pittura venegiana.
Florence, 1946. p. 35.

Malamani, Vittorio. Rosalba Carriera. Bergamo: Instituto d'arti
grafiche, 1910.
A monograph which includes the diary she kept in Paris.
Harris cites an earlier version with fuller documentation pub-
lished in Le Gallerie Nazionali Italiane. IV (1899):27-149.

Munsterberg. History of Women Artists. pp. 35-37.
Mentions her possibly influencing Maurice Quentin de la
Tour during her Paris visit.

Nochlin. "Why Have There Been No Great Women Artists. " p. 31.
A beautiful, full-page reproduction of Carriera's pastel por-
trait of Mme. Irene Crozat as "Spring. "

Orlandi, P. A. Abecedario pittorico.... Bologna, 1704.
Harris cites a Venice edition of 1753, pp. 448-449.

Petersen and Wilson. Women Artists. pp. 47-48.

Sensier, Alfred, trans. Journal de Rosalba Carriera: pendant son
sejour à Paris en 1720 et 1721. Paris: J. Techeuer, 1865.
This translation of her diary is followed by a biographical
statement, a list of works done during this period and a list
of her works on display.

Sparrow. Women Painters of the World. pp. 20, 37, 48, 51.

Schwartz. "They Built Women a Bad Art History. "

Tufts. Our Hidden Heritage. pp. 107-115.

Watson, F. J. B. "Two Venetian Portraits of the Young Pretend-
er: Rosalba Carriera and Francesco Guardi. " Burlington
Magazine. III (June 1969):333-337.
Discusses her portrait of Prince Charles Edward Stuart and
the sales history of this work.

Wilhelm, Jacques. "Le portrait de Watteau par Rosalba Carriera. "
Gazette des beaux arts. 42 (Nov. 53):235-246, 271-274.
Illustrates and traces the provenance of one of her drawings.

Zanetti, Antonio Maria. Della pittura veneziana e della opere pib-
bliche de veneziana maestr. 5 vols. Venice, 1771.

Collections:

Boston, Museum of Fine Art.

Cleveland, Museum of Art.
Copenhagen, Statens Museum for Kunst.
Dijon, Musée des Beaux Arts.
Florence, Galleria Uffizi.
London, Victoria and Albert Museum.
Venice, Galleria Accademia.
Vienna, Kunsthistorisches Museum.
Washington, D. C. , National Gallery of Art.
Windsor Castle, Collection of Her Majesty the Queen.

CONSTANCE-MARIE CHARPENTIER (née BLONDELU). 1767-1849.
 French.

 She did ambitious mythological and allegorical scenes, in
addition to portraits and genre work. She was principally influ-
enced by David and Gérard, though her teachers were minor paint-
ers. Only three works are attributed to her today, the best known
being her portrait of Charlotte du Val d'Ognes, in the Metropolitan
Museum. It was long considered a David. She exhibited in the
Salon between 1798 and 1819.

Art News. 69, no. 9 (January 1971). Cover.
 The cover of the special women's issue is a reproduction of
 the famous portrait of Charlotte du Val d'Ognes.

Bellier de la Chavignerie, Emile and Auvray, Louis. Dictionnaire
 général des arts du dessin jusqu'à nos jours. 2 vols. Paris,
 1882-1885.

Bénézit. Dictionnaire. Vol. 2, p. 449.

Bryan. Dictionary of Painters. Vol. 1, p. 284.

Clement. Women in the Fine Arts. p. 78.
 Clement calls her the pupil of David and lists the titles of
 several allegorical works lost today.

Ellet. Women Artists in All Ages. p. 236.

Eva. "Women Artists...."

Fleisher. "Love or Art."

Gabhart and Brown. "Old Mistresses."

Harris and Nochlin. Women Artists, 1550-1950. pp. 207-8, 348.

Munsterberg. A History of Women Painters. p. 48.

Paris. Grand Palais. French Painting 1774-1830: The Age of
 the Revolution. 1974-1975.
 Catalogue by Frederick J. Cummings, Pierre Rosenberg,

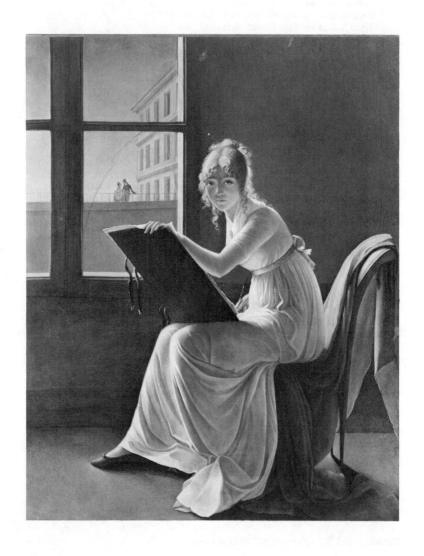

Attributed to Constance-Marie Charpentier. Portrait of Mlle. Charlotte du Val d'Ognes. ca. 1801. Oil on canvas. 63 1/2" x 50 5/8". The Metropolitan Museum of Art, New York.

Antoine Schnapper, Robert Rosenblum, et al. This exhibit traveled to The Detroit Institute of Arts and the Metropolitan Museum in New York. See the catalogue entry by Rosenblum, 1974, Nos. 19 and 345-47.

Petersen and Wilson. Women Artists. pp. 61-63.

Soby, James T. "A 'David' Reattributed." Saturday Review of Literature. 34 (March 3, 1951):42-43.

Sterling, Charles. "Fine David Reattributed: Portrait of Charlotte du Val d'Ognes by Mme. Charpentier?" Metropolitan Museum of Art Bulletin. 9 (January 1951):121-132.
　　An excellent article demonstrating art historical sleuthing at its best. Good black and white reproductions are offered of the two other works today given to Charpentier, another oil entitled Melancholy, and a pencil portrait in profile. He cites the biographical dictionaries of Gabet and Bellier-Auvray as providing what little is known of her life. The article is flawed only by Sterling's typical but wearisome sexism, "... its (the portrait's) very evident charms, and its cleverly concealed weaknesses, its ensemble made up from a thousand subtle artifices, all seem to reveal the feminine spirit."

Collections:

　　Amiens, Musée de Picardie.
　　Dijon, Musée Magnin.
　　New York, The Metropolitan Museum of Art.

JEANNE-ELISABETH CHAUDET. 1767-1832. French.

　　Chaudet studied with Vigée-LeBrun. In 1793 she married Antoine-Denis Chaudet, a sculptor and painter with whom she had also studied. He died in 1810. In 1812 she married an archivist, Pierre-Arsène-Denis Husson. When he died in 1843 he left most of her works to the museum in Arras. Most of them were destroyed in the Second World War. Between 1798 and 1817 she exhibited at the Salon. Her works were often sentimentalized paintings of children and animals, composed in antique bas-relief-like profiles.

Bénézit. Dictionnaire. Vol. 2, p. 462.

Bryan. Dictionary of Painters. Vol. 1, p. 286.

French Painting 1774-1830: The Age of Revolution. Detroit: Institute of Arts, 1975, pp. 347-348.
　　The source of the above biographical material. Includes a reproduction of her work.

Harris and Nochlin. Women Artists, 1550-1950. pp. 46-47, 198.

Brief mentions.

Sparrow. Women Painters of the World. p. 202.

Thieme and Becker. Allgemeines Lexikon. Vol. 6, p. 435.

Collections:

Musée de Rochefort.

MARIE-ANNE COLLOT (FALCONET). 1748-1821. French.

Collot entered the studio of the sculptor Falconet at age fifteen and before long he admitted that she had the most skill in doing portrait busts. Her earliest known busts date from 1765. When Falconet went to Russia in 1766 to work on his commission of a monument to Peter the Great, Collot went along as his assistant, doing the head of that equestrian monument. She remained there until 1778, except for one visit to Paris in 1775/76. These were her most prolific years. She was appointed official portrait sculptor to Catherine II, from whom she received twenty-five commissions, and did private commissions as well. In 1777 she married Falconet's son, Pierre-Etienne, a painter. In 1778 she returned to Paris with her young daughter, a few months behind her husband, and encountered a hostile reception. By 1779 she had taken refuge with Falconet in the Hague and didn't return to Paris until the following year. In 1783 (the date of her last known sculpture) Falconet became ill. From then until his death in 1791 she devoted her attention to him, totally neglecting her art. A few months later her husband also died. She then left Paris, purchased property in Lorraine and lived there the remaining thirty years of her life.

Bénézit. Dictionnaire. Vol. 2, p. 587.

Cournault, Charles. "Etienne-Maurice Falconet et Marie-Anne Collot." Gazette des beaux arts. Series II (1869):117-144.

Ellet. Women Artists. p. 201.

Hill. Women. An Historical Survey.... Catalogue, p. xi.

Kosareva, Nina. "Masterpieces of Eighteenth-Century French Sculpture." Apollo. 101 (June 1975):446-447.
 Briefly discusses a few of Collot's works in surveying the 18th-century French sculpture collection of The Hermitage. Says the Empress was her chief patroness during the Russian years.

Levitine, George. The Sculpture of Falconet. Greenwich, Conn.: New York Graphic Society, 1972. pp. 18-21.
 Believes Collot was Falconet's mistress before she was his

daughter-in-law. Says her marriage ended in a "social scandal."

Opperman, H. N. "Marie-Anne Collot in Russia: Two Portraits." Burlington Magazine. 107 (Aug. 1965):408-415. Good summary of her biography. Discusses two commissions from Lord Cathcard, Falconet's abuse of her and compares her work with Falconet's. Includes good black and white reproductions.

Petersen and Wilson. Women Artists. p. 60. Summarizes the relationship between Collot and Falconet and the resulting neglect of her art.

Raymond, A. G. "Le buste d'Etienne-Noel Damilaville per Marie-Anne Collot." Revue du Louvre. 23 (1973):255-260.

Reau, Louis. "Les bustes de Marie-Anne Collot." Renaissance. 14 (Nov. 1931):306-312.

_____. "Une femme-sculpteur française au dix-huitième siècle, Marie-Anne Collot (Madame Falconet)." L'Art et les artistes. (Feb. 1923):165-171.

Thieme and Becker. Allgemeines Lexikon. Vol. 11, p. 221.

Collections:

Nancy, Musée des Beaux Arts.

MARIA HADFIELD COSWAY. 1759-1838. English.

Cosway was born in Florence, Italy, the child of wealthy English parents. A devout Roman Catholic, she expressed an early interest in the religious life but her parents disapproved. She was talented in art and linguistics and was an excellent musician. She studied with Fuseli and Wright of Derby. In 1778 she became a member of the Florence Academy. At the urging of her friend, Angelica Kauffman, she moved to England around 1778/79. She married the painter Richard Cosway in 1781, but it was not a happy union. Cosway was afflicted with bouts of depression throughout her life. Three months after the birth of her only child, a daughter, she left her husband and child and began travelling. She returned to England briefly in 1794 and in 1796 when her six-year-old daughter died. Around 1800 she was again living in London and showing at the Royal Academy. For awhile she was the head of a seminary for young ladies in Lyon, France. She fulfilled a long ambition by founding a college in Lodi, Italy. She died there at the age of seventy-nine. Much of her work consisted of miniatures, but she also engraved and painted large mythological canvases, adopting the pastoral mode of Gainsborough and Lawrence. She had a brief affair with Thomas Jefferson in 1786,

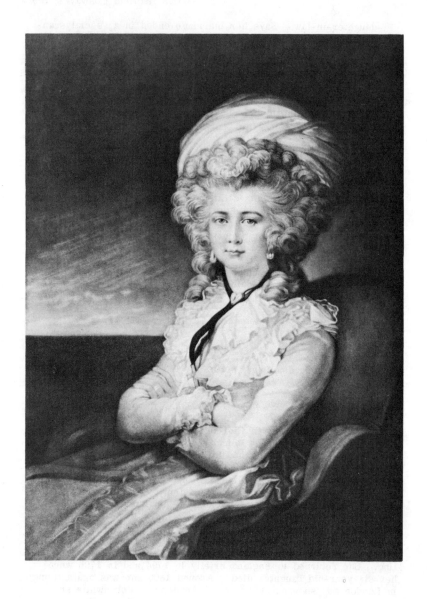

Maria Cosway. Self-Portrait (a mezzotint copy by Valentine Green).
National Gallery of Art, Washington, D.C., John Ellerton Lodge
Collection.

meeting him through a mutual friend, the artist John Trumbull.

Bénézit. Dictionnaire. Vol. 2, p. 666.

Bryan. Dictionary of Painters. Vol. 1, pp. 337-388.
Although the marriage was difficult, Cosway did return to England to nurse her husband through his mental disorder and death.

Clayton. English Female Artists. pp. 314-335.

Clement. Women in the Fine Arts. pp. 89-91.

Cunningham, Allan. The Lives of the Most Eminent British Painters. 2nd edition, annotated and continued by Mrs. Charles Heaton. London: George Bell and Sons, 1880, 3 vols. Vol. II, pp. 347-357.
Includes many interesting anecdotes, including how she was almost murdered as an infant by a trusty servant and her early desire to be a nun. Notes that many accounts, especially foreign ones, thought she possessed more talent than her husband. Mentions that her husband was too proud to allow her to paint professionally.

Ellet. Women Artists in All Ages. pp. 191-198.

Guhl. Die Frauen....

Kimball, Marie. "Jefferson's Farewell to Romance." Virginia Quarterly Review. 4 (July 1928):402-419.
Summarizes his relationship with Cosway, reproducing several letters exchanged by them.

Nochlin. "Why Have There Been No Great Women Artists?" p. 27.
A small reproduction of Cosway's painting, Mrs. Fuller and Son.

Petersen and Wilson. Women Artists. p. 46.

Scheerer, Constance. "Maria Cosway: Larger-than-Life Miniaturist." Feminist Art Journal. 5 (Spring 1976):10-13.
Interesting account of her life, but lacks bibliography or footnotes. Proposes that "miniaturism" was not her art form of choice, but the result of the times and circumstances. Notes that she probably fell in love with Thomas Jefferson. They corresponded for many years, and he kept her letters.

Thieme and Becker. Allgemeines Lexikon. Vol. 7, pp. 544-546.

Thomas Jefferson, A Biography in His Own Words. Editors of Newsweek Books. New York: Newsweek, 1974, pp. 172-176.
Their clandestine meetings lasted only a month. Reproduces part of Jefferson's "Head and Heart" dialogue, a 17-page

letter to Cosway in which two sides of Jefferson converse with each other, his emotional side (the "heart") and his rational side (the "head").

Williamson, George C. Richard Cosway, R. A., His Wife and Pupils. London: George Bell and Sons, 1905.
 Some idea of Maria Cosway's dominance is obtained by noting that in this work about her husband, four of the nine chapters actually center on Maria. Interesting account of her early youth and art studies. Much of the information was obtained from a letter she wrote to Allan Cunningham, providing information for his book. Discusses in detail her founding of the college at Lodi and quotes her will in its entirety.

"Women Artists" (review of Guhl).

Collections:

Washington, D. C., National Gallery.

ANNE SEYMOUR DAMER. 1748-1828. English.

 Damer was born into an aristocratic family and was the cousin of Horace Walpole, who bequeathed his villa, Strawberry Hill, to her. She studied with John Bacon and Guiseppe Ceracchi. Her work consisted of neoclassic marble sculpture--mainly portrait busts and small animal pieces. She exhibited at the Royal Academy from 1784 to 1818. Although she had social distinctions and was acquainted with many of the European notables of her day, her life was marked by domestic tragedy. Her brief marriage to John Damer, who gambled and drank to excess, ended with his suicide. She took an active interest in political affairs.

Bénézit. Dictionnaire. Vol. 3, p. 20.

Clement. Women in the Fine Arts. pp. 96-100.

Ellett. Women Artists in All Ages. p. 170.

Guhl. Die Frauen....

Harris and Nochlin. Women Artists, 1550-1950. p. 29.
 A brief mention.

Munsterberg. History of Women Artists. pp. 86 and 88.

Petersen and Wilson. Women Artists. pp. 46-47.

Post, Chandler. A History of European and American Sculpture. New York: Cooper Square Publishers, 1969, Vol. 2, p. 57.
 The idea that women can be capable sculptors continues to

elude even modern writers. "It has sometimes been supposed that her masters put the best touches in the works ascribed to her."

Thieme and Becker. <u>Allgemeines Lexikon.</u> Vol. 8, pp. 318-319.

Walpole. <u>Anecdotes of Painting in England.</u> Vol. 1, pp. xx-xxii. Lists her works.

FRANÇOISE DUPARC. 1726-1778. French.

The daughter of Antoine Duparc, a sculptor. Though not influenced by his style, she was possibly the student of Jean Baptiste van Loo. She depicted unknown, working class people in half length. Her paintings are devoid of setting or narrative, making them quite unusual. Harris calls her work a blend of portraiture and genre. Her choice of subjects relates her to Chardin, but it has yet to be determined whether she had seen his work before painting them. Of forty-one paintings listed as in her studio upon her death, only four are definitely known today.

Achard, C. F. <u>Les hommes illustrés de la Provence.</u> 1878. pp. 174ff.

Auquier, Philippe. "An Eighteenth-Century Painter: Françoise Duparc." <u>Burlington Magazine.</u> VI (1905):477-78.

Billioud, Joseph. "Un peintre des types populaires: Françoise de Marseille (1726-1778)." <u>Gazette des beaux-arts.</u> XX (1938): 173-184.

Harris and Nochlin. <u>Women Artists, 1550-1950.</u> p. 42, 171-173, 180, 188, 346.
Harris provides most of the bibliography offered here.

Petersen and Wilson. <u>Women Artists....</u> pp. 49, 50.

<u>Collections</u>:

Marseilles, Musée des Beaux-Arts.
Perpigam, Musée Hyacinthe Rigaud.
Roanne, Loire, Musée Joseph-Déchelette.

MARGUERITE GERARD. 1761-1837. French.

As Fragonard's sister-in-law, student, and a member of his ménage in the Louvre, Gérard had an unparalleled opportunity to pursue a career in art--free from the obligations of marriage and children. Though she is less acclaimed than Vigée-LeBrun or Labille-Guiard, she was the first French woman to succeed in genre painting, considered a notch above portraiture and still life.

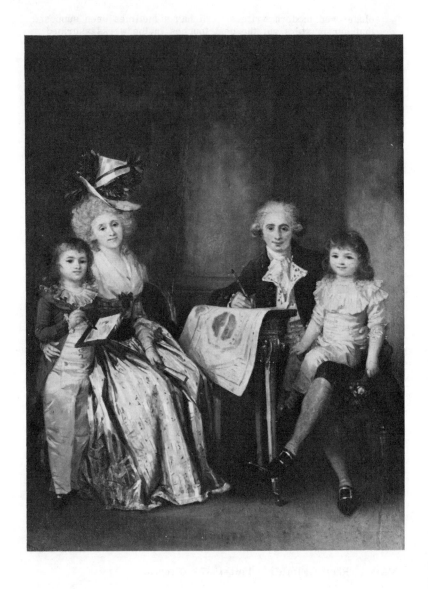

Marguerite Gérard. Portrait of an Architect and His Family.
ca. 1787-89. Oil on panel. 12" x 9 1/2". The Baltimore Mu-
seum of Art.

She did small, sentimental genre scenes based on Dutch prototypes (Metsu, Torborch) and successfully emulated their painstaking technique of multiple glazes. She exhibited in the Salon for twenty-five years. Her fifty-year career endured numerous political changes. The ugly assumption that Gérard was Fragonard's mistress and that he directly assisted her in painting is one that often persecutes women artists with a close association to a male master. There is no proof whatever to substantiate the slander about Gérard, and much evidence that would deny it.

Algond, H. "Marguerite Gérard au Musée Fragonard de Grasse." Revue de l'art. 70 (Jan. 1937):239-246.

Bénézit. Dictionnaire. Vol. 4, p. 213.
She showed at the salon from 1799 to 1824.

Bryan. Dictionary of Painters. Vol. 2, p. 231.

Doin, Geanne. "Marguerite Gérard (1761-1837)." Gazette des beaux-arts. CIX (1912):429-52.

Ellett. Women Artists in All Ages. p. 201.

Gabhart and Broun. "Old Mistresses."
Gabhart and Broun unfortunately repeat the old gossip about Gérard and Fragonard.

Goulinet. "Les femmes peintres au XVIII siècle."

Harris and Nochlin. Women Artists, 1550-1950. pp. 29, 46, 197-201, 348.

Hill. Women. An Historical Survey. Catalogue. pp. xi, 10.
A black and white reproduction of one of her literary paintings with a long caption that includes an exhibition record.

Levitine, G. "Marguerite Gérard and Her Stylistic Significance." Baltimore Museum Annual. III (1968):21ff.

Linzeler. "L'exposition des femmes peintres du XVIIIe siècle."
A review of the same show that is discussed by Goulinet, above.

Nochlin. "Why Have There Been No Great Women Artists?" p. 26.
Nochlin provides a small black and white reproduction.

Perate, A. "Les esquisses de Gérard." L'art at les artistes. (1909):4-7.

Petersen and Wilson. Women Artists.... p. 61.

Thieme and Becker. Allgemeines Lexikon. Vol. 13, p. 439.

Collections:

Baltimore, Museum of Art.
Cambridge, Mass. Fogg Museum of Art. Harvard University.
Paris, Musée Cognacq-Jay.
Paris, Musée du Louvre.

HENRIETTA JOHNSTON. Active 1708-1710, died 1728/29. English.

Johnston was an Englishwoman who spent part of her life in America. She was active in Charleston, South Carolina. She did "primitive" portraits in pastel on tinted linen paper. Biographical information about her is sparse. She was possibly the wife of an impoverished clergyman.

Hill. Women. An Historical Survey. Catalogue. p. 3.
A small black and white reproduction.

Keyes, Homer Eaton. "Coincidence and Henrietta Johnston. "
Antiques. 16 (Dec. 1929):490-494.
On the basis of pastels in English collections that are attributed to her, he tentatively places Johnston as an English-woman working in Surrey under the influence of Edmund Ashfield or one of his pupils. Thinks she probably left for South Carolina around 1700-1710. Notes that she visited New York City around 1725. A color reproduction is included.

Middleton, Margaret Simons. Henrietta Johnston, America's First Pastellist. Columbia, S.C., 1966.

Rutledge, Anna Wells. "Who Was Henrietta Johnston?" Antiques. 51 (March 1947):183-185.
Mentions early sources of information on her. Believes she was Irish and was recently widowed when she came to America.

Tufts. Our Hidden Heritage. p. 139.

Willis, Eola. "The First Women Painter in America. " International Studio. 87 (July 1927):13-20.
She is at least one of the earliest to be documented.

_____. "Henrietta Johnston, South Carolina Pastellist. " Antiquarian. 11 (Sept. 1928):46-47.
Thinks she was English and the pupil of John Riley. Mentions that she also worked in North Carolina and New York. Good black and white reproductions.

Collections:

Richmond, Virginia Museum of Fine Arts.

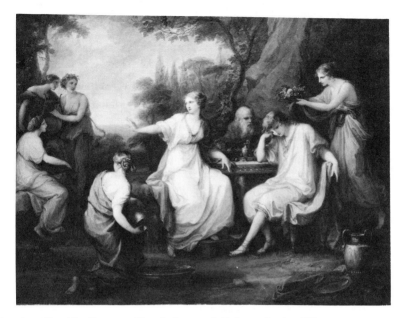

Angelica Kauffman. The Sadness of Telemachus. Oil on canvas.
32 3/4" x 45". Metropolitan Museum of Art, New York, bequest
of Collis P. Huntington.

ANGELICA KAUFFMAN. 1741-1807. Swiss.

Kauffman is a splendid exponent of neoclassical painting.
She holds a special place in the history of women artists because
she was the first to succeed at the hitherto all-male endeavor--
history painting. She was born in Switzerland, the daughter of a
painter. Following the death of her mother, the teenage Angelica
worked as an itinerant painter with her father in Italy. She spent
most of her life in England and Italy. She was accomplished in
music and fluent in many languages. She studied in Italy and
France and settled in England in 1766/67 where she stayed until
1781. She was the friend of Sir Joshua Reynolds, Goethe, Mengs
and Winkelmann. Fuseli fell in love with her. She made an un-
fortunate marriage in 1767 to a Swedish "Count de Horn" who sub-
sequently turned out to be a married commoner. Her devout
Catholicism prevented a divorce. In 1781 she finally remarried,
Antonio Zucchi, who replaced her aging father in managing her
business affairs. In addition to her history painting, she also did
portraits and some decorative arts--designs for Wedgewood and
Meissen china, and decorations for ceilings and mantelpieces. She
was a founding member of the English Royal Academy, as well as

a member of many of the European academies. The esteem in which she was held was reflected in her funeral. Organized by Antonio Canova, it was styled on Raphael's.

Bénézit. Dictionnaire. Vol. 5, pp. 219-220.

Bergenz. Voralberger Landsmuseum. Angelica Kauffman und ihre Zeitgenossen. 1968.
 Organized by Dr. Oscar Sander.

Boase, T. S. R. "Macklin and Bowyer." Warburg and Courtauld Institute Journal. 26 (1963):150, 165-166, and 177.
 Discusses the work she did for two English publishers, Thomas Macklin and Robert Bowyer.

Bryan. Dictionary of Painters. Vol. 3, p. 124.
 Lists her paintings and etchings.

Busiri Vici, Andrea. "Angelica Kauffman and the Bariatinskis." Apollo. 77 (March 1963):201-208.

Clark, Anthony M. "Neo-classicism and the Roman Eighteenth-Century Portrait." Apollo. 78 (Nov. 1973):358-359.
 Black and white reproduction and brief description of her portrait of Cardinal Rezzonico.

Clayton. English Female Artists. pp. 233-294.

Clement. Women in the Fine Arts. pp. 179-190.

Croft-Murray, Edward. Decorative Painting in England, 1537-1837. London, 1964-70. Vol. II, pp. 227-29.
 This concerns the neoclassical decorative insets she did for domestic interiors.

Edwards. Women: An Issue.

Ellet. Women Artists in All Ages. pp. 144-163.

Eva. "Women Artists...."

Fleisher. "Love and Art."

Gerard, Frances A. Angelica Kauffman. A Biography. London: Ward and Downey, 1893.
 Appendix has extensive listing of her works and a guide to houses decorated by her.

Goethe. Italian Journey, trans. by W. H. Auden and Elizabeth Mayer. Baltimore, 1970.

Guhl. Die Frauen....

Harris and Nochlin. Women Artists, 1550-1950. pp. 28, 38, 41-44, 81, 174-178, 190, 249, 346, 363.

Hartcup, Adeline. Angelica, the Portrait of an Eighteenth Century Artist. London: W. Heinemann, 1954.
This biography is illustrated.

Hutchison, Sidney C. The Homes of the Royal Academy. London, 1956. pp. 9ff, 16, 28.

Kamerick, Maureen. "The Woman Artist in the Eighteenth Century: Angelica Kauffman and Elizabeth Vigée-LeBrun." New Research on Women at the University of Michigan, 1974. pp. 14-22.

Maguinness, Irene. British Painting. London: Sidgwick and Jackson, 1920. p. 76.
Says her work "... is of no particular interest at this time and is best known through engravings."

Manners, Lady Victoria and Williamson, G. C. Angelica Kauffmann, R.A., Her Life and Works. London: John Lane, The Bodley Head, 1924; reprint edition, New York: Hacker Art Books, 1976.
Please note the different spelling. "Kauffmann" is often seen in writing about her. The spelling she always used was, "Kauffman."

Mayer, Dorothy Moulton. Angelica Kauffman, R.A., 1741-1807. Gerrards Cross: Colin Smythe, 1972.
Many reproductions; several in color.

Moser, Joseph. An obituary. European Magazine. LV (1809): 259.

Munsterberg. History of Women Artists. pp. 40-45.

Neilson. Seven Women.... pp. 9-29.

Petersen and Wilson. Women Artists. pp. 43-46.

Poensgen, Georg. "Ein Kunstlerbildnis von Angelika Kauffmann." Pantheon. III (1973):294-297.

Redgrave, Richard and Redgrave, Samuel. A Century of Painters of the English School. London: Smith, Elder and Co., 1866, pp. 176-178.
Calls her works "weak and faulty in drawing," and elaborates by saying her works "... are of small value.... If any progress were to be made in Art the British School did well to forget her."

"Richard Arkwright's Cabinet," Connoisseur. 136 (Jan. 1956): 356-357.

Excellent color reproduction of ornate cabinet with bow-fronted doors attributed to Kauffman. Discusses briefly her work in interior decoration.

Ritchie, Mrs. Richmand. "Miss Angel." Cornhill Magazine. (1875).
A fictionalized and popularized version.

"A Roman Portrait by Angelica Kauffman." Connoisseur. 135 (May 1955):190-191.
Discussion of her portrait of Mrs. Henry Benton, with a color illustration. Notes that after she moved to Italy she had many commissions from the resident English colony in Rome.

de Rossi, Giovanni Gherado. Vita de Angelica Kauffmann, pittrice. Florence, 1810.

Schwartz. "If De Kooning...."

Sparrow, Walter Shaw. "Angelica Kauffman's Amazing Marriage." Connoisseur. XCII (1933):242-248.
Sparrow at his most gossipy.

_____. Women Painters of the World. pp. 58-59.

Thieme and Becker. Allgemeines Lexikon. Vol. 20, pp. 1-5.

Tomory, Peter A. "Angelica Kauffman--'Sappho'." The Burlington Magazine. 113 (May, 1971):275-276.
Discusses the history of the painting. Mentions a possible romantic attachment between Kauffman and the engraver William Ryland.

Tufts. Our Hidden Heritage. pp. 117-125.

Vienna. Austrian Museum für Angewandte Kunst. Angelika Kauffman und ihre Zeitgenossen. 1969.
Exhibition catalogue with several essays on her work. Excellent color reproductions and good black and white reproductions of her work and that of her contemporaries.

Walch, Peter S. Angelica Kauffman. Princeton University, doctoral dissertation, 1969.

_____. "Angelica Kauffman and Her Contemporaries." Art Bulletin. LI, no. 1 (1969):83-85.
Review of the exhibition listed above, held in Vienna and in Bregenz in 1968.

_____. "Charles Rollin and Early Neo-classicism." Art Bulletin. 49 (June 1967):124-125.
Discussion of the impact of the historian Rollin and the engraver Gravelot on neoclassical art, with Kauffman being one

of the artists examined.

de Wally, Leon. Angelica Kauffman. 1838.
 A novel.

"Women Artists" (review of Guhl).

Collections:

 Bergenz, Landsmuseum.
 Berlin, Kupferstichkabinett.
 Florence, Uffizi.
 London, National Portrait Gallery.
 London, Royal Academy of Art.
 Naples, Museo Capodimonte.
 New York, The Metropolitan Museum of Art.
 Philadelphia, Pennsylvania Academy of Art.
 Princeton University Art Museum.
 Richmond, Virginia Museum of Fine Arts.
 Rome, Galleria dell'Accademia di San Luca.
 Sarasota, Florida, Ringling Museum of Art.
 Vienna, Osterreichische Galerie.
 Weimar, Goethe-Nationalmuseum.
 Yorkshire, Nostell Priory.
 Zurich, Kunsthaus.

ANNA BARBARA KRAFFT. 1764-1825. Austrian.

 Krafft painted history, genre and portraits. She was the
daughter and student of Johann Steiner. She was a member of the
Vienna Academy and was named Painter to the City of Bamberg.
She and her apothecary husband lived in Prague, Salzburg and
Bamberg.

Bénézit. Dictionnaire. Vol. 5, p. 305.

Bryan. Dictionary of Painters. Vol. 3, p. 150.

Clement. Women in the Fine Arts. p. 201.

Ellet. Women Artists. p. 241.

Harris and Nochlin. Women Artists, 1550-1950. p. 50.

Thieme and Becker. Allgemeines Lexikon. Vol. 21, pp. 384-385.

ADELAÏDE LABILLE-GUIARD. 1749-1803. French.

 Labille-Guiard first learned the art of pastel painting from
Maurice Quentin de la Tour in 1769-1774. She later became an in-
cisive and virtuoso painter of oil portraits. She came from a

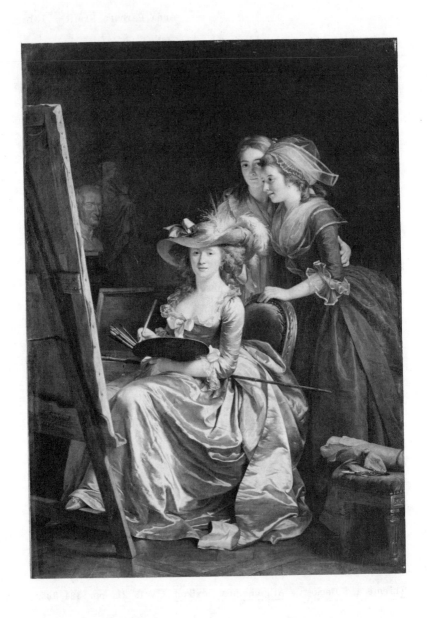

Adélaïde Labille-Guiard. Portrait of the Artist with Two Pupils, Mlle. Marie-Gabrielle Capet (1761-1818) and Mlle. Carreaux de Rosemond (d. 1788). 1785. Oil on canvas. 83" x 59 1/2". The Metropolitan Museum of Art, New York, gift of Julia A. Berwind.

non-artistic family but was probably encouraged in her career none the less. At the age of twenty she married W. M. Guiard; they separated and were divorced ten years later. Her second husband and teacher was painter François André Vincent. She had no children. She and Vigée-LeBrun were admitted to the Royal Academy on the same day in 1783, shortly before it was dissolved by the revolution. She and Vigée-LeBrun were supposed to be rivals, but this may well be more journalism than history. She supported the aims of the revolution, during which she agitated for women's rights. She remained in Paris to do portraits of the leading revolutionaries. When the Academy was reconstituted in 1795 as the Academy of Fine Arts, women were barred from membership. Labille-Guiard was a particularly gifted teacher to a number of women students.

Bénézit. Dictionnaire. Vol. 4, p. 492.
 Lists her Salon showings by year.

Cailleux, Jean. "Royal Portraits of Mme. Vigée-LeBrun and Mme. Labille-Guiard." The Burlington Magazine. III (March 1969): supp. iii-vi.
 Discusses the rivalry between the two artists.

Clement. Women in the Fine Arts. pp. 202-203.

Edwards. Women: An Issue.

Gabhart and Broun. "Old Mistresses."

Goulinat. "Les femmes peintres au XVIIIe siècle."

Harris and Nochlin. Women Artists, 1550-1950. pp. 36-37, 40, 42-43, 180, 185-187, 189, 195, 347.

Hill. Women, An Historical Survey.... Catalogue. p. x.
 A good reproduction of Portrait of the Artist with Two Pupils, Mlle. Marie-Gabrielle Capet, and Mlle. Carreaux de Rosemond, which belongs to the Metropolitan Museum of Art. Capet was a particularly devoted student who specialized in miniatures. She cared for Labille-Guiard during her last illness. See Doria, Comte Arnaud. Une émule d'Adélaïde Labelle-Guiard: Gabrielle Capet, portraitiste. Paris, 1934. Also see Harris and Nochlin. Women Artists, 1550-1950. pp. 40, 186, 195-196, 348; and Petersen and Wilson. Women Artists.... p. 55, for discussions and illustrations of Capet's work.

Jallut, Marguerite. "Le portrait du Prince de Bauffremont par Madame Labille-Guiard." Revue du Louvre. 12 (1962):217-222.

Kagen, Andres. "A Fogg 'David' Reattributed to Mme. Adélaïde Labille-Guiard." Acquisitions Report, 1969-1970, Fogg Art

Museum. Cambridge, Mass., 1971. pp. 31-40.

Linzeler. "L'exposition des femmes peintres du XVIII^e siècle."

Munsterberg. History of Women Artists. pp. 38-40.

Nochlin. "Why Have There Been No Great Women Artists."
p. 27.
A small reproduction in black and white.

Passez, Anne Marie. Adélaïde Labille-Guiard: biographie et
catalogue raisonné de son oeuvre. Paris: Arts et metiers
graphiques, 1975.
Thorough account of her life and work. Discusses the ri-
valry with Vigée-LeBrun. Records and accepts 183 works,
however the locations of only 81 are currently known.

_____. Adélaïde Labille-Guiard, 1749-1803. Paris, 1973.

Petersen and Wilson. Women Artists. pp. 54-58.

Portalis, Baron Roger. "Adélaïde Labille-Guiard." Gazette des
beaux-arts. 26 (1901):353-356, 477-494. 26 (1902):100-118,
325-347.
Until the catalogue by Passez, this four-part article was
the principal work on Labille-Guiard. Many black and white
reproductions of fair quality are included.

_____. Adélaïde Labille-Guiard (1749-1803). Paris,
1902.

Thieme and Becker. Allgemeines Lexikon. Vol. 22, pp. 167-168.

Wilenski, R. H. French Painting. Boston: Charles T. Branford
Co., 1931. pp. 160-164.

Collections:

New York, Metropolitan Museum of Art.
Paris, Musée du Louvre.
Phoenix, Art Museum.
Versailles, Musée National du Château de Versailles.

GIULIA LAMA. Circa 1685-after 1753. Italian.

Lama's life is poorly documented. Her father was perhaps
Agostino Lama, an obscure Venetian painter who died in 1714.
Possibly she was a student of Giovanni Battista Piazetta (1683-
1754), to whom some of her oeuvre has been previously attributed.
She did large-scale religious and narrative paintings. She was
commissioned to do at least three Venetian altarpieces, of which
two are still extant. Currently some twenty-six paintings are

given to her, in addition to many drawings. Of these drawings, some are of the male nude; a landmark event in women's art history considering the restrictions under which women received art educations. Harris says of her that she is "one of the few women active before the nineteenth century whose figure paintings deserve serious study."

Goering, M. "Giulia Lama." Jahrbuch der Königlich preussischen Kunstsammlungen. 1935.

Harris and Nochlin. Women Artists, 1550-1950. pp. 26, 29, 30, 165-166, 345.
We are indebted to Harris for the information and bibliography presented here.

Pallucchini, R. "Di una pittrice veneziana del settecento: Giulia Lama." Revista d'arte. (1933):400.

_____. "Miscellanea piazzettesca." Arte veneta. (1968):107-130.

_____. "Per la conoscenza di Giulia Lama." Arte veneta. (1970):161-172.
This article includes a reprint of a letter from Abbot Luigi Conti to Mme. de Caylus, written in 1728, that reveals something of Giulia Lama's personality. Harris' translation shows Lama as a woman who studied mathematics, was persecuted by other painters, was interested in a machine for making lace, wrote poetry, and who was witty if not pretty.

_____. Piazzetta. Milan, 1956.

Ruggeri, Ugo. Dipinti e disegni di Giulia Lama. Bergamo: Monumenta Bergmensia XXXIV, 1973.

Collections:

Florence, Uffizi.
Malamocco, Parish Church.
Venice, Ca'Rezzonico, Museo del Settecento.
Venice, Santa Maria Formosa.
Venice, San Vitale.

JEANNE PHILIBERT LEDOUX. 1767-1840. French.

She was the pupil of Greuze and her style is derivative of his. Thus their work has been confused. The lack of dates and signatures on her paintings, and the lack of a catalogue of Greuze will continue to contribute to the problem. She did head and shoulder portraits of children and young women. Ledoux exhibited in the Salon from 1793 until 1819; the Salon records are probably the principal documentary source for her.

Jeanne Philibert Ledoux. Portrait of a Boy. ca. 1800. Oil on
canvas. 16" x 12 1/2". The Baltimore Museum of Art, bequest
of the estate of Leonce Rabillon.

Bellier-Auvray. Dictionnaire général.... s. v.

Bénézit. Dictionnaire. Vol. 5, p. 472.
Describes her as being "moderate in ambition. "

Ellet. Women Artists in All Ages. p. 236.

Gabhart and Broun. 'Old Mistresses. "

Harris and Nochlin. Women Artists, 1550-1950. pp. 84, 188,
205-206, 213, 348.

Hill. Women. An Historical Survey.... Catalogue. p. x and
10.

Sparrow. Women Painters of the World. p. 176.

Thieme and Becker. Allgemeines Lexikon. Vol. 22, p. 538.

Collections:

Baltimore, Museum of Art.
Budapest, Magyar Nemzeti Galéria.
Dijon, Musée des Beaux-Arts.
Dijon, Musée Magnin.
Paris, Louvre.
San Francisco, The Fine Arts Museums.
Vienna, Akademie der bildenden Künste.

MARIE-VICTOIRE LEMOINE. 1754-1820. French.

Little is presently known about this Paris-born painter.
She studied with Ménageot (1744-1816). Though there is evidence
to deny that Lemoine was ever Vigée-LeBrun's student; her 1796
painting, Interior of the Atelier of a Woman Painter (Metropolitan),
is an obvious and fascinating homage to Vigée-LeBrun. She ex-
hibited at the Salon de la Correspondence in 1778 and 1785 and at
the official Salons from 1796-1814. She did genre and portrait oils
and also miniatures.

Bellier-Auvray. Dictionnaire général.... s. v.

Bénézit. Dictionnaire. Vol. 5, p. 505.

Gabhart and Broun. 'Old Mistresses. "

Harris and Nochlin. Women Artists, 1550-1950. pp. 188-189,
347.

Hill. Women. An Historical Survey.... Catalogue. p. x and
8.

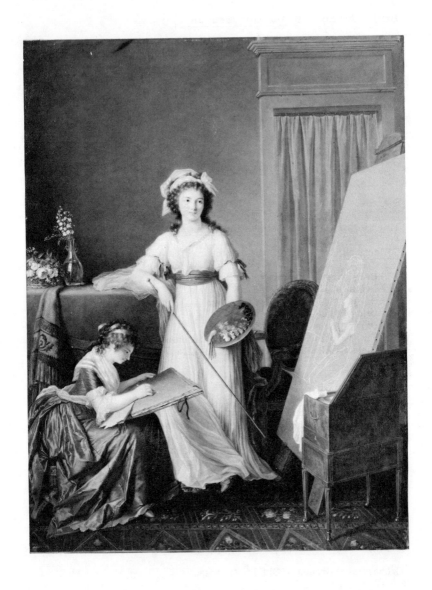

Marie-Victoire Lemoine. Interior of the Atelier of a Woman Artist. 1796. Oil on canvas. 45 7/8" x 35 1/4". Metropolitan Museum of Art, New York, gift of Mrs. Thorneycroft Ryle.

Ojalvo, David. "Musée des Beaux-Arts D'Orleans: peintures des
XVIIe et XVIIIe Siècles." Revue du Louvre. 22 (1972):333.
Says the influence of Vigée-LeBrun is very distinct. In-
cludes black and white reproduction of a self portrait.

Petersen and Wilson. Women Artists. p. 52.

Thieme and Becker. Allgemeines Lexikon. Vol. 23, p. 34.

Collections:

New York, The Metropolitan Museum of Art.
Orléans, Musée des Beaux-Arts.

THERESE CONCORDIA MARON-MENGS. 1725-1808. German.

Maron-Mengs was born in Aussig. She studied with her
father, Ismal Mengs, and shared the art education of her brother,
Anton Raphael Mengs. She was a superb pastel portraitist. In
1741 she traveled to Rome where she met and married painter
Anton Maron. She lived in Rome the remainder of her life.

Bénézit. Dictionnaire. Vol. 6, p. 61.

Bryan. Dictionary of Painters. Vol. 3, p. 289.

Harris and Nochlin. Women Artists, 1550-1950. pp. 39-40.

Thieme and Becker. Allgemeines Lexikon. Vol. 24, p. 393.

Collections:

Dresden, Gemäldegalerie.
Rome, Galleria dell'Accademia di San Luca.
Würzburg, University of Würzburg.

MARY MOSER. 1744-1819. English.

Moser was the daughter of a German artist residing in
London. He was a prominent drawing instructor and official in the
Royal Academy. She was a precocious artist, having her first
showing at age fourteen. With Kauffman she was one of the found-
ing members of the Royal Academy; and like her was relegated to
being depicted as a portrait bust on the wall in Zoffany's 1772
painting of the Academy's life-class. (A reproduction of that
painting is available in Nochlin's "Why Have There Been No Great
Women Artists?" p. 28.) Between 1768 and 1790 she was a regu-
lar exhibitor at the Royal Academy, showing an occasional history
painting, but mainly contributing flower pieces. She was reported-
ly in love with Fuseli, a passion that was not returned. In 1797
she married a military officer and painted only as an amateur
thereafter.

Bénézit. Dictionnaire. Vol. 6, p. 239.

Bryan. Dictionary of Painters. Vol. 3, p. 374.
 Notes that she received royal patronage to decorate a room
 at Frogmore.

Clayton. English Female Artists. pp. 295-313.

Clement. Women in the Fine Arts. p. 244.

Ellet. Women Artists in All Ages. p. 181.

Eva. "Women Artists...."

Harris and Nochlin. Women Artists, 1550-1950. pp. 38, 174, 249.

Mitchell, Peter. Great Flower Painters: Four Centuries of Flor-
 al Art. London, 1973. p. 185, fig. 259.

Mitchell. European Flower Painters. pp. 182-183.

Redgrave. A Century of Painters. p. 418.

Short, E. H. The Painter in History. Lippincott Co.

Sparrow. Women Painters of the World.

Thieme and Becker. Allgemeines Lexikon. Vol. 25, p. 183.

Tufts. Our Hidden Heritage. p. 118.

Collections:

 Cambridge, Fitzwilliam Museum.
 London, British Museum.
 London, Collection of the Royal Academy.
 London, Victoria and Albert Museum.

RACHEL RUYSCH. 1664-1750. Dutch.

 Rachel Ruysch was a fruit and flower painter of extraordi-
nary quality. She was born in Amsterdam, the daughter of a bot-
any professor, anatomist and amateur painter. Her father's scien-
tific influence is apparent in the wide range of flora and fauna she
depicted and the concern for accuracy that her paintings demon-
strate. At age fifteen she was apprenticed to Willem van Aelst.
In 1693 she married portrait painter Juriaen Pool II (1666-1745).
They had ten children! Unlike some other women painters, her
production did not seem to decline with marriage. Her work was
initially influenced by the work of Otto Marseus van Schriek but
soon surpassed it in inventiveness. Her still lifes often include
small dramas between the insects and little creatures that usually
inhabited the foreground. In 1701 she and her husband were ad-

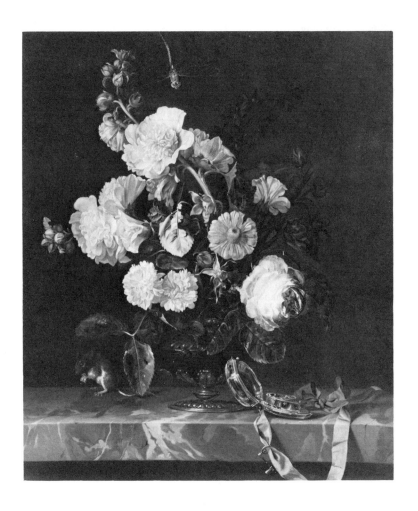

Rachel Ruysch. A Vase of Flowers. Oil on canvas. 22" x 18".
North Carolina Museum of Art, Raleigh, N.C.

mitted to the Hague Guild. From 1708 until 1716 they were pa-
tronized by the German court in Dusseldorf. She always signed
her paintings with her birth name.

Bénézit. Dictionnaire. Vol. 7, pp. 443-444.
Gives lengthy listing of museum holdings of her work.

Bryan. Dictionary of Painters. Vol. 4, pp. 306-307.

Clement. Women in the Fine Arts. pp. 304-305.

Grant, Maurice H. Flower Painting Through Four Centuries; A
Descriptive Catalogue of the Collection Formed by Major the
Honorable Henry Rogers Broughton, Including a Dictionary of
Flower Painters from the XVI to the XIX Century.... Leigh-
on-Sea: F. Lewis, 1952.

_____. Rachel Ruysch 1664-1750. Leigh-on-Sea: F. Lewis, 1956.
Harris describes this work as an uncritical catalogue, compil-
ing a list of 230 works, but with no discussion of the evidence.

Guhl. Die Frauen....

Harris and Nochlin. Women Artists, 1550-1950. pp. 29, 32, 34-
35, 41-44, 65, 78, 141, 152, 158-160, 344-345.
Harris notes that there are records of sixty signed and
dated works and another thirty that are just signed. The
locations of many of these are unknown today. She concludes
that a critical catalogue raisonné is seriously needed.

Hill. Women, An Historical Survey.... Catalogue. p. 4 and ix-x.
A reproduction with exhibition and bibliographical informa-
tion included in the caption.

Hofstede de Groot, Cornelis. Beschreibendes und kritisches Ver-
zeichnis der Werke der hervorragendsten holländischen Maler
des XVII Jahrhunderts; nach dem muster John Smith's Cata-
logue raisonné zusammengestelt.... Esslingen, 1907-1928;
reprint edition London, 1928.

Mitchell. European Flower Painters. pp. 222-223.
Discusses her style and gives two reproductions. Summa-
rizes the biographical facts.

Munsterberg. History of Women Artists. p. 26.

Nochlin. "Why Have There Been No Great Women Artists?" p. 30.

Petersen and Wilson. Women Artists. p. 41.

Renraw, R. "The Art of Rachel Ruysch." The Connoisseur. 92
(1933):397-399.
Good discussion of the stylistic development of her work.
Includes three good black and white reproductions.

Short, E. H. The Painter in History. Lippincott.

Sĭp, Jaromir. "Notities bij het Stilleven van Rachel Ruysch. "
Nederlands Kunsthistorisch Jaarboek. 19 (1968):157-170.
 Traces her interest in botany and biology to her father and
his collection of specimens. Illustrated with engravings of her
father's collection by Josef Mulden and Cornelis Huyberts.
Notes that her still lifes usually included biological specimens.

Sparrow. Women Painters of the World.

Sterling, Charles. Still Life Painting from Antiquity to the Pre-
sent Time. Paris, 1959. p. 48.

Timm, Werner. "Bemerkungen zu einem Stilleben von Rachel
Ruysch. " Oud-Holland. 77 (1972):137-138.

Tremaine, George. "A Queen of Flower Painters: Rachel Ruysch."
Garden Design. 22 (1935):52-54.

Tufts. Our Hidden Heritage. pp. 99-107.

Valentiner, W. R. "Allegorical Portrait of Rachel Ruysch. "
North Carolina Museum of Art Bulletin. Vol. 1 (Summer
1957):7.
 This may be the same painting that faces the chapter on
Ruysch in Tuft's book (above), by Constantin Netscher, Rachel
Ruysch in Her Studio.

"Women Artists" (review of Guhl).

Collections:

 Amsterdam, Boyman's.
 Cambridge, Fitzwilliam Museum.
 Florence, Galeria Palatina.
 Florence, Palazzo Pitti.
 Florence, Uffizi.
 Glasgow, Glasgow Art Gallery.
 Karlsruhe, Staatliche Kunsthalle.
 New York, The Metropolitan Museum of Art.
 Oxford, Ashmolean Museum.
 Prague, Národní Galerie.
 Raleigh, North Carolina Museum of Art.
 Rotterdam, Museum Boymans-van Beuningen.
 Toledo, Museum of Art.
 Vienna, Gemäldegalerie der Akademie der bildenden Künste.

ANNA DOROTHEA THERBUSCH-LISZEWSKA. 1721-1782. German.

 She was born in Berlin into a family of Polish artists, and
received her first training from her father. She might have been

the student of Antoine Pesne (1683-1757) and/or have studied in Paris. Her earliest work is influenced by Watteau. She married an amateur painter (Therbusch) and did not accept a major commission until 1761 when her children were grown. She worked for the court at Stuttgart, the court of Mannheim and Frederick the Great. She was admitted to the French Academy in 1767, also the academies of Bologna, Berlin and Vienna. She did portraits, genre and some mythological and historical scenes. Her work was not well received in France, where her lack of youth, beauty or coquetry worked to her disadvantage. Her work's frank realism and lack of idealism was not appreciated. Her sister Rosina Liszewska-deGasc (1713-1783) was also an artist.

Bartoschek, Gerd. Anna-Dorothea Therbusch, 1721-1782. Potsdam-Sansouci: Kulturhaus Hans Marchwitza, 1971. A catalogue.

Bénézit. Dictionnaire. Vol. 5, p. 602.

Bryan. Dictionary of Painters. Vol. 3, p. 234.

Clement. Women in the Fine Arts. pp. 213-214.

Diderot, Denis. Diderot Salons (1759-1779), edited by Jean Adhemar and Jean Seznac. Oxford, 1957-67.
In Vol. III, 250ff. he describes posing nude for Therbusch-Liszewska.

Ellet. Women Artists in All Ages. p. 143.
Lists her date of birth as 1722.

Harris and Nochlin. Women Artists, 1550-1950. pp. 36-37, 42-43, 79, 169-70, 345-46.
Uses the name Lisiewska-Therbusch.

Hill. Women, An Historical Survey.... Catalogue. p. x.
Says she earned Diderot's praise for her depiction of a male nude.

Petersen and Wilson. Women Artists. p. 48.
Describes her as ambitious and obviously having the strong ego necessary to deal with the excessively masculine Prussian court.

Thieme and Becker. Allgemeines Lexikon. Vol. 22, pp. 282-283.
This entry is by C. Reidemeister, based on his unpublished 1924 dissertation.

Collections:

Berlin, Staatliche Museum.
Moscow, Puschkin Museum.
Vienna, Gemäldegalerie der Akademie der bildenden Künste.

Anne Vallayer-Coster. Still Life with Plums and a Lemon. 1778.
Oil on canvas. 16 3/4" x 18 5/8". Fine Arts Museums of San
Francisco, California Palace of the Legion of Honor, Mr. and Mrs.
Louis Benoist Fund.

ANNE VALLAYER-COSTER. 1744-1818. French.

Vallayer-Coster was the daughter of a goldsmith who moved
his family to Paris when she was ten years old. Nothing is known
of her training. The bulk of her oeuvre consists of still life of
every sort. She made some efforts at portraiture but they were
not well received. She was admitted to the Académie Royale in
1770, one of only three women to be so honored. She married a
lawyer in 1781 and received an apartment in the Louvre. Sterling
calls her, "after Chardin and Oudry, the best French still life
painter of the eighteenth century. "

Bénézit. Dictionnaire. Vol. 2, p. 665.

Bryan. Dictionary of Painters. Vol. 5, p. 230.

Goulinat. "Les femmes peintres au XVIIIe siècle. "

Harris and Nochlin. <u>Women Artists, 1550-1950.</u> pp. 32, 35, 41-43, 82, 152, 179-185, 197, 346-347.

Hill. <u>Women, An Historical Survey.</u> Catalogue. pp. 2, 7, 8.
Two reproductions and exhibition and bibliographical information.

Linzeler. "L'exposition des femmes peintres du XVIII^e siècle."

Mirimonde, A. P. de. "Les oeuvres françaises à sujet de musique au Musée en Louvre. II. Natures mortes des XVIII^e et XIX^e siècles." <u>Revue du Louvre.</u> 15 (1965):111-124.
Illustrates and briefly discusses her work <u>The Attributes of Music.</u>

Nochlin. "Why Have There Been No Great Women Artists?" p. 30.
Reproduction.

Petersen and Wilson. <u>Women Artists.</u> pp. 58-60.

Roland Michel, Marianne. "A propos d'un tableau retrouvé de Vallayer-Coster." <u>Bulletin de la Société de l'Histoire de l'Art Français.</u> 1965.

_____. <u>Anne Vallayer-Coster 1744-1818.</u> Paris: C.I.L., 1970.
Definitive catalogue of her work, but the beautiful illustrations are unfortunately only in black and white. Assesses her relation to the artistic trends of the time.

_____. "A Basket of Plums." <u>Cleveland Museum Bulletin.</u> 60 (Feb. 1973):52-59.
Points out that Vallayer-Coster did a wide variety of still-lifes, not just flowers, and that she did portraits also. Summarizes her choice of subject matter chronologically. Discusses the motif of the plum basket in her work.

_____. "Tapestries on Designs by Anne Vallayer-Coster." <u>Burlington Magazine.</u> 102 (Nov. 1960):Supp. i-ii.
Before the revolution the Gobelins tapestry factory employed designs by Vallayer-Coster and later reused the same designs. Includes three black and white illustrations of these designs.

Sterling, Charles. <u>Still Life Painting from Antiquity to the Present Time.</u> New York: Universe Books, Inc., 1959, p. 89.

Thieme and Becker. <u>Allgemeines Lexikon.</u> Vol. 35, p. 76.

Tufts. <u>Our Hidden Heritage.</u> p. 128.

<u>Collections</u>:

 Cleveland, Museum of Art.

Geneva, Musée d'art et d'histoire.
New York, The Metropolitan Museum of Art.
Paris, The Louvre.
San Francisco, Fine Art Museums.
Toledo, Ohio, Museum of Art.

MARIA VARELST. 1680-1744. Born in Vienna, worked in England.

She was the daughter of the painter Herman Varelst and the
student of her uncle Simon Varelst. She came to London at the age
of three. Linguistics and music were among her talents. Her
painting consisted of portraits and small history paintings.

Bénézit. Dictionnaire. Vol. 8, p. 519.

Clayton. English Female Artists. pp. 71-77.

Clement. Women in the Fine Arts. pp. 339-340.

Ellet. Women Artists in All Ages. pp. 165-166.

Hill. Women. An Historical Survey.... Catalogue. p. ix.

Thieme and Becker. Allgemeines Lexikon. Vol. 34, p. 237.

MARIE LOUISE ELIZABETH VIGEE-LeBRUN. 1755-1842. French.

Elizabeth Vigée-LeBrun, as she is usually called today, was
the daughter of pastellist Louis Vigée. Her earliest lessons were
from friends of her father's, Doyen and Davesne. At fourteen she
took lessons in the Louvre with Gabriel Briard. She made an un-
wise marriage at twenty to the art dealer, LeBrun. He turned out
to be a gambler and a constant drain on her earnings for the rest
of his life. They had one daughter. A prolific painter, she had
an output of perhaps eight hundred portraits. In 1783, with Adé-
laïde Labille-Guiard, she was admitted to the Académie Royale.
She was painter to Marie-Antoinette, who is supposed to have
picked up the artist's dropped paint brushes when the artist was
too far into pregnancy to stoop down. Because of her close rela-
tionship to Marie-Antoinette, Vigée-LeBrun was forced to flee
France at the outbreak of the revolution in 1789. For the next
twelve years she traveled and painted portraits. She worked in
Rome, for the Royal Court in Naples, in Berlin, and spent six
years in Russia. She met with an enthusiastic reception wherever
she went, finding many commissions. In 1801 she returned to
France, but later spent some time in England. She belonged to
the academies of Berlin, Rome, Bologna, Florence, and St. Peters-
burg. Until a catalogue raisonné is available for her immense
oeuvre it will be impossible to assess her importance to eighteenth-
century portraiture.

Elizabeth Vigée-LeBrun. The Marquise de Pezé and the Marquise
Rouget with Her Two Children. 1787. Oil. National Gallery of
Art, Washington, D.C. Gift of the Bay Foundation in memory of
Josephine Bay Paul and Ambassador Charles Ulrich Paul.

Babin, G. "Mme. Vigée-LeBrun, portrait de Mme. Grand, plus
 tard princesse de Tallyrand." L'illustration. (June 1912).

Baillio, Joseph. A Ph.D. dissertation in progress on Vigée-Le-
 Brun at the University of Rochester.

Bénézit. Dictionnaire. Vol. 8, pp. 562-563.
 Long listing of museums having her work.

Bischoff, Ilse. "Vigée-LeBrun's Portraits of Men." Antiques.
 93 (Jan. 1968):109-111.
 Discusses the differences in her portrait treatment of men
 and women. Details her relationships with the sitters. Seve-
 ral black and white reproductions.

Blum, André. Madame Vigée-LeBrun, peintre des grandes dames
 du XVIIIe siècle. Paris, 1919.

Bouchot, Henri. "Une artiste française pendant l'émigration, Madame Vigée-LeBrun. " Revue de l'art ancien et moderne. I (1898):51-62, 219-30.

Bryan. Dictionary of Painters. Vol. 3, pp. 193-194.

Cailleux, Jean. "Royal Portraits of Mme. Vigée-LeBrun and Mme. Labille-Guiard. " Burlington Magazine. (March 1969):iii-vi.

Clement. Women in the Fine Arts. pp. 340-350.

Constans, Claire. "Un portrait de Catherine Vassilievna Skavronskaia par Madame Vigée-LeBrun. " Revue du Louvre. 17 (1967):265-272.
　　Compares several portraits of the same sitter. Good black and white reproductions.

Ellet. Women Artists in All Ages. pp. 206-220.

Eva. "Women Artists.... "

Faxon, Alicia. "Elisabeth LeBrun: A Queen's Favorite. " Boston Globe. (July 18, 1972).

Frankfurter, Alfred. "Museum Evaluations, 2: Toledo. " Art News. 63 (Jan. 1965):26 and 55-56.
　　Discusses her painting Lady Folding a Letter and speculates on the reason for inclusion of genre accessories in her portraits.

Gabhart and Broun. "Old Mistresses. "

Golzio, Vincenzo. "Il soggiorno romano di Elisabeth Vigée-Le-Brun. " Studio romani. IV (1956):182-83.

Goulinat. "Les femmes peintres au XVIIIe siècle. "

Guhl. Die Frauen....

Harris and Nochlin. Women Artists, 1550-1950. pp. 28-29, 37, 40-44, 46, 49, 83, 176, 180, 185-189, 190-194, 197, 200, 209, 347-48.

Hautecour, Louis. Mme. Vigée-LeBrun. Paris, 1914.

Helm, William Henry. Vigée-LeBrun, Her Life, Works and Friendships. Boston: Small, Maynard and Co. , 1915; London, 1916.

Hill. Women. An Historical Survey.... Catalogue. pp. x, 9.
　　Vigée-LeBrun was also an important teacher. The work of one of her students, Marie-Victoire Lemoine (1754-1820), can be seen on page 8.

Kamerick, Maureen. "The Woman Artist in the Eighteenth Century: Angelica Kauffman and Elizabeth Vigée-LeBrun." New Research on Women at the University of Michigan, 1974. pp. 14-22.

Kyle, Elizabeth [pseud.]. (Agnes Dunlop). Portrait of Lisette. New York: Thomas Nelson and Sons, 1963.
A fictionalized account for juvenile readers.

LeBrun, Jean Baptiste Pierre. Précis historique de la vie de la citoyenne LeBrun, peintre. Paris, 1794.
Here Vigée-LeBrun's husband is petitioning for his wife to be allowed to return to France.

Levey, Michael. Art and Architecture of the Eighteenth Century in France. Harmondsworth: Penguin, 1972. pp. 187-88.

Linzeler. "L'exposition des femmes peintres du XVIIIe siècle."

Lucas, E. V. Chardin and Vigée-LeBrun. London, New York, n. d.
Two unrelated essays.

MacColl, D. S. "Madame Vigée-LeBrun's 'Boy in Red'." Burlington Magazine. 42 (April 1923):182-187.
Brief account of the iconography of this work and the reasons for its attribution to her.

Macfall, Haldane. Vigée-LeBrun. London, New York: Masterpieces in Colour Series, n. d. (1900?).
Lightweight biography, with inferior color reproductions.

Munsterberg. A History of Women Artists. pp. 37-38.

Muntz, E. "Lettres de Mme. Vigée-LeBrun relatives à son portrait de la galerie des offices (1791)." Nouvelle archives de l'art français. 1874-75. pp. 449-52.

Musick, James. "An Early Portrait by Vigée-LeBrun." St. Louis Museum Bulletin. 26 (July 1941):53-55.

Neilson. Seven Women.... pp. 31-45.

Nikolenko, Lada. "The Russian Portraits of Mme. Vigée-LeBrun." Gazette des beaux-arts. 70 (July-Aug. 1967):91-120.
Catalogues the portraits of Vigée-LeBrun done during her six years in Russia (1795-1801). Discusses her style and includes many reproductions.

Nochlin. "Why Have There Been No Great Women Artists?" p. 34.
A full-page color reproduction of a portrait of her daughter.

de Nolhac, Pierre. Mme. Vigée-LeBrun, peintre de la reine Marie-Antoinette, 1755-1842. Paris, 1908; reprint, Paris:

Goupil et Cie., 1912.
 The second edition was titled Madame Vigée-LeBrun: Painter of Marie-Antoinette.

Paris. Grand Palais. French Painting 1774-1830: The Age of the Revolution. 1974. pp. 664-68.

Petersen and Wilson. Women Artists. pp. 49-54.

Pillet, Charles. Madame Vigée-LeBrun. Paris, 1890.

"St. Louis Obtains Charming Vigée-LeBrun." Art Digest. 15 (Jan. 1, 1941):13.
 Portrait of her younger brother, painted when she was eighteen. Black and white illustration.

Shelley, Gerard, trans. The Memoirs of Mme. Elisabeth Vigée-LeBrun. New York: George H. Doran and Co., n.d. (1927).
 An abridged translation. See also Strachey later in this bibliography for a somewhat less abridged translation.

Sizer, Theodore. "The John Trumbulls and Mme. Vigée-LeBrun." Art Quarterly. 15 (Summer 1952):170-178.
 Trumbull met Vigée-LeBrun in Paris in 1786, where he participated in soirées at her studio. Discusses the similarities in their lives and their art, concluding that she had a lasting and beneficial effect on his style.

Sparrow. Women Painters of the World. pp. 175-178.

Strachey, Lionel, trans. Memoirs of Elisabeth Vigée-LeBrun. New York: Doubleday, Page and Co., 1903.
 Lengthy appendix listing her paintings. An abridged translation, but less so than Shelley's, listed previously.

Sutton, Denys. "Russian Francophiles of the Dix-huitième." Apollo. 101 (June 1975):426.
 Summarizes her six-year Russian sojourn.

Tripier-Le Franc, Justin. Notice sur la vie et les ouvrages de Mme. LeBrun, extract from Le journal dictionnaire de biographie moderne. Paris, 1928.

Tuetey, A. "L'émigration de Mme. Vigée-LeBrun." Bulletin de la Société de l'Histoire de l'Art Français. (1911):169-82.

Tufts. Our Hidden Heritage. pp. 127-137.

Vigée-LeBrun, Marie Louise Elizabeth. Souvenirs de Mme. Vigée-LeBrun. 2 vols. Paris, 1835-37.
 Vigée-LeBrun's fascinating memoirs. Two abridged English translations were listed earlier. She did not realize aristocratic society was doomed. She gives marvelous practical

advice, such as how to do a man's portrait without letting him flirt with you.

"Women Artists" (review of Guhl).

Collections:

Boston, Museum of Fine Arts.
Columbus, Ohio, Gallery of Fine Arts.
Florence, Galleria Uffizi.
Fort Worth, Kimbell Art Museum.
Geneva, Musée d'art et d'histoire.
London, The Wallace Collection.
Montpellier, Musée Fabre.
New York, The Metropolitan Museum of Art.
Paris, Musée du Louvre.
Raleigh, North Carolina Museum of Art.
St. Louis, City Art Museum.
San Francisco, Fine Arts Museums.
Toledo, Ohio, Museum of Art.
Versailles, Clichés de musées nationaux.
Washington, D.C., National Gallery.

NINETEENTH CENTURY

LADY LAURA THERESA ALMA-TADEMA. 1852-1909. English.

Born in London, the daughter of Dr. G. N. Epps, a paint-
er. He encouraged her early interest in drawing and at age eigh-
teen she became the pupil of Laurence Alma-Tadema. They even-
tually married and had a daughter, Anna, who was also a painter.
She showed at the Royal Academy beginning in 1873, and in Berlin
and Paris. She did portraits, usually of children, in pastel. On
her visits to Italy she painted landscapes. The majority of her
work, however, consisted of genre scenes, often depicting children,
set in 17th-century Holland.

Bénézit. Dictionnaire. Vol. 1, p. 119.

Clayton. English Female Artists. Vol. II, p. 6.

Clement. Women in the Fine Arts. pp. 9-10.

Meynell, Alice. "Laura Alma-Tadema." Art Journal. 22 (Nov.
1883):345-347.
This is the major source of information, written when Alma-
Tadema was only thirty-one. Notes that at this early stage of
her career she had completed fifty-six paintings, "... although
like most women Mrs. Alma-Tadema works with interrup-
tions...." Although her husband is well known and she is vir-
tually obscure, she evidently had some influence on his art:
"... her teacher does her charming work the honour of con-
sulting her studies now and then in aid of his own accessory
landscapes...." Four engravings of her work are included.

Sparrow. Women Painters of the World. p. 70.

Thieme and Becker. Allgemeines Lexikon. Vol. 1, p. 325.

Collections:

The Hague.

SOPHIE ANDERSON. 1823-after 1898. English.

Anderson specialized in sentimental narrative scenes of

143

domestic life, and also did landscapes. She was born in Paris and was active in London. She exhibited steadily at the English Royal Academy from 1855 until 1896.

Antiques. 109 (January 1976):1-20.
A reproduction of her pastel, Lucy Goodman.

Clayton. English Female Artists. Vol. II, p. 7-9.

Connoisseur. 158 (March 1965):xv.
A reproduction of her painting, Sweet Dreams.

Graves, Algernon. The Royal Academy of Arts. London, 1905.
Vol. 1, p. 33.

Harris and Nochlin. Women Artists, 1550-1950. p. 53.

Hill. Women. An Historical Survey.... Catalogue. pp. xi, 12.
A reproduction with collection and bibliographical information.

Nochlin. "By a Woman Painted...." p. 70.
A small color reproduction with a short stylistic analysis.

Sparrow. Women Painters of the World. p. 105.

Thieme and Becker. Allgemeines Lexikon. Vol. 1, p. 438.

RUTH HENSHAW BASCOM. 1772-1848. American.

Bascom spent her life in New Hampshire and Massachusetts. She first married a Dartmouth professor in 1804. After his death she married, in 1806, the Reverend Ezekiel Bascom. She was a portraitist, who rarely charged for her work. She did full-size profiles in pastels, usually tracing a projected shadow of the subject in pencil. Sometimes the profiles were cut out and pasted onto a colored sheet of paper. Occasionally she pasted bits of metal foil to simulate jewelry or spectacles. She is considered a primitive.

Dods, Agnes. "Connecticut Valley Painters." Antiques. 46 (October 1944):207-209.

Ebert, John and Katherine. American Folk Painters. New York: Charles Scribner's Sons, 1975. pp. 48-50.
A good account of her life and an excellent description of her stylistic characteristics.

Lipman, Jean and Winchester, Alice, editors. Primitive Painters in America: 1750 to 1950. New York: Dodd, Mead, 1950.
Includes several illustrations. Notes that the diaries Bascom kept most of her adult life are in the American Antiquarian

Society, Worcester, Mass. This chapter on Bascom is by
Agnes Dods.

Sears, Clara Endicott. Some American Primitives. Port Wash-
ington, N. Y. : Kennikat Press, 1968. pp. 118-125.
Includes excerpts from the diaries.

MARIE BASHKIRTSEFF. 1860-1884. Russian, active in France.

After her parents separated, Bashkirtseff's mother took her
and her brothers from Russia to Europe, first to Nice and then to
Paris. She was a gifted child, talented in linguistics and music.
Her early ambition was to be a singer, but she finally settled on
art in an attempt to keep from dissipating her efforts in too many
directions. In 1877 she entered the Julian Academy and in 1881
made a trip to Spain. She painted realistic Paris urban scenes
and portraits at the Salon. At the age of twenty-four she died of
tuberculosis.

Bashkirtseff, Marie. Le journal de Marie Bashkirtseff. Ed.
Andre Theuriet, 2 vols. Paris, 1887.
There are several English translations. In addition to the
ones by Sufford and Serano, listed later, there are ones by
Hall and Moore. See Harris and Nochlin, p. 353 for addition-
al references.

Bénézit. Dictionnaire. Vol. 1, p. 445.

Borel, P. "L'idyll mélancolique, histoire de Maria Bashkirtseff
et de Jules Bastien-Lepage. " Annales politiques et littéraires.
78 (1922):535-36, 563-65, 591-92, 617-18, 643-44.

Breakell, M. L. "Marie Bashkiertseff. The Reminiscences of a
Fellow-Student. " Nineteenth Century and After. 62 (1907):
110-25.

Bryan. Dictionary of Painters. Vol. 1, p. 93.

Cahuet, Alberic. Moussia, ou la vie et la mort de Marie Bash-
kirtseff. Paris: E. Fasquelle, 1926.

Clement. Women in the Fine Arts. pp. 26-33.

Creston, Dormer [pseud.]. (Baynes, Dorothy.) Fountains of Youth:
The Life of Marie Bashkirtseff. London: T. Butterworth,
Ltd. , 1936.

Ettinger, P. "Exposition Marie Bachkirtzeff à Leningrad. "
Beaux arts. 8 (May 1930):12.

Gilder, Jeanette. (Foreword). The Last Confessions of Marie
Bashkirtseff and Her Correspondence with Guy de Maupassant.

New York: Frederick A. Stokes, 1901.

Harris and Nochlin. Women Artists, 1550-1950. pp. 53, 56, 221, 255-57, 353.

Moore, Doris. Marie and the Duke of H: The Day Dream Love Affair of Marie Bashkirtseff. London: Cassell, 1966.

Paris. Union des Femmes Peintres et Sculpteurs. Catalogue des oeuvres de Mlle. Bashkirtseff. 1885.

Parker, Rosie. "Portrait of the Artist as a Young Woman: Marie Bashkirtseff." Spare Rib. 30 (April 1975):32-35.

Safford, Mary, trans. The New Journal of Marie Bashkirtseff (from Childhood to Girlhood). New York: Dodd, Mead and Co., 1912.

Serrano, Mary, trans. Marie Bashkirtseff, The Journal of a Young Artist, 1860-1884. New York: E. P. Dutton and Co., 1889.

Sparrow. Women Painters of the World. p. 182.

Theuriet, Andre. Jules Bastien-Lepage and his Art: A Memoir. London: T. Fisher Unwin, 1892.
 Bashkirtseff was a close friend of the artist Bastien-Lepage. A chapter by Mathilde Blind is included, "A Study of Marie Bashkirtseff." Included is a complete list of her works, which includes sculpture. Engravings of her work are used as illustrations.

Collections:

Nice, Musées de la Ville de Nice.
Paris, Louvre.

CECILIA BEAUX. 1853-1942. American.

 Born in Philadelphia, Beaux was raised in the matriarchal environment of aunts and a grandmother, as her mother died twelve days after her birth. Her first teacher was Catherine Drinker, followed by William Sartain. She first exhibited at the Pennsylvania Academy of Fine Arts in 1879 and at the Paris Salon in 1887. In 1888 she made her first trip to Europe, enrolling in the Academy Julien. She left there in 1889, traveling in Italy and England before returning to Philadelphia. In 1895 she began teaching at the Pennsylvania Academy of Fine Arts and continued in that capacity until 1915. In 1899 she became the first woman to win first prize in the Carnegie International. During her long career she won numerous other prizes and awards. She was primarily a portrait painter and her freely brushed style is similar to Sargent's.

Cecilia Beaux. Man with a Cat (Henry Sturgis Drinker). 1898.
Oil on canvas. 48" x 34 5/8". National Collection of Fine Arts,
Smithsonian Institution. Washington, D. C. Bequest of Henry
Ward Ranger through the National Academy of Design.

Bailey, Elizabeth. "The Cecilia Beaux Papers." Archives of the
 American Art Journal. 13 (1973):14-19.
 Summarizes 1500 items of personal correspondence, begin-
 ning in 1863, consisting of twelve notebooks and diaries and
 sixty-five manuscripts of speeches, essays and poetry. Pre-
 served on microfilm and available at regional offices.

Beaux, Cecilia. Background with Figures. Boston and New York:
 Houghton Mifflin Co., 1930.
 This is Beaux's autobiography, illustrated with black and
 white reproductions.

Bell, Mrs. Arthur. "The Work of Cecilia Beaux." Studio. 17
 (September 1899):215-22.

Bénézit. Dictionnaire. Vol. 1, pp. 498-499.

Bowen, Catherine Drinker. Family Portrait. Boston: Little,
 Brown and Co., 1970.

Burrows, Carlyle. "The Portraits of Cecilia Beaux." Internation-
 al Studio. 85 (October 1926):74-80.

"Cecilia Beaux." Art Digest. 17 (October 1, 1942):20.
 Obituary.

Clement. Women in the Fine Arts. pp. 35-38.

Drinker, Henry S. The Paintings and Drawings of Cecilia Beaux.
 Philadelphia: Pennsylvania Academy of Fine Arts, 1955.
 The foreword is by Royal Cortissoz.

Evans, Dorinda. "Cecilia Beaux, Portraitist." American Art Re-
 view. 2 (Jan./Feb. 1975):92-102.
 Reviews the retrospective exhibition of Beaux's work.
 Notes an area she feels was neglected in the catalogue--Beaux's
 preoccupation with value contrasts and sequence of value. Com-
 pares her work to Cassatt's, concluding that Cassatt was more
 versatile, more prolific and a better colorist, but Beaux's work
 has an underlying deeper seriousness.

Goodyear, Frank and Bailey, Elizabeth. Cecilia Beaux, Portrait
 of an Artist. Philadelphia: Pennsylvania Academy of Fine
 Arts, 1974-1975.
 Catalogue of retrospective exhibition of Beaux's work. Ex-
 cellent color plates, good essay on her life and work, and a
 chronology.

Hancock, Walker. Cecilia Beaux, Catalogue of the 150th Anniver-
 sary Exhibition. Philadelphia: Pennsylvania Academy of Fine
 Arts, 1955.

Harris and Nochlin. Women Artists, 1550-1950. pp. 56, 92.

251-254, 352-353.

Hill, F. D. "Cecilia Beaux, the Grand Dame of American Port-
raiture." Antiques. 105 (January 1974):160-168.
Fourteen illustrations, some in color. Bibliography in-
cluded.

Hill. Women, An Historical Survey.... Catalogue. pp. xii, 18,
19.

Huber, Christine. The Pennsylvania Academy and Its Women.
Philadelphia: Pennsylvania Academy of Fine Arts, 1974.

Mechlin, Leila. "The Art of Cecilia Beaux." International Studio.
41 (July 1910):iii-x.

Neilson. Seven Women.... pp. 97-124.

Neuhaus, Eugene. History and Ideals of American Art. Stanford
University Press, 1931.

New York. American Academy of Arts and Letters. A Catalogue
of an Exhibition of Paintings by Cecilia Beaux. 1935.
Text by Royal Cortissoz.

Oakley, Thornton. Cecilia Beaux. Philadelphia: Howard Biddle
Printing Co., 1943.

Petersen and Wilson. Women Artists.... pp. 88-89.

Philadelphia. Philadelphia Museum of Art. Philadelphia: Three
Centuries of American Art. April 11-Oct. 10, 1976, pp. 426-
427 and 443-444.
Notes that in the 1880's-90's she did china painting to gain
financial independence.

Sparrow. Women Painters of the World.

Stein, Judith. "Profile of Cecilia Beaux." Feminist Art Journal.
4 (Winter 1975/76):25-33.

Thieme and Becker. Allgemeines Lexikon. Vol. 3, pp. 126-127.

Walton, William. "Cecilia Beaux." Scribner's Magazine. 22
(Oct. 1897):477-485.
Describes her early work with the United States Geological
Reports in 1875, doing lithograph illustrations of fossils.
Many quotes from contemporary critics, providing insight of
her status at the time. Several good black and white repro-
ductions.

Whipple, B. "Eloquence of Cecilia Beaux." American Artist.
38 (Sept. 1974):44.

Collections:

> Baltimore, Johns Hopkins University.
> Brooklyn, Brooklyn Museum.
> Chicago, Art Institute.
> Florence, Galleria Uffizi.
> Indianapolis, John Herron Art Institute.
> Memphis, Brooks Memorial Art Institute.
> New York, The Harvard Club.
> New York, The Metropolitan Museum.
> New York, National Academy of Design.
> New York, Whitney Museum.
> Philadelphia, Pennsylvania Academy of Art.
> Toledo, Art Museum.
> Washington, D.C., Corcoran Gallery.
> Washington, D.C., National Collection of Fine Arts.
> Youngstown, Ohio, Butler Art Institute.

ROSA BONHEUR. 1822-1899. French.

Bonheur was an artist's daughter and came from a poor family. Her father's disdain for convention set the pattern for her life. He was a follower of the Saint-Simonian movement, based on economic socialism and equality of the sexes. She did vigorous animal paintings and sculpture, a mode much appreciated in her day. Her most famous work is the monumental Horse Fair, that can be seen today in the Metropolitan Museum in New York. Her behavior was refreshingly unconventional; she wore men's clothing (for which she had to obtain government permission) and had her hair cut short. This she claimed necessary in order to study animal anatomy in the slaughter houses. Her lifelong companion was Natalie Micas. Bonheur was the first woman artist to be made an Officer of the Legion of Honor.

Bacon, Henry. "Rosa Bonheur." Century. 28 (Oct. 1884):833-840.

Bénézit. Dictionnaire. Vol. 1, pp. 759-760.

Benjamin. Contemporary Art in Europe. p. 91.
 Describes some of her works. Notes that two of her brothers were also artists.

Bonheur, Rosa. "Fragments of My Autobiography." Magazine of Art. 26 (1902):531-536.

Bryan. Dictionary of Artists. Vol. 1, pp. 165-166.

Clement. Women in the Fine Arts. pp. 48-54.

Ellet. Women Artists in All Ages. pp. 261-284.
 Ellet's article was prepared with Bonheur's help.

Rosa Bonheur. The Horse Fair. 1853-55. Oil on canvas. 99 1/4" x 199 1/2". The Metropolitan Museum of Art. New York, gift of Cornelius Vanderbilt.

Faxon, Alicia. "Rosa Bonheur: The Emperor Neglected." Boston Globe. (July 1972).

Forbes-Robertson, John. "Rosa Bonheur." Magazine of Art. 5 (1882):45-50.
 Lists her works and summarizes her biography.

Harris and Nochlin. Women Artists, 1550-1950. pp. 53, 57-58, 87, 223-225, 249, 349-350.

Hill. Women, An Historical Survey.... Catalogue. pp. xi, 11.

Iskin. "Sexual Imagery in Art...."

Klumpke, Anna Elizabeth. Memoirs of an Artist. Boston, 1940.
 Klumpke became Bonheur's companion after Micas' death. All three were buried together. Bonheur had Klumpke write the biography that Micas had originally intended to do.

_____. Rosa Bonheur, sa vie, son oeuvre. Paris, 1909.
 A large format with illustrations.

Masters in Art, Rosa Bonheur. Boston, 1903.

Munsterberg. A History of Women Artists. pp. 49-53.

Nochlin. "By a Woman Painted...." pp. 69-70.

_____. "Why Have There Been No Great Women Artists?"
pp. 36, 39, 67-69.
 In addition to some reproductions, Nochlin offers some as-
tute analysis into the problems of nineteenth century women
artists with Bonheur as her chief example.

Petersen and Wilson. Women Artists. pp. 74-78.
 Good summary of Bonheur's friendships with Micas and
Klumpke.

Roger-Miles, Leon. Rosa Bonheur, sa vie, son oeuvre. Paris,
1900.

Rorem. "Women: Artist or Artist-ess."

Smith, Christine. "Rosa Bonheur, How She was Victimized by the
(Male) Critics." Women and Art. (Winter 1971):1, 4, 6, 20.

Sparrow. Women Painters. pp. 180-181.

Stanton, Theodore, ed. Reminiscences of Rosa Bonheur. New
York: D. Appleton and Co., 1910; reprint edition, New York:
Hacker Art Books, 1976.
 Huge, chatty, anecdotal account. Many black and white il-
lustrations by Bonheur and other members of her family. Uti-
lizes many quotes from letters.

Sterling, Charles and Salinger, M. French Paintings in the Col-
lection of the Metropolitan Museum. New York, 1966. Vol.
II, pp. 160-164.

Thieme and Becker. Allgemeines Lexikon. Vol. 4, pp. 289-291.

Tufts. Our Hidden Heritage. pp. 147-157.

Collections:

 Cody, Wyoming, Buffalo Bill Historical Center.
 Fontainebleau, Musée National du Château de Fontainebleau.
 New York, The Metropolitan Museum of Art.
 New York, The Shepard Gallery.
 Paris, Musée du Louvre.
 Stockton, California, Pioneer Museum and Haggin Gallery.

MARIE LOUISE BRESLAU. 1856-1928. Swiss.

 Breslau was born in Munich, but at age ten moved to Zurich
where her father had accepted a university post. She studied in
Zurich, in Paris at the Julien Academy where she was a student
of Robert-Fleury, and later was helped by Bastien-Lepage and De-
gas. At the Julien Academy one of her classmates was Bashkirt-
seff, who mentions her in her diaries. She was a painter,

lithographer and pastellist, doing mainly portraits and figure studies.

Bénézit. Dictionnaire. Vol. 2, p. 124.

Clement. Women in the Fine Arts. pp. 61-63.

Harris and Nochlin. Women Artists, 1550-1950. pp. 57, 255.

Hovelaque, Emile. "Mlle. Louise Breslau." Gazette des beaux arts. 34 (1905):195-206.
 Includes several black and white reproductions.

Thieme and Becker. Allgemeines Lexikon. Vol. 4, p. 586.

LADY ELIZABETH SOUTHERDEN THOMPSON BUTLER. 1850-1933. English.

Lady Butler was born in Lausanne. She studied first at South Kensington and later in Florence under Bellucci. Her speciality was military painting and she was praised for the depiction of action in her horses. Her first picture exhibited in the Royal Academy was in 1873, but her biggest success was the following year. Her entry, "Calling the Roll After an Engagement," was purchased by the Queen. In 1877 she married Colonel William Butler, a well known African explorer. She failed to become a member of the Academy by two votes, but her success in the revival of military painting (a male-dominated field) eased the way for election of other women painters.

Ash, Russell. "English Paintings of 1874." Connoisseur. 185 (Jan. 1974):33-40.
 Gives a vivid account of her 1874 Academy success and discusses her obsessive attention to detail. Has a black and white reproduction of "Calling the Role After an Engagement."

Benjamin. Contemporary Art. pp. 37-39.
 Includes her portrait and a black and white reproduction.

Butler, Lady Elizabeth. An Autobiography. London: Constable and Co., Ltd.: 1923.
 Includes sketches by the author.

_____. From Sketch-book and Diary. London: A. and C. Black, 1909.
 Is illustrated by the author (28 color, 21 black and white). Content consists of description and accounts of travel in Africa, Ireland and Italy.

_____. Letters from the Holy Land. London: A. and C. Black, 1903.
 Description and account of travel in Palestine. Has 16

color illustrations by the author.

Clement. Women in the Fine Arts. pp. 68-70.

Harris and Nochlin. Women Artists, 1550-1950. pp. 53-54, 58,
91, 249-50, 352.

"Lady Butler," Connoisseur. 92 (November 1933):341.

Meynell, W. (Alice). "The Life and Work of Lady Butler." The
Art Annuals. 18 (1898). London.

Oldcastle, J. "Elizabeth Butler." Magazine of Art. 2 (1879):
257-62.

Wood, C. Dictionary of Victorian Painters. Woodbridge (Suffolk),
1971. p. 20.

Collections:

Leeds, City Art Galleries.
London, Tate Gallery.
Melbourne, National Gallery of Victoria.

JULIA MARGARET CAMERON. 1815-1879. English.

Cameron was born in Calcutta. She was educated in France
and England. In 1838 she married Charles Hay Cameron, a re-
tired member of the Supreme Court of India. They had six chil-
dren and adopted several others. They settled on the Isle of
Wight where they became the center of an artistic and literary
circle and she became active in social causes. In 1863, when she
was forty-eight, she received a camera from her daughter as a
gift. She devoted herself completely to this new art. Without
working for money and with disregard for conventions, she became
a pioneer in this new art form. She did her own developing and
printing, utilizing a coal house for a dark room and converting a
chicken house into a studio. She did many large portrait close-ups,
genre pictures, and allegorical works. She illustrated Idylls of
the King in 1874 at the request of her friend Tennyson. In 1875
she returned to Ceylon where she spent the remainder of her life.

Beaton. The Magic Image. pp. 62-67.
Excellent description of her eccentric personality. Calls
her the ugly duckling of seven sisters famous for their beauty.
Good reproductions of her work.

Fry, Roger and Woolf, Virginia. Victorian Photographs of Famous
Men and Fair Women, by Julia Margaret Cameron. New
York: Harcourt, 1928.

Gernsheim, Helmut. History of Photography. pp. 250-251, 304-

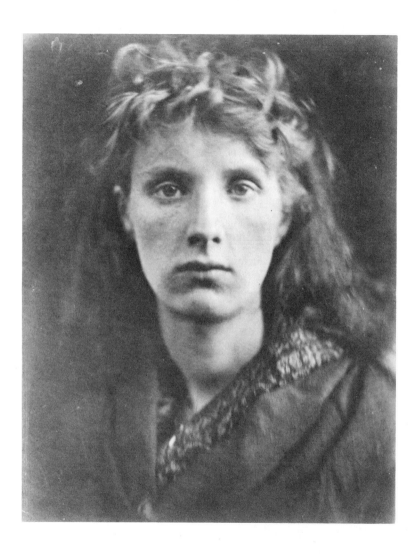

Julia Margaret Cameron. The Mountain Nymph, Sweet Liberty.
1866. Photograph. The Metropolitan Museum of Art, New York,
Harris Brisbane Dick Fund.

306.
 Good discussion of her technique.

_____. Julia Margaret Cameron: Her Life and Photographic
Work. New York: Transatlantic Arts, 1950.

_____. Masterpieces of Victorian Photography. London:
Phaidon Press, 1951. pp. 98-99.
 Includes six reproductions of her portrait studies.

_____. "Sun Artists: Victorian Photography." Camera. 47
(Dec. 1968):13-14.
 Describes her as having superior artistic conception, but
too little regard for technical perfection. Discusses the in-
fluence of her chief artistic advisor, George Frederick Watts,
who encouraged her to rival the compositions of the Renais-
sance and Pre-Raphaelite painters.

Hinson, Tom. "Photography: Recent Acquisitions." Bulletin of
the Cleveland Museum of Art. 62 (Feb. 1965):36-46.
 Describes her portraits as interpretive studies rather than
mere physical equivalents.

Munsterberg. History of Women Artists. pp. 122-123.

New York. Museum of Modern Art. Victorian Photographers.
1968.

Newhall, Beaumont. The History of Photography. pp. 64-65.

_____ and Newhall, Nancy. Masters of Photography. New
York: George Braziller, Inc., 1958, pp. 46-53.

Ovenden, Graham, ed. A Victorian Album: Julia Margaret Came-
ron and Her Circle. New York: DaCapo Press, 1975.
 Introductory essay by Lord David Cecil.

Strasser, Alex. Victorian Photography. New York: Focal Press,
1942, pp. 113-114.
 Several good reproductions.

Szarkowski, J. Looking at Photographs: 100 Pictures from the
Collection of the Museum of Modern Art. New York: Museum
of Modern Art, 1973.

Wintersgill, Donald. "Mrs. Cameron's Hobby." Art News. 73
(Dec. 1974):88.

Collections:

 New York, Metropolitan Museum of Art.
 Wellesley College Art Museum.

MARY STEVENSON CASSATT. 1844-1926. American expatriot, lived in France.

Mary Cassatt has long been used as art history's token woman. She was the daughter of a well-to-do Pennsylvania family and got her first training from the Pennsylvania Academy of Fine Arts. Later she studied in Europe against her father's wishes. The turning point in her development was Degas' invitation to her to join the Impressionists. Breeskin believes her to have been Degas' respected colleague, rather than his student or mistress as art history has hitherto assumed. While one of her favorite themes was mothers and children, it only comprised about one-third of her output. She was an innovative printmaker of color drypoints and aquatints. Though she never married she had heavy family responsibilities with her parents and sister for many years. She was in sympathy with the suffrage movement. Her encouragement to American collectors was instrumental in the acquisition of many Impressionist and earlier European masterpieces in American museums today. Her long life ended in blindness. The following is a selected bibliography from the great mass of literature available about her.

Alexandre, Arsène. "La collection Havemeyer et Miss Cassatt." La Renaissance de l'art. 13 (Feb. 1939):51-56.

_____. "Miss Mary Cassatt, aquafortiste." La Renaissance de l'art. 7 (March 1924):127-133.

Baltimore. Museum of Art. Paintings, Drawings, Graphic Works by Manet, Degas, Morisot and Cassatt. April 18-June 13, 1962.

Bénézit. Dictionnaire. Vol. 2, pp. 361-362.

Biddle, George. "Some Memories of Mary Cassatt." Arts. 10 (August 1926):107-112.

Breeskin, Adelyn Dohme. The Graphic Work of Mary Cassatt, Catalogue Raisonné. New York: H. Bitter and Co., 1948.
This important work is difficult to locate today since it was a limited edition of only five hundred copies.

_____. "The Line of Mary Cassatt." Magazine of Art. 35 (January 1942):29-31.

_____. Mary Cassatt, A Catalogue Raisonné of the Oils, Pastels, Watercolors and Drawings. Washington, D.C.: Smithsonian Institute Press, 1970.
Breeskin catalogues 941 works, almost all of which are illustrated with a sharp black and white photograph. Information is extremely complete for each entry, including reproductions, literature and often anecdotes in addition to the usual information.

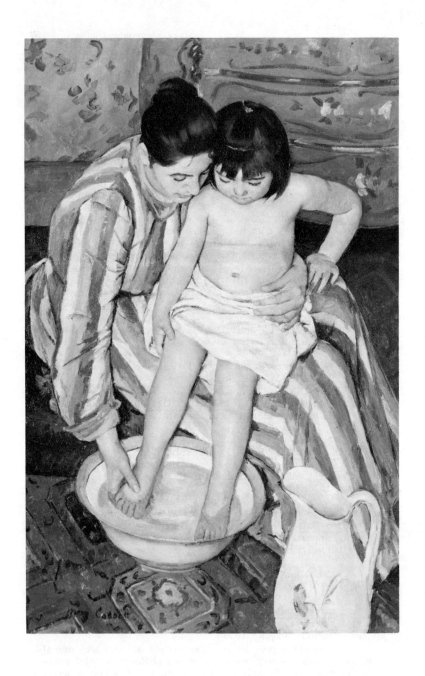

Mary Cassatt. The Bath. ca. 1891. Oil on canvas. 39" x 26".
The Art Institute of Chicago, Robert A. Waller Fund.

Breuning, Margaret. Mary Cassatt. New York: Hyperion Press, 1944.
Reference is made to her important mural, Modern Woman, commissioned for the Woman's Building of the Chicago World's Fair of 1893.

Brinton, Christian. "Concerning Miss Cassatt and Certain Etchings." International Studio. 27 (Feb. 1916):I-VI.

Bullard, E. John. Mary Cassatt, Oils and Pastels. New York: Watson-Guptill, 1972.
This is a good introduction to Mary Cassatt the painter. It consists of thirty-two full-page color reproductions of oils and pastels, some of which are undeservedly lesser known works. They are arranged chronologically and each is accompanied by a page long discussion.

Carey, Elizabeth Luther. "The Art of Mary Cassatt." The Script. 1 (1905):1-5.

Carson, Julia M. Mary Cassatt. New York: David McKay Co., Inc., 1966.
A biography that is adequate and correct but not especially scholarly.

Cassatt, Mary. Correspondence Addressed to Mrs. H. O. Havemeyer, 1900-1920.
Typescripts of original letters on deposit at the National Gallery of Art, Washington, D. C.

Cortissoz, Royal. American Artists. New York: Charles Scribner's Sons, 1923, pp. 183-189.
Summarizes the biographical facts obtained by Segard and emphasizes that Cassatt spoke freely with him.

Custer, A. "Archives of American Art; Group of MS and other Documents of Mary Cassatt Microfilmed." Art Quarterly. 18, no. 4 (1955):391.

Clement. Women Artists in the Fine Arts. pp. 76-78.

Drexler, R. "Mary Cassatt in Washington; Retrospective Exhibition at the National Gallery." Life. 69 (October 30, 1970):10.

Elliot. Art and Handicraft in the Woman's Building.
Reference is made to her important mural, Modern Woman, commissioned for the Woman's Building of the Chicago World's Fair of 1893.

Fuller, Sue. "Mary Cassatt's Use of Soft-Ground Etching." Magazine of Art. 43 (Feb. 1950):54-57.

Gaitskell, C. C. "Imaginary and Probably Inaccurate Musings of

a Drawing Master, 1853." School Arts. 61 (February 1962): 14.
 This is a short humorous essay purporting to be an entry in the diary of a drawing master in a young ladies' boarding school, such as nine-year-old Miss Cassatt might very well have attended (little is known about her early education). He is greatly perturbed at her "unwomanly and unseemly ambition!" While we do not know if Cassatt actually encountered one of his species, great numbers of young women did. Dilettantism was the highest aim of that undermining training.

Gardner. "A Century of Women."
 Discusses the reaction to Cassatt's mural for the Columbian Exposition Woman's Building.

Geffroy, Gustave. "Femmes artistes--Un peintre de l'enfance: Mary Cassatt." Les Modes. 4 (Feb. 1904):4-11.

Grafly, Dorothy. "In Retrospect--Mary Cassatt." American Magazine of Art. 18 (June 1927):305-312.

Hale, Nancy. Mary Cassatt: A Biography of the Great American Painter. New York: Doubleday and Co., 1975.
 Very readable biography that attempts a psychological analysis of the artist.

Harris and Nochlin. Women Artists, 1550-1950. pp. 57-58, 66, 90, 197, 233, 237-244, 282, 351-352.

Havemeyer, Louisine. "The Cassatt Exhibition." The Pennsylvania Museum Bulletin. 22 (May 1927):373-382.

_____. Sixteen to Sixty--Memoirs of a Collector. New York: Metropolitan Museum of Art, 1961.
 Havemeyer was Cassatt's closest woman friend for most of her life. Cassatt advised the Havemeyers in their collection of art, art which today is shared in the Metropolitan Museum.

Huysmans, Joris-Karl. L'art moderne. Paris, 1883.

Hyslop, Francis E., Jr. "Berthe Morisot and Mary Cassatt." Art Journal. 13 (Spring 1954):179-184.

Iskin, Ruth. "Mary Cassatt's Mural of Modern Woman." Abstract of a paper delivered before the College Art Association in January 1975.
 This is a chapter in her dissertation which is to be a monographic study of Mary Cassatt.

_____. Review of "Mary Cassatt, Oils and Pastels," by E. John Bullard. Womanspace Journal. 1 (April-May 1973):13-14, 34.
 Iskin objects to Bullard's interpretation of Modern Woman

as a mere genre scene, ignoring its political content.

Johnson, Una. "The Graphic Art of Mary Cassatt." American Artist. 9 (Nov. 1945):18-21.

King, Pauline. American Mural Painting. Boston: Noyes, Platt and Co., 1902.
 King has two chapters about the mural projects generated by the Chicago World's Fair of 1893. She provides two black and white details plus considerable commentary about Cassatt's mural.

Kysela, John D., S. J. "Mary Cassatt's Mystery Mural and the World's Fair of 1893." Art Quarterly. 29, no. 2 (1966):128-145.
 Kysela has done the definitive job of documenting the circumstances of the commission, the critical response to the mural and the data pertaining to its disappearance. He concerns himself less with the work's visual qualities and iconography. He offers excellent reproductions and bibliographical resources.

McChesney, Clara. "Mary Cassatt and Her Work." Arts and Decoration. 3 (June 1913):265-267.

McKown, Robin. The World of Mary Cassatt. New York: Dell Publishing Co., 1972.
 An examination of the life, times, and associates of Cassatt. A volume in a series of biographical works designed for young adult readers.

Mauclair, Camille. "Un peintre de l'enfance: Mary Cassatt." L'Art decoratif. 4 (April 1902):177-185.

Mellerio, André. "Mary Cassatt." L'Art et les artistes. 12 (Nov. 1910):69-75.

Mowell, Nancy. Mary Cassatt and the Image of the Madonna in Late Nineteenth Century Art. (Ph.D. dissertation, in progress, New York University, Institute of Fine Arts.)

Munsterberg. History of Women Artists. pp. 53, 55, 56-59, 65, 104, 105, 109, 110, 146.

Newman, Gemma. "Greatness of Mary Cassatt." American Artist. 30 (February 1966):42-49.

Nochlin. "By a Woman Painted...."

Omaha, Nebraska. Joslyn Art Museum. Mary Cassatt Among the Impressionists. April 10-June 1, 1969.
 A short essay by Breeskin detailing the relationships between Cassatt and individual impressionist artists.

Paris. Centre Culturel Americain. Mary Cassatt: peintre et graveur. Nov. 25, 1959-Jan. 10, 1960.
Exhibition catalogue with black and white reproductions.

Pica, Vittorio. "Artisti contemporanei--Berthe Morisot e Mary Cassatt." Emproium. 26 (Jan. 1907):11-16.

Petersen and Wilson. Women Artists. pp. 87-90.

Richardson, E. P. "Sophisticates and Innocents Abroad; Sargent, Whistler and Mary Cassatt in Metropolitan Loan Show." Art News. 53 (April 1954):20-23.

Segard, Achille. Une peintre des enfants et des mères--Mary Cassatt. Paris: Librairie Ollendorf, 1913; reprint ed., New York: Burt Franklin.
This work is important because Segard was designated her biographer by Cassatt; however, it includes numerous mistakes.

Smith, David L. "Observations on a Few Celebrated Women Artists." p. 80.
Strongly objects to theory that Cassatt's spinsterhood was the reason for her preoccupation with the mother/child theme. He suggests it is the male ego that prefers to sentimentalize the woman as imprisoned by her offspring.

Sparrow. Women Painters of the World. pp. 157, 327.

Sweet, Frederick A. Mary Cassatt, 1844-1926. Retrospective Exhibit. Chicago: International Galleries, November-December 1965.

_____. Miss Mary Cassatt, Impressionist from Pennsylvania. Norman: University of Oklahoma Press, 1966.
The most scholarly biography of Cassatt to date. Much of it consists of translated letters augmented with footnotes, allowing the reader to draw his or her own conclusions.

_____. Sargent, Whistler and Mary Cassatt. Chicago: Art Institute. January 14-February 25, 1954.

Teal, Gardner. "Mother and Child--The Theme as Developed in the Art of Mary Cassatt." Good Housekeeping. 50 (Feb. 1910):141-146.

Thieme and Becker. Allgemeines Lexikon. Vol. 6, p. 126.

Valerie, Edith. Mary Cassatt. Paris: Cres et cie, 1930.

Walter, William. "Miss Mary Cassatt." Scribner's Magazine. 19 (March 1896):353-361.

Washington, D. C. Museum of Graphic Art and Smithsonian Institute Press. The Graphic Art of Mary Cassatt. 1967.
This volume catalogues and presents high quality black and white reproductions of eighty-two of Cassatt's prints. It is introduced by Breeskin, easily the foremost Cassatt scholar.

Washington, D. C. National Gallery of Art. Mary Cassatt, 1844-1926. September 27-November 8, 1970.
Introduction by Breeskin.

Watson, Forbes. Mary Cassatt. New York: Whitney Museum of American Art, 1932.

_____. "Philadelphia Pays Tribute to Mary Cassatt." The Arts. 11 (June 1927):289-297.

Weitenkampf, Frank. "The Drypoints of Mary Cassatt." Print Collector's Quarterly. 6 (Dec. 1916):397-409.

_____. "Some Women Etchers." Scribner's Magazine. 46 (Dec. 1909):731-739.

Yeh, Susan Fillin. "Mary Cassatt's Images of Women." Art Journal. 35 (Summer 1976):359-363.
Instead of stressing the sentimentality of Cassatt's works, especially her mother and child depictions, Yeh reassesses Cassatt's images of women. Yeh's interpretation stresses Cassatt's view of women as independent beings, pursuing individual interests, and often enjoying the company of other women.

Collections:

Andover, Massachusetts, Addison Gallery of American Art, Phillips Academy.
Baltimore Museum of Art.
Boston, Museum of Fine Art.
Brooklyn Museum.
Chicago Art Institute.
Cincinnati Museum of Art.
Cleveland Museum of Art.
Detroit Institute of Art.
Hartford, Connecticut, Wadsworth Atheneum.
Indianapolis, John Herron Art Institute.
Kansas City, Mo., Nelson Gallery of Art, Atkins Museum.
Los Angeles County Museum of Art.
Minneapolis, Walker Art Center.
New York, The Metropolitan Museum of Art.
Newark, N.J., Newark Museum.
Philadelphia Museum of Art.
Pittsburgh, Museum of Art, Carnegie Institute.
Richmond, Virginia Museum of Fine Art.
San Diego Museum.
Washington, D. C., Corcoran Art Gallery.

Washington, D.C., National Collection of Fine Arts.
Washington, D.C., National Gallery of Art.
Worcester, Mass., Worcester Art Museum.

MARIE-ELIZABETH CAVE. 1809-after 1875. French.

The information that survives about Cavé is only concerned with her relationship to Delacroix--a brief affair and an enduring friendship. Artistically she is considered his follower. When she first met Delacroix in 1833, at age eighteen, she was already married to the painter Clément Boulanger. The following year they met on a trip to the Low Countries, the scene of their brief romantic involvement. In 1842 her husband died and in 1844 she married Francois Cavé, a Beaux Arts administrator. She was a member of the Amsterdam Academy of Fine Arts.

Angrand, Pierre. Marie-Elizabeth Cavé, disciple de Delacroix, Lausanne, 1966.

Bénézit. Dictionnaire. Vol. 2, p. 61.

Cavé, Marie-Elizabeth. L'aquarelle sans maitre. Paris: N. Chaix, 1851.
 This book followed up the first book's success. See below.

_____. Le dessin sans maitre. Paris: Suisse frères, 1850.
 This was an extremely popular "how to draw" book, which may have incorporated views of Delacroix. It was in the form of letters to a friend concerning the art education of her daughter; thus confining herself to accepted notions of women's sphere. The first edition was eighty-two pages long; later editions, of which there were several, were each longer than the last. The English version of the book also contains a translation of Delacroix's review and a report on her method, submitted to the Minister of the Interior. [Drawing Without a Master. New York: G. P. Putnam and Son, 1868.]

_____. La femme aujourd'hui, la femme d'autrefois. Paris, 1863.

Clement. Women in the Fine Arts. p. 57.

Delacroix, Eugene. Review of Le dessin sans maitre by Cavé. Revue des deux-mondes. (September 15, 1850).
 Delacroix's opening sentence is, "Here is the first method of drawing that teaches anything."

Johnson, Lee. "Recent Delacroix Literature." Burlington Magazine. 110 (Feb. 1968):105.
 Most scholarly interest in Cavé seems to rest on the hope of her supplying information on Delacroix, rather than on her own work. Johnson considers her worthy of serious study

because her ideas on teaching possibly would reflect Delacroix's ideas.

Joubin, A. 'Deux amies de Delacroix: Mme. Elisabeth Boulanger-Cavé et Mme. Rang-Babut. " Revue de l'art ancien et moderne. 52 (Jan. 1930):57-94.

Levitine, George. Review of "Marie-Elizabeth Cavé, Disciple of Delacroix, " by Angrand. Art Bulletin. LLI, no. 4 (Dec. 1970):465.

Prideux, Tom. The World of Delacroix, 1798-1863. New York: Time-Life Books, 1966. pp. 124, 134-135.
A small reproduction of an Ingres pencil portrait of her is included.

Thieme and Becker. Allgemeines Lexikon. Vol. 4, p. 447.

Trapp, Frank. "A Mistress and a Master: Mme. Cavé and Delacroix. " Art Journal. XXVII, no. 1 (Fall 1967):40-47, 59-60.
Summarizes her two books, using many quotations from them. Recounts the biographical data.

VICTORIA DUBOURG. 1840-1926. French.

She was born in Paris and married the artist Henri Fantin-Latour. She was highly influenced by him and always signed her works with her maiden name so they wouldn't be thought to be fraudulent Fantins. She exhibited her works regularly in the salons beginning in 1868. Her subject matter, like her husband's, was still lifes. Most of her career she spent on perpetuating the reputation and fame of her husband. After his death in 1904 she devoted her time to cataloguing his work.

Apollo. 93 (April 1971):Front.
A reproduction of Dubourg's painting, Nasturtiums.

Bénézit. Dictionnaire. Vol. 3, p. 668.

Clement. Women in the Fine Arts. p. 111.

'Denver's 24 Acquisitions of Paintings Since Jan. 1 Show Verve. " Art Digest. 10 (Oct. 15, 1935):15.
Most of the biographic information was obtained from this short article.

Collections:

Denver Museum.
Paris, Museum of Modern Art.

SUSAN HANNAH MacDOWELL EAKINS. 1851-1938. American.

Eakins was the daughter of the engraver, William Mac-
Dowell. She studied at the Pennsylvania Academy of Fine Arts in
1876 with Christian Schussele and from 1880-1882 with Thomas
Eakins. When she married Eakins in 1884, at age thirty-two, she
was a professional painter. Although her husband considered her
one of the best women artists in America, following their mar-
riage she subordinated her life to him and to his art. There was a
marked increase in her artistic activity following his death in 1916,
as though she were busy making up for lost time. She did por-
traits, genre, still life and landscapes in a lovely brushed
style.

"The Artist's Wife." Apollo. 98 (July 1973):60.
Review of the first showing of her work, in 1973 at the
Pennsylvania Academy of Fine Arts. Includes a black and white
reproduction.

Bregler, Charles. "Obit. of S. M. E." The Art Digest. 13
(January 15, 1939):26.

Brownell, William C. "The Art Schools of Philadelphia." Scrib-
ner's Monthly Illustrated Magazine. XVIII, no. 5 (September
1879):745, 749.

Casteras, Susan P. Susan MacDowell Eakins, 1851-1938. Phila-
delphia: Pennsylvania Academy of Fine Arts, May 4-June 10,
1973.
The introduction is by Seymour Adelman. This is an excel-
lent illustrated catalogue of her retrospective exhibition. The
bibliography on pages 38-40 has supplied most of the refer-
ences here. More can be found there.

Domit, Moussa M. The Sculpture of Thomas Eakins. Washington,
D.C.: Corcoran Gallery of Art, 1969. p. 7.

Goodrich, Lloyd. Thomas Eakins: His Life and Work. New
York: Whitney Museum of American Art, 1933.

Hill. Women, An Historical Survey.... Catalogue. pp. xii, 17.

McHenry, Margaret. Thomas Eakins Who Painted. Oredale, Pa.:
privately printed, 1946.

Pach, Walter. Queer Things, Paintings: Forty Years in the
World of Art. New York: Harper and Brothers, 1938.
p. 64.

Sherril, Sarah. "Susan MacDowell Eakins." Antiques. 103 (May
1973):834.

FELICIE DE FAUVEAU. 1799-1886. French.

This artist was born in Florence to French parents, but grew up in Paris, Bayonne and other French cities. She received no formal artistic training. She fled Paris after the Revolution, was captured and spent several months in prison. She participated in the Royalist Insurrections against Louis Philip. From 1834-1886 she lived and worked in Florence. She was infatuated with the Middle Ages and worked in a neo-gothic style. While she was primarily a sculptor, she also designed weapons, jewelry and decorative objects.

Bénézit. Dictionnaire. Vol. 3, pp. 684-685.
 Says she studied with Hersent. Discusses her political difficulties in depth.

Clement. Women in the Fine Arts. p. 123.

Ellet. Women Artists. pp. 247-261.
 Lengthy, but obscure, account of her life.

Munsterberg. A History of Women Artists. pp. 88, 89.
 He gives a full page reproduction of the tomb she sculpted for Louise Favreau. He says that Charles X was her patron.

Thieme and Becker. Allgemeines Lexikon. Vol. 11, pp. 304-305.

Collections:

 Florence, Church of Santa Croce.
 Toulouse, Musée.

MARGARET FOLEY. 1820(?)-1877. American.

Foley was a native of Vermont. She attended school in Vergennes and taught there. After a brief stint of working in the textile mills, she moved to Boston in 1848. She became proficient in the art of cameo cutting and taught drawing and painting at the New England School of Design. She arrived in Rome in 1860 and quickly became known for her portrait busts and large marble relief medallions. She became ill while executing a fountain for the Philadelphia Centennial Exhibition and died in Austria.

Bénézit. Dictionnaire. Vol. 3, p. 797.
 Says she worked in London and exhibited at the Royal Academy from 1870-1877.

Clement. Women in the Fine Arts. p. 127.

Ellet. Women Artists. p. 287.

Munsterberg. A History of Women Artists. p. 90.

Payne. "The Work of Some American Women in Plastic Art. "
p. 313.

Taft. The History of American Sculpture. pp. 211-212.

Thorp, Margaret Ferrand. "The White, Marmorean Flock. " New
England Quarterly. 32 (June 1959):161-162.

Tuckerman. Book of the Artists. p. 603.

EVA GONZALES. 1849-1883. French.

Gonzalès was born in Paris. Her father, a novelist, was
of Spanish descent. She grew up in a circle of literary and artis-
tic personalities. While still in her teens she began studying with
Charles Chaplin and showed an aptitude for pastel work. Manet
was first interested in her for her beauty and wanted to paint her.
In 1869, against the protests of her parents, she went to his studio
for the dual purpose of posing for him and receiving criticism of
her work. Manet did two portraits of her and she became his only
real student. Her work is closely related to his. She began ex-
hibiting at the Salon in 1870. In 1879 she married the engraver
Henri Guérard and afterwards worked with less regularity. She
died at age thirty-four from complications of child birth.

Bayle, Paul. "Eva Gonzalès. " La Renaissance. (June 1932).

Bénézit. Dictionnaire. Vol. 4, p. 341.
Lists her works.

Harris and Nochlin. Women Artists, 1550-1950. pp. 246-48, 260,
352.

Hill. Women, An Historical Survey.... Catalogue. pp. xii, 17.

Mathey. Six femmes peintres. p. 8.

Monaco. Eva Gonzalès exposition. 1952.
Catalogue by Claude Roger-Marx.

Moreau-Nélaton, E. Manet raconti par lui-même. Paris, 1926,
Vol. I.

Nochlin. "Why Have There Been No Great Women Artists?" p. 32.

Paris. Galerie Bernheim-Jeune. Eva Gonzalès. 1914.

Paris. Galerie Daber. Eva Gonzalès. May 28-June 13, 1959.
Exhibition catalogue with six black and white illustrations.
Introduction by Claude Roger-Marx.

_____. Eva Gonzalès rétrospective. May 28-June 13, 1959.

Catalogue by Alfred Daber. Introduction by Claude Roger-
Marx.

Paris. Galerie Marcel Bernheim. Eva Gonzalès, exposition
rétrospective. 1932.
Catalogue by Paule Bayle.

Paris. Salons de la Vie Moderne. Catalogue des peintres et
pastels de Eva Gonzalès. 1885.
Preface by Phillipe Burty, essay by Théodore de Banville.

Petersen and Wilson. Women Artists.... pp. 91, 92, 97.

Roger-Marx, Claude. Eva Gonzalès. St. -Germain-en-Lage: Les
Editions de Neuilly, 1950.
Notes that the Morisot sisters were annoyed by Manet's
praise of Gonzalès. Lists her Salon presentations. Includes
many black and white reproductions.

Sparrow. Women Painters of the World. p. 181, 223 and 231.

Sweet, Frederick. "Eva Gonzalès." Chicago Art Institute Bulle-
tin. 34 (Sept. -Oct. 1940):74-75.

Collections:

Paris, Louvre.
Villeneuve-sur-Lot. Musée des Beaux-Arts.
Waltham, Mass. Rose Art Museum.

SARAH GOODRICH. 1788-1853. American.

Goodrich was born in Templeton, Massachusetts. She was
self-taught as an artist. Her early interest was sculpture, but a
scarcity of materials caused her to abandon this. Her career be-
gan around 1812 when she began doing portraits in watercolor and
colored crayons. In 1820, after a period of teaching in village
schools, she moved to Boston to live with her sister. In Boston
she opened a studio and met Gilbert Stuart, who took some interest
in her work. Her work, watercolor miniatures on ivory, is char-
acterized by almost photographic detail.

Comstock, Helen. "Miniatures of Isaiah Thomas by Sarah Good-
rich." Connoisseur. 119 (March 1947):40.

Dods, Agnes. "Sarah Goodrich." Antiques. 51 (May 1947):328-
329.
Lists forty known works and includes several black and
white reproductions.

Dresser, Louisa. "Portraits Owned by the American Antiquarian
Society." Antiques. 96 (Nov. 1969):725-726.

Petersen and Wilson. Women Artists. pp. 67-68.

KATE GREENAWAY. 1846-1901. English.

Greenaway, the daughter of the wood engraver John Greenaway, was one of the most prolific illustrators of her day. She studied in South Kensington and at the Slade School of Oxford. Her first exhibition was in 1868. In 1889 she became a member of the Royal Institute of Painters in Watercolors. Her illustration career began with the Illustrated London News, the paper for which her father had worked. She also did some illustrating for the Ladies Home Journal. Her work consisted primarily of color wood engravings and was wide in its scope. She designed Christmas and Valentine cards, published almanacs and drew for Punch. She illustrated children's books, wrote the rhymes and invented the process to photographically reproduce her drawings. She had intimate friendships with Violet Dickinson and John Ruskin. For seventeen years she carried on a voluminous correspondence with Ruskin, beginning in 1879, although they didn't meet until 1882. Only a partial list of her illustrated works is included below.

"Art in the Nursery." Magazine of Art. 6 (1883):127-132.
Discussion of several illustrators for children, including Greenaway.

Bénézit. Dictionnaire. Vol. 4, p. 409.

Browning, Robert. The Pied Piper of Hamelin. Illustrations by Kate Greenaway. London: Frederick Warne, 1909(?).

Bryan. A Dictionary of Painters. Vol. 2, pp. 275-276.
Extensive chronology of her work. Lists books she published in partnership with Edmund Evans.

Clement. Women in the Fine Arts. pp. 150-151.

Dobson, Austin. De Libris, Prose and Verse. New York: MacMillan Co., 1908, pp. 91-107.
Discusses Greenaway's art.

Engen, Rodney. Kate Greenaway.
Account of her life and work, with reproductions and bibliography.

Ernest, Edward, ed. The Kate Greenaway Treasury: An Anthology of the Illustrations and Writings of Kate Greenaway. Cleveland: World Publishing Co., 1967.

Foster, Myles B. A Day in a Child's Life. Illustrations by Kate Greenaway. Music by Myles Foster. London: G. Routledge, 1881.
Collection of children's songs.

Greenaway, Kate. A Apple Pie. London: Routledge and Sons, 1886.
 Twenty-two color illustrations.

 . Marigold Garden; Pictures and Rhymes. London: G. Routledge and Sons, n.d.

Mavor, William Fordyce. The English Spelling Book. Illustrations by Kate Greenaway. London: G. Routledge and Sons, 1885.

Munsterberg. A History of Women Artists. pp. 105, 109.

Paul, Frances. "A Collection of Children's Books Illustrated by Walter Crane, Kate Greenaway, and Randolph Caldecott." Apollo. 43 (Jan.-June 1946):141-143.

Spielmann, M. H. and Layard, G. S. Kate Greenaway. London: Adam and Charles Black, 1905.
 Extensive biography that contains photographs of Greenaway and many reproductions of her work. Traces the role of Ruskin as a critic of her work--"I want her to make more serious use of her talent...." Also discusses her anti-suffrage views, "Men have more ability."(!)

Taylor, Jane and Taylor, Ann. Little Ann and Other Poems. Illustrations by Kate Greenaway. London: G. Routledge, 1883.

ANTOINETTE-CECILE-HORTENSE HAUDEBOURT-LESCOT. 1784-1845. French.

 Haudebourt-Lescot became a pupil of Guillaume Lethière at age seven. He also introduced her into society, where she acquired a reputation as a graceful dancer. A scandal ensued when she followed him to Rome when he was named Director of the French Academy in Rome. She became one of the first women to study there. During her several years in Italy she met and later married the architect Haudebourt. She specialized in genre scenes of Italian customs and Italian landscape, totally devoid of her teacher's influence. She exhibited regularly at the Salon from 1810 to 1840, presenting over 110 paintings. She was also a superb portraitist and after 1828 exhibited only portraits. In 1830 she was one of the artists commissioned to paint the great personalities of French history for Versailles. She was also a teacher.

Bénézit. Dictionnaire. Vol. 4, p. 611.

Bryan. Dictionary of Painters. Vol. 3, p. 20.

Harris and Nochlin. Women Artists, 1550-1950. pp. 46, 48, 86, 198, 218-219, 349.

Hautecoeur, L. Bulletin des musées. (1925):324-25 (68-69).

Paris. Grand Palais. French Painting 1774-1830: The Age of the Revolution. 1974, pp. 486-487.
 This show traveled to the Detroit Institute of the Arts and to the Metropolitan Museum of Art. The entry on Haudebourt-Lescot is by Sally Wells-Robertson and Isabella Julia.

Sparrow. Women Painters of the World. pp. 179ff.

Thieme and Becker. Allgemeines Lexikon. Vol. 16, pp. 125-126.

Valabrèque, A. "Mme. Haudebourt-Lescot." Les lettres et les arts. 1 (1887):102-109.

Wells-Robertson, Sally. "A. C. H. Haudebourt-Lescot: 1784-1845." New York University, Institute of the Fine Arts, 1973.
 An unpublished paper.

Collections:

 Paris, Louvre.
 Versailles.

EDITH HAYLLAR. 1860-1948. English.
JESSICA HAYLLAR. 1858-1940. English.

 James Hayllar, an English painter, was the father and teacher of four artist daughters. In the late 1880's-1890's he and his daughters exhibited at least one picture each in the Royal Academy every year. The daughters received no other artistic training and used each other as models. Thus, many of their works depict family scenes in their riverfront home, Castle Priory.
 Jessica specialized in domestic scenes. She exhibited at the Royal Academy from 1880 to about 1915. In 1900 she was crippled in an accident, but continued to paint from her wheelchair, doing mainly flower studies. She stopped painting around 1915.
 Edith exhibited at the Royal Academy from 1882-1897. Her style and subject matter were similar to Jessica's, and in addition she was interested in depicting sporting events. She married Rev. Bruce Mackay and gave up painting around 1900.
 The other two sisters, Kate and Mary, were not as talented and had briefer careers. Kate exhibited at the Academy from 1885 to 1898. Around 1900 she gave up painting to become a nurse. She worked primarily with still lifes. Mary, who also did still lifes, exhibited at the Academy from 1880 to 1885. She married Henry Wells and gave up painting around 1887. She had several children and then painted miniatures of children.

Bénézit. Dictionnaire. Vol. 4, p. 621.
 Mentions all four sisters.

Forbes, Christopher. The Royal Academy (1837-1901) Revisited: Victorian Painting from the Forbes Magazine Collection. New York: Forbes Magazine, Inc., 1975.

Harris and Nochlin. Women Artists, 1550-1950. pp. 54-55, 93, 258-59, 353.

Hill. Women. An Historical Survey.... Catalogue, p. xi. Mentions Edith Hayllar.

Thieme and Becker. Allgemeines Lexikon. Vol. 16, p. 179. Has entry on Jessica Hayllar.

Wood, Christopher. "The Artistic Family Hayllar. Part I. James." Connoisseur. 186 (April 1974):266-273.

_____. "The Artistic Family Hayllar. Part II. Jessica, Edith, Mary, Kate." Connoisseur. 186 (May 1974):2-10.
These two articles provided the bulk of the biographical information. They document the family history and contain numerous black and white reproductions.

Collections:

New York, Forbes Magazine Collection.

CLAUDE RAQUET HIRST. 1855-1942. American.

Hirst was born in Cincinnati, where she studied at the Art Academy with Nobel. She also studied in New York. Her husband was the landscape painter, William Fitler. Her work first appeared in the National Academy of Design in 1884. William Harnett was a friend and had a studio next door to hers. His influence is seen in her similar still-lifes of books, pipes and tobacco jars. She also worked in watercolor. She was a member of the National Academy of Women Painters and Sculptors and of the New York Watercolor Club.

Ball, Charlotte, ed. Who's Who in American Art, 1940-41. Washington, D.C.: American Federation of Arts, 1940. Vol. 3, p. 303.

"Claude R. Hirst." New York Times. May 4, 1942. p. 19. Obituary.

Gabhart and Broun. "Old Mistresses."

HARRIET G. HOSMER. 1830-1908. American.

After having lost his wife and three children to tuberculosis, Hosmer's physician father encouraged her to pursue a physically

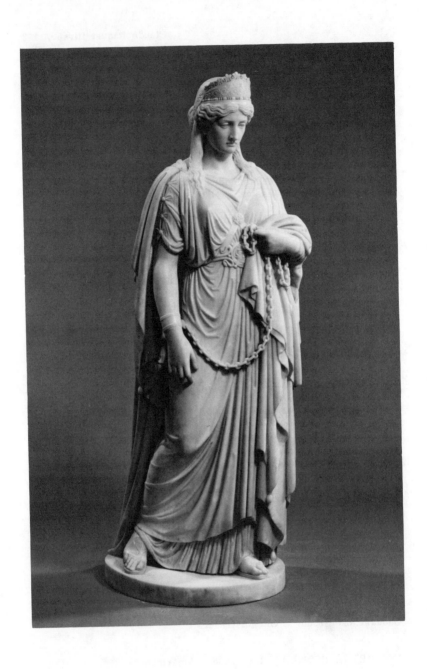

Harriet Hosmer. Zenobia in Chains. Marble. Wadsworth Athen-
eum, Hartford, Conn. Gift of Mrs. Josephine M. J. Dodge.

active, outdoor life. Thus she grew up confident and independent, traits that marked her life. She became interested in sculpture and studied first in Boston. Through connections with a school friend she traveled to St. Louis to study anatomy and later traveled unattended in the midwest--shocking behavior for her day. Under the sponsorship of the actress Charlotte Cushman she went to Rome in 1852 and entered the studio of John Gibson. She rapidly attained success and became widely known in artistic and literary circles. When she returned to America in 1860 for a brief visit she was described as having had her hair cut and wearing the clothes of a boy. She boasted of not having worn a bonnet in five years. She continued to live abroad until 1900, when she returned to the States for the last years of her life. She never married, being convinced of the impossibility of combining art and marriage. She worked in a neo-classic style, frequently drawing on literary and mythological subject matter. Among her many friends were the Robert Brownings, the actress Fanny Kemble, the Nathaniel Hawthornes and Sir Frederic Leighton.

Armstrong. Two Hundred Years of American Sculpture. pp. 280-281.
 Good summary of biographical data.

Art Journal. 35, no. 4 (Summer 1976):Front.
 The cover of this issue is embellished with a sepia-toned photograph of Hosmer surrounded by twenty-four male assistants, circa 1860.

"The Beatrice Cenci." The Crayon. IV, part 12 (December 1857): 379.

Bénézit. Dictionnaire. Vol. 4, p. 766.

Bidwell, W. H. "Harriet G. Hosmer." Eclectic Magazine. 77, n.s. 14 (August 1871):245-246.

Bradford, Ruth A. "The Life and Works of Harriet Hosmer." New England Magazine. n.s. 45, no. 2 (October 1911):265-269.

Carr, Cornelia, ed. Harriet Hosmer, Letters and Memories. 1912.

Child, L. Maria. "Miss Harriet Hosmer." Littell's Living Age. LVI, no. 720 (March 13, 1858):697-698.

Clement. Women in the Fine Arts. pp. 164-165.

Ellet. Women Artists in All Ages. pp. 349-369.

Faxon, Alicia. "Harriet Hosmer: from Watertown to World Fame." Boston Globe. (August 10, 1972).

Gerdts. American Neo-Classic Sculpture.... pp. 19, 47-48, 62-63, 122-123, 136-137, 155.
　　Gerdts has supplied much of the bibliography presented here.

_____. The White Marmorean Flock....

Hanaford. Daughters of America. pp. 300-303.

"Harriet Hosmer." Cosmopolitan Art Journal. III, no. 5 (Dec. 1859):214-217.

Hart. Some Lessons of Encouragement....

Hosmer, Harriet. "The Process of Sculpture." Atlantic Monthly. 14 (Dec. 1864):734-737.
　　A definitive article describing the stages of production of sculpture and the differences in the work of a marble cutter. Reportedly written to rebut gossip that stonecutters did her work.

Leach, Joseph. "Harriet Hosmer: Feminist in Bronze and Marble." Feminist Art Journal. 35 (Summer 1976):9-13, 44-45.
　　Summarizes her work and discusses the influence of Charlotte Cushman.

Logan, Mary. The Part Taken by Women in American History. Wilmington, Del.: Perry-Nalle Publishing Co., 1912, pp. 761-762.

"Miss Hosmer's Statue of Zenobia." The New Path. II, no. 4 (April 1865):49-53.

Munsterberg. A History of Women Artists. p. 90.

Osgood, Dr. Samuel. "American Artists in Italy." Harper's. 41 (Aug. 1870):423.
　　Briefly mentions Hosmer and notes that "... men must have something more than their sex to boast of if they would keep the track of honor and wealth to themselves."

Payne. "The Work of Some American Women in Plastic Art." pp. 311-313.
　　Says she had a preference for the draped figure and minute detail.

Petersen and Wilson. Women Artists.... pp. 80-81, 82, 84.

Proske. "American Women Sculptors."
　　Notes that Hosmer sued for libel when it was printed that her Zenobia was actually by John Gibson.

"Puck." The Art Journal. 14 (1875):312.

"Puck" was the title of one of her works. This article de-
scribes her work as having "... a robust, masculine charac-
ter. "

Taft, Lorado. The History of American Sculpture. New York:
Macmillan Co. , 1930, pp. 203-11.

Thieme and Becker. Allgemeines Lexikon. Vol. 17, pp. 546-547.

Thorp, Margaret Farrand. "The White, Marmorean Flock. " New
England Quarterly. 32 (June 1959):147-169.
Good summary of her life and work. Includes description
of some of Hosmer's mechanical experiments.

Thurston. Eminent Women of the Age. pp. 566-598.

Tuckerman. Book of the Artists. pp. 601-602.

Van Rensselaer, Susan. "Harriet Hosmer. " Antiques. 84, no.
4 (October 1963):424-428.
Excellent summary of her life, with many quotes from her
famous friends. Between 1870 and 1889 she apparently closed
her studio in Rome and lived in England with Lady Ashburton
while she did original work on the study of perpetual motion
and on technical processes. Includes several good reproduc-
tions of her work.

Withers. "Artistic Women and Women Artists. " pp. 334-335.

Collections:

Hartford, Connecticut, Wadsworth Atheneum.
St. Louis, Mercantile Library.

VINNIE REAM HOXIE. 1847-1914. American.

Hoxie was born in Madison, Wisconsin. At the remarkable
age of fifteen, after one year of study, she received a commission
from Congress for a statue of Lincoln. It is on display in the
rotunda of the Capital. Her life-size marble statue of Sappho is
also in the National Collection of Fine Arts, in Washington. She
traveled to Rome to learn neo-classical sculpture techniques.

Ames, Mary Clemmer. An article in The Independent. New York
City. (February 16, 1871).

"Art in Arkansas--Sculpture. " Arkansas Historical Quarterly.
(Winter 1944):324.

Baker, Isadore. "The Ream Statue of Farragut. " Carter's Month-
ly. XV (May 1899):405-410.

_____ . "Vinnie Ream Hoxie: Her Statue of Lincoln and Other
Works. " The Midland Monthly. VIII (November 1897):405ff.

Becker, Carolyn Berry. "Vinnie Ream: Portrait of a Young
Sculptor. " Feminist Art Journal. 5 (Fall 1976):29-31.
Excellent account of Hoxie's life and work. Includes photo-
graph of the artist and bibliography.

Brandes, George Morris Cohen. Recollections of My Childhood
and Youth. 1906.

Clement. Women in the Fine Arts. pp. 165-166.

Gerdts. American Neo-Classic Sculpture.... pp. 64, 87, 157-
158 and others.

_____ . The Marmorean Flock....

Haefner, Marie. "From Plastic Clay. " The Palimpsest. XI,
No. 11 (November 1930):473-482.

Hall, Gordon Langley. Vinnie Ream, the Story of the Girl Who
Sculptured Lincoln. 1963.

Hanaford. Daughters of America. p. 300.

Hoxie, Richard L. Vinnie Ream. 1908.

Hoxie, Vinnie Ream. "Lincoln and Farragut. " The Congress of
Women, Held in the Woman's Building, World's Columbian Ex-
position, Chicago, U. S. A. 1893.
This work was edited by Mary Cavanaugh Oldham Eagle in
1894.

Payne. "The Work of Some American Women in Plastic Art. "
p. 313.
Sees her work as immature and interesting for the novelty
of her youth.

Petersen and Wilson. Women Artists.... p. 83.

Taft. The History of American Sculpture. pp. 212-213.

Collections:

Washington, D. C. , Capitol Rotunda.

EDMONIA LEWIS. 1843-after 1890. American.

Her father was Black, her mother was a Chippewa Indian.
She was orphaned at an early age. Abolitionists supported a brief
period of schooling for her at Oberlin College, Ohio. She left

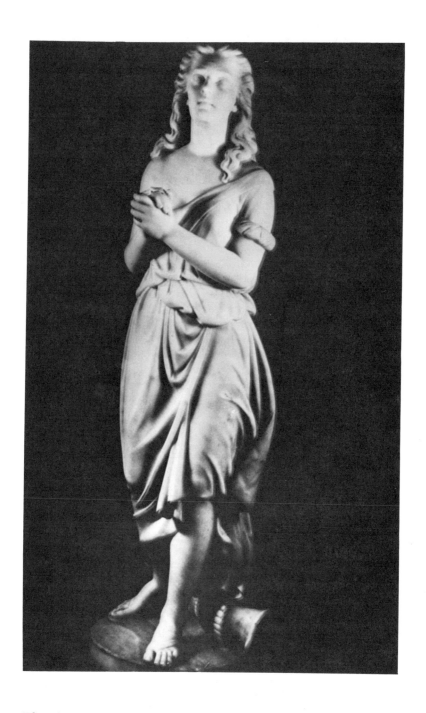

Edmonia Lewis. <u>Hagar</u>. ca. 1875. Marble. 52" x 14" x 17".
Museum of African Art, Eliot Elisofon Archives, Washington, D. C.

there at age fifteen after being accused of poisoning two of her
white classmates, a charge she was acquitted of. She later opened
a studio in Boston and briefly studied with Edward Brackett. She
exhibited for the first time in Boston in 1865. With the support of
the William Story family she went to Rome in 1867 and there
studied with Harriet Hosmer. Information about the remaining
years of her life has not been uncovered. Even her date of death
is unknown.

The Aldine. II, no. 8 (August 1869):76.

Bénézit. Dictionnaire. Vol. 5, p. 558.

Bontemps, Arna. One Hundred Years of Negro Freedom. New
 York, 1962. p. 121.

Blodgett, Gregory. "John Mercer Langston and the Case of Ed-
 monia Lewis: Oberlin 1862." The Journal of Negro History.
 LIII, no. 3 (July 1968):201-218.

Brown, William Wells. The Rising Sun. 1874. pp. 465-468.

Bullard, Laura C. "Edmonia Lewis." The Revolution. (April 20,
 1871).

Clement. Women in the Fine Arts. pp. 210-211.

Cover, Cedric. American Negro Art. Greenwich, Conn.: New
 York Graphic Society, pp. 19, 26-28, 82.
 Good summary of her life.

Dannett, Sylvia G. Profiles of American Negro Womanhood.
 Yonkers, N.Y., 1965.
 The chapter on Lewis is entitled, "Mary Edmonia Lewis
 1846-1890, the First American Negro to Achieve Recognition
 in the Field of Sculpture." It is in Vol. 1, pp. 118-123.

The Freedman's Record. 11, no. 4 (1866):67.
 This refers to an article.

Freeman, Murray. Emancipation and the Freed in American
 Sculpture. 1916.

Gerdts. American Neo-Classic Sculpture.... pp. 80-81, 156 and
 others.

_____. Ten Afro-American Artists of the Nineteenth Century.
 Howard University, The Gallery of Art, February 3-March 30,
 1967.

_____. The White Marmorean Flock....

H. W. "A Negro Sculptress." The Athenaeum. no. 2001 (March

3, 1866):302.

Hanaford. Daughters of America. pp. 286-288.

Locke, Alain. Negro Art Past and Present. 1936.

Majors, M. A. Noted Negro Women and Their Triumphs. 1893.
 p. 27.

Montesane, Philip M. "The Mystery of the San Jose Statues."
 Urban West. 1, no. 4 (March-April 1968):25-27.

Munsterberg. A History of Women Artists. p. 90.

New National Era. 11, no. 17 (May 4, 1871):1.
 This refers to an article.

New York. City University of N.Y. The Evolution of Afro-
 American Artists: 1800-1950. October 16-November 5, 1967.

Petersen and Wilson. Women Artists. pp. 81-82.

Porter, James A. "Versatile Interests of Early Negro Artists:
 A Neglected Chapter in American Art History." Art in Ameri-
 ca. XXIV (January 1936):16-27.

Progressive American Colored Weekly. (September 28, 1876).
 This refers to an article.

Proske. "American Women Sculptors."

Taft. The History of American Sculpture. p. 212.

Thorp, Margaret Ferrand. "The White, Marmorean Flock."
 New England Quarterly. 32 (June 1959):163-164.

Tuckerman. Book of the Artists. pp. 603-604.

Tufts, Eleanor. "Edmonia Lewis, Afro-American Neo-Classicist."
 Art in America. 62 (July 1974):71-72.

_____. Our Hidden Heritage. pp. 159-167, 245.

Wyman, Lillian Buffum and Arthur C. Elizabeth Buffum Chase,
 1806-1899, Her Life and Its Environment. 1911.

Collections:

 New York, Kennedy Galleries, Inc.
 San Jose, California, San Jose Public Library.
 Washington, D.C., Museum of African Art, Collection of the
 Frederick Douglass Institute.

MARIE FRANÇOISE CONSTANCE MAYER. 1775-1821. French.

Mayer studied with Sauvée, Greuze and with Prud'hon who became her lover. She probably met him around 1802. From 1809-1821 they both had studios in the Sorbonne. Prud'hon painted several portraits of her and they probably painted several pictures in collaboration. She committed suicide in 1821. It is felt that several works attributed to both Greuze and Prud'hon are by Mayer.

Bellier-Auvray. Dictionnaire général.... s.v.

Bryan. A Dictionary of Painters. Vol. 3, p. 308.
Lists several of her works.

Clement. Women in the Fine Arts. pp. 384-385.

Doin, Jean. "Constance Mayer." Le revue de l'art ancien et moderne. (January 1911):49-60; (February 1911):139-150.

Ellet. Women Artists. p. 236.

Goulinat. "Les femmes peintres." pp. 290, 292.
Includes a reproduction of Phrosine and Mélidor.

Gueullette, Charles. "Mademoiselle Constance Mayer et Prud'hon." Gazette des beaux-arts. (May, October, December, 1879).

Guiffrey, Jean. L'oeuvre de Pierre-Paul Prud'hon. Musée National du Louvre (Documents d'Art), 1924.

Harris and Nochlin. Women Artists, 1550-1950. pp. 46, 205, 207, 213-214, 349.

Munsterberg. A History of Women Artists. p. 49.

Muther, Richard. History of Modern Art. London, 1894. Vol. I, pp. 310-313.

Collections:

Paris, Louvre.

ANNE FOLDSTONE MEE. 1771(?)-1851. English.

Mee was the daughter of a painter, John Foldstone. She was his oldest child, and when he died, the duty of supporting the large family fell to her. She had learned the rudiments of painting from her father and was encouraged by Romney. She was patronized by Horace Walpole and King George IV. In 1793 she married a man who "pretended to family and fortune, and had neither." They had six children. She exhibited at the Royal Academy from 1804 to 1837. She was a miniaturist.

Bénézit. Dictionnaire. Vol. 6, p. 35.
Gives her birth date as 1775.

Bryan. A Dictionary of Painters. Vol. 3, p. 313.

Clayton. English Female Artists. p. 391.

Long, Basil S. "Mrs. Mee, Miniature Painter." Connoisseur.
95 (April 1935):218-221.
The source of most of the above biographical material. Includes several black and white reproductions.

Sparrow. Women Painters of the World. pp. 60 and 93.

Thieme and Becker. Allgemeines Lexikon. Vol. 25, p. 331.

Collections:

London, Victoria and Albert Museum.

PAULA MODERSOHN-BECKER. 1876-1907. German.

Her mainly figurative works were precursors of the German Expressionist movement. Her principal influences were Cézanne, Gauguin and Van Gogh. Like Van Gogh's, her working career was very short--ten years. However, she managed to leave four hundred paintings and over one thousand drawings and prints. She was born in Dresden and moved to Bremen at age twelve. At age sixteen she went to London to study art, living with relatives. She graduated from a school teachers' seminary in Bremen. In 1900 she studied in Paris. She became a part of the Worpswede Artist's Colony and there met her husband, the painter Otto Modersohn. They married in 1901. She also became close friends with Rainer Maria Rilke, who wrote the poem, "Requiem for a Friend" about her. She was virtually unencouraged during her career and sold only two works during her lifetime. She died at the age of thirty-one of a heart attack shortly after giving birth to a daughter.

Bénézit. Dictionnaire. Vol. 6, p. 147.

Bremen. Kunsthalle. Paula Modersohn-Becker: zum hundertsten Geburtstag. 1976.
Essays by Günter Busch and museum staff.

Butler, Eliza Marian. Rainer Maria Rilke. Cambridge, England, 1961. p. 100.

Davidson, Martha. "Paula Modersohn-Becker: Struggle between Life and Art." Feminist Art Journal. 11, no. 4 (Winter 1973-1974):1, 3-5.

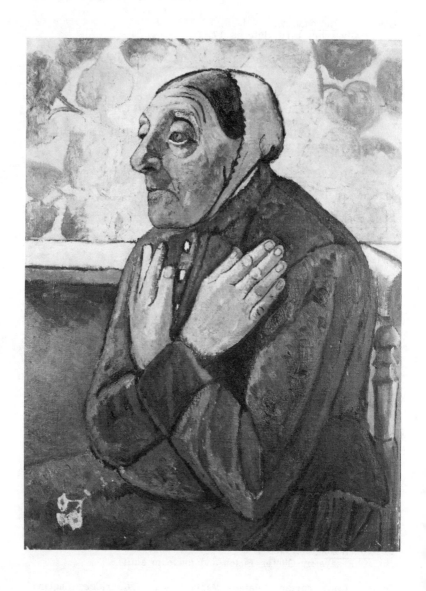

Paula Modersohn-Becker. Old Peasant Woman Praying. 1905.
Oil on canvas. 29 3/4" x 22 3/4". Detroit Institute of Arts,
gift of Robert H. Tannahill.

Edwards. Women: An Issue.

Fleisher. "Love or Art. "

Glozer, Lisolette Erlanger.
This woman is currently translating the letters of Modersohn-Becker into English, a long overdue task. Her address is 6028 Albion Little River Road, Little River, California 95456.

Haftmann, Werner. Painting in the Twentieth Century. New York: Frederick Praeger, 1965. Vol. 1, pp. 82-83.

Harris and Nochlin. Women Artists, 1550-1950. pp. 58-59, 65-67, 273-80, 355.

Hetsch, Rolf. Paula Modersohn-Becker: Ein Buch der Freundschaft. Berlin, 1932.

Modersohn-Becker, Paula. Briefe und Tagebuchblätter. Berlin: Kurt Wolff Verlag, 1920.

Munsterberg. A History of Women Artists. pp. 68-69.

Oppler, Ellen. "Paula Moderson-Becker: Some Facts and Legends. " Art Journal. 35 (Summer 1976):364-369.
Important re-evaluation of this "innovator of modern painting. " Discusses the reasons study of her work has been neglected and reviews what has been written about her.

Pauli, Gustav. Paula Modersohn-Becker. Munich: Kurt Wolff Verlag, 1920.
Complete catalogue. The reproductions are poor but the introduction helps make up for that.

Petersen and Wilson. Women Artists. pp. 108-111.

Rilke, Rainer Maria. Worpswede. Leipzig, 1903.
An illustrated monograph on Worpswede. Rilke only discusses the five male Worpswede artists.

Selz, Peter. German Expressionist Painting. Berkeley: University of California, 1957.

Stelzer, Otto. Paula Modersohn-Becker. Berlin, 1958.

Tufts. Our Hidden Heritage. pp. 189-193.

Werner, Alfred. "Paula Modersohn-Becker. " Art and Artists. 10 (March 1976):18-21.
Excellent summary of her life and art. Good black and white reproductions.

_____. "Paula Modersohn-Becker: A Short Creative Life. "

American Artist. XXXVII (June 1973):16-23, 68-70.

Wydenbruck, Nora. Rilke, Man and Poet. London, 1949.

Collections:

> Basle, Kunstmuseum.
> Basle, Öffentliche Kunstsammlung.
> Bremen, Becker-Modersohn Haus.
> Bremen, Böttcherstrasse B. M. B. H.
> Bremen, Kunsthalle Bremen.
> Bremen, Roselius Collection.
> Detroit, Institute of the Arts.
> Dortmund, Museum am Ostwall.
> Essen, Folkwang Museum.
> New York, Allan Frumkin Gallery.
> Wuppertal, City Gallery.
> Wuppertal, von der Heydt-Museum.

MARY NIMMO MORAN. 1842-1899. American.

Although born in Scotland, Moran came to the United States as a child. She married the artist Thomas Moran in 1862 and from him developed her interest in art. She became his student after their marriage. Their first child was born in 1864. In 1866/67 they traveled in Europe. In 1874 she traveled with him to the far West. Until 1879 she worked principally in watercolor. Her husband then encouraged her to try etching and she rapidly excelled in this medium. For the next twenty years she concentrated on etching and became the foremost woman etcher in the country. She exhibited in 1887 at an exhibition of women etchers at the Boston Museum of Fine Arts. She became a member of the London Society of Painter-Etchers, and the New York Etching Club. She continued to be her husband's most trusted critic and his manager, taking charge of practical matters in order to free him for his work. In 1899 she died of typhoid fever.

Benson, Frances M. "The Moran Family." Quarterly Illustrator. 1 (April-June 1893):67-84.

Biographical Sketches of American Artists. Lansing: Michigan State Library, 1924, pp. 219-220.
 The source for most of the above biographical information.

Brodsky. "Some Notes on Women Printmakers." p. 375.

Everett, Morris T. "The Etchings of Mary Nimmo Moran." Brush and Pencil. 8 (April 1901):3-16.

Koehler, S. R. "The Works of the American Etchers: Mrs. Mary Nimmo Moran." American Art Review. 2 (1881):183.

New York. Klackner Gallery. A Catalogue of the Complete
Etched Works of Thomas Moran, N. A. and M. Nimmo Moran,
S. P. E. , 1889.

"Two American Etchers: The Work of Mr. and Mrs. Moran."
New York Daily Tribune. March 11, 1889, p. 7.

Weitenkampf, Frank. "Some Women Etchers." Scribner's Maga-
zine. 46 (Dec. 1909):731-739.
Some discussion of her technical methods and a reproduc-
tion of one of her works.

Wilkins, Thurman. Thomas Moran: Artist of the Mountains.
Norman: University of Oklahoma Press, 1966.
This biography of her husband also contains biographical
facts of her life.

BERTHE MORISOT. 1841-1895. French.

Morisot was the granddaughter of Fragonard, and the stu-
dent of Corot, Oudinot, Daubigny, Daumier and Aimée Millet. She
and her sister, Edma, were encouraged in their artistic pursuits
by their mother. They met Manet in 1867. Edma married shortly
after this and gave up painting. Five years later Berthe married
Manet's brother, Eugène, and it was she who led Manet to take up
plein-air painting. She also was used as a model by Manet. With
Cassatt, she was the only other woman Impressionist. The only
exhibit of the Independents in which she did not participate was the
one which occurred the year her daughter was born. Only she and
Monet remained true to Impressionism throughout their careers.

Angoulvent, Monique. Berthe Morisot. Paris: Morance, 1933.
A monograph of 164 pages and fifteen plates. It includes a
preface by Robert Rey, an essay on her life and work, an
excellent catalogue of 665 works, and an extensive bibliography.

Baltimore. Museum of Art. Paintings, Drawings, Graphic Works
by Manet, Degas, Morisot and Cassatt. April 18-June 3,
1962.

Bataille, M. L. and Wildenstein, G. Berthe Morisot--catalogue
des peintres, pastels et aquarelles. Paris, 1961.
A catalogue with eighty-three full page reproductions and
numerous small ones, arranged in chronological order. There
is a total of 815 reproductions in all. Three pages of bibliog-
raphy are included. This work was prepared in collaboration
with the artist's daughter, Mme. Julie Rouart.

Bénézit. Dictionnaire. Vol. 6, pp. 226-227.

Bernier, Rosamond. "Dans la lumière impressionniste." L'oeil.
5 (May, 1959):38-47.

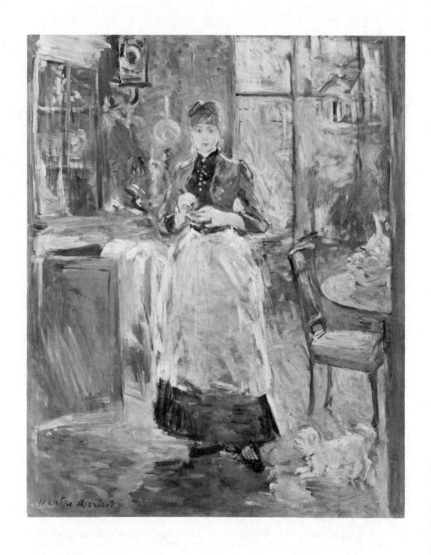

Berthe Morisot. In the Dining Room. Oil on canvas. 24 1/8" x
19 3/4". National Gallery of Art, Washington, D.C., Chester
Dale Collection.

Discussion of Morisot and her artistic circle of friends. Includes several photographs of her and her home.

Bryan. Dictionary of Artists. Vol. 3, pp. 368-369.

Clement. Women in the Fine Arts. pp. 388-389.

Cortissoz, Royal. American Artists. New York: Charles Scribner's Sons, 1923, pp. 190-192.
Summarizes her biography.

Duret, Theodore. Manet and the French Impressionists. Philadelphia, 1910.
A brief chapter on Morisot.

Forreau, Armand. Berthe Morisot. Paris: Maitres de l'art moderne, 1925. Wellington, H., trans. New York: Master of Modern Art Series, 1925.
Includes an essay and forty plates.

Harris and Nochlin. Women Artists, 1550-1950. pp. 57, 66, 89, 231-36, 240, 247, 260, 350-51.

Hill. Women, An Historical Survey.... Catalogue, pp. 21-22.

Huisman, Philippe. Morisot: Enchantment. New York: French and European Publications, Inc. n.d.
Biographical account drawing heavily on excerpts from her diaries. Many color reproductions.

Hyslop, Francis E., Jr. "Berthe Morisot and Mary Cassatt." College Art Journal. 13 (Spring 1954):179-184.

Mathey. Six femmes peintres.

Mellquist, Jerome. "Berthe Morisot." Apollo. 70 (Dec. 1959): 158-160.
Good analysis of her art historical status. Color reproductions.

Moreau-Nélaton, E. Manet raconté par lui-même. Paris, 1926, Vol. I.

Morgan, Elizabeth. Berthe Morisot, Drawings, Pastels and Watercolors. New York: Shorewood Publishing Co., 1960.
This has been called a feminine rather than a feminist biography, referring to its text. There are some excellent, large color plates and a thorough bibliography.

Munsterberg. A History of Women Artists. pp. 53-56.

Neilson. Seven Women.... pp. 47-67.

New York. Wildenstein and Co. <u>Berthe Morisot, Loan Exhibition of Paintings</u>. 1960.

Newton, Eric. "French Painters VII--Edouard Manet (with a Reference also to Berthe Morisot)." <u>Apollo</u>. 57 (Feb. 1953):51-52.

Paris. <u>Berthe Morisot and Her Circle</u>. 1952. Introduction by Denis Rouart.

Paris. Musée National du Louvre. <u>Peintures, école française, XIX^e siècle</u>. 1960, III.

Paris. Petit Palais. <u>Catalogue</u>.

Petersen and Wilson. <u>Women Artists</u>. pp. 90-94.

Rewald, John. <u>The History of Impressionism</u>. New York, 1946. A chronology of Impressionists in relation to world events. Bibliography.

Rouart, Denis. <u>Berthe Morisot</u>. Paris, 1948. This volume is from the series, "Les maitres." There are forty-eight plates and a brief essay in French, English and German.

_____. <u>Berthe Morisot</u>. Paris, 1941. From the series, "Editions d'histoire et d'art." The essay is by Morisot's nephew.

_____, ed. <u>Correspondence de Berthe Morisot avec sa famille et ses amis Manet, Puvis de Chavannes, Dégas, Monet, Renoir et Mallarmé</u>. Paris: 1950; Hubbard, Betty W., trans. <u>The Correspondence of Berthe Morisot....</u> New York: E. Weyhe, 1959. The text is by her grandson. This book includes many reproductions of Morisot's work and that of her circle. Extensive quotations from letters are incorporated with a discussion of her life and work.

<u>Seize aquarelles</u>. Paris, 1946. Essays on Morisot by Mallarmé (untitled, published originally in Durand-Ruel 1896 catalogue), and by Valéry (published elsewhere as "Au sujet de Berthe Morisot" and as "Berthe Morisot").

Sparrow. <u>Women Painters of the World</u>.

Sterling, Charles and Salinger, M. <u>French Paintings in the Collection of the Metropolitan Museum</u>. New York, II, 1966; III, 1967, 163-64.

Thieme and Becker. <u>Allgemeines Lexikon</u>. Vol. 25, pp. 156-57.

Tufts. Our Hidden Heritage. pp. xvi, 169, 172.

Valéry, Paul. Dégas/Manet/Morisot. New York: 1960.
This is volume twelve of Bollingen Series XLV, The Col-
lected Works of Paul Valéry, translated by David Paul. It in-
cludes two essays on Morisot, "Tante Berthe" and "Berthe
Morisot. "

Vevey, Switzerland. Musée Jenisch. Berthe Morisot. June 24-
September 3, 1961.
Illustrated with drawings only.

Werner, Alfred. "Berthe Morisot, Major Impressionist. " Arts.
32 (March 1958).

Wilding, Faith. "Women Artists and Female Imagery. " Everywo-
man (May 7, 1971).

de Wyzewa, Teodore. Peintres de jadis et d'aujourd'hui. Paris,
1903.
This includes a short essay on Morisot.

Collections:

Boston, Museum of Fine Arts.
Brooklyn Museum.
Buffalo, New York, Albright Art Gallery.
Chicago Art Institute.
Cleveland Museum of Art.
London, Tate Gallery.
New York, Metropolitan Museum of Art.
Paris, Louvre.
Rome, Doria Pampli.
Toledo, Ohio, Museum of Art.
Washington, D.C., National Gallery of Art.
Washington, D.C., Phillips Gallery.

ELISABETH NEY. 1830-1907. German.

Ney was born in Westphalia. She studied in Munich and in
Berlin. She was patronized by Ludwig II of Bavaria, who gave her
a studio in one of his palaces. She emigrated in 1870, looking for
freedom of thought she could not find in Europe. She spent some
time in Madeira, Georgia and finally settled in Austin, Texas.
She was a friend of Schopenhauer and had a long association with
Edmund Montgomery, a scientist, although this union was never
legalized. She received commissions for the state capital in Aus-
tin and for the Chicago and St. Louis World Fairs. She returned
to Berlin in 1897. She was a sculptor who did figurative works.

Bénézit. Dictionnaire. Vol. 6, p. 347.

Clement. <u>Women in the Fine Arts.</u> p. 390.

Logan, Mary. <u>The Part Taken by Women in American History.</u>
Wilmington, Del.: Perry-Nalle Publishing Co., 1912. p. 763.

Muller-Munster, Eugen. <u>Elizabeth Ney.</u> Leipzig: Koehler and
Amelang, 1931.

Payne. "The Work of Some American Women in Plastic Art."
p. 313.

Proske. "Part I. American Women Sculptors." pp. 3-15.

Taft, Lorado. <u>The History of American Sculpture.</u> New York:
Macmillan Co., 1930, pp. 214-215.

Thieme and Becker. <u>Allgemeines Lexikon.</u> Vol. 25, p. 428.

<u>Collections</u>:

Austin, Texas, Elisabeth Ney Museum.

EMILY MARY OSBORN. 1834-ca. 1885. English.

Osborn was born in London, the daughter of a clergyman
and the oldest of nine children. They moved to London when Os-
born was eleven. She studied with Mr. Magford at Mr. Dickinson's
Academy and estensively with Leigh. Her first Academy showing
was in 1851. By 1855 she was successful enough to be able to add
a studio to her residence. She visited Germany frequently. She
did primarily genre paintings but also did some history paintings.
She was a member of the Society of Lady Artists.

Bénézit. <u>Dictionnaire.</u> Vol. 6, p. 449.

Clayton. <u>English Female Artists.</u>

Dafforne, James. "British Artists: Their Style and Character.
No. LXVV. Emily Mary Osborn." <u>Art Journal.</u> 3 (1864):
261-263.
Good account of her life and the source of the biographical
material above. Describes several of her works and includes
three black and white engravings from her works.

Harris and Nochlin. <u>Women Artists, 1550-1950.</u> pp. 53-55, 88,
218, 228-29, 350.

Maas, Jeremy. <u>Victorian Painters.</u> New York, 1969, p. 121.

Nochlin. "By a Woman Painted...." p. 74.
Here Nochlin discusses <u>Nameless and Friendless,</u> unfortu-
nately with only a small black and white reproduction. She

believes its subject of a poor orphaned young woman artist trying to sell her painting to a crafty looking dealer to be possibly autobiographical. She asks why the extremely complex symbolism of nineteenth-century narrative painting has been ignored by scholars while the iconography of fifteenth- and sixteenth-century religious paintings has been taken so seriously.

————. "Some Women Realists." Arts. 48 (Feb. 1975):46-51.
In discussing current women painters such as Sylvia Mangold, Yvonne Jacquette and Janet Fish, Nochlin cites Osborn as their foremother. She mentions some of her other titles, The Governess of 1860 and For the Last Time, Half the World Knows Not How the Other Half Lives, and God's Acre. Points out how her work deals with problems specifically as they relate to women--issues of poverty and social oppression.

————. "Why Have There Been No Great Women Artists?"
p. 33.
A reproduction of Nameless and Friendless, dated 1857.

"Selected Pictures." Art Journal. 7 (Aug. 1868):148-149.
Describes and reproduces her work, God's Acre.

Thieme and Becker. Allgemeines Lexikon. Vol. 26, p. 69.

Wood, Christopher. Dictionary of Victorian Painters. Woodbridge, Suffolk, 1971. p. 207.

THE PEALE WOMEN. Americans.
The famous Peale family of artists of Philadelphia included a number of talented women:

ANNA CLAYPOOLE PEALE. 1791-1878.
MARGARETTA ANGELICA PEALE. 1795-1882.
SARAH MIRIAM PEALE. 1800-1885.
ROSALBA CARRIERA PEALE. 1799-1874.
HARRIET PEALE. c. 1800-1869.
MARY JANE SIMES. 1807-1872.
MARY JANE PEALE. 1827-1902.

ANNA CLAYPOOLE PEALE.
She was the daughter of James Peale, who gave her lessons in watercolor on ivory and oil on canvas. She exhibited for the first time in 1811. Her most active period was from 1820 to 1840, when she gained a reputation as a miniature painter, working in Baltimore, New York, Boston, Washington, and Philadelphia. Her work is noted for its brilliant color and detail. She married twice, but had no children.

MARGARETTA ANGELICA PEALE.
Anna's sister and a still-life painter. She began painting

c. 1810 and exhibited in Philadelphia from 1828 to 1837. She never married.

SARAH MIRIAM PEALE.
 Anna's sister and a portrait painter. She is often recognized as the first professional woman artist in America in that she supported herself by her art work. She never married. She was strongly influenced by her cousin Rembrandt Peale during visits to Baltimore in 1818 and 1820--there she developed her sense of detail and skill in superimposition of delicate glazes. She was elected to membership in the Pennsylvania Academy of Art in 1824. She lived and worked in St. Louis from 1847 to 1875. Late in her career she did still lifes.

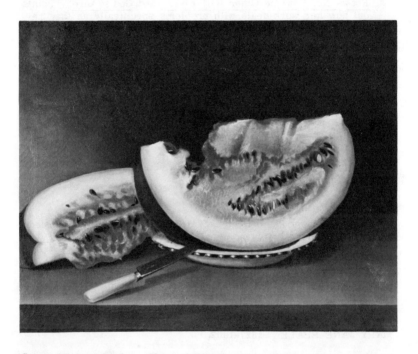

Sarah Miriam Peale. Slice of Watermelon. 1825. Oil on canvas. 17" x 21 13/16". Wadsworth Atheneum, Hartford, Conn. Ella Gallup Sumner and Mary Catlin Sumner Collection.

ROSALBA CARRIERA PEALE.
 She was the daughter and student of Rembrandt Peale. She was a lithographer. She married in 1860.

HARRIET PEALE.
>She was the pupil and second wife of Rembrandt Peale.
Most of her works seem to be copies after those of other artists.

MARY JANE SIMES.
>She was the niece of Anna, Margaretta and Sarah. She was a miniaturist.

MARY JANE PEALE.
>The daughter of Rubens Peale. She studied with her uncle, Rembrandt Peale, and with Thomas Sulley. She never married.

Baltimore. Maryland Historical Society. Four Generations of Commissions. The Peale Collection of the Maryland Historical Society. March 3, 1975-June 29, 1975.

Born, Wolfgang. "The Female Peales: Their Art and Its Tradition. " American Collector. 15 (Aug. 1946):12-14.

Clement. Women in the Fine Arts. p. 268.

Edwards. Women: An Issue.

Elam, Charles H. , ed. The Peale Family, Three Generations of American Artists. Detroit Institute of the Arts and Wayne State University Press, 1967.
>Many black and white reproductions. Includes a helpful family tree schematization and a chart characterizing the Peale family still lifes.

Ellet. Women Artists in All Ages. pp. 290-294.

Gerdts, William. "The Peale Family at Detroit and Utica. " Burlington Magazine. 109 (April 1967):258 and 260-262.
>Brief summary of the quality and diversity of the Peale artistic dynasty.

_____ and Burke, Russell. American Still-Life Painting. New York, 1971.

Hanaford. Daughters of America. p. 273.

Harris and Nochlin. Women Artists, 1550-1950. pp. 221-22, 349.

Hill. Women. A Catalogue.... p. 13.
>Black and white reproduction of work by Mary Jane Peale.

Hunter, Wilbur H. Miss Sarah Miriam Peale. Baltimore: The Peale Museum, 1967.
>An excellent monograph with an astute stylistic analysis. Many good black and white reproductions. It is also distin-

guished by Hunter's appreciation of how exceptional was Sarah Peale's vocation for a woman in the nineteenth century.

_____. The Peale Family and Peale's Baltimore Museum, 1814-1850. Baltimore: The Peale Museum, 1965.

Jensen, Oliver. "The Peales." American Heritage. 6 (April 1955):40-51 and 97-101.
 Primarily discusses Charles Willson Peale, but includes interesting illustrated genealogical chart.

Munsterberg. A History of Women Artists. pp. 59-60.
 Discusses Sarah Miriam Peale.

Nochlin. "By a Woman Painted...." pp. 72-73.
 Two color reproductions of still lifes by Sarah Miriam and Margaretta with some stylistic analysis.

_____. "Why Have There Been No Great Women Artists?" p. 30.
 A black and white reproduction of a still life by one of their kinswomen, Anna Peale.

Petersen and Wilson. Women Artists. pp. 70-71, 74.
 Discusses Sarah Miriam Peale.

Philadelphia. Philadelphia Museum of Art. Philadelphia: Three Centuries of American Art. April 11-October 10, 1976. pp. 254-255, 281.
 Discusses Anna Claypoole Peale.

Schwartz. "If De Kooning...."

Sellers, Charles Coleman. The Peale Heritage. Hagerstown: Washington County Museum of Fine Arts, 1963.

Tufts. Our Hidden Heritage. pp. 139-145.
 Tuft's chapter is given to Sarah Peale. She tells of their uncle, Charles Willson Peale, giving artists' names to his numerous children; the sons were named Raphaelle, Rembrandt, Rubens and Titian. He did no less for his daughters, who were called, Angelica Kauffman, Sofonisba Anguissola, Rosalba Carriera and Sybilla Miriam, "thus demonstrating remarkable knowledge, not generally paralleled today ... of women artists of the past."

Collections:

 Baltimore, Peale Museum.
 Hartford, Connecticut, Wadsworth Atheneum.
 Richmond, Virginia Museum of Fine Arts.
 St. Louis, Missouri Historical Society.

EUNICE PINNEY. 1770-1849. American.

Pinney, born in Connecticut, was the well educated daughter of a wealthy family. She was married twice and had several children. After her second marriage in 1798 she pursued her hobby of painting. This "primitive" artist had no formal training. Over fifty watercolors have survived, with a wide range of subject matter. Most date between 1809 and 1826.

Ebert, John and Ebert, Katherine. American Folk Painters. New York: Charles Scribner's Sons, 1975.

Lipman, Jean. "Early Connecticut Water-Colorist." Art Quarterly. 6 (1943):213-221.
 Reproductions of her work.

_____ and Winchester, Alice. Primitive Painters in America 1750-1950. New York: Dodd Mead and Co., 1950, pp. 22-30.

Munsterberg. A History of Women Artists. pp. 61-63.

Petersen and Wilson. Women Artists.... pp. 69, 72.

Collections:

 Williamsburg, Virginia, Abby Aldrich Rockefeller Folk Art Collection.

ELIZABETH ELEANOR SIDDAL. 1834-1862. English.

Siddal's father was a Sheffield cutler. When the family moved to London she became an assistant in a bonnet shop. There she was discovered by the Pre-Raphaelites and began modeling for several of them, including Dante Rossetti, Hunt and Morris. Rossetti fell in love with her, and after a long engagement they married in 1860. He is credited with discovering her aptitude for art and gave her lessons in painting and drawing. She also wrote poetry. Her work shows the influence of her husband. John Ruskin was impressed by her work, offering to purchase all her drawings. Her work was included in the 1857 Pre-Raphaelite Exhibition and in the same year in an exhibition of British Art in New York. In 1853 she showed the first indications of tuberculosis and began to continually fight the illness. In 1861, following the birth of a still-born infant, she developed depression. A physician advised frequent doses of laudanum (morphine) and in February 1862 she died of an overdose of the drug.

Bénézit. Dictionnaire. Vol. 7, p. 362.

Doughty, Oswald. A Victorian Romantic: Dante Gabriel Rossetti. London, 1960.

Fredeman, William. Pre-Raphaelitism: A Bibliocritical Study. Cambridge, Massachusetts, 1965. Section 59, pp. 209-11.
Contains an annotated bibliography.

Harris and Nochlin. Women Artists, 1550-1950. pp. 229-31, 350.

John. "The Woman Artist."

Mander, Rosalie. "Rossetti's Models." Apollo. 78 (July 1963): 18-32.
Brief discussion of her role as a model.

Nochlin. "By a Woman Painted...." pp. 73-74.
This contains a good color reproduction of her small watercolor, Clerk Sanders.

Procter, Ida. "Elizabeth Siddal: The Ghost of an Idea." Cornhill Magazine. (Winter 1951-52):368-86.

Reynolds, Graham. "The Pre-Raphaelites and Their Circle." Apollo. 93 (June 1971):494-501.
This article reproduces a pen and wash drawing by Siddal, dated 1854, entitled Pippa Passes.

Rossetti, William M. "Dante Rossetti and Elizabeth Siddal." Burlington Magazine. 1 (May 1903):273-295.
A brief monograph of Siddal's life with a listing of her works. Includes five drawings of her by Rossetti and a listing of works for which she posed. Describes her encounters with Ruskin.

Thieme and Becker. Allgemeines Lexikon. Vol. 29, p. 48.

Troyen, Aimee B. "The Life and Art of Elizabeth Eleanor Siddal." Senior essay, History of Art Department, Yale University, 1975.

Vitale, Zaira. "Eleanor Siddal Rossetti." Emporium. 19 (June 1904):430-47.

Waugh, Evelyn. Rossetti: His Life and Works. London: Duckworth, 1928, pp. 54-58, 70-75, 87-92 and 107-111.
Describes her personality and her relationship with Rossetti.

Wood, Esther. Dante Rossetti and the Pre-Raphaelite Movement. London: Sampson Low, Marston and Co., 1895, pp. 99-103 and 159-161.

Collections:

Cambridge, Fitzwilliam Museum.
London, Maas Gallery.
London, Tate Gallery.

LILLY MARTIN SPENCER. 1822-1902. American.

A self-taught but acclaimed narrative and genre painter.
Her work became quite popular in her own day through prints,
which were frequently reproduced by Currier and Ives. She was
born in England to French parents. They emigrated to the United
States and she grew up in Marietta, Ohio. She was a precocious
artist and had her first show at age seventeen. She married in
1844 and her husband devoted himself to helping her with both pro-
fessional and domestic tasks. Although she considered herself an
amateur, she was the breadwinner for the family. She had thir-
teen children, seven of whom lived to maturity. She had a chance
to study in Europe, but turned it down. Although she had an out-
put of some five hundred paintings and was a credible portraitist,
her lack of training (especially in anatomy and life drawing) severe-
ly limited her scope. She painted until the day of her death, at
age seventy-nine.

Bénézit. Dictionnaire. Vol. 8, p. 49.

Bolton-Smith, Robin. "The Sentimental Paintings of Lilly Martin
 Spencer." Antiques. 104 (July 1973):108-115.
 Good color and black and white reproductions.

_____ and Truettner, William H. Lily Martin Spencer, 1822-
 1902, The Joys of Sentiment. Washington, D.C.: The Nation-
 al Collection of Fine Arts, June 15-September 13, 1973.
 Her first extensive retrospective. Today the National Col-
 lection has two of her paintings on permanent display. They
 are Peeling Onions, circa 1852, a half-length genre painting of
 a tearful but smiling lass; and We Both Must Fade (Mrs.
 Fithian), dated 1869 and illustrated on the following page.
 Spencer's command over textures, the gorgeous blue satin
 gown in the previous painting for example, helps one get
 past her other shortcomings.

Cowdrey, Bartlet. "Lily Martin Spencer, 1822-1902, Painter of
 the American Sentimental Scene." The American Collector.
 (August 1944):6-7, 14, 19.
 This article has some clear black and white reproductions.

Dwight, Edward. "Art in Early Cincinnati." Cincinnati Art Mu-
 seum Bulletin. 3 (Aug. 1953):4-10.

Ellet. Women Artists in All Ages. pp. 317-326.

Freivogel, Elsie. "Lily Martin Spencer: Feminist Without Poli-
 tics." Archives of American Art Journal. 12 (1972):9-14.

Gabhart and Broun. "Old Mistresses...."
 We Both Must Fade was included in the Walters Art Gal-
 lery show in Baltimore. They say that "in some of her finest

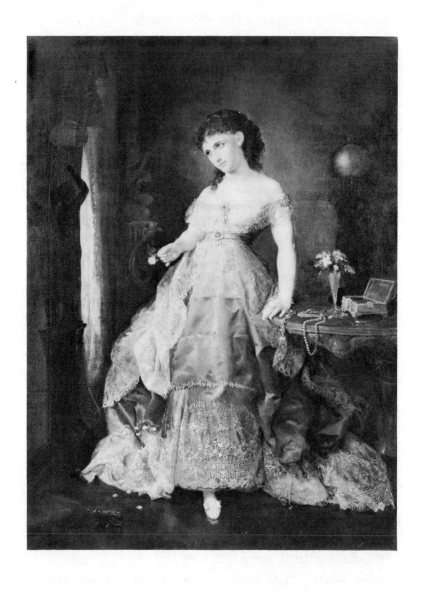

Lilly Martin Spencer. We Both Must Fade (Mrs. Fithian). 1869.
Oil on canvas. 72 5/8" x 53 3/4". National Collection of Fine
Arts, Smithsonian Institution, Washington, D.C.

works, however, her stunning colors and painterly expression transcend the awkward rendering of her figures. "

Gardner, Albert Ten Eyck. "A Century of Women. " Metropolitan Museum Bulletin. 7 (Dec. 1948):110-118.

Hadery, Henrietta. "Mrs. Lilly M. Spencer. " Sartain's Magazine. 9 (Aug. 1851):152-157.

Hanaford. Daughters of America.

Harris and Nochlin. Women Artists, 1550-1950. pp. 226-27, 350.

Hill. Women, An Historical Survey.... Catalogue. pp. xii, 12. A reproduction of an insipid pencil drawing, titled Young Lovers.

Hitchcock, H. R. "Romantic Nineteenth-Century American Paint- ing: Reading the Legend. " Smith College Bulletin. 35-36 (1954/55):22-23.

Munsterberg. A History of Women Artists. pp. 60-61.

Petersen and Wilson. Women Artists. pp. 84-87.

Roberson, S. A. and Gerdts, W. H. "Greek Slave. " The Museum (Newark). 17 (Winter/Spring 1965):10-11.

Rylance, Mecca. "Truth Unveiling Falsehood. " Off Our Backs. (July-August 1972). This is the title of one of her most celebrated paintings, now lost.

Schwartz. "If De Kooning.... " In reviewing the Baltimore, Walters Art Gallery show, "Old Mistresses... " Schwartz cites Spencer's work as demonstrat- ing the fading convictions of women artists in their own powers.

Withers. "Artist Women and Women Artists. " pp. 332-334.

Collections:

Brooklyn Museum.
Columbus, Ohio Historical Center.
Newark, Art Museum.
Washington, D. C. , National Collection of Fine Arts.

EMMA STEBBINS. 1815-1882. American.

Stebbins was a native of New York City. She began her art career as an amateur, doing drawings and painting for her own amusement, after taking instruction from Henry Inman. She finally

committed herself to her art and at age forty-two moved to Rome
to study sculpture with Paul Akers. She worked in the prevailing
neo-classical style.

The Aldine. VI, no. 10 (October 1873):207.
 This refers to a mention made about Stebbins in an article.

Clement. Women in the Fine Arts. pp. 323-324.

Ellet. Women Artists in All Ages. pp. 346-349.

Gerdts. American Neo-Classic Sculpture....

_____. The White Marmorean Flock.... Catalogue.

Hanaford. Daughters of America.

Payne, Frank. "The Work of Some American Women in Plastic
 Art." p. 313.

Proske, Beatrice. "Part I: American Women Sculptors."

Stebbens, Emma. Charlotte Cushman: Her Letters and Memories
 of Her Life. 1879.
 Cushman was an American actress who took an interest in
and befriended many of the American women sculptors working
in Rome.

Taft, Lorado. The History of American Sculpture. p. 211.

Thorp, Margaret Farrand. "The White, Marmorean Flock." New
 England Quarterly. 32 (June 1959):160.

Tuckerman. Book of the Artists. pp. 602-603.
 Summarizes the work she was doing in Rome.

Tufts. Our Hidden Heritage. pp. xvi, 160, 162.

ALICE BARBER STEPHENS. 1858-1932. American.

 Stephens was born in Salen, New York. She studied wood-
engraving at the Philadelphia School of Design for Women and at-
tended the Pennsylvania Academy from 1876-77 and 1879-89. She
was influenced by and possibly studied with Eakins. She was pri-
marily an illustrator and her work began to appear steadily in
Harper's publications by 1884. Her work appeared also in other
magazines and her subject matter usually portrayed everyday home
life, children, and rural scenes. She also did book illustrations
and portraits. She went to London in 1886 and then to Paris to
study at the Academy Julien. She taught classes at the Philadel-
phia School of Design for Women from 1888 to 1893. She married

in 1890 and had one son. She exhibited at the Philadelphia Academy
from about 1881 to 1890.

"Alice Barber Stephens. " Art Digest. 6 (August 1932):6.
 This obituary recounts the basic biographical facts.

Biographical Sketches of American Artists. Lansing, Michigan:
 Michigan State Library, 1924, p. 296.

Clement. Women in the Fine Arts. p. 324.

Harris and Nochlin. Women Artists, 1550-1950. pp. 52, 221.

Mahony, Bertha and Whitney, Elinor. Contemporary Illustrators
 of Children's Books. Boston: Women's Educational and In-
 dustrial Union, 1930, p. 70.

Philadelphia. Philadelphia Museum of Art. Three Centuries of
 American Art. April 11-October 10, 1976, pp. 446-448.

Collections:

 Philadelphia, Pennsylvania Academy of Fine Art.

MARIE-CLEMENTINE ("SUZANNE") VALADON. 1865-1938.
 French.

 Valadon, a Post-Impressionist painter, was the illegitimate
daughter of Madeleine Valadon, a laundress. Valadon started draw-
ing as a child and worked menial jobs from the age of nine. At
age sixteen she was a circus trapeze artist, but an injury halted
that career. During the 1880's-1890's she was a favorite model
for many Paris artists, including Toulouse-Lautrec, Renoir, and
Puvis de Chavannes. Degas encouraged her and arranged for some
of her drawings to enter galleries. Toulouse-Lautrec had another
important effect upon her life. He persuaded her to change her
name from the "Marie-Clementine" she had been baptized, to the
more colorful 'Suzanne. " Some years previous to this, in 1883,
she had borne a son, Maurice. Eight years later Miguel Utrillo
signed a legal document giving Maurice his surname. His pater-
nity is by no means certain. As a young man, Maurice Utrillo be-
came an alcoholic, from which he suffered throughout his short
life. While recuperating from a "cure" Valadon taught her son to
paint--thus providing a reversal of the usual pattern in which it is
a father who teaches his daughter to be an artist. Her vitality is
attested by her affair and eventual marriage to Andre Utter, twenty-
one years her junior and originally the friend of Maurice. Her
first one-woman show was held in 1915. After World War I, Vala-
don's and Utrillo's paintings began to sell for higher prices, mak-
ing possible the purchase of a chateau. She continued painting
throughout her life. Her oeuvre includes still lifes, landscapes
and some portraiture; but her most consistent theme was the

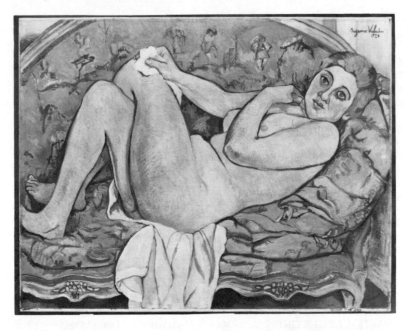

Suzanne Valadon. Nude on Sofa. 1928. Oil on canvas. 23 5/8"
x 31 11/16". Metropolitan Museum of Art, New York, Lehman
Collection.

unidealized female nude, vigorously and lyrically outlined and juxta-
posed to the patterned surfaces of an interior.

Beachboard, Robert. La trinité maudite. Paris, 1952.
 The "wicked" or "damned" three refers to Valadon, Utrillo
 and Utter.

Bénézit. Dictionnaire. Vol. 8, p. 449.

Beverly Hills, Calif. Sari Heller Gallery Ltd. An exhibit of her
 paintings reported in Art in America (September-October 1971).

Bouret, Jean. Suzanne Valadon. Paris: Editions O. Pétridés,
 1947.

Brumer, Miriam. "Words, the Critical Hangup. " Women and Art.
 (Winter 1971).

Colombier, Pierre de. "Suzanne Valadon. " L'amour de l'art. 7
 (Sept. 1926):303-306.

Coughlan, Robert. "Dark Wine of Genius." Life. 28 (Jan. 16, 1950):88-102.
 Excellent summary of Valadon and Utrillo with many repro-
ductions.

Dorival, Bernard. The School of Paris in the Musée d'Art
 Moderne. New York: Harry N. Abrams, 1962. pp. 23, 24,
 25, 29, 90, 91, 92, 262, 265, 266, 267, 299.
 Page 91 is an excellent color plate, the rest are small
black and white reproductions.

_____. Twentieth-Century Painters. New York: Universe
 Books, 1958.

Edwards. Women, An Issue.

Fels, Florent. Maurice Utrillo. Paris, 1930.

Guilleminault, Gilbert. Les maudits de Cezanne à Utrillo. Paris,
 1959.
 An essay about Valadon by Anne Manson, "Suzanne Valadon
la frénétique," is included on pages 249-311.

Harris and Nochlin. Women Artists, 1550-1950. pp. 259-61, 354.

Iskin. "Sexual Imagery in Art...."

Jacometti, Nesto. Suzanne Valadon. Geneva: P. Cailler, 1947.

"Maria of Montmartre." Time. 67 (May 28, 1956):84 and 87.

Mathey. Six femmes peintres.

Mermillon, Marius. Suzanne Valadon. Paris, circa 1950.

Munsterberg. A History of Women Artists. p. 65.

Paris. Galerie Pétridès. Suzanne Valadon. 1947.
 Catalogue by Jean Bouret.

Paris. Musée National d'Art Moderne. Suzanne Valadon. 1967.
 Catalogue by Bernard Dorival.

Paris. Petit Palais. Catalogue.

Petersen and Wilson. Women Artists. pp. 95-97.

Pétridès, Paul. L'oeuvre complet de Suzanne Valadon. Paris,
 1971.

Rey, Robert. Suzanne Valadon. Paris, 1922.

Reynal, Maurice. Modern French Painters. New York: Brentano,

1928.

Storm, John. <u>The Valadon Drama, the Life of Suzanne Valadon.</u>
New York: Dutton and Co., 1958.
 A somewhat speculative, but extremely readable, biography
of Valadon and her circle. As an uneducated woman, she left
few literary remains, and Storm was thus forced to depend
upon the verbal testimony of the friends who survived her.

"Suzanne Valadon." <u>Art Digest.</u> 12 (April 15, 1938):15.
 Obituary.

Tabarant, André. "Suzanne Valadon et ses souvenirs de modèle."
<u>Le Bulletin de la vie artistique.</u> (December 15, 1921):626-629.

Thieme and Becker. <u>Allgemeines Lexikon.</u> Vol. 34, pp. 46-47.

Tufts. <u>Our Hidden Heritage.</u> pp. 169-177.
 The biographical information and most of the bibliography
here are derived from Tufts.

Utter, Andre. "Maurice Utrillo and Suzanne Valadon." <u>Royal So-
ciety of Arts Journal.</u> 86 (Oct. 7, 1938):1125-1127. Trans-
lated by G. Rees.

Valadon, Suzanne and Bazin, G. "Suzanne Valadon par elle-même."
<u>Prométhée.</u> (March 1939).

Werner, Alfred. "The Unknown Valadon." <u>Arts Magazine.</u> 30,
no. 8 (May 1956):169-177.
 An excellent and well illustrated article. "Degas empha-
sized a woman's ugliness, Renoir her charm, Lautrec her de-
pravity, Gauguin her sexuality; if for Rousseau she was a fan-
tastic doll, for Cézanne a pictorial pretext, and for his anti-
pode, Bouguereau, an object for lecherous bankers, Valadon's
women were sound proletarian types as nobody had painted be-
fore. Her nude was neither a Venus nor an Amazon, neither
courtesan nor odalisque, nor a bourgeoise surprised in an in-
timate moment. The women she painted were just the oppo-
site of Marie Laurencin's sickly ladies.... Hers were un-
groomed working women who never went to hairdressers or
wore make-up. But unlike those of Kollwitz, they were not
symbols of suffering humanity or victims of capitalism."

Collections:

 Cleveland, Museum of Art.
 New York, Metropolitan Museum, Lehman Collection.
 Paris, Musée d'Art Moderne de la Ville de Paris.
 Paris, Musée National d'Art Moderne.
 San Francisco, Achenbach Foundation for Graphic Arts, Cali-
 fornia Palace of the Legion of Honor.
 Smith College Museum of Art.

JOANNA MARY BOYCE WELLS. 1831-1861. English.

Boyce began her art studies at age eighteen in the studio of Mr. Carey. She later studied with Leigh. In 1855 she joined the ladies class at the atelier of Couture in Paris. After a few weeks she became ill and had to quit. She traveled in Italy in 1857 and became acquainted with one of the members of the traveling group, Henry T. Wells, a miniature and portrait painter. They married in Rome in December, 1857, and in March, 1858, returned to England. She died at age thirty of fever following childbirth. Between 1853-1857 she exhibited at the Royal Academy. Her work was influenced by the Pre-Raphaelites and she was mentioned in Ford Maddox Brown's diary.

Bénézit. Dictionnaire. Vol. 2, p. 89.
 Describes her as a figure painter.

Bryan. Dictionary of Painters. Vol. 5, p. 354.
 Did portraits, genre, and occasional landscapes.

London. Tate Gallery. An Exhibition of Painting by Joanna Mary Boyce. June 14-July 27, 1935.
 Exhibition catalogue that reproduces several of her works in black and white and provides much biographical information.

"Mrs. Wells." Art Journal. 23 (1861):273.
 Obituary that gives biographical information.

Thieme and Becker. Allgemeines Lexikon. Vol. 35, p. 359.

ANNE WHITNEY. 1821-1915. American.

Whitney was born in Watertown, Massachusetts. Her first artistic mode was poetry. She turned to sculpture when she was thirty-four. She studied in New York, Philadelphia and Boston. She made three trips to Europe between 1867 and 1876. She was an abolitionist and a suffragist and as subject matter she often chose champions of intellectual freedom or those oppressed by the lack of it. She won anonymously the only competition she ever entered. However, the commission was refused her when the judges discovered she was a woman! She lived with Adeline Manning, who devoted her life to her. Whitney's papers are in the Wellesley College collection.

Armstrong. Two Hundred Years of American Sculpture. p. 320.

Bénézit. Dictionnaire. Vol. 8, p. 733.

Clement. Women in the Fine Arts. p. 362.

Payne, Elizabeth Rogers. "Anne Whitney, Art and Social Justice." The Massachusetts Review. 12 (Spring 1971):245-260.

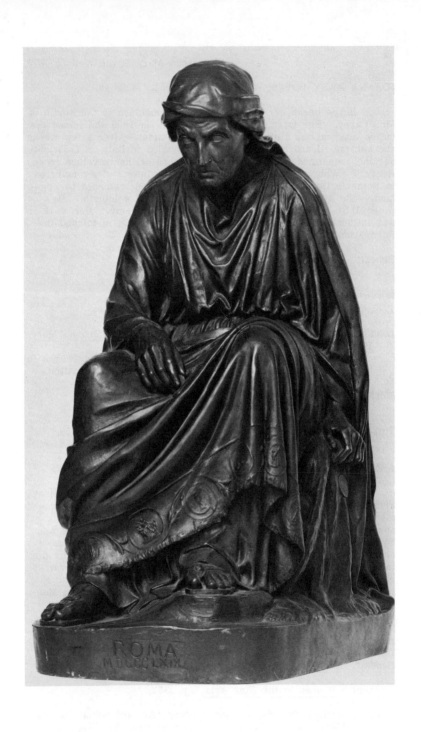

Anne Whitney. Roma. Bronze. Wellesley College Museum,
Wellesley, Mass.

_____. "Anne Whitney, Sculptor. " Art Quarterly. 25 (Autumn 1962):244-261.
Excellent biographical review. Lists her sculpture.

Payne, Frank. "The Work of Some American Women in Plastic Art. " p. 313.

Petersen and Wilson. Women Artists.... pp. 82-84.

Proske. "Part I. American Women Sculptors. " pp. 3-15.

Taft, Lorado. The History of American Sculpture. New York: Macmillan Co. , 1930, pp. 213-214.

Thorp, Margaret Farrand. "The White Marmorean Flock. " New England Quarterly. 32 (June 1959):147-169.

Tuckerman. Book of the Artists. p. 605.

Whitney, Anne. Poems. New York: D. Appleton, 1859.

Collections:

Cambridge, Massachusetts, Harvard Commons.
Wellesley, Massachusetts, Wellesley College Art Museum.

MARY ANN WILLSON. Active 1800-1825. American.

Willson was a self-taught primitive artist. She resided on a farm near Greenville, New York with a Miss Brundage, with whom she had a romantic attachment. Her work was not discovered until the 1940's. At that time a portfolio of her work surfaced, accompanied by a letter recording what little is known of her life and work. Her pigments were prepared from brick dust, berry juices and vegetable dyes. She worked with a wide range of subject matter, using greatly distorted scale and perspective and a stylization of natural elements that borders on abstraction.

Black, Mary. "American Primitive Watercolors. " Art in America. 51 (Aug. 1963):64-82.
Several color reproductions.

Ebert. American Folk Painters. p. 214.

Lipman, Jean. "Miss Willson's Watercolors. " American Collector. 13 (Feb. 1944):8-9 and 20.
Includes descriptions of twenty of her works.

_____ and Winchester, Alice. Primitive Painters in America, 1750-1950; An Anthology. New York: Dodd, Mead, 1950.
pp. 50-56.

The prodigal Son Wasted his Substance With riotous living Luke 15 13

Mary Ann Willson. The Prodigal Son Wasted His Substance with Riotous Living. Watercolor. National Gallery of Art, Washington, D.C., gift of Edgar William and Bernice Chrysler Garbisch.

Miller, Isabel [pseud.]. <u>Patience and Sarah</u>. New York: McGraw-
Hill, 1972.
 A historical novel that reconstructs the relationship between
Willson and Miss Brundage.

Petersen and Wilson. <u>Women Artists</u>. pp. 68-69.

<u>Collections</u>:

 Cooperstown, New York, New York State Historical Association.
Washington, D.C. National Gallery of Art, Garbisch Collec-
tion.

TWENTIETH CENTURY

BERENICE ABBOTT. 1898- . American.

Born in Ohio. Abbott was first a sculptor, studying in Ber-
lin and Paris with Bourdelle and Brancusi. In 1923 she became a
photographic assistant to Man Ray. Later she opened her own
studio in Paris. She became interested in the photographic work
of Eugene Atget and was instrumental in saving his work. In 1929
she returned to New York and became fascinated with the city.
She decided to photograph it, as Atget had photographed Paris.
One of her most important contributions was her work between
1923 and 1925, the photographing of other expatriates and Paris celeb-
rities. Beginning in 1940 she devoted herself to scientific and ex-
perimental photography. She taught at the New School of Social
Research, beginning in 1938, for over twenty years.

Abbott, Berenice. Changing New York. Text by Elizabeth Mc-
 Causland. New York: E. P. Dutton and Co., 1939.
 This work was sponsored by the Federal Art Project.

_____. "Eugene Atget." Creative Art. 5 (Sept. 1929):651-656.
 Abbott breifly summarizes his biographical data and style
of photography.

_____. Greenwich Village Today and Yesterday. Text by
Henry W. Lanier. New York: Harper and Brothers, 1949.

_____. A Guide to Better Photography. New York: Crown
Publishers, 1941.

_____. "The Image of Science." Art in America. 47 (Winter
1959):76-79.
 Discusses briefly the visual image as an educational tool in
science and the role of photography in providing this.

_____. A Portrait of Maine. Text by Chenoweth Hall. New
York: Macmillan, 1968.

_____. The View Camera Made Simple. Chicago: Ziff-Davis
Pub. Co., 1948.

_____. "What the Camera and I See." Art News. 50 (Sept.

212

1951):36-37 and 52.
Brief statement presenting her views of photography as an art form.

_____. The World of Atget. New York: Horizon Press, 1964.

Beaton. The Magic Image. p. 149.

Lyons, Nathan, ed. Photographers on Photography. Englewood Cliffs, N.J.: Prentice-Hall, Inc., 1966.
Reprints two essays written by Abbott in 1951: "It Has to Walk Alone" (from Infinity 7 (1951):6-7 and 14), and "Photoggaphy at the Crossroads" (from the 1951 Universal Photo Almanac, pp. 42-47).

McCausland, E. "Berenice Abbott ... Realist." Photo Arts. Spring 1948, pp. 46-50+.

Munsterberg. A History of Women Artists. pp. 135-137.

Newhall. History of Photography. pp. 149-50.

Petersen and Wilson. Women Artists....

Rukeyser, Muriel and Vestal, David. Berenice Abbott. New York: Horizon Press, 1970.

Collections:

New York, Museum of the City of New York.

ANNI ALBERS. 1899- . German.

Albers was born in Berlin. She studied in Berlin and Hamburg before entering the Bauhaus in 1922. There she met her husband, Josef Albers. She began as a painter and credits Klee as being influential on her work. Her later work was primarily design and textiles. From 1933 to 1949 she and her husband taught at the Black Mountain College in North Carolina. She has also worked as a textile designer for industry and has written extensively.

Albers, Anni. "Anni Albers on the Beginnings of Weaving," American Fabrics. 69 (Fall 1965):89-92.
An excerpt from her book On Weaving which discusses the historical evolution of thread interlacing.

_____. "Design: Anonymous and Timeless." Magazine of Art. 40 (Feb. 1947):51-53.
Sees the designer as having lost the direct experience of a medium as the result of craft being broken down into areas of specialization. Information is then substituted for experience.

_____. "Fabric, the Pliable Plane." <u>Craft Horizons</u>. 18
(July/August 1958):15-17.
Discusses the possible uses of fabric in the overall concep-
tion of an architectural plan, rather than as an afterthought.

_____. <u>On Designing</u>. New Haven, Conn.: Pellango Press,
1960.
Ten essays with photographic accompaniment, seeking to
relate permanent values of craft to the values of our time.
Comments on the problems of designing for industry.

_____. "On the Designing of Textiles and the Handweavers
Place in Industry," <u>American Fabrics</u>. 50 (Summer 1960):98-
99.
Excerpt from her book <u>On Designing</u>. Good black and white
reproductions.

_____. <u>On Weaving</u>. Middletown, Conn.: Wesleyan University
Press, 1965.
Discusses design fundamentals related to the visual and
structural aspects of weaving. Includes sixteen plates of her
work, some in color.

_____. "Work with Material." <u>College Art Journal</u>. 3 (Jan.
1944):51-54.
Discusses the relationship between crafts and industrializa-
tion and the resulting estrangement of man from materials in
their original form.

Harris and Nochlin. <u>Women Artists, 1550-1950</u>. p. 59.

Hill. <u>Women, An Historical Survey....</u> Catalogue, pl. 54.

Weber, Nicholas Fox. "Anni Albers and the Printerly Image."
<u>Art in America</u>. 63 (July 1975):89.
Albers began printmaking in 1974 at the urging of June
Wayne. The similarities between her weaving and her print
imagery are discussed.

Welliver, Neil. "A Conversation with Anni Albers." <u>Craft Hori-</u>
<u>zon</u>. 25 (July/August 1965):17-21 and 40-45.
Albers discusses weaving from a historical standpoint, her
experiences at the Bauhaus, and her role as a teacher. Seve-
ral reproductions are included.

Collections:

New York, Museum of Modern Art.

DIANE ARBUS. 1923-1971. American.

Arbus was married at age eighteen and became the mother

of two daughters. Both she and her husband began as fashion photographers, working for her father, the owner of a prominent woman's fashion store. In 1959 she studied with the photographer Lisette Model. She was the recipient of two Guggenheim fellowships and was the first photographer ever to exhibit at the Venice Bienniale. From 1965 to 1966 she taught at the Parsons School of Design, and from 1968 to 1969 at the Cooper Union. The last ten years of her life she devoted to recording her unique subject matter--images of malformed people, marred by birth or psychological aberrations and ritual oddities of America. She committed suicide in 1971.

Arbus, Doon. 'Diane Arbus.'' Camera 51 (Nov. 1972):22 and 41-42.
 Personal reminiscences by her daughter, reprinted from Ms. (Oct. 1972).

_____ and Israel, Marvin, eds. Diane Arbus. Millerton, N.Y.: Aperture Books, 1972.
 Text edited from a series of classes Diane Arbus gave in 1971, some interviews and some of her writings.

Beaton, Cecil and Nicolson, Gail Buckland. The Magic Image: The Genius of Photography from 1839 to the Present Day. London: Weidenfeld & Nicolson, 1975, p. 244.
 Summary of biographical data.

'Five Photos by Diane Arbus.'' Artforum. 9 (May 1971):64-69.
 Introduced by brief quote from Arbus.

Goldin, Amy. 'Diane Arbus: Playing with Conventions.'' Art in America. 61 (March/April 1973):72-75.
 A critical look at Arbus' subject matter and the relationship of the viewer to it.

Goldman, Judith. 'Diane Arbus: The Gap between Intention and Effect.'' Art Journal. 34 (Fall 1974):30-35.
 Discussion in depth of her subject matter.

Jeffrey, Ian. 'Diane Arbus and American Freaks.'' Studio International. 187 (March 1974):133-134.

Kozloff, Max. 'The Uncanny Portrait: Sander, Arbus, Samaras.'' Artforum. 11 (June 1973):58-66.
 Comparison of the portrait styles of these three photographers.

Levy, Alan. 'Working with Diane Arbus: A Many-splendored Experience.'' Art News. 72 (Summer 1973):80-81.
 A personal reminiscence by the author, who briefly worked with Arbus.

Munsterberg. History of Women Artists. pp. 141-143.

The source for most of the above biographical material.

Porter, Allan. "Diane Arbus." Camera. 51 (Nov. 1972):4-21.
 Introduces a portfolio of sixteen of her works with personal
 recollections.

Collections:

 New York, Museum of Modern Art.
 New York, Witkin Gallery.

VANESSA BELL. 1879-1961. English.

 Bell was the older sister of Virginia Woolf. She studied at
the Slade School for a time. She was widely traveled, going to
Italy and Paris in 1904, Greece in 1906, and Constantinople in
1911. In 1906 she married the art critic Clive Bell with whom she
had three children. Between 1911 and 1914 the marriage broke up
as the result of her interest in Roger Fry. By 1915 she was liv-
ing with Duncan Grant. Between 1913 and 1919 she worked with
Roger Fry in his Omega Workshops and from 1914 to 1916 she
collaborated with Duncan Grant on interior decoration. Her paint-
ing style has been described as English post-impressionism, with
subject matter consisting of figure subjects and still lifes. She
also designed pottery, carpets and book jackets.

Bell, Quentin. Virginia Woolf: A Biography. London: Hogarth
 Press, 1973. 2 vols.
 Written by Bell's son, this biography contains much infor-
 mation about her. Accounts of her childhood and her close
 relationship with Virginia Woolf are detailed. Her uninhibited
 views on sex are discussed, but the actual progression of her
 affairs is not clearly indicated. Evidently she continued a
 close relationship with Clive Bell after the affair with Roger
 Fry, and Fry and Bell were close friends themselves.

_____ and Chaplin, Stephe. "The Ideal Home Rumpus." Apollo.
 80 (Oct. 1964):284-291.
 The Omega workshop, of which Bell was a part, became
 involved in a dispute with Wyndham Lewis over the commission
 to design a room for an "Ideal Home Exhibition." Letters be-
 tween Bell and Roger Fry discussing the dispute are included
 as well as photographs of Bell.

Clutton-Brock, A. "Vanessa Bell and Her Circle." The Listener.
 65 (May 4, 1961):790.

Dictionary of Twentieth-Century Art. New York: Phaidon, 1973.
 p. 29.
 Basic biographical facts.

Harris and Nochlin. Women Artists, 1550-1950. pp. 60-61, 63,

283-85, 356.

Lipke, William. "The Omega Workshops and Vorticism." Apollo. 91 (March 1970):224-231.
 Roger Fry started this workshop in 1913 to create a new movement in decorative art, translating the avant-garde into terms of applied art. Bell was one of the participants. The resulting figurative work drew on the contribution of the Vorticists. A reproduction of a screen by Bell is included.

London. Anthony d'Offay Gallery. Vanessa Bell: Paintings and Drawings. 1973.
 Introduction by R. Morphet.

London. Arts Council Gallery. Vanessa Bell: A Memorial Exhibition of Paintings. 1964.
 Introduction by R. Pickvance.

London. Lefevre Galleries. Catalogue of Recent Paintings by Vanessa Bell. 1934.
 Introduction by Virginia Woolf.

London. London Artist's Association, the Cooling Galleries. Recent Paintings by V. B. 1930.
 Introduction by Virginia Woolf.

"Lord Benbow's Apartments. The Architectural Review Competition." Architectural Review. 68 (Dec. 1930):242.
 Bell won third prize in this competition based primarily on her color scheme and largeness of conception. However, she was faulted with treating the plan of the room as a "comparative irrelevancy." Color reproductions of her room and rug designs are included.

Morphet, Richard. "The Significance of Charleston." Apollo. 86 (Nov. 1967):342-345.
 A well illustrated look at an important era in the decorative history of England. Bell and her group (including Duncan Grant, Quentin Bell, and others) leased this farm house so they could continue their work during the first World War. Design work by Bell included radiator screens, wall decorations and cushions.

Petersen and Wilson. Women Artists.... p. 106.

Rienaecker, Victor. "An Interesting Experiment." Apollo. 43 (Feb. 1946):34-35 and 38.
 Description of a decor designed by Bell and Duncan Grant for the Duchess of Wellington.

Rosenbaum, S. P., ed. The Bloomsbury Group: A Collection of Memoirs, Commentary and Criticism. Toronto, 1975. pp. 169-177.

Shone, Richard. Bloomsbury Portraits: Vanessa Bell and Duncan Grant and Their Circle. New York: Phaidon, 1976.
A chronicle of the group's origins, members, role, influence, and decline.

Sickert, Walter. "Vanessa Bell." Burlington Magazine. 41 (July 1922):33-34.
Includes three black and white reproductions.

Wallis, Nevile. "Vanessa Bell and Bloomsbury." Connoisseur. 156 (Aug. 1964):247.
In 1916 she settled close to Brighton, in rural seclusion, with her husband Clive Bell and Duncan Grant. This group became known as the "Bloomsbury Group."

Waters, Grant. Dictionary of British Artists Working 1900-1950. Eastbourne: Eastbourne Fine Art, 1975.
Says she studied with Sir Arthur Cope and at the Royal Academy schools.

Collections:

London, Alex Reid and Lefevre Ltd.
London, Anthony d'Offay Gallery.
London, Tate Gallery.

CHARLOTTE BEREND-CORINTH. 1880-1935. German.

Berend-Corinth was born in Berlin. She was a student of Eva Short and of Max Schafer. In 1904 she married the painter Lovis Corinth. Her first exhibition was in Berlin in 1906. She did mainly portraits and genre works, influenced by Expressionist sources. Much of her early work was destroyed in the Second World War. Rather than promoting her own work, which has been virtually unnoted, she devoted much of her time to cataloguing her husband's work following his death in 1925.

Bénézit. Dictionnaire. Vol. 2, p. 631.

Berend-Corinth, Charlotte. Die Gemälde von Lovis Corinth: Werk Katalog. Munich: F. Bruckmann, 1958.

Schultzman, Monty. Die Malerin Charlotte Berend-Corinth. Munich: F. Bruckmann, n.d. (?1968).
Includes forty black and white reproductions.

Thieme and Becker. Allgemeines Lexikon. Vol. 7, p. 413.

LOUISE BLANCHARD BETHUNE. 1856-1913. American.

Bethune was the first professional woman architect in the

United States. She studied in the office of the Buffalo, New York architect R. A. Waite. She married a draftsman in the office, Robert Bethune, in 1881. They practiced together for a decade before she retired in 1890. She joined the Western Association of Architects in 1885 and in 1886 helped organize the Buffalo Society of Architects. In 1888 she was the first woman to gain membership in the American Institute of Architects. She designed a wide variety of buildings, including a number of schools.

Bethune, Louise. "Women and Architecture." Inland Architecture and Building News. 17 (March 1891):20-21.

Edward, James, ed. Notable American Women 1607-1950. Cambridge: Belknap Press of Harvard University Press, 1971. Vol. I, pp. 140-141.

Marquis, Albert Nelson, ed. Who's Who in America 1912-1913. Chicago: A. N. Marquis and Co., 1912. Vol. 7, p. 161.

National Cyclopaedia of American Biography. New York: James T. White and Co., 1904. Vol. 12, p. 9.

Stern, Madeline. "America's First Woman Architect?" Journal of the Society of Architectural Historians. 18 (May 1959):66.

_____. We the Women; Career Firsts of Nineteenth-Century America. New York: B. Franklin, 1974.

ISABEL BISHOP. 1902- . American.

Born in Cincinnati, Bishop spent her youth in Detroit and moved in 1918 to New York. She settled in New York's Union Square area and entered the New York School of Applied Design for Women to study illustration. She next studied at the Art Students League with Kenneth Hayes Miller. After traveling in Europe she returned to the Art Students League as an instructor. In 1934 she married a prominent neurologist. They live in Riverdale, New York, but she continues to work in her Union Square studio. The Union Square atmosphere has supplied her subject material--nudes, working girls and street scenes crowded with people. A confessed perfectionist, she works slowly, with a painting usually following numerous pen and ink sketches. The resulting work, which often expresses her interest in body movements, has been described as having a "hazy luminosity."

Alloway, Lawrence. "Isabel Bishop, the Grand Manner and the Working Girl." Art in America. 63 (Sept. 1975):61-67.
 Discusses her style and subject matter, noting that she has a marked responsiveness to specifically feminine situations. Three good color illustrations.

Archives of American Art. Smithsonian Institution. "Isabel

Isabel Bishop. Girl Reading Newspaper. Oil on canvas. 29" x 18". Nelson Gallery of Art-Atkins Museum, Kansas City, Mo. Bequest of Marie P. McCune.

Bishop Papers. "

Austen, Jane. Pride and Prejudice. New York: E. P. Dutton, 1976.
This old commission of 1945 has finally surfaced with illus-trations by Bishop.

Bishop, Isabel. "Concerning Edges." Magazine of Art. 38 (May 1945):168-173.
Historical examination of linear and painterly styles and argues for not mixing the two.

_____. "Drawing the Nude." Art in America. (December 1963):117.

_____. "Isabel Bishop Discusses 'Genre' Drawings." Ameri-can Artist. 17 (June 1953):46.
Brief historical summary of drawing styles.

_____. "Kenneth Hayes Miller." Magazine of Art. 45 (April 1952):169.
Personal reminiscences of her former teacher.

Canaday, John. "A Certain Dignity for the Figure." New York Times. (May 11, 1975):31.

Denz, Sarah. "Isabel Bishop." Womansphere. 1 (Sept. 1975): 12-13.
Brief synopsis of her subject matter.

"The Drawings of Isabel Bishop." Magazine of Art. 13 (June 1949):49-51.
Good illustrations.

Glueck, Grace. "New Honors for Painter of Union Square." New York Times. (April 11, 1975):18.

Harmes, Ernest. "Light Is the Beginning--The Art of Isabel Bishop." American Artist. 25 (Feb. 1961):28-33 and 60-62.
An in-depth analysis of her style. Discusses her lengthy creative process from pencil sketch, to etching, to paint-ing.

Harris and Nochlin. Women Artists, 1550-1950. pp. 64, 325-26, 360-61.

Hill. Women, An Historical Survey.... pl. 59.

Johnson, Una and Miller, Jo. Isabel Bishop. Brooklyn: The Brooklyn Museum, 1964.
A monograph in the American Graphic Artists of the Twentieth Century series.

Lunde, Karl. Isabel Bishop. New York: Harry Abrams, 1975.

Nemser, Cindy. "Conversation with Isabel Bishop. " Feminist
 Art Journal. 5 (Spring 1976):14-20.
 Discusses her Union Square subject material, her education
 as an artist, and her work.

Petersen and Wilson. Women Artists.... p. 3, 4.

"Poet in the Square. " Time. 75 (May 16, 1960):80 and 82.

Reich, Sheldon. "Isabel Bishop: The 'Ballet' of Everyday Life. "
 Art News. 74 (Sept. 1975):92-93.
 Describes Bishop as the primary portrayer of the American
 working woman.

Russell, John. "A Novelist's Eye in Isabel Bishop's Art. " New
 York Times. (April 12, 1975):25.

Sayre, Ann. "Substantial Technique in Isabel Bishop's Work. "
 Art News. 34 (Feb. 22, 1936):8.
 Discusses her technique.

Seckler, Dorothy. "Bishop Paints a Picture. " Art News. 50
 (Nov. 1951):38-41 and 63-64.
 Photo essay and discussion of her working methods and use
 of models.

Trenton, New Jersey. New Jersey State Museum. Painting by
 Isabel Bishop; Sculpture by Dorothea Greenbaum. May 2-July
 5, 1970.
 Exhibition catalogue.

Tucson. University of Arizona Museum of Art. Isabel Bishop.
 1974.
 This is the catalogue of the first retrospective exhibition of
 her work held in America. The Introduction is by Sheldon
 Reich. Many black and white illustrations.

Watson, Forbes. "Isabel Bishop. " Magazine of Art. 32 (Jan.
 1939):53-54.
 Brief review of an exhibition.

Collections:

 Kansas City, Mo. , Atkins Museum-Nelson Gallery.
 New York, The Metropolitan.
 New York, The Whitney Museum of American Art.
 Newark, N.J. , The Newark Museum.
 Philadelphia, Academy of Fine Arts.
 Springfield, Mass. , Museum of Fine Arts.

MARIE BLANCHARD. 1881-1932. Spanish.

Blanchard was a painter, working in the Cubist idiom. She was born in Spain. Her father was Spanish and her mother was half French and half Polish. Her name was really Gutierez, but she changed it when she moved to Paris in 1906. She was hunchbacked from birth and lived in continuous pain. She often painted from her wheelchair. Her first art studies were in Madrid. She left Spain because children taunted her about her handicap. She studied in Paris from 1908 to 1913 and then settled there. She also supported her sister and her three children. For a period, her works were cubist, but after 1919 became more realistic. She excelled in capturing scenes of family life and childhood.

Casson, J. "La jeune peintre espagnole." Renaissance. 16 (July 1913):160-161.

Charmet, R. "Les Individualistes du Cubisme au Petit Palais· de Geneve." Galerie. 125 (March 1973):51-54.
 Briefly discusses the work of several Cubists, including Blanchard.

Dorival, Bernard. The School of Paris in the Musee d'Art Moderne. New York: Abrams, 1962.
 A reproduction of one painting, dated 1921.

_____. Twentieth Century Painters. New York: Universe Books, 1958.

Hill. Women. An Historical Survey.... Catalogue. p. xiii.

Mathey. Six femmes peintres.

Petersen and Wilson. Women Artists.... pp. 97, 98.

Phaidon Dictionary of Twentieth Century Art. New York: Phaidon, 1973, p. 38.

Reynal, Maurice. Modern French Painting. New York: Brentano, 1928.

Sumner, Maud. "Recollections of Paris." Apollo. 102 (Oct. 1975):289-291.
 Sumner lived in Blanchard's home around 1929 and recalls the artist briefly.

LOUISE BOURGEOIS. 1911- . French.

Bourgeois was raised in Aubusson, France. There she began her art career as a child, assisting in the family craft of restoring old tapestries. Her art schooling was obtained from the Ecole du Louvre, Ecole des Beaux-Arts, Académie du Louvre, and

in Leger's studio in Paris. In 1938 she came to New York City and studied at the Art Students League. She began as an abstract painter, exhibiting at the Whitney's Painting Annuals between 1948 and 1958. Her first all-sculpture show was in 1949. She has taught sculpture at several colleges. She works in a variety of sculptural forms, using brass, plastic, marble and latex. Much of her more recent work has an anatomical basis--referring to body parts--breasts, penises, etc.

Anderson, Wayne. American Sculpture in Process 1930-1970. Boston: New York Graphic Society, 1975.

Armstrong. Two Hundred Years of American Sculpture. pp. 261-262.

Baldwin, Carl. "Louise Bourgeois: An Iconography of Abstraction." Art in America. 63 (March 1975):82-83.
A chronological discussion of her style. Sees in the biomorphic abstraction of her work the recurring theme of the problem of helplessness and the difficulty of self-reliance.

Bloch, Susi. "An Interview with Louise Bourgeois." Art Journal. 35 (Summer 1976):370-373.

Bourgeois, Louise. "The Fabric of Construction." Craft Horizon. 29 (March/April 1969):30-35.
Reviews a Museum of Modern Art exhibition of wall hangings. Contrasts fabric work with sculpture.

Krasne, Belle. "10 Artists in the Margin." Design Quarterly. 30 (1954):18.
Includes a brief description by Bourgeois of her own work.

Lippard, Lucy. "Louise Bourgeois: From the Inside Out." Art Forum. 13 (March 1975):26-33.
Excellent summary of her life and analysis of her work with good reproductions. Notes the wide variety of materials and techniques utilized by Bourgeois.

Marandel, J. Patrice. "Louise Bourgeois." Art International. 15 (Dec. 1961):46-47 and 73.

Robbins, Daniel. "Sculpture by Louise Bourgeois." Art International. 8 (Oct. 1964):29-31.

Rubin, William. "Some Reflections Prompted by the Recent Work of Louise Bourgeois." Art International. 13 (April 1969):17-20.
Compares her sculpture to the painting being produced in the 1940's and '50's. Sees the sexuality of her work as being not conducive to "aesthetic contemplation."

MARGARET BOURKE-WHITE. 1904-1971. American.

Bourke-White was one of the outstanding women photogra-
phers of the twentieth century. Her interest in photography began
during her college days at Cornell University. She also studied
with Clarence White at Columbia. When her early marriage ended
in divorce, she began her career as a free-lance photographer.
In 1927 she moved to Cleveland and began photographing architec-
ture and steel mills. Soon her work was appearing in national
magazines, such as Architectural Record. She moved to New York,
becoming the main photographer and an associate editor of Fortune.
In 1936 she was hired as one of the first photographers for Life
magazine. Her career with Life took her around the world and
gained her numerous distinctions. In the 1930's she was the first
professional American photographer allowed access to Russia,
where she documented the progress of the first five-year plan. In
the Second World War she was the first woman photographer to be
accredited by the United States Armed Forces. She was the only
Western photographer to cover the first German bombardment of
Moscow. After the war she covered events such as religious con-
flict in India, African gold mining, and the Korean conflict. She
worked with Erskine Caldwell on a study of rural poverty in the
South, entitled You Have Seen Their Faces. She married Caldwell
in 1939 and they were divorced in 1942. In the early 1950's she
developed Parkinson's disease and spent the last years of her life
in a heroic struggle against her illness. She retired from the staff
of Life in 1969.

Beaton. The Magic Image. p. 182.

Bourke-White, Margaret. "How the Pictures Were Made." Popu-
 lar Photography. 2 (March 1939):15-16 and 94-95.
 Describes the equipment used, lighting techniques, film and
 other technical aspects involved in the preparation of You Have
 Seen Their Faces.

_____. Portrait of Myself. New York: Simon and Schuster,
 1963.
 Autobiography.

_____. They Called it "Purple Heart Valley." New York:
 Simon and Schuster, 1944.
 Her personalized account of the Second World War in Italy.

_____ and Erskine Caldwell. You Have Seen Their Faces.
 New York: Modern Age Books, Inc., 1937.
 A study of rural poverty in the South.

"Bourke-White's 25 Years." Life. 38 (May 16, 1955):16-18.
 A photo-essay of Bourke-White at work.

Brown, Theodore. Margaret Bourke-White: Photojournalist.
 Ithaca, N.Y.: Cornell University, Andrew Dickson White

Museum of Art, 1972.
 Lavishly illustrated exhibition catalogue, documenting her
extensive travels. Comprehensive bibliography included, and
listing of published photographs.

Callahan, Sean, ed. The Photographs of Margaret Bourke-White.
 Boston: New York Graphic Society, 1972.
 Includes chronology and bibliography.

Kelley, Etna M. "Margaret Bourke-White." Photography. 31
 (August 1952):34-43 and 85.
 Traces her career with Life.

Munsterberg. A History of Women Artists. pp. 139-141.

Newhall. History of Photography. pp. 149 and 158.

Tucker. The Woman's Eye.

Collections:

 Brooklyn, Museum of Art.
 Cleveland, Museum of Art.
 New York, Museum of Modern Art.
 Washington, D.C., Library of Congress.

ROMAINE BROOKS. 1874-1970. American (but a lifelong resident
 of France).

 Brooks was an active painter in the early twentieth century
of unusual female nudes and portraits of personal friends; all done
in a somber palette of neutral grey tones. She had a bizarre and
even Gothic childhood. Her father deserted the family before she
was born. Her mother was eccentric and her younger brother
was emotionally disturbed. Her mother traveled perpetually and
Brooks frequently had to change schools. She studied professional
singing briefly before choosing a career in art. Not until both her
mother and brother had died and she had inherited the family for-
tune was she free to pursue her own life. She was born with the
name Goddard, but took John Brooks' name after a brief marriage
of convenience. She was a lesbian and lived in a lifelong relation-
ship with Natalie Barney, whom she portrayed in her 1920 paint-
ing, L'Amazone.

Bénézit. Dictionnaire. Vol. 2, p. 152.

Blume, Mary. "Romaine Brooks." Réalités. 205 (Dec. 1967):
 96-99.
 Discusses her close friendship with Gabriele d'Annunzio.

Brooks, Romaine. No Pleasant Memories. Unpublished manu-
 script of her autobiography, circa 1930.

Romaine Brooks. Self Portrait. 1923. Oil on canvas. 46 3/4"
x 26 7/8". National Collection of Fine Arts, Smithsonian Institu-
tion, Washington, D.C. Gift of the artist.

Is discussed in Life and Letters Today, vol. 18, pp. 38-44
and vol. 19, pp. 14-32.

Breeskin, Adelyn Dohme. Romaine Brooks, "Thief of Souls."
Washington, D.C.: National Collection of Fine Arts, Smith-
sonian Institution Press, March 1971.
 Breeskin's essay in the catalogue of Romaine Brooks' retro-
spective exhibition provides a visual analysis. The preface of
this catalogue was written by Joshua Taylor. Several of her
paintings are on permanent display at the National Collection,
chief amongst them her compelling, half-length self portrait.

Butler, J. T. "Romaine Brooks, Whitney Museum, N.Y. Exhibit."
Connoisseur. 178 (October 1971):136-137.
 This is an obituary with three reproductions. Butler places
her activity between 1910 and 1935.

D'Annunzio, Gabriele. An article on Brooks' painting. Illustra-
zione. (April 1931).
 This is an Italian periodical. D'Annunzio and Brooks had a
brief love affair.

Gabhart and Broun. "Old Mistresses...."

Harris and Nochlin. Women Artists, 1550-1950. pp. 268-71,
354-55.

Hill. Women, An Historical Survey.... Catalogue. p. 22.
 Brooks' painting of Ida Rubenstein is reproduced.

Kahn, Gustave. "Romaine Brooks." L'Art et les Artistes. 37
(May 1923):307-314.
 Fourteen reproductions of her work are included.

Kramer, Hilton. "Revival of Romaine Brooks." The New York
Times (April 25, 1971).

_____. "Romaine Brooks, Revelation in Art." The New York
Times. (April 14, 1971).

London. The Fine Art Society, Ltd. Romaine Brooks, Centenary
1876-1976. January 19-February 14, 1976.
 A brief catalogue reprinted from Breeskin's 1971 catalogue
for the National Collection, in Washington, D.C.

Nelson, Harold. The Paintings and Drawings of Romaine Brooks.
(A Ph.D. dissertation in progress, SUNY, Binghampton.)

Petersen and Wilson. Women Artists. pp. 100-101.

Raven, Arlene. "Romaine Brooks." Womanspace Journal. I, no.
2 (April-May 1973):508.

Secrest, Meryle. Between Me and Life. New York: Double-
day and Co., 1974.
An in-depth biography of Romaine Brooks. It contains re-
productions of her paintings and unusual drawings and photo-
graphs of her circle. It is indexed and contains an exhaustive
bibliography, some of which has been utilized here. Secrest
uses an ingenious format to deal with some of the contradictory
primary sources about Brooks, in particular her childhood.
For example, she writes one chapter from the point of view of
Brooks' mother, Ella Goddard, as preserved in her letters.
Rather than presuming to resolve the enigma, Secrest presents
both sides of the evidence.

Usher, John. "A True Painter of Personality." International
Studio. (February 1927).

Wicks, George. The Amazon of Letters, The Life and Loves of
Natalie Barney. New York: G. P. Putnam, 1976.

Young, M. S. "Thief of Souls." Apollo. n.s. 93 (May 1971):
425-427.
The sobriquet "thief of souls" refers to her often eerie por-
traits.

Collections:

Paris, Musée du Petit Palais.
Washington, D.C., National Collection of Fine Arts.

DORIS CAESAR. 1892- . American.

Caesar was born in New York and lives in Litchfield, Con-
necticut. In 1909 she studied at the Art Students League. She
married in 1913 and stopped her art work for a while. In 1925
she studied with Archipenko. Around 1953 she began to concen-
trate almost exclusively on her individual sculptural interpretations
of elongated female figures, simplified and slightly distorted. She
has exhibited regularly in New York galleries since 1931. She
has also published poetry. Syracuse University has her papers
and the largest single collection of her works.

Bush, Martin. Doris Caesar. Syracuse: Syracuse University
Press, 1970.
Monograph including numerous reproductions, chronology,
exhibition list, extensive bibliography, and list of collections
containing her work.

Caesar, Doris. Certain Paths. New York: G. P. Putnam's Sons,
1937.

_____. Phantom Thoughts. New York: G. P. Putnam's Sons,
1934.

Both these volumes are poetry.

Goodrich, Lloyd and Baur, John. Four American Expressionists.
New York: Frederick Praeger for the Whitney Museum, 1959.
pp. 22-36.
The chapter on Caesar is by Baur and contains many good
black and white reproductions.

EMILY CARR. 1871-1945. Canada.

Carr was born into a large family in Victoria, British Co-
lumbia. Her parents died when she was young and she was raised
by her sisters. She attended the School of Art in San Francisco
from 1889 to 1894. In 1894 she returned to Victoria, set up a
studio and began to teach children's art classes. Her first voyage
to Ucluelet, an isolated Indian village on Vancouver Island, was
made in 1898. The Indians gave her the name "Klee Wyck,"
meaning "laughing one." This began her interest in documenting
Indian life and legend. She enrolled in Westminster School of Art
in London, but became ill and was confined to a sanitarium for
two years with pernicious anemia. She studied at the Académie
Colorossi in Paris in 1910/1911, where she acquired her heavy
brushwork and violent color. Two of her works were exhibited in
the Salon d'Automne of 1911. After her return from France she
virtually gave up painting and struggled to support herself by open-
ing up a boarding house, making pottery and hooked rugs, and
raising puppies. The turning point came in 1927 when she met a
group of painters called The Group of Seven. They, and especially
Lauren Harris, had an understanding of her art and brought her
work to the attention of the Director of the National Gallery in
Ottawa. Her best work was done in the 1950's as she continued to
document Indian life and the Canadian landscape. She was also a
writer, doing autobiographical material, novels and numerous
stories.

Art Gallery of Ontario: The Canadian Collection. Toronto: Mc-
Graw-Hill Co. of Canada Limited, 1970. pp. 60-63.
Brief biographical summary and three black and white re-
productions.

Bénézit. Dictionnaire. Vol. 2, p. 333.

Buchanan, D. W. "Emily Carr: Canadian Painter." Studio. 126
(Aug. 1943):60.
Good color illustration.

Carr, Emily. The Book of Small. Toronto: Clarke, Irwin, 1951.
Recollections of her childhood.

————. Fresh Seeing. Toronto: Clarke, Irwin and Co. , Ltd. ,
1972.

Emily Carr. Western Forest. ca. 1931. Oil on canvas. 50 1/2"
x 36 1/8". Art Gallery of Ontario, Toronto, Canada.

Reprints of the only two public talks she gave--both dealing with her view of aesthetics. Preface by Doris Shadbolt and an introduction to the 1930 speech by Ira Dilworth.

_____. Growing Pains. Toronto: Oxford University Press, 1946.

_____. The House of All Sorts. Toronto: Clarke, Irwin, 1967.

_____. Hundreds and Thousands: The Journals of Emily Carr. Toronto: Clarke Irwin, 1968.

_____. Klee Wyck. Toronto: Oxford University Press, 1941.
Autobiographical work encompassing her interpretation of Indian legends and the lives and fears of the Indian tribes.

_____. Pause, A Sketch Book. Toronto: Clarke, Irwin, 1953.
Her correspondences and reminiscences.

Dilworth, Ira, ed. The Heart of a Peacock. Toronto: Oxford University Press, 1953.
Collection of Carr's unpublished writings and stories with her line drawings of animals and birds.

Harris and Nochlin. Women Artists, 1550-1950. pp. 58, 60.

Hirsch, Gilah Yelin. "Emily Carr." Feminist Art Journal. 5 (Summer 1976):28-31.
Comprehensive survey of her life and work. Unfortunately a bibliography is not included, but Hirsch generously offers to share her material with anyone interested.

"The Laughing One." Time. 64 (Nov. 22, 1954):82.
Color illustration.

"Memories of Emily Carr in a Tobey Exhibition." Canadian Art. 16 (Autumn 1959):274.
Mark Tobey stayed briefly in Carr's boarding house, and gave her some instruction while there. Illustrated with his 1928 painting of her studio.

Shadbolt, Doris. "Emily Carr: Legend and Reality." Artscanada. 28 (June/July 1971):17-21.
An excellent analysis of Carr's personality and its relationship to her work, contrasting her sense of "otherness" to the isolation of the Indians with whom she closely identified. Includes photographs of Carr and reproductions of her work.

"The Ucleulet Wharf." Apollo. 94 (Oct. 1971):314.
Review of the 1971 centennial retrospective at the Vancouver Art Gallery.

Collections:

Toronto, Art Gallery of Ontario.

LEONORA CARRINGTON. 1917- . English.

Carrington was born in England and made paintings and drawings without any formal training until she was nineteen. In 1937 she entered the Ozenfant Academy in London and in the same year met Max Ernst. She lived with Ernst from 1937 to 1940. She participated in the first Surrealist exhibition of 1939 in Paris. In the 1940's she suffered a nervous breakdown. After spending some time in New York, in 1942 she moved to Mexico to make her home and still resides there. She is a Surrealist and a feminist. Her work often satirizes her English, upper-middle class social background and frequently includes mythical creatures, magic animals and female symbols. She has also produced sculpture, designed tapestry and has written and illustrated stories. She was one of the originators and leaders of the women's liberation movement in Mexico.

Alexandrian, Sarane. Surrealist Art. New York: Praeger Publishers, 1970.

Bénézit. Dictionnaire. Vol. 2, p. 347.

Carrington, Leonora. Down Below. Chicago: The Black Swan Press, 1972; reprint edn. by the Surrealist Group of Radical America (1878 Massachusetts Ave., Cambridge, MA 02140).
 This is a re-issue of her account of her bout with nervous depression, originally entitled En bas. The English translation first appeared in VVV 4 (Feb. 1944).

_____. El mundo magico de los Mayas. Reprinted by the Surrealist group of Radical America, see above.

_____. The Oval Lady. Santa Barbara: Capra Press, 1975. Translated by Rochelle Holt.
 A collection of six surreal stories and illustrations.

Gablik, Suzi. "Leonora Carrington at Iolas and the Center for Inter-American Relations." Art in America. 64 (March 1976): 111.
 Exhibition review.

Hill. Women. An Historical Survey.... Catalogue. p. iii.

Jean, Marcel. The History of Surrealist Painting. New York: Grove Press, Inc., 1959. Translated by Simon W. Taylor.
 Gives an account of her emotional breakdown. Includes her own description of her painting The Temptation of Saint Anthony. Also includes one of her surrealist cooking recipes.

Orenstein, Gloria. "Leonora Carrington--Another Reality." Ms. (August 1974).

_____. "Women of Surrealism." Feminist Art Journal. 2 (Spring 1973):1, 15-21.

Petersen and Wilson. Women Artists.... pp. 131, 132.

Collections:

Mexico City, Museum of Natural History.

IMOGEN CUNNINGHAM. 1883- . American.

As a college student, Cunningham worked in the Seattle studio of Edward S. Curtis. In 1909 she won a scholarship to study photographic chemistry in Dresden. When she returned she opened a portrait studio in Seattle. She married, moved to San Francisco and had three sons. While her first interest was por- traits, she turned to the study of flowers while raising her family. Following her divorce, she returned to portraits. In 1930 she be- came one of the founding members of the F/64 group, along with Edward Weston and Ansel Adams. Between 1931 and 1936 she occasionally did assignments for Vanity Fair. In 1947 she opened a portrait studio in San Francisco. She has taught at the San Francisco Art Institute.

Beaton, Cecil and Nicolson, Gail Buckland. The Magic Image: The Genius of Photography from 1839 to the Present Day. London: Weidenfeld, 1975, p. 756.
A good analysis of the stylistic changes in her work.

Craven, George. "Imogen Cunningham." Aperture. 11, no. 4 (1964).
Entire issue devoted to Cunningham, including a chronology of her life, list of major exhibitions, and many reproductions. Major portion of the text is by Craven.

Mann, Margery. Imogen! Imogen Cunningham Photographs 1910- 1973. Seattle: University of Washington Press, 1974.
Survey of over 60 years of her career. The short essay by Mann is followed by 105 photographs presented in roughly chronological order.

Munsterberg. History of Women Artists. pp. 126 and 131.

Stanford University Art Gallery. Imogen Cunningham: A Celebra- tion. January 1977.

_____. Imogen Cunningham: Photographs 1921-1967. March 31-April 23, 1967.
Introduction is by Beaumont Newhall.

Collections:

New York, Museum of Modern Art.
New York, Witkin Gallery.
Oakland, Museum of Art.
Washington, D. C. , Library of Congress.

SONIA DELAUNAY. 1885- . French (born in Russia).

Delaunay-Terk grew up in St. Petersburg. At age eighteen she studied two years in Karlsruhe, Germany with Schmidt-Reuter. In 1905 she enrolled in the Académie de la Palette in Paris. She married the German art dealer and critic, Wilhelm Uhde, in 1909 --mainly to prevent her family from insisting on her return to Russia. The marriage was brief, for the following year she married Robert Delaunay. They had one son. From 1914 to 1920 they lived in Spain and Portugal. They worked together on a mural for the 1937 Paris Exposition Internationale. Robert Delaunay died in 1941 and she spent the remaining war years in Southern France, returning to Paris in 1944. She spent considerable time promoting her husband's work after his death--organizing exhibitions and inventorying his works. It has often been assumed that her work replicates and documents her husband's achievements. Actually, they collaborated closely and the exact nature of their influence on each other is difficult to analyze. Her work was wide-ranging in its scope. With her husband she worked out Orphic Cubism; she did book-binding, tapestry work, designed clothes, interior decorations, painted, designed theatre costumes, and even worked out the design for painting a car. She is still an active artist today.

Baber, Alice. "Sonia Terk Delaunay. " Craft Horizons. 33 (Dec. 1973):32-39.
 Excellent summary of her life with a good assortment of reproductions of work in various media.

Bénézit. Dictionnaire. Vol. 3, p. 148.

Clay, Jean. "The Golden Years of Visual Jazz: Sonia Delaunay's Life and Times. " Réalités. [English language edition.] 1965, pp. 42-47.

Cohen, Arthur. The New Art of Color: The Writings of Robert and Sonia Delaunay. New York: Viking Press, in preparation.

_____. Sonia Delaunay. New York: Harry N. Abrams, Inc., 1975.
 Definitive work with many reproductions, photographs, and an extensive bibliography. Clearly compares the work of Robert and Sonia Delaunay and discusses the interrelation of her work as a designer and a painter.

Craven, Arthur. "L'Exposition des indépendants. " Maintenant.

Special issue (March-April 1914).

Damase, Jacques. Sonia Delaunay. Paris: Gallerie de Varenne, 1971.
Biographical notes are by Edouard Mustelier.

_____. Sonia Delaunay: Rhythms and Colours. Greenwich, Conn.: New York Graphic Society, 1971.
The preface is by Michel Hoog.

Delaunay, Sonia. Alphabet and robes-poèmes. Paris, 1969.
The text is by Jacques Damase. This apparently is one of her collaborative efforts.

_____. Sonia Delaunay, ses peintres, ses objets, ses modes. Paris: Librarie des Arts Decoratifs, 1925.

Dorival, Bernard. "La donation Delaunay au Musée National d'Art Moderne." La Revue du Louvre. Paris, 1963.

_____. "Les Oeuvres récentes de Sonia Delaunay." XXe Siècle. 36 (June 1971):42-50.

_____. Retrospective S.D. Paris: National Museum of Modern Art, 1965.

_____. The School of Paris in the Musée d'Art Moderne. New York: Harry N. Abrams, Inc., 1962.

_____. Twentieth Century Painters. New York: Universe Books, 1958.

Ferreira, Paulo. Correspondance de quatre artistes portugais avec R. et S. D. Paris, 1972.

Geneva. Galerie du Perron. Sonia Delaunay. 1969.
Exhibition catalogue.

Gilioli, E. "Les tapis de Sonja Delaunay." XXe Siècle. 34 (June 1970):145-149.

Harris and Nochlin. Women Artists, 1550-1950. pp. 60-61, 63, 65, 97, 291-94, 357.

Hill. Women. An Historical Survey.... Catalogue. p. 28.

Hoog, Michel. R. et S. Delaunay, Inventaire des collections publique françaises.

Lansner, Fay. "Arthur Cohen on Sonia Delaunay." Feminist Art Journal. 5 (Winter 1976/77):5-10.
Excellent summary of her life and work.

Mulhouse. Musée de l'Impression sur Etoffes. Sonia Delaunay: Etoffes imprimées des années folles. 1971.

Munsterberg. A History of Women Artists. pp. 67-68.

Nemser. Art Talk. pp. 35-51, 360.
 An interview with good black and white reproductions and the bulk of the bibliography presented here. Nemser explores the belated recognition of Delaunay-Terk's contribution to the development of Orphism and her continuing self effacement today.

Nochlin. "Why Have There Been No Great Women Artists?" p. 39.
 A beautiful color reproduction of Delaunay-Terk's tondo painting Rythme Couleur, Opus 1541, of 1967. Nochlin cites her as being a major figure in the liberation of color.

Ornellas, B. "L'Hommage de Lisbonne à Robert et à Sonia Delaunay." XXe Siècle. 100 (Dec. 1972):100-112.

Ottawa. The National Gallery of Canada. Robert and Sonia Delaunay. 1965.

Paris. Galérie Denis René. Sonia Delaunay. 1968.
 Exhibition catalogue.

Paris. Musée National d'Art Moderne. Sonia Delaunay. 1967-68.
 Retrospective exhibition.

Paris. Petit Palais. Catalogue.

Peppiatt, Michael. "Sonia Delaunay: A Life in Color." Art News. 74 (March 1975):88 and 91.

Petersen and Wilson. Women Artists.... pp. 104, 107, 111-113.

Vriesen, Gustav and Imdahl, Max. Robert Delaunay. New York: Harry N. Abrams, 1967.

Collections:

 London, The Tate Gallery.
 New York, Museum of Modern Art.
 Paris, Musée National d'Art Moderne.

MABLE DWIGHT. 1876-1955. American.

 Dwight was born in Cincinnati, but spent her childhood in New Orleans and California. She traveled extensively in Europe and the Orient. She studied painting in San Francisco at the Hopkins School of Art. Her first lithography work was done in Paris in 1927. Some of her work was supported by the WPA Federal

Art Project. Her work, depicting urban dwellers, is described as satire and caricatures of the foibles of society. She did prints, water colors and drawings but was best known for her work in lithography.

Davidson, Martha. "Graphic Art of Exceptional Quality: Mable Dwight. " Art News. 36 (Jan. 8, 1938):14.

Kistler, Aline. "Prints of the Moment. " Prints. 6 (Oct. 1935): 47-48.

"Mable Dwight, 79, An Artist, Is Dead. " New York Times. Sept. 5, 1955, p. 11.
Mentions that by 1929 she had turned out more than one hundred prints of New York personalities.

"Satire in the Spirit of 'Aren't We All'. " Art Digest. 12 (Jan. 15, 1938):25.
Brief review of her subject matter.

"Scenes from the Cinema by Mable Dwight. " Vanity Fair. 32 (March 1929):54.
Includes two reproductions.

Zigrosser, Carl. "Mable Dwight, Master of Comedie Humaine. " American Artist. 13 (June 1949):42-45.
Reviews biographical facts, discusses subject content, mentions an unpublished autobiography. Includes several reproductions.

ABASTENIA SAINT LEGER EBERLE. 1878-1942. American.

Born in Iowa, she was raised in Ohio and Puerto Rico. She was an accomplished musician, but abandoned that art form for sculpture. She moved to New York in 1899 to study at the Art Students League. Among her teachers were George Gray Barnard, Gutzon Borglum, and Kenyon Cox. At one point she shared a studio and collaborated on sculpture with Anna Hyatt Huntington. Eberle did the figures, while Huntington contributed the animals. One of their collaborations won a prize at the 1904 St. Louis Exposition. Eberle traveled abroad twice--to Italy in 1907-08 and to Paris in 1913. Much of her work relates to labor and the life of the working people. To immerse herself in this theme, in 1914 she opened a studio in the crowded tenement section of Manhattan's Lower East Side. She equipped her studio with a playroom, so visiting children could become her unconscious models. She was elected to membership in the National Sculpture Society in 1906. In 1919 she became seriously ill and was forced to give up sculpture for the remainder of her life. Her work has been described as impressionistic, with genre themes, and with an interest in depiction of motion.

"Abastenia Eberle, Long a Sculptor," New York Times, Feb. 28, 1952. p. 17.

Armstrong. Two Hundred Years of American Sculpture, p. 270.
The source for much of the biographical information. Includes a photograph of her.

Bénézit. Dictionnaire. Vol. 3, p. 479.

Biographical Sketches of American Artists. p. 105.

Hill. Women. An Historical Survey.... Catalogue, p. xiii.

Payne, Frank. "The Tribute of American Sculpture to Labor."
Art and Archeology. 6 (1917):87-91.
Discusses her subject matter related to working material.
Includes one reproduction, The Windy Doorstep.

_____. "The Work of Some American Women in Plastic Art."
pp. 321-322.

Proske, Beatrice. "Part I. American Women Sculptors." pp. 3-15.

"Sculptor of Children Dies." Art Digest. 16 (March 15, 1942): 15.
Obituary.

Collections:

Chicago Art Institute.
New York, Metropolitan Museum.
New York, Whitney Museum.

ALEXANDRA EXTER. 1882-1949. Russian.

Exter was born near Kiev and died in Paris. In 1907 she studied art in Kiev and took part in several Kiev exhibitions. She traveled to Europe frequently. In 1918 she opened her own studio in Kiev and had several students. She moved to Paris in 1924 and became quite involved in stage design while teaching at Léger's Académie d'Art Moderne until the early 1930's. She painted and did collages in a cubist style. She also designed some rather cubist marionettes and worked in textile design. She died in poverty.

Betz, Margaret. "Alexandra Exter, Marionettes." Art News. 75 (Jan. 1976):128.

Bowlt, John. "Russian Exhibitions, 1904-1922." Form. (September 1968).

Cologne. Galerie Gmurzynska. From Surface to Surface. Russia 1916-24. Sept. 18-Nov. 1974. p. 88.
 Exhibition catalogue with translation and introduction by John Bowit. Notes that she was a supporter of Suprematism.

Compton, Susan. "Alexandra Exter and the Dynamic Stage." Art in America. 62 (Sept. 1974):100-102.
 Good review of her stage and film art. Discusses the influence of the director Alexander Tairov on her work. Excellent reproductions.

Elderfield, John. "On Constructivism." Artforum. 9 (May 1971): 61 and 62.
 Two reproductions.

Exter, Alexandra. Décors de théâtre. Paris, 1930.
 Preface by Alexander Tairov.

Gray, Camilla. The Russian Experiment in Art: 1863-1922. New York, 1972.

Harris and Nochlin. Women Artists, 1550-1950. pp. 60-63, 288-90, 357.
 Nochlin gives Exter's birth name as Grigorovich.

Hilton, Alison. "When the Renaissance Came to Russia." Art News. 70 (Dec. 1971):36-39.
 Good color reproduction. Notes that she was also associated with the Futurists.

Kramer, Hilton. "Bringing Cubism to the Stage." New York Times. (May 5, 1974):21.

Lozowick, Louis. "Alexandra Exter's Marionettes." Theatre Arts Monthly. 12 (July 1928):514-519.

New York. Leonard Hutton Galleries. Alexandra Exter: Marionettes Created in 1926. 1975.

_____. Russian Avant-Garde, 1908-1922. 1971.

New York. Public Library. Artist of the Theatre: Alexandra Exter. Summer, 1974.
 Exhibition catalogue.

Paris. Galérie Jean Chauvelin. Alexandra Exter. 1972.
 Catalogue by Andrei B. Nakov.

Petersen and Wilson. Women Artists. pp. 113 and 115.

Tairov, Alexander. Notes of a Director. Trans. by William Kuhlke. Miami: University of Miami Press, 1969.
 Tairov is the director for whom Exter did stage designs.

Tugendhold, Yakov A. Alexandra Exter. Berlin, 1922.

Collections:

New York, Leonard Hutton Galleries.
New York, Luis Mestre Fine Arts.

LEONOR FINI. 1908- . Italian.

Born in Buenos Aires to Italian parents. She settled in
Paris in 1935. Though she never attended surrealist meetings,
preferring to maintain her autonomy, she has participated in all
their group shows and is considered a surrealist painter. She has
also been involved in theatre design and book illustration. Her
work frankly explores matriarchy, lesbianism and androgyny. Her
work is noted for its brilliant color. She often works in egg tem-
pera. Her use of glazes is especially noteworthy.

Bénézit. Dictionnaire. Vol. 3, p. 756.

Brion, Marcel. Leonor Fini et son oeuvre. Paris: Jean-Jacques
 Pauvert, 1953.
 An illustrated monograph.

Carrieri, Raffaele. Leonor Fini. Collona di monografie d'arte
 italiana moderna, VII. 1951.

_____. Leonor Fini. Milan: Galleria, 1951.

Clément, Virginia. "Leonor, un souterrain nommé désir."
 Aesculape. 36e année, no. 3 (March 1954):67.

Fini, Leonor and Alvarez, Jose. Le livre de Leonor Fini: pein-
 tures, dessins, écrits, notes de Leonor Fini. Paris, 1975.

Gauthier, Xavière. Leonor Fini. Paris: Le Musée de Poche,
 1973.

Genet, Jean. Lettre à Leonor Fini. Paris: Loyau, 1951.

Harris and Nochlin. Women Artists, 1550-1950. pp. 329-31, 361.

Jean, M. History of Surrealist Paintings. 1959.

Jelenski, Constantin. Leonor Fini. New York: Olympia Press,
 Inc., 1968.
 A beautiful book--numerous tipped in color plates augmented
 by black and white reproductions and photographs. The exten-
 sive bibliography has supplied most of the references offered
 here. The book is severely flawed, however, by a text which
 is obscure to the point of being ridiculous! In spite of this
 the reproductions and cataloguing make it invaluable.

Leonor Fini. L'amazone. Color lithograph. 23 1/2" x 18".
Photograph of print XXI/LXXV reproduced with the kind permission
of Mme. Katherine Manescau Phelps, Tulsa, Oklahoma.

Joloux, Edmond; Eluard, Paul; Moravia, Alberto; Hugnet, George; Ford, Charles Henri; Praz, Mario; and Savino, Alberto. Leonor Fini. Rome, 1945.

Jouffrey, Alain. "Portrait d'un artiste (iv): Leonor Fini." Arts. No. 541 (November 9-15, 1955):9.

Lanoux, Armand. "Instants d'une psychanalyse critique; Leonor Fini." la table ronde. No. 108 (December 1956):184.

de Mandiargues, André Peyré. Les masques de Leonor Fini. Paris: Andre Bonne, 1951.

Monegal, Emir R. "La pintura como exorcismo." Mundo nuevo. 16 (October 1967):5-21.

Munsterberg. A History of Women Artists. pp. 80-81.

Orenstein, Gloria. "Women of Surrealism." The Feminist Art Journal. 2, no. 2 (Spring 1973):1, 15-21.
 This is a good survey article. Leonor Fini, Leonora Carrington, Meret Oppenheim, Toyen, Remedios Varo, Elena Garro, Joyce Mansour, Jane Garverol and Dorothea Tanning are discussed. Fair black and white reproductions.

Petersen and Wilson. Women Artists. pp. 132-133.

Wilding, Faith. "Women Artists and Female Imagery." Everywoman. (May 7, 1971).

HELEN FRANKENTHALER. 1928- . American.

 Her father was a New York State Supreme Court Justice. Rufino Tamayo was her art teacher in high school. She traveled in Europe in 1948 and in 1949 entered Columbia University as a graduate student in art history. Her first one-woman show was in 1951. She married the painter, Robert Motherwell, in 1958. Her work is categorized as post-painterly expressionism. Both Morris Louis and Kenneth Noland have publicly acknowledged their debt to her. She works on very large canvases of cotton duck (providing a bright white rather than the tan of linen) without priming. Colors are then "stained" on in brilliant washes. Her paintings are evocative of landscapes.

Baro, Gene. "The Achievement of Helen Frankenthaler." Art International. (September 20, 1967):38.

Champa, Kermit. "New Work of Helen Frankenthaler." Art Forum. 10 (January 1972):55-59.
 Good stylistic analysis. Includes a color reproduction.

Faxon, Alicia. "Helen Frankenthaler: Radical Technique, Created

Color School. " Boston Globe. (August 16, 1972).

"Frankenthaler's Floating Radiance. " Time. (March 28, 1969).
A portfolio.

Geldzahler, Henry. "An Interview of Helen Frankenthaler. " Art-
forum. 4 (October 1965):36-38.
Discussion of early influences on her work and on her use
of acrylic.

Goldman, Judith. "Painting in Another Language. " Art News.
(September 1975):Cover Photo, 28-31.

Goosen, E. C. Helen Frankenthaler. New York: Praeger.
Catalogue from 1969 Whitney Museum exhibition of her work.
Chronological discussion of her work. Extensive bibliography
with many reproductions, some in color.

Hill. Women, An Historical Survey.... Catalogue. p. 51.

Judd, Donald. "Helen Frankenthaler. " Arts. 37, no. 7 (April
1963).

Munsterberg. A History of Women Artists. pp. 77-78.

Rose, Barbara. Frankenthaler. New York: Harry N. Abrams,
Inc. , 1970.
A lavish monograph. Many color reproductions. Includes
biographical outline, bibliography and lists of reviews and ex-
hibitions.

_____. "Painting Within the Tradition: The Career of Helen
Frankenthaler. " Artforum. 7 (April 1969):28-33.
Discusses the influence of Jackson Pollock on her method
of painting and her contributions in color-field work.

Schuyler, James. "Helen Frankenthaler Exhibition. " Art News.
58, no. 6 (May 1960).

Washington, D. C. Corcoran Gallery of Art. Helen Frankenthaler:
Paintings 1969-1974. April 20-June 1, 1975.
Exhibition catalogue.

ANNE GOLDTHWAITE. c. 1875-1944. American.

Called an American regionalist, Goldthwaite came from a
sheltered conservative background. She studied at the National
Academy of Design in New York and at the Académie Moderne in
Paris. For over twenty-three years she taught at the New York
Art Students League. From 1937 to 1938 she was President of the
New York Society of Women Artists. Her art was wide in scope.
She was commissioned to do murals for the state of Alabama, did

over two hundred prints, painted, and produced some fired clay
sculpture. Her subject matter often drew on Southern scenes and
included portraits, still lifes and landscapes.

"Anne Goldthwaite." Art Digest. 18 (Feb. 15, 1944):23.
 Obituary.

Bénézit. Dictionnaire. Vol. 4, p. 331.

Breeskin, Adelyn. "Impressionist from the South: Remembering
 Anne Goldthwaite." Art News. 43 (Oct. 15, 1944):24.
 Four good black and white reproductions.

Breuning, Margaret. "League Honors Anne Goldthwaite." Art
 Digest. 20 (Nov. 15, 1945):25.
 Brief review of an exhibition of her work.

Hill. Women. An Historical Survey.... Catalogue, pl. 32.

Collections:

 New York, Metropolitan Museum of Art.
 New York, Whitney Museum of American Art.
 Rhode Island School of Design.
 Washington, D. C. , National Collection of Fine Arts.

NATALIA GONCHAROVA. 1881-1962. Russian, settled in Paris
 after World War I.

 She and her husband, Mikhail Larionov, were the founders
of the Rayonist movement, a Russian offshoot of Cubism that was
also related to Futurism. She was an important influence upon
Franz Marc. In addition to avant-garde painting (particularly
Fauvism) she was greatly influenced by traditional Russian folk art.
She was partly responsible for a renewed interest in primitive
art and religious icons. She was from a noble family. She
first studied in Moscow and began showing in 1900. She worked
closely with Malevich from 1906 to 1912. She exhibited with the
second Blaue Reiter exhibition in 1912 and, in the same year, in
Roger Fry's post-impressionist exhibition in London. In 1914 she
and Larionov moved to Paris. Goncharova had a second career in
innovative costume and stage design, beginning with the Diaghilev
Ballet Russe. Her name is alternately spelled Gontcharova.

Apollinaire, Guillaume. "La vie anecdotique--Madame de Gontcha-
 rova et Monsieur Larionov." Mercure de France. (January
 16, 1916):373.

Basel. Galerie Beyeler. Larionov: Gontcharova. July-Sept.
 1961.
 Exhibition catalogue with several color reproductions.

Natalia Goncharova. <u>Cats</u>. ca. 1913. Oil on canvas. 33 1/4" x 33". Solomon R. Guggenheim Museum, New York.

Bowlt, John. "Neo-Primitivism and Russian Painting. " <u>Burlington Magazine</u>. 116 (March 1974):133-140.

Chamot, Mary. "The Early Work of Goncharova and Larionov. " <u>Burlington Magazine</u>. XCVII (1955):170-174.

_____. <u>Gontcharova</u>. Paris: La bibliothèque des arts, 1972. This book contains color reproductions.

_____. "Russian Avant-garde Graphics. " <u>Apollo</u>. 98 (Dec. 1973):494.

Color reproductions and discussion of her graphic work.

_____ and Gray, Camilla. A Retrospective Exhibition of Paintings and Designs for the Theatre: Larionov and Goncharova. London: London Arts Council, 1961. Catalogue.

Dabrowski, Magdalena. "The Formation and Development of Rayonism." Art Journal. 34 (Spring 1975):200-207.
Discusses her role in the development of the Rayonist movement.

Davies, Ivor. "Primitivism in the First Wave of the Twentieth-Century Avant-garde in Russia." Studio International. 186 (Sept. 1973):80-84.
Discusses the 17th-century icons, toys and popular woodcuts that Larinov and Goncharova utilized in their development of neo-primitive art.

Denvir, Bernard. "The Lost Generation." Art International. 17 (Dec. 1973):15-17.
Discussion of Russian art from 1900-1920.

Eganbiuri, Eli. "Goncharova i Larionov." Zharptitsa (Jar-Ptiza). No. 7 (1922):39-40.

_____. (pseud. of I. Zdanevich). Nataliia Goncharova, Mikhail Larionov. Moscow, 1913.
Note the different spelling, Nataliia.

Goncharova, Nataliia Sergeevna. "Predislovie K Katalogu vystavki. 1913g." (Preface to exhibition catalogue, 1913). Reprinted in Maestera iskusstva ob iskusstve. Fedorov-Davydov, A. and Nedoshivin, G., eds. Moscow, 1970. VII, pp. 497-90.

Gray, Camilla. "The Russian Contribution to Modern Painting." Burlington Magazine. CII (1960):205-211.

_____. The Russian Experiment in Art 1863-1922. New York: Harry N. Abrams, Inc., 1962.
Color reproductions are included. The work of other women artists are represented in this book.

Harris and Nochlin. Women Artists, 1550-1950. pp. 60-64, 96, 283, 286-88, 356.
We are indebted to Nochlin for much of the bibliography presented here.

Hill. Women. An Historical Survey.... Catalogue. p. xiii.

Hilton, Alison. "When the Renaissance Came to Russia." Art News. 70 (Dec. 1971):34-39 and 56-62.

Khardzhiev, N. "Pamiati Natalii Goncharovy (1881-1962) i Mikhail

a Larionova (1881-1964). " Iskusstvo knigi. V (1968):306-18.

Loguine, Tatiana, ed. Gontcharova et Larionov: 50 ans a St. Germain des Prés. Paris: Editions Klincksieck, 1971. 240 pp. Illustrated.

Orenstein, Gloria. "Natalia Goncharova: Profile of the Artist-- Futurist Style. " Feminist Art Journal. 3, no. 2 (Summer 1974):1, 3-6, 19.

Parnak, V. Gontcharova et Larionov: L'art décoratif théâtral moderne. Paris, 1920.

Petersen and Wilson. Women Artists.... pp. 104, 112, 113-116.

Sarab'ianov, D. "Neskol'ko slov o Natalii Goncharovoi. " ("Some Words on Natalia Goncharova. ") Prometei. VII (1969):201-3.

Tsvetaeva, M. "Natal'ia Goncharova. " Prometei. VII (1969):144- 201. Written in 1929.

Tufts. Our Hidden Heritage. pp. 210-221.

TugendKol'd, Ya. "Vystavka Kartin Natalii Goncharovoi (Pis'mo iz Moskvy). " (Exhibition of paintings by Natalia Goncharova-- Letter from Moscow.) Apollon. (1913):71-73.

Collections:

Berlin, National Gallery.
Hartford, Conn. , Wadsworth Atheneum.
London, Tate Gallery.
New York, Guggenheim Museum.
New York, Leonard Hutton Galleries.
New York, Luis Mestre Fine Arts.
New York, Museum of Modern Art.
Paris, Musée National d'Art Moderne.

EILEEN GRAY. 1879- . Born in Ireland, resides in France.

Gray's father was a painter. She was born in Ireland, but grew up in London. In 1898 she entered the Slade School. In 1907 she moved to Paris, where she still lives. From 1912 to 1926 she concentrated on lacquer work for furniture and interior decoration. In the early 1920's she opened a shop in Paris to show furniture and other art work. She designed a few houses at the encourage- ment of her close friend, the architect Jean Badovici. She was a friend of Corbusier. Her interior decoration was abstract in its design.

"Eileen Gray: A Neglected Pioneer of Modern Design." Royal Institute of British Architects Journal. 80 (Feb. 1973):58-59.

Garner, Philippe. "The Lacquer Work of Eileen Gray and Jean
 Dunand." Connoisseur. 183 (May 1973):2-11.
 Good biographical summary. Excellent photographs of the
 apartment design commissioned by Suzanne Talbot.

Gray, David. "Complete Designer: The Work of Eileen Gray."
 Design. 289 (Jan. 1973):68-73.
 Many black and white photographs.

Rykwert, Joseph. "Eileen Gray: Pioneer of Design." Architec-
 tural Review. 152 (Dec. 1972):357-361.
 Chronology of her work.

Schlumberger, Eveline. "Eileen Gray." Connaissance Arts. 258
 (Aug. 1973):72-81.
 Excellent color reproductions of her furniture. Architectur-
 al plans.

Thompson. "World of the Double Win...." p. 20.

Vaizey, Marina. "The Collection of Mr. and Mrs. Robert Walker.
 Part 2." Connoisseur. 182 (April 1973):232-235.
 Good reproductions of her furniture.

ELIZABETH SHIPPEN GREEN. 1871-1954. American.

 Green studied at the Pennsylvania Academy with Thomas
Anshutz, Thomas Eakins and Robert Vonnoh. In 1896, when she
began studying with Howard Pyle, she had already sold illustrations
to several well-known magazines. She began her career as an il-
lustrator by doing advertisements and later did drawings for chil-
dren's poems and stories. She had the responsibility of being the
sole financial support of her parents. For fourteen years she
shared studio space and a home with Violet Oakley and Jessie Will-
cox Smith. After the death of her parents in 1911, she married
the architect Huger Elliott and moved with him to Rhode Island.
Following his death in 1951 she returned to live with her Phila-
delphia friends. This trio of artists held a joint exhibition in 1902.
She was named first woman staff artist for Harper's magazine and
remained under contract with them until 1924. She especially liked
to illustrate historical books and short stories. Her work has been
described as having strong formal qualities and a subtle color
sense.

Biographical Sketches of American Artists. p. 135.
 Says that she also studied abroad for six years.

Delaware Art Museum. Studios at Cogslea. 1976.

Likos, Patt. "The Ladies of the Red Rose." Feminist Art Jour-
nal. 5 (Fall 1976):11-15 and 43.
Excellent review tracing the relationship of Green, Oakley
and Smith. Includes photograph of Green and a reproduction
of her work. The source for the above biographical informa-
tion. Likos also participated in the 1977 Annual Meeting of
the College Art Association, discussing the relationship of the
three women in a program on Women and Communal Art.

Morris, Harrison. "Elizabeth Shippen Green." The Book Buyer.
24 (March 1902):111-115.
Mentions the numerous magazines for which she did illus-
trations. Includes several good reproductions of her work.

MARY MAHONY GRIFFIN. 1871-1961. American.

Griffin was born in Chicago. She attended the Massachu-
setts Institute of Technology from September, 1890, to May, 1894,
when she received a Bachelor of Science degree in Architecture.
In 1894 she became a draftswoman in the Chicago office of her
cousin, Dwight Perkins. Between 1895 and 1909 she did a great
amount of work in the office of Frank Lloyd Wright, but also ac-
cepted commissions of her own and worked for other architects.
In 1909 she became an associate in the office of Hermann von
Holst and the designing architect of the firm. She married
architect Walter Burley Griffin in 1911. At that time she had
been an architect for seventeen years, but some claim her
work declined in individuality and merged with that of her husband.
In 1914 they moved to Australia, where they were active in com-
munity affairs. Next they moved to India, where he died in 1937.
She continued to live there while completing a commission and in
1940 returned to Chicago to work for two more decades.

Berkon, Susan F. and Kay, Jane Holtz. "Marion Mahony Griffin,
Architect." Feminist Art Journal. 4 (Spring 1975):10-14.
Excellent survey of her life and work. Discussion of her
marriage.

Brooks, H. Allen. 'Frank Lloyd Wright and the Wasmuth Draw-
ings." Art Bulletin. 48 (June 1966):193-202.
Attributed over half of the drawings in this portfolio of
Wright drawings that was published by Ernst Wasmuth in Ber-
lin in 1910 to Griffin.

Griffin, Mary Mahony. 'Democratic Architecture." Building
(Sydney). Part I (June 12, 1914):101-102 and Part II (Aug. 12,
1914):88-91.

_____. The Magic of America. Unpublished manuscript, New
York Historical Society and Chicago Art Institute.

Van Zanten, David. "The Early Work of Mary Mahony Griffin."

Prairie School Review. 3 (1966):5-23.
Chronological discussion of her early work. Describes her as "... capable only of decorative elaboration. Consistent architectural conceptualization and invention were beyond her. "

GRACE HARTIGAN. 1922- . American.

She worked with the first generation abstract expressionists and is particularly influenced by de Kooning and Pollack. She is married, with one son from a previous marriage. She is involved in teaching at Maryland Institute of Art. She was honored as a teacher by the College Art Association in 1977.

"Artists on Tape. " New York Times. (April 26, 1968).

Barber, Alan. "Making Some Marks. " Arts. 48 (June 1974):49-51.
An interview with Hartigan.

Baur, John I. H. "Eastern Artists. " Art in America. No. 1, (1954).

Friedman, B. H. , ed. School of New York: Some Young Artists. New York: Grove Press, 1959.
There is a chapter on Grace Hartigan by Emily Dennis.

Hakanson, Jay. "Robust Paintings at Hartigan Show. " The Sunday News--Detroit. (April 28, 1974).

Hartigan, Grace. "An Artist Speaks. " The Arrow. (December 9, 1960).

Hill. Women. An Historical Survey.... Catalogue, pl. 76.

Hunter, Sam. Art Since 1954. New York: Harry N. Abrams, 1959.

"Miss Hartigan and Her Canvas: The Rawness and the Vast. " Newsweek. (May 11, 1959).

Nemser. Art Talk. pp. 148-177, 363.
An excellent interview touching upon her personal history and choices as well as her work. Nemser has supplied all of the bibliography offered here.

Petersen and Wilson. Women Artists.... p. 128.

Schwartz, D. M. "Hartigan at Tibor de Nagy. " Apollo. (September 1959).

Soby, James Thrall. "Interview with Grace Hartigan. " Saturday Review. (October 1957).

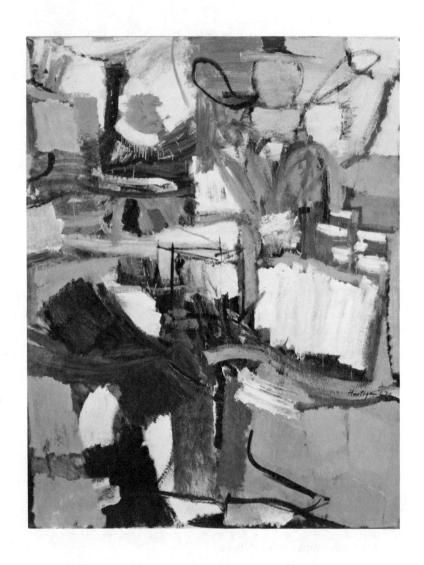

Grace Hartigan. Broadway Restaurant. 1957. Oil on canvas.
79" x 62 3/4". Nelson Gallery of Art-Atkins Museum, Kansas
City, Mo. Gift of Mr. William T. Kemper.

_____. "Non-Abstract Authorities. " Saturday Review. (April 23, 1955).

Twelve Americans. New York: The Museum of Modern Art, 1956.

"The Weather Vane. " Time. (January 3, 1964).

"Women Artists in Ascendence. " Life. (May 3, 1957).

"Women in American Art. " Look. (1960).

Collections:

Kansas City, Mo. , Atkins Museum-Nelson Gallery.
New York, Whitney Museum of American Art.
Raleigh, North Carolina Museum of Art.

BARBARA HEPWORTH. 1903-1975. English.

"In the 1930's along with Henry Moore, among others, Hepworth infused new vitality into a sculptural tradition that had been languishing since Rodin.... An extremely innovative artist who sought to incorporate open space into the solidity of the closed form, Hepworth was the first to pierce the stone in 1931 ... revitalized monumental sculpture" (quoted from Nemser, below). Her work is abstract in form, yet based on nature. She studied at Leeds, South Kensington and Rome. Her first one-woman show was in 1928. She also designed sets and costumes for theatrical productions. She was married twice; first to sculptor John Skeaping, then to painter Ben Nicholson. She and Nicholson were the parents of triplets. That marriage was dissolved in 1951.

Bownes, Alan. Barbara Hepworth--Drawings from the Sculptor's Landscape. Bath: Cory, Adams and Mackay, 1966.

_____. The Complete Sculpture of Barbara Hepworth, 1960-1969. London: Lund Humphries, 1971.
Mainly a visual resource, but has an introductory transcript of Bowness and Hepworth discussing her work.

Hammacher, A. M. Barbara Hepworth. London: Modern Sculpture Series, A. Zwemmer, 1958.

_____. Barbara Hepworth. London: World of Art Series, Thames and Hudson, 1968.
Discussion of the development of her work. Biography, illustrations, and extensive bibliography.

Hepworth, Barbara. Barbara Hepworth--A Pictorial Autobiography. Bath: Adams and Dart, 1970.

Hill. Women, An Historical Survey.... Catalogue. pl. 60, 61.

Hodin, J. P. Barbara Hepworth, Life and Work. London: Lund Humphries, 1961.

London. Marlborough Gallery. Barbara Hepworth: The Family of Man--Nine Bronzes and Recent Carvings. 1972.
Excellent color reproductions of her work from 1970 to 1972.

London. Tate Gallery. Barbara Hepworth. 1968.
Exhibition catalogue with reproductions and an important discussion of her artistic development.

Munsterberg. A History of Women Artists. pp. 90-95.

Nemser. Art Talk. pp. 12-33, 359-360; originally printed in The Feminist Art Journal. 11, no. 2 (Spring 1973):3-6, 22, as "Conversation with Barbara Hepworth. "
Nemser supplied much of the bibliography here.

New York. Marlborough Gallery. Barbara Hepworth: "Conversations. " March-April 1974.
Excellent color work. Introduced by Dore Ashton.

Petersen and Wilson. Women Artists.... pp. 120-1, 123, 124.

Read, Herbert. Barbara Hepworth, Carvings and Drawings. London: Lund Humphries, 1952.
Notes are by the artist.

Shepherd, Michael. Barbara Hepworth. London: Methuen, 1963.
Includes small statement by artist discussing her technique.

Collections:

 Baltimore, Museum of Art.
 Detroit, Institute of Art.
 New York, Museum of Modern Art.
 New York, United Nations Building.
 Raleigh, North Carolina Museum of Art.
 St. Louis, Washington University.
 Smith College Museum of Art.
 Washington, D. C., Hirshhorn Museum and Sculpture Garden.

HANNAH HÖCH. 1889- . German

 Höch studied painting in Berlin in 1914 with Orlik, working in an Impressionist style. By 1915 she was painting in an abstract style. From 1916 to 1930 she was one of the principal members of the Berlin Dada movement. Her most important works were collages and photomontages, often with a strong political commentary.

Berlin. Akademie der Künst. Hannah Höch, Collagen aus den Jahren 1916-71. 1971.

Gebhardt, Heiko and Moses, Stefan. "Ein Leban lang im Gartenhaus." Stern. (April 22, 1976):96, 99, 101, 103.

Harris and Nochlin. Women Artists, 1550-1950. pp. 58, 307-9, 359.

London. Marlborough Fine Art, Ltd. Hannah Höch. 1966. Catalogue by Will Grohman, trans. Michael Ivory.

Mehring, Walter. Berlin Dada: Ein Chronik. Zurich, 1959.

Munsterberg. A History of Women Artists. pp. 131, 132.

New York. German Cultural Institute, Goethe House. Berlin Now, Contemporary Art 1977. March 18-April 19, 1977. Höch is one of four women among fifty men represented in the show.

New York. The Museum of Modern Art. Extraordinary Women--Drawings. July 22-September 29, 1977.

Ohff, Heinz. Hannah Höch. Berlin, 1968.

_____. "Hannah Höch." Künstwerk. 17 (May 1964):41. Includes a reproduction.

Paris. Musée d'Art Moderne, and Berlin. Nationalgalerie. Hannah Höch, collages, peintures, aquarelles, gouaches, dessins. 1976. Includes: "Interview with Hannah Höch," by Suzanne Page; "Hannah Höch, ihr Werk und Dada," by Peter Krieger; and "Hannah Höch, Künstlerin im Berliner Dadaismus," by Hanna Bergius.

Petersen and Wilson. Women Artists.... p. 115.

Picard, Lil. "Hannah Höch in Berlin Now." Women Artists Newsletter. 3 (May 1977):7.

Roditi, Edouart. "Interview with Hannah Höch." Arts. 34 (Dec. 1959):24-29. Although little biographical information on Höch is included, she does recall her associations with the Berlin Dada group.

_____. "Surrealism: Jubilee or Jamboree?" Apollo. 79 (May 1964):430. Includes a black and white reproduction.

Zurich. Kunstgewerbemuseum. Collagen. 1968. Edited by Mark Buchmann and Erika Billeter.

Collections:

Berlin, National Gallery.

MALVINA HOFFMAN. 1885-1966. American.

Hoffman was the daughter of a musician and grew up in a family that encouraged her artistic ambitions. She first studied painting, then switched her interest to sculpture. She studied in New York at the Women's School of Applied Design and at the Art Students League. She studied in Paris at the Académie Colarossi and with Rodin from 1910 to 1914. She also studied anatomy at Columbia University's College of Physicians and Surgeons. In 1929 she received a commission from the Field Museum of Natural History to model racial types for a "Hall of Man" project. She traveled worldwide for two years with her husband sculpting natives in their natural environments. Anna Pavlova was a close friend, and Hoffman became the sculptural interpreter of the great dancer.

Armstrong. Two Hundred Years of American Sculpture. p. 280.

Bénézit. Dictionnaire. Vol. 4, p. 725.

Biographical Sketches of American Artists. pp. 152-153.

Bouve, Pauline C. "The Two Foremost Women Sculptors in America: Anna Vaughn Hyatt and Malvina Hoffman." Art and Archeology. 26 (Sept. 1925):77-82.

Hill. Women. An Historical Survey.... Catalogue. pl. 43.

Hoffman, Malvina. Heads and Tales. New York: Charles Scribner's Sons, 1936.
 Detailed account of her "Hall of Man" project and her career up to that point, including her studies with Rodin. Copiously illustrated.

_____. Sculpture Inside and Out. New York: W. W. Norton, 1939.

_____. Yesterday Is Tomorrow: A Personal History. New York: Crown Publishers, 1965.

Petersen and Wilson. Women Artists.... p. 84.

Proske, Beatrice. "Part I. American Women Sculptors." pp. 3-15.

Thieme and Becker. Allgemeines Lexikon. Vol. 17, pp. 275-276.

Whiting, F. A., Jr. "Malvina Hoffman." Magazine of Art. 14 (April 1937):246-247.

Collections:

Chicago, Field Museum of Natural History.
New York, The Metropolitan Museum of Art.

ANNA HYATT HUNTINGTON. 1876-1973. American.

Huntington was trained as a concert violinist, but began modeling in clay while recuperating from an illness. She studied at the Art Student's League with Herman MacNeil, Gutzon Borglum and Henry Hudson Kitson. Her first show, at age twenty-four, was of forty sculptured animal pieces at the Boston Arts Club. She continued to specialize in animal sculpture, perhaps related to the fact that her father was a professor of zoology at Harvard. She collaborated for two years with Abastenia St. Leger. In 1907-1908 she traveled and worked in Europe. In 1923 she married the philanthropist, Archer Milton Huntington. In 1931 they established and endowed the Brookgreen Sculpture Garden in Georgetown, South Carolina. Much of her work is of cast aluminum.

American Academy of Arts and Letters. New York. Catalogue of an Exhibition of Sculpture by Anna Hyatt Huntington. 1936.

Armstrong. 200 Years of American Sculpture. p. 281.
Lists her many prizes.

Bénézit. Dictionnaire. Vol. 5, p. 32.

Bouve, Pauline. "The Two Foremost Women Sculptors in America: Anna Vaughn Hyatt and Malvina Hoffman." Art and Archeology. 26 (Sept. 1925):74-77.

Eden, Myrna Garvey. Anna Hyatt Huntington, Sculptor, and Mrs. H. H. A. Beach, Pianist and Composer: A Comparative Study of Two Women Representatives of the American Cultivated Tradition in the Arts. (A Ph.D. dissertation, 1977, Syracuse University.)

Evans, Cerinda. Anna Wyatt Huntington. Newport News, Va.: The Mariners Museum, 1965.

Hill. Women. An Historical Survey.... Catalogue. pl. 38.

Hispanic Society of America. New York. Sculpture by Anna Hyatt Huntington. Oct. 15, 1956-March 5, 1958.
Introductory essay by Beatrice Proske.

Ludd, Anna Coleman. "Anna V. Hyatt--Animal Sculptor." Art and Progress. 4 (1912):773-776.

MacAgy, Jermayne. "Exhibition of Aluminum Sculpture by Anna Hyatt Huntington." Bulletin of the California Palace of the

Anna Hyatt Huntington. Joan of Arc. 12' 1/8'' x 9' 7/8'' x 3'
9 5/8''. Fine Arts Museums of San Francisco, California Palace
of the Legion of Honor. Gift of Archer M. Huntington.

Legion of Honor Museum. 2 (July 1944):24-29.

National Sculpture Society. Anna Hyatt Huntington. New York:
W. W. Norton and Co., 1947.
 Foreword by Eleanor Mellon.

Payne. "The Work of Some American Women in Plastic Art."
pp. 319-321.

Petersen and Wilson. Women Artists.... p. 84.

Proske. "American Women Sculptors."

Royère, Jean. Le musicisme sculptural: Madame Archer Milton
Huntington. Paris: Messein, 1933.

Schaub-Koch, Emile. A obra animalista e monumental de Anna
Hyatt Huntington. Portugal: Braga, 1955.

_____. L'oeuvre d'Anna Hyatt-Huntington. Paris: Editions
Messein, 1949.
 Many illustrations.

_____. Madame Anna Hyatt Huntington et la statuaire moderne.
New York: Hispanic Society of America, 1936.

_____. Vie et modelage. Lisbon: Tipografia Gaspar, 1957.
 A fairly detailed discussion of her work with a short bio-
graphical note. Includes many illustrations, not only of her
animal sculpture but of her earlier portrait busts and monu-
ments.

Smith, Bertha. "Two Women Who Collaborate in Sculpture." The
Craftsman. 9 (June/Sept. 1905):623-633.
 Discussion of the period of collaboration with St. Leger.

Collections:

 Carnegie Institute.
 New York, The Hispanic Society of America.
 New York, The Metropolitan Museum of Art.
 San Francisco, Fine Arts Museums, The California Palace of
 the Legion of Honor.

GWENDOLYN JOHN. 1876-1939. English, spent most of her ca-
reer in Paris.

 She was the sister of Augustus John, who was an enormous-
ly successful artist and the President of the Royal Academy; she,
however, lived and worked in extreme obscurity. She attended the
Slade School in 1895 and in 1898 entered Whistler's Académie Car-
men in Paris. She remained in France the rest of her life except

Gwendolyn John. Girl with Bare Shoulders. 1909-10. Oil on can-
vas. 17 1/8" x 10 1/4". Museum of Modern Art, New York.
Gift of Edgar Kaufmann, Jr.

for brief visits to England. She earned her living partially as a model. In 1903 she posed for Rodin and an intimate frienship developed between them. In 1903 she was in what was purportedly a two-person show with her brother. However, the exhibition consisted of forty-five works by him and only three by her! One of her works was in the 1913 Armory Show. The only major exhibition of her work during her lifetime was in 1936, when she was sixty. The last seven years of her life she didn't paint. The majority of her works are female figures with introspective gazes. She converted to Catholicism in 1913 and after this date painted a number of nuns and school children. She never married.

Daniels, J. "Exhibition in London." Apollo. n.s. 91 (June 1970): 43.

Edwards. Women, An Issue.

Gablick, Suzi. "Gwendolyn John." Studio International. 191 (May/June 1976):301-302.
　　Good discussion of her use of color.

Hall, D. "Acquisitions of Modern Art by Museums; Edinburgh." Burlington Magazine. 114 (April 1972):269.

Harris and Nochlin. Women Artists, 1550-1950. pp. 52, 59-60, 270-272, 355.

Hill. Women. An Historical Survey.... Catalogue. p. 23.

Holroyd, M. Augustus John: The Years of Innocence. London, 1974.

_____. Augustus John: The Years of Experience. London, 1975.

John, Augustus. Chiaroscuro. London: Cape, 1954; reprinted London: Grey Arrow, 1962.
　　His autobiography.

_____. Gwen John, 1876-1939. London: Arts Council, 1946.

_____. "Gwendolyn John." Burlington Magazine. 81 (1942): 237-238.
　　Caustic reminiscences about her dark studios, concern for her cats, and her poverty. He still calls her "... the greatest woman artist of her age...."

Maritain, Jacques. Carnet de notes (Annexe au chapetre VI: A propos de Gwendoline et Augustus John.) Paris: Desclée de Brouwer, 1965.

Melville, Robert. "Kinds of Loving." New Statesman. (Feb. 2, 1968):150.

"It is her almost desperate response to women that is inextricably involved in her devotion to painting."

New York. Davis and Long Company. Gwen John: A Retrospective Exhibition. 1975.
Introduction by C. Langdale.

Petersen and Wilson. Women Artists.... pp. 99, 100, 103, 104.

Phaidon Dictionary of Twentieth Century Art. New York: Phaidon, 1973, pp. 180-181.

Rothenstein, John. Modern English Painters--Sickert to Smith. London: Eyre and Spottiswoode, 1952.

Shone, Richard. "Gwendolyn John at Anthony d'Offay." Burlington Magazine. 118 (March 1976):175-176.
Exhibition review. Notes that Rilke was a close friend.

Taubman, Mary. Gwen John. London: The Arts Council, 1968.
A catalogue of a retrospective exhibition. It also contains an abridged version of the above short article by Augustus John. Good black and white reproductions with a full color frontispiece.

Tufts. Our Hidden Heritage. pp. 198-209.

Vaizey, Marina. "Portrait of the Artist as a Romantic Recluse." Art News. 75 (May 1976):103.
Exhibition review.

Watson, Forbes, foreword. John Quinn: 1870-1925; Collection of Paintings, Watercolors, Drawings and Sculpture. Huntington, N.Y., c.1926. p. 149.

Collections:

London, National Portrait Gallery.
London, Tate Gallery.
New York, Museum of Modern Art.
Sheffield, City of Sheffield Art Galleries.
Southampton, Art Gallery.

FRANCES BENJAMIN JOHNSTON. 1864-1952. American.

Born in Grafton, West Virginia. Went to Paris in 1883 for two years to study drawing and painting at the Académie Julien. On her return she studied at the Art Students League in Washington, D.C. Her first job was as a correspondent for a magazine and through this she developed an interest in photography for the Smithsonian Institution. Her first photos were published in 1889/90 in Demorest's Family Magazine. In 1890 she opened a studio in

Washington, D. C. for portraits. In 1899 she was commissioned to photograph the school system of Washington, D. C. and the Hampton Institute in Virginia. At the turn of the century she was one of the first news photographers in Washington. She used her art in her involvement in the women's rights and civil rights movements. She was one of the few women delegates to the International Photographic Congress in Paris where she delivered a lecture on American women photographers. She wrote a series of articles on the same subject for the Ladies Home Journal. In 1933 she began photographing architecture, concentrating on the Southern states. She was a friend of Gertrude Kasebier and a member of the New York Camera Club.

Beaton. The Magic Image. pp. 84-85.
 Good summary of her biography.

Brock, Henry Irving. Colonial Churches in Virginia. Richmond: Dale Press, 1930.
 Johnston did the photographs.

"Frances Benjamin Johnston: Her Photographs of Our Old Buildings." Magazine of Art. 30 (Sept. 1937):548-555.
 Several good reproductions of her work.

"Houses of the Old South." American Architect. 147 (Sept. 1935): 57-64.
 Photographic portfolio of her documentation of the historic architecture of Virginia.

Johnston, Frances Benjamin. The Hampton Album; 44 Photographs from an Album of the Hampton Institute. New York: Museum of Modern Art, 1966.
 Introduction and note on the photographer by Lincoln Kirstein.

_____. Mammoth Cave by Flash-Light. Washington, D. C. : Gibson Brothers, 1893.
 Twenty-five photographs by Johnston.

_____. The White House. Washington, D. C. : Gibson Brothers, 1893.
 Thirty-six illustrations by Johnston.

Munsterberg. A History of Women Artists. p. 126.

Nichols, Frederick D. The Early Architecture of Georgia. Chapel Hill: University of North Carolina Press, 1957.
 Photographs by Johnston.

Vanderbilt, Paul. "Frances Benjamin Johnston 1864-1952." Journal of American Institute of Architects. 18 (Nov. 1952): 224-228.
 In-depth discussion of her architectural photography from

1933-1940. Dates her first architectural commission from
1909, and notes that she continued for many years to photo-
graph the homes of millionaires.

Waterman, Thomas T. The Early Architecture of North Carolina.
Chapel Hill: University of North Carolina Press, 1941.
Photographs by Johnston.

Collections:

New York, Museum of Modern Art.
Washington, D.C., Library of Congress.

FRIDA KAHLO. 1910-1954. Mexican.

Frida Kahlo suffered an automobile accident at sixteen which
permanently injured her spine and broke her pelvis in three places;
injuries which made it impossible for her to bear the child she
wanted and condemned her to a series of miscarriages, hemor-
rhages and unsuccessful caesarian sections. Her physical suffer-
ing is graphically depicted in her powerful painting, in which self
portraits with anatomical motifs predominate. André Breton con-
sidered her a surrealist without theoretical background. She was
married to Diego Rivera, whose influence upon her was political
rather than artistic. He honored her by depicting her several
times in his murals and by founding the Museo Frida Kahlo in the
home they shared in Coyoacan. Eventually she was confined to a
wheel chair; and after the amputation of her leg, to bed--in which
she did her last paintings lying down. She died at the age of
forty-four. No monographic study of her production exists.

Breton, André. "Frida Kahlo de Rivera." 1938.
A brochure for the Frida Kahlo Exhibition at the Julien Levy
Gallery.

_____. Surrealism and Painting. New York: Harper and Row,
1972.
Contains the essay "Frida Kahlo de Rivera," reprinted from
above.

del Conde, Teresa. "La Pintora Frida Kahlo." Artes Visuales.
4 (October-December 1974):1-5.

Flores, Guerrero Raul. Cinco Pintores Mexicanos. Mexico City,
1957.

The Frida Kahlo Museum. A catalogue with brief notes by Diego
Rivera, Lola Olmedo de Olvera, and Juan O'Gorman. Mexico
City, 1968.

Harris and Nochlin. Women Artists, 1550-1950. pp. 59, 61, 335-
37, 361-62.

Frida Kahlo. Self Portrait with Cropped Hair. 1940. Oil on canvas. 15 3/4" x 11". Museum of Modern Art, New York. Gift of Edgar Kaufmann, Jr.

Helm, McKinley. Modern Mexican Painters. New York, 1941.

Herrera, Hayden. "Frida Kahlo, Her Life and Art." Artforum. (May 1976):38-44.
Excellent survey with good color reproductions of her work.

O'Gorman, Juan. Frida Kahlo. Mexico: Editions Miguel Galas S. A., 1970.
This is the catalogue of the Frida Kahlo Museum. In addition to a large number of her paintings, her diary is also on display there. This catalogue also contains an essay by Rivera, "Frida Kahlo and Mexican Art."

Orenstein, Gloria. "Frida Kahlo: Painting for Miracles." Feminist Art Journal. 2, no. 3 (Fall 1973):7-9.
The above biographical paragraph's content was supplied by this article, as well as all of the bibliography offered here. It is illustrated with black and white reproductions.

Petersen and Wilson. Women Artists.... pp. 4, 133, 134, 135.

Prampolini, Ida Rodrigues. El surrealismo y el arte fantastico de Mexico. Universidad Nacional Autonoma de Mexico, 1969.

Rivera, Diego (with Gladys March). My Art, My Life. New York: 1960.

Wolfe, Bertram D. The Fabulous Life of Diego Rivera. New York: Stein and Day, 1963.

Collections:

Coyoacân, Museo Frida Kahlo.
Mexico City, Museum of Modern Art.
New York, Museum of Modern Art.
San Francisco, Museum of Art.

GERTRUDE KASEBIER. 1852-1934. American.

Kasebier was born in Iowa and traveled by covered wagon to Colorado, where her father operated a goldmine. She married in 1874 and until 1888 was occupied raising her three children. For the next six years she studied portrait painting at the Pratt Institute in Brooklyn. It was not until 1893, during a trip to Paris, that she began to use a camera seriously. She opened a studio in Paris in 1894. In 1897 she went to Germany where she studied the technical aspects of photography. She then returned to New York and opened a portrait studio, doing most of the printing herself. Although she did many portraits and studies of artists, writers and Indians, some of her most important works were her soft-focus studies of mothers and children. The effects she achieved have been compared to Impressionist paintings. She was one

of the founders of the Photo-Secessionist movement in 1902. The entire first issue of Camera Work, in 1903, was devoted to her photography.

Beaton. The Magic Image. pp. 102.
Good biographical summary.

"Camera Pioneer. " Art Digest. 9 (Dec. 1, 1934):10.

Johnston, Francis B. "Photographic Work of Gertrude Kasebier. " Ladies Home Journal. 18 (May 1901):1.

Munsterberg. A History of Women Artists. pp. 123-126.

O'Mara, Jane Cleland. "Gertrude Kasebier: The First Professional Woman Photographer, 1852-1934. " Feminist Art Journal. 3 (Winter 1974/75):18-20.

Tighe, Mary Ann. "Gertrude Kasebier, Lost and Found. " Art in America. 65 (March-April 1977):94-98.

"Trade Notes and News. " American Photography. (Dec. 1934): 786.
Obituary.

Collections:

New York, Museum of Modern Art.
Washington, D. C., Library of Congress.

KÄTHE KOLLWITZ (née SCHMIDT). 1867-1945. German.

A graphic artist who along with Goya is one of the few artists ever successfully to combine social and political protest with art of universal stature. In 1891 she married Karl Kollwitz, a physician. This gave her moderate economic security but exposed her to the suffering of the poor, especially women and children. Her small studio was next to her husband's office for many years. From 1885 to 1886 she studied at a women's art school in Berlin, in 1904 in Paris, and in 1907 in Italy. Her first woodcuts were done in 1919. The loss of one of her two sons in World War I intensified her hatred of war, a theme which is greatly reflected in her work. Though the exposure of various social evils in her work had often drawn official criticism, beginning with Kaiser Wilhelm II, this trend culminated during the Nazi regime when she was purged from the faculty of the Prussian Academy of Art and her work was removed from public view throughout Germany. In addition to her drawings and printmaking, she was a sculptor.

"Anger, Sorrow, Pain and Beauty: The Work of Kollwitz. " The Berkeley Book Review. (Spring 1972).

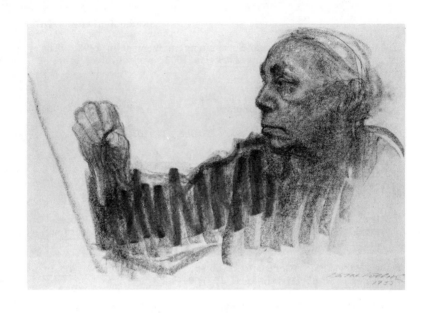

Käthe Kollwitz. Self Portrait with Charcoal (above). 1933. Char-
coal on paper. Unemployment (below). 1909. Charcoal and
opaque wash on paper. National Gallery of Art, Washington, D.C.,
Rosenwald Collection.

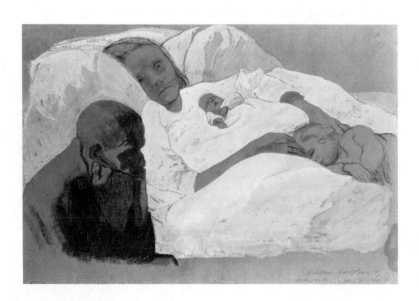

A review of the Kleins' biography of Kollwitz, below.

"Artists and the War." Freedom News. (June 1970).

Berlin. Paul Cassirer Gallery. Sonder-Ausstellung Käthe Koll-
witz zu ihrem 50. Geburtstag. 1917.

Bittner, Herbert. Käthe Kollwitz, Drawings. New York: Thomas
Yoseloff, 1959.
The bibliography on pages 17-18 includes a great many
sources that have not been included here, in particular contempo-
rary German material.

Bonus, Arthur. Das Käthe Kollwitz-Werk. Dresden, 1925.

Bonus-Jeep, Beate. Sechzig Jahre Freundschaft mit Käthe Koll-
witz. Boppard, Germany: Karl Rauch Verlag, 1948; reprint
Bremen, 1963.
An account of the author's sixty-year friendship with Koll-
witz.

Dobard, Raymond. "Subject Matter in the Work of Käthe Kollwitz:
An Investigation of Death Motifs in Relation to Traditional
Iconographic Patterns." Unpublished Ph.D. dissertation, Johns
Hopkins University, 1975.

Fanning, Robert Joseph. Kaethe Kollwitz. Karlsruhe, Germany
and New York: George Wittenborn, 1956.

Faxon, Alicia. "Käthe Kollwitz: Voice of the Sacrificed." Boston
Globe. (July 21, 1972).

Harris and Nochlin. Women Artists, 1550-1950. pp. 59, 65-67,
242, 263-65, 273, 275-76, 354.

Hill. Women, An Historical Survey.... Catalogue. p. 20.

Kearns, Martha Mary. "Book Review: Kaethe Kollwitz, Life in
Art." Feminist Art Journal. 11, no. 1 (Winter 1973).
Kearns reviews the Kleins' biography, below. She applauds
it generally but is disappointed in the lack of emphasis upon
the limitations imposed upon her as a young woman art student.

_____. Käthe Kollwitz. Old Westbury, N.Y.: The Feminist
Press, 1976.
Account of her life from a "contemporary feminist perspec-
tive." Excellent annotated bibliography.

Klein, Mina C. and H. Arthur. Käthe Kollwitz, Life in Art. New
York: Holt, Rinehart and Winston, 1972.
The first in-depth biography in English. Excellent illustra-
tions including photographs. A good selected bibliography.

Klipstein, August. Käthe Kollwitz; Verzeichnis des graphischen Werkes. Bern: Klipstein & Co., and New York: Galerie St. Etienne, 1955.
A catalogue raisonné of all her known etchings, lithographs and woodcuts.

Kollwitz, Hans, ed. Briefe der Freundschaft. Munich: List Verlag, 1966.
Hans Kollwitz is her surviving son.

_____, ed. The Diary and Letters of Kaethe Kollwitz. Chicago: Henry Regnery, 1955. Translated from German by Richard and Clara Winston.

_____. Ich sah die Welt mit liebevollen Blicken. Hannover: Fackelträger-Verlag, 1968.
"A portfolio of photographs of the artist's sculptures."

_____. Käthe Kollwitz: Das plastische Werk. Hamburg: Wegner, 1967.

_____, ed. Käthe Kollwitz Tagebucherblätter und Briefe. Berlin, 1949.

Kollwitz, Käthe. Aus meinem Leben. Munich: List Verlag, 1958.
She wrote a short memoir of her early years for her sons, published here after her death.

_____. Twenty-one Late Drawings. Boston: Boston Book and Art, 1970.

McCauseland, Elizabeth. Frau Käthe (Schmidt) Kollwitz: Ten Lithographs. New York: Henry C. Kleeman Curt Valentine, 1941.

McKay, Pauline and Barris, Roan. "Kaethe Kollwitz: Her Life and Art, 1967-1945." Herself. (September 1972).

Melville, Robert. "Good Grief." New Statesman. (December 8, 1967).

Munich. Käthe Kollwitz, Handzeichnungen und graphische Seltenheiten, eine Ausstellung zum 100. Geburtstag. 1967.
Catalogue by A. vonder Beche.

Munsterberg. A History of Women Artists. pp. 109-115.

Nagel, Otto. Die Selbstbildnisse der Käthe Kollwitz. Berlin: Henschelverlag, 1965.
"The complete cycle of the artist's self-portraits from 1885 to 1943."

_____. Käthe Kollwitz. Greenwich, Conn.: New York Graphic Society, 1971.

_____. Käthe Kollwitz: Die Handzeichnungen. Berlin, 1972.

New York. Marlborough Galleries. Ernst Barlach, Käthe Kollwitz.
 Nov. -Dec. 1967.
 Exhibition catalogue with introduction by Wolfgang Fischer.
 Many black and white reproductions of sculpture, drawings,
 graphics.

New York. St. Etienne Gallery. Memorial Exhibition, Käthe Koll-
 witz. 1945.

Northampton. Smith College. Käthe Kollwitz. 1958.
 Catalogue by Leonard Baskin.

Nundel, Harri. Käthe Kollwitz. Leipzig: Bibliographisches Insti-
 tut, 1964.

Petersen and Wilson. Women Artists. pp. 116-119.

"Reviews and previews...." Art News. (January 1971).
 The twenty-fifth anniversary of her death and the occasion
 of a major retrospective at the St. Etienne Gallery.

St. Paul. Minnesota Museum of Art. Exhibit of Graphic Work by
 Käthe Kollwitz from the Permanent Collection. September 26-
 November 10, 1973.
 Beautiful design and reproduction!

Schmalenbach, Fritz. Käthe Kollwitz. Königstein im Taunus,
 Germany: K. R. Langewiesche, 1965.

Shikes, Ralph E. The Indignant Eye: The Artist as Social Critic
 in Prints and Drawings. Boston: Beacon Press, 1969.

Sievers, Johannes. Die Radierungen und Steindrucke von Käthe
 Kollwitz innerhalf der Jahre 1890 bis 1912. Dresden, 1913.

Thieme and Becker. Allgemeines Lexikon. Vol. 21, pp. 245-247.

Tufts. Our Hidden Heritage. pp. 178-187.

Weltenkampf, Frank. "Some Women Etchers." Scribner's Maga-
 zine. 46 (Dec. 1909):731-739.

Zigrosser, Carl, ed. Kaethe Kollwitz. New York: Bittner, 1946.

_____, ed. Prints and Drawings of Käthe Kollwitz. New York:
 Dover Publishing, 1951.

Collections:

 Belgium, Roggevelde Soldiers' Cemetery.
 Berlin, Staatliche Museum.

Cologne, Rheinisches Bildarchiv.
Harvard University, The Fogg Museum.
Los Angeles, County Museum of Art.
Palo Alto, Stanford University Art Museum.
Washington, D.C., National Gallery of Art.

LEE KRASNER. 1908- . American.

Krasner was born in Brooklyn. She attended the Cooper Union and the National Academy of Design. From 1938 to 1940 she studied with Hans Hoffman. She is an abstract expressionist painter. As the widow of Jackson Pollock, Lee Krasner has been arbitrarily dismissed as only a follower of her husband. Though he was certainly the major influence upon her development, she too was involved in an exploration of the unconscious in the years between 1943 and 1946. After three years of slabs of grey paint, what she calls her "little image" finally emerged in 1946. As Mrs. Pollock she has paid quite a price--her work was not shown until 1951, she was asked to leave the Parsons Gallery when Pollock left it and she generally had to contend with being considered a wife rather than a serious artist. Nemser praises the continuity of her development with its rich variety. She is still an active painter.

Campbell, Lawrence. "Of Lilith and Lettuce." Art News. 67 (March 1968):42-43 and 61-64.
 Good color reproductions. Chronologic analysis of her work. Emphasizes the influence she had on Pollock.

Friedman, B. H. Lee Krasner: Drawings and Collages. London: Whitechapel Art Gallery, 1965.

_____. "Manhattan Mosaic." Craft Horizon. 19 (Jan./Feb. 1959):26-29.
 Discusses a mosaic done by Krasner and Ronald Stein.

Harris and Nochlin. Women Artists, 1550-1950. pp. 64, 331-33, 361.

Hill. Women. An Historical Survey.... Catalogue. p. 44.

Nemser, Cindy. Art Talk. pp. 80-111, 361-362.
 We have derived the above biographical paragraph and the bibliography presented here from Nemser's excellent interview of Krasner.

_____. "A Conversation with Lee Krasner." Arts Magazine. XLVII, no. 6 (April 1973):48.

_____. "The Indomitable Lee Krasner." Feminist Art Journal. 4 (Spring 1975):4-9.

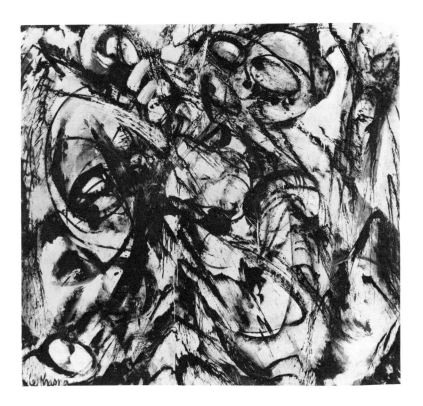

Lee Krasner. The Guardian. 1960. Whitney Museum of American Art, New York.

_____. "Lee Krasner's Paintings, 1946-49." Artforum. (December 1973).
Discussion of a major group of Krasner's paintings, works she calls her "little image" paintings. Analysis of these works stylistically and assessment of their relation to the contemporary works of Pollock, Tobey and Gottlieb.

New York. Marlborough Gallery. Lee Krasner, Recent Paintings. 1973. Catalogue.

New York. Marlborough-Gerson Gallery. Lee Krasner. 1968. Catalogue.

New York. Museum of Modern Art. Extraordinary Women--Drawings. July 22-September 29, 1977.

New York. Whitney Museum of American Art. Lee Krasner: Large Paintings. 1973. Catalogue by Marcia Tucker.

Petersen and Wilson. Women Artists.... p. 128.

Robertson, Bryan. "The Nature of Lee Krasner." Art in America. (November-December 1973):83-87.

Rose, Barbara. "American Great: Lee Krasner." Vogue. CLIX (June 1972):118-121, 154.

Washington, D.C., Corcoran Gallery of Art. Lee Krasner: Collages and Works on Paper, 1933-1974. 1975.
　　Essay by Gene Baro.

Wasserman, Emily. "Lee Krasner in Mid-Career." Artforum. (March 1968).

Collections:

　　New York, Marlborough Gallery.
　　New York, Whitney Museum of American Art.

DOROTHEA LANGE. 1895-1965. American.

　　Lange was born in Hoboken, New Jersey. In 1917 she enrolled in a photography course taught at Columbia by Clarence White. Her early work was also influenced by Arnold Genthe, who acted as her critic. In 1919 she opened a portrait studio in San Francisco and the following year married painter Maynard Dixon. During the 1930's she did photography for the California State Emergency Relief Administration and the Farm Security Administration and became increasingly interested in documentary photography. In the 1950's she contributed several photo-essays to Life. The uncompromising realism of her photographs of the poor and of migrant workers was responsible for bringing their plight to public attention.

Beaton. The Magic Image. pp. 168-169.

Dixon, Daniel and Lange, Dorothea. "Photographing the Familiar." Aperture. 1 (1952):4-15 and 68-72.

Elliott, George. Dorothea Lange. New York: Museum of Modern Art, 1966.
　　Exhibition catalogue with extensive bibliography and detailed chronology.

Fort Worth. Amon Carter Museum. Dorothea Lange Looks at Country Women. 1967.
　　A photographic essay with works dating from 1930's to 1950's. Commentary by Beaumont Newhall.

Lange, Dorothea and Jones, Pirkle. "Death of a Valley." Aperture. 8 (1960).
 Entire issue devoted to photo-essay of the change of a farm valley into a reservoir.

_____ and Taylor, Paul. An American Exodus: A Record of Human Erosion. New York: Reynal and Hitchcock, 1939.

Munsterberg. A History of Women Artists. pp. 133-135.

Newhall. History of Photography. pp. 146, 148 and 150.

Van Dyck, W. "The Photographs of Dorothea Lange, A Critical Analysis." Camera Craft. 41 (Oct. 1934):461-467.

Collections:

 Oakland, Museum of Art.
 Washington, D.C., Library of Congress.

MARIE LAURENCIN. 1885-1956. French.

 She studied at the Ecole de Sèvres and the Académie Humbert. She was a friend of Apollinaire and was introduced by him into cubist circles. Gertrude Stein bought her work. She exhibited for the first time in the Salon des Indépendents in 1906. Her brief marriage to a German shortly before World War I forced her to wait out the war in Spain. Her work consisted of paintings that depicted a dreamy private fantasy world of ladies, animals and birds. They are so distinctive that they cannot be mistaken for those of anyone else. She was also involved in theatre design and book illustration.

Allard, Roger. Marie Laurencin. Paris, 1921.

Apollinaire, Guillaume. Apollinaire on Art: Essays and Reviews, 1902-1918. New York, 1972.
 Edited by LeRoy C. Breunig, translated by Susan Suleiman.

Crowninshield, Frank. Catalogue. New York: Findlay Galleries, 1937.

Day, George (pseud.). Marie Laurencin. Paris, 1947.

Dorival, Bernard. The School of Paris in the Musée d'Art Moderne. New York: Harry N. Abrams, 1962.
 Reproductions of her work.

_____. Twentieth Century Painters. New York: Universe Books, 1958.
 Reproductions.

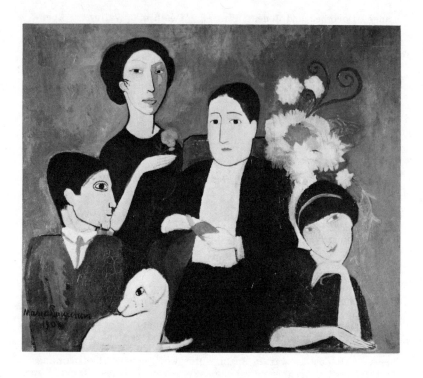

Marie Laurencin. Group of Artists. 1908. Oil on canvas.
24 3/4" x 31 1/8". Baltimore Museum of Art, Cone Collection.

Fabre-Favier, Louise. Souvenirs sur Guillaume Apollinaire. Paris, 1945.

Gray, C. "Marie Laurencin and her Friends." Baltimore Museum of Art, News. 21 (Feb. 1958):6-15.

Harris and Nochlin. Women Artists, 1550-1950. pp. 58, 260, 295-96, 357-58.

Laboureur, Jean-Emile. "Les estampes de Marie Laurencin." L'art d'aujourd'hui. I, no. 4 (Autumn-Winter 1924):17-21.

Laurencin, Marie. Le carnet des nuits. Geneva, 1956.

Lethève, Jacques; Gardey, Françoise; and Adhémar, Jean. "Marie Laurencin." In Bibliothèque Nationale du fonds français après 1800. Paris, 1965.

Marie Laurencin. Paris, 1928.
 Preface by Marcel Jouhandeau.

Mathey. Six femme peintres.

Munsterberg. A History of Women Artists. pp. 65-67.

Neilson. Seven Women.... pp. 125-143.
 The information in the biographical paragraph and most of
 the bibliography here is supplied in the Neilson's book.

"Obituary." Art News. (July 1956).

"Obituary." Arts. (July 1956).

"Obituary." New York Times. (June 9, 1956).

Petersen and Wilson. Women Artists.... pp. 97, 104, 106-107.

Phaidon Dictionary of Twentieth Century Art. New York: Phaidon,
 1973, p. 211.

Reynal, Maurice. Modern French Painting. New York: Brentano,
 1928; reprinted Tudor Publishing, 1934.

Sanouillet, Michel. Francis Picabia et "391." 2 Vols. Paris,
 1928.

Steegmuller, Francis. Apollinaire: Poet Among Painters. New
 York, 1963.

Strasbourg. Ancienne Douanne. Les Ballets Russes de Serge de
 Diaghilev 1909-1929. 1969. pp. 204-7.

Tokyo. Isetan Gallery. Marie Laurencin. 1971.

Wedderkop, H. von. Marie Laurencin. Leipzig, 1921.

Collections:

 Baltimore, Museum of Art.
 Boston, Museum of Fine Arts.
 Kansas City, Mo., Atkins Museum-Nelson Gallery.
 London, Tate Gallery.
 New York, Museum of Modern Art.
 Philadelphia, Museum of Art.
 Smith College Museum of Art.
 Washington, D. C., National Gallery of Art.

MARISOL. 1930- . American.

 Marisol dropped her last name, Escobar. She was born in

Marisol. <u>Women and Dog</u>. Whitney Museum of American Art, New York.

Paris to Venezuelan parents. She came to the United States in 1950. From 1951 to 1954 she studied painting with Hans Hoffman. She then switched to her own unique sculptural style, which she has exhibited regularly in New York since the early 1960's. Her sculpture is done in different media--wood, terra-cotta, welded metal. Her sculpture is figurative, often in classical settings or frontal poses. She frequently uses castings or tracings of various parts of her own body in her work. Her art is usually described as a form of Pop art, with satirical, mysterious overtones. She co-starred in Andy Warhol's film <u>The Kiss</u>.

Campbell, Lawrence. "Marisol's Magic Mixtures. " <u>Art News</u>.
 63 (March 1964):38-41.
 Stylistic analysis and discussion of her techniques. Color
 reproductions.

"The Dollmaker." " Time. 85 (May 28, 1965):80-81.
 Color reproductions.

Glueck, Grace. "It's Not Pop, It's Not Op--It's Marisol. " New
 York Times Magazine. March 7, 1965.

Hill. Women. An Historical Survey.... Catalogue. pl. 81.

Loring, John. Marisol: Prints 1961-1973. New York: New
 York Cultural Center, 1973.

_____. "Marisol's Diptych Impressions, Tracings, Hatchings. "
 Arts. 47 (April 1973):69-70.
 Discusses her sculpture and her print-making.

Munsterberg. A History of Women Artists. pp. 97 and 101.

Nemser, Cindy. Art Talk. pp. 179-199 and 363-364.

_____. "A Conversation with Marisol. " Feminist Art Journal.
 2 (Fall 1973):1, 3-6.

New York. Sidney Janis Gallery. Marisol. May 3-31, 1973.
 Exhibition catalogue with several black and white reproduc-
 tions.

_____. New Drawings and Wall Sculpture by Marisol. March
 5-29, 1975.

O'Doherty, Brian. "Marisol: The Engima of the Self-Image. "
 New York Times. June 21, 1973.

Schjeldahl, Peter. "Marisol: A Humorist in Three Dimension. "
 New York Times. June 21, 1973.

Collections:

 Buffalo, Albright-Knox Art Gallery.
 Memphis, Brooks Memorial Art Gallery.
 New York, Museum of Modern Art.
 New York, Whitney Museum of American Art.

AGNES MARTIN. 1912- . American.

 Martin is a native of Canada. She came to the United
States in 1932 and obtained citizenship in 1940. She has lived and
worked periodically in New York. In the late 1940's she taught at
the University of New Mexico. Her first one-woman show was in
1958. She has also done some writing and her unpublished manu-
scripts are at the Institute of Contemporary Art of the University
of Pennsylvania. Around 1959/60 she began doing her grid works.
These are covered square canvases with over-all grids penciled on

monochrome oil or acrylic backgrounds. In 1967 she abruptly left New York for New Mexico and ceased painting.

Alloway, Lawrence. "Agnes Martin." Artforum. 11 (April 1973): 32-37.
 Discusses the developmental changes within the uniform fields set up by her grids. One color reproduction.

_____. Agnes Martin. Philadelphia: Institute of Contemporary Art, University of Pennsylvania, 1973.
 This is the catalogue of an exhibition of her work, shown Jan. 22-March 1, 1973. The essay is by Alloway. Written statements by the artist are included.

_____. "Formlessness Breaking Down Form: The Paintings of Agnes Martin." Studio International. 185 (Feb. 1973):61-63.
 Discusses her grid works, pointing out the importance of her titles to our perceptions of the work.

Barron, Stephanie. "Giving Art History the Slip." Art in America. 62 (March 1974):80-84.
 Résumé of Coenties Slip, a Manhattan warehouse district that was home to a group of artists between 1954-1964, including Martin. Summarizes the art produced there and the interrelationships of the artists. Between 1959 and 1961 Martin did some sculptural assemblages, one of which is illustrated.

Borden, Lizzie. "Early Work." Artforum. 11 (April 1973):39-44.
 Recounts Martin's early life and discusses the abstract, biomorphic form her art took before the grid works.

Elderfield, John. "Grids." Artforum. 10 (May 1972):52-59.
 Discussion of several artists utilizing the grid approach with a brief mention of Martin. Includes a good color reproduction of her Night Sea.

Linville, Kasha. "Agness Martin: An Appreciation." Artforum. 9 (June 1971):72-73.
 Discusses stylistic changes in Martin's work.

Martin, Agnes. "Reflections." Artforum. 11 (April 1973):38.
 Brief personal statement concerning her view of art and its role in life.

_____. "The Untroubled Mind." Studio International. 185 (Feb. 1973):64-65.
 Collection of statements by the artist.

Michelson, Annette. "Agnes Martin: Recent Paintings." Artforum. 5 (Jan. 1967):46-47.
 Description of her grid paintings.

Petersen and Wilson. Women Artists.... p. 27.

Ratcliff, Carter. "Agnes Martin and the Artificial Infinite." Art News. 72 (May 1973):26-27.
Summarizes the biographical facts.

Who's Who in American Art, 1976. New York: R. R. Bowker, Co., 1976. p. 367.

Wilson, Ann. "Agnes Martin. The Essential Form: The Committed Life." Art International. 18 (Dec. 1974):50-52.
Poetic analysis of her art, drawing on the New Mexico atmosphere for background. Illustrated with drawings by Martin.

_____. "Linear Webs." Art and Artists. 1 (Oct. 1966):48.
Discusses her use of the fabric of the canvas; includes quotes by the artist.

Collections:

Poughkeepsie, Vassar College Art Gallery.

MARIA MARTINEZ. 1887- . Native American.

Martinez, a full-blooded Pueblo Indian, was born in San Ildefonso, New Mexico. Part of her girlhood was spent at St. Catherine's Indian School in Santa Fe. She married and became economically secure through mastery of the Pueblo craft of pottery. While her husband Julian worked closely with her, he also held odd jobs and was plagued with a drinking problem. He died in 1943. Between 1908 and 1912 they were working on a small scale, trying to develop pottery as a home industry. Most of the pottery in this period was decorated by Julian. Maria was employed at the Museum of New Mexico as a pottery demonstrator. Around 1919 they rediscovered the black-on-black method of pottery and helped San Ildefonso develop pottery-making into a full time industry.

Bahti, Tom. An Introduction to Southwestern Indian Arts and Crafts. Flagstaff, Ariz.: K. C. Publications, 1964.

Ball, Charlotte, ed. Who's Who in American Art. Vol. 3, 1940-1941. Washington, D.C.: American Federation of the Arts, 1940, p. 423.
Martinez exhibited at the 1934 Chicago Century of Progress Exhibition and taught pottery to girls in her village.

"Best--Stone and Clay." Newsweek. 43 (April 26, 1954):95.
Martinez won the A.I.A. fine arts metal in craftsmanship.

Covarrubias, Miguel. The Eagle, the Jaguar, and the Serpent: Indian Art of the Americas. New York: Alfred A. Knopf, 1954. pp. 229-230.

Grothe, Carl. Pueblo Pottery Making. A Study at the Village of San Ildefonso. New Haven: Yale University Press, 1925.

Marriott, Alice. Maria: The Potter of San Ildefonso. Norman: University of Oklahoma Press, 1948.
 Popularized biography that contains good chronology, but unfortunately has no photographs.

Munsterberg. A History of Women Artists. pp. 5, 6.

Collections:

New York, Museum of the American Indian.

JOAN MITCHELL. 1926- . American.

 Mitchell was born in Chicago to a socially prominent family. She was educated at Smith College and the Chicago Art Institute. She spent two years working in Europe and from 1950 to 1955 she lived in New York. Since 1955 she has lived in France with the Canadian artist Jean-Paul Riopelle. She is an action painter, creating abstract landscape space, using a primary palatte.

Harithas, James. "Weather Paint." Art News. 71 (May 1972): 40-43 and 63.
 Good summary of the stylistic evolution of her work. Argues against evaluating her work as a second-generation abstract-expressionist. Includes two good color reproductions.

Johnson, Ellen. "Is Beauty Dead?" Oberlin College Bulletin. 20 (Winter 1963):57-59.
 Review of an exhibition "Three Young Americans," that included Mitchell.

Munsterberg. A History of Women Artists. p. 77.

Nemser, Cindy. "An Afternoon with Joan Mitchell." Feminist Art Journal. 3 (Spring 1974):5-6 and 24.
 More an analysis of the personality of Mitchell than an evaluation of her work.

Petersen and Wilson. Women Artists.... p. 129.

Sandler, Irving. "Mitchell Paints a Picture." Art News. 56 (Oct. 1957):44-47 and 69-70.
 Examination of Mitchell's technique of painting.

Schneider, Pierre. "From Confession to Landscape." Art News. 67 (April 1968):42-43 and 72-73.
 Convoluted analysis of her work, but does include a good color reproduction. Notes that "... nothing discloses that it was painted by a woman." (!)

Joan Mitchell. The Clearing. Whitney Museum of American Art, New York.

Tucker, M. <u>Joan Mitchell</u>. New York: Whitney Museum, 1974.

<u>Collections</u>:

Washington, D.C., Hirshhorn Museum and Sculpture Garden.

BARBARA MORGAN. 1900- . American.

Morgan grew up in Southern California. She majored in art at UCLA, beginning as an abstract painter. She married a photographer and began working with photography after the birth of her children. Her most important work consists of photomontages of movement with a special interest in dance photography.

Beaton. <u>Magic Image</u>. p. 173.

Hering, Doris. "Barbara Morgan." <u>Dance Magazine</u>. 45 (July 1977):43-56.
 Excellent analysis of her dance photography from 1935 to 1945, with many reproductions of her work.

Morgan, Barbara. <u>Aperture</u>. 11, no. 1 (1964):1-44.
 Entire issue designed and written by Morgan--a monograph on herself.

_____. <u>Barbara Morgan</u>. Fort Worth: Amon Carter Museum, 1972.
 Lists her exhibitions.

_____. "In Focus: Photography, the Youngest Visual Art." <u>Magazine of Art</u>. 35 (Nov. 1942):248-255.
 Discusses the aesthetics of photography.

_____. <u>Martha Graham, Sixteen Dances in Photographs</u>. New York: Duell, Sloan, and Pearce, 1941.

_____. <u>Summer's Children</u>. Scarsdale, N.Y.: Morgan and Morgan, 1951.

Newhall. <u>History of Photography</u>. pp. 158-159.

JULIA MORGAN. 1872-1957. American.

Morgan was a prolific architect, working in California. She designed over seven hundred buildings, including a number for William Randolph Hearst. Bernard Maybeck was a friend and influence on her work. In 1894 she became the first woman to earn a degree in engineering at the University of California. In 1902 she was the first woman to receive a degree from L'Ecole des Beaux Arts in France.

"Covered Walkway for an Uncloistered Complex. " Interiors. 130
(Jan. 1971):86-89.
Discusses the modern incorporation of a student-faculty
center at Mills College utilizing the original 1916 student union
designed by Morgan.

Molten, Philip L. "Asilomar. " Architectural Review. 157 (Feb.
1975):123-124.
Brief review of her group of buildings at Asilomar Confer-
ence grounds at Pacific Grove, California.

Steilberg, W. T. "Some Examples of the Work of Julia Morgan. "
Architect and Engineer of California. 55 (1918):39-107.

Woodbridge, Sally. "Preservation: St. John's. " Architectural
Forum. 139 (Sept. 1973):18.
Account of the threatened 1908 Berkeley Church.

ANNA MARY ROBERTSON MOSES (GRANDMA MOSES). 1860-1961.
American.

Moses was born in Greenwich, New York. She was self-
taught and didn't begin painting until age seventy-eight. Her work
was first exhibited in a 1939 exhibition of unknown American artists.
She had her first one-woman show that same year. Her "primi-
tive" works were done from memory, usually of rural scenes and
landscapes. She had ten children.

Armstrong, William. Barefoot in the Grass: The Story of Grand-
ma Moses. Garden City, N.Y.: Doubleday and Co. , Inc. ,
1970.

Ebert. American Folk Painters. p. 211.

Kallir, Otto. Grandma Moses: American Primitive. Garden City,
N.Y. : Doubleday and Co. , Inc. , 1946.
Includes forty reproductions with commentaries by the artist.

Moses, Anna Mary. My Life's History. Edited by Otto Kaller.
New York: Harper and Bros. , 1952.

New York. Galerie St. Etienne. Grandma Moses. 1957.
A New York showing of works that were exhibited in Europe
during 1955-57. Includes a selection of reviews by the Euro-
pean press.

_____. My Life's History. 1960.
An exhibition assembled on the occasion of the artist's 100th
birthday. Black and white reproductions are accompanied by
quotes from her autobiography.

Seckler, Dorothy. "The Success of Mrs. Moses. " Art News. 50

(May 1951):28-29 and 64-65.
Attributes her success partially to an American nostalgia for the rural past.

GABRIELE MÜNTER. 1877-1962. German.

A member of the Blue Rider. She and Wassily Kandinsky lived together for approximately fourteen years, from 1903 to 1917. He had originally been her teacher. Münter's work appeared in the first and second Blue Rider shows. While Kandinsky experimented with the purely abstract, Münter continued to paint from life. Near the time that their "marriage" broke up, Kandinsky wrote a twenty-one page article in which he praised her one-woman show. (We have not been able to find this article.) After they parted, her work seemed to falter for some years. In 1937 her work was removed from the walls of the Munich Art Association; she painted secretly throughout the balance of World War II. She continued painting up until her death.

Buchheim, Lothar-Günther. Der blaue Reiter und die "Neue Kunstlervereinigung." Munich: Feldafing, 1959.

Eddy, Arthur Jerome. Cubists and Post Impressionists. Chicago, 1914.
 In which he says, "Gabriele Münter has a vision of things quite her own, a sense of humor and of life that penetrates beneath the surface, and that manifests itself in a technique that is, one might almost say, nonchalant." This is a good example of what Nemser discusses as "phallic criticism" in "Stereotypes and Women Artists" (cited in the periodical section).

Eichner, Johannes. Kandinsky und Gabriele Münter vom Ursprüngen moderner Kunst. Munich, 1957.
 Eichner and Münter lived together from the late 1920's until his death.

Erlanger, Liselotte. "Gabriele Münter: A Lesser Life?" Feminist Art Journal. III, no. 4 (Winter 1974-1975):11-13, 23.
 This article has supplied the information for the above bibliographical paragraph and most of the bibliography offered here.

Fleisher. "Love and Art."

Gollek, R. Der Blaue Reiter im Lenbachhaus München. Munich, 1974. pp. 220-246.

Grohman, Will. Wassily Kandinsky. Cologne, 1958.

Handler, Von Holten. German Painting in Our Time. Berlin, 1956.

Gabriele Münter. Portrait of a Young Woman. 1909. Oil on canvas. 19" x 27 5̅/̅8̅". Milwaukee Art Center. Gift of Mrs. Harry Lynde Bradley.

Harris and Nochlin. Women Artists, 1550-1950. pp. 58, 59, 95, 281-83, 355-56.

Hill. Women. An Historical Survey.... Catalogue. p. 25.

Lahnstein, Peter. Münter. Ettal, 1971.
Though the text is in German, the magnificent color plates make this a good introduction to Münter.

London. Marlborough Fine Art, Ltd. Gabriel Münter: Oil Paintings, 1903-1937. 1940.

Munich. Stadtische Galerie im Lenbachhaus. Der Blaue Reiter. 1966.
An enormous exhibit catalogue with many color reproductions of Munter's paintings.

Munich. Städtische Galerie im Lenbachhaus. Gabriele Münter, 1877-1962. 1962.

Munsterberg. A History of Women Artists. pp. 69-70, 118.

Neigemont, Olga. German Expressionists, The Blue Rider School. New York: Crown Publishing Co., n.d.
One of the ten color plates is Münter's.

New York. Leonard Hutton Galleries. Der Blaue Reiter. February 19-March 30, 1963.
In addition to Münter this catalogue also presents another woman in the Blue Rider, Marianna von Werefkin, a Russian (1860-1938). There are nine reproductions of Werefkin's paintings.

New York. Leonard Hutton Galleries. Gabriele Münter, 1877 to 1962, Fifty Years of Her Art, Paintings: 1906-1956. March-April 1966.

Petersen and Wilson. Women Artists.... pp. 104, 107-8.

Roditi, Edouard. "Interview with Gabriele Münter." Arts. 34 (Jan. 1960):39.

Rothel, Hans Konrad. Gabriele Münter. Munich, 1957.

Selz, Peter. German Expressionistic Painting. Berkeley, 1957.
A short mention of Münter.

Werner, Alfred. "Gabriele Münter: Naive Genius." American Artist. 39 (Jan. 1975):54-59 and 82-83.
Excellent summary of her life and work. Good color reproductions.

Wingler, Hans Maria. Der Blaue Reiter. Feldafing, 1954.

Collections:

Milwaukee Art Center.
Munich, Städtische Galerie.
Munich, Lenbachhaus.
New York, Leonard Hutton Gallery.

ALICE NEEL. 1900- . American.

She is primarily a painter of portraits, though her oeuvre
has included other figurative work as well. Hers is a direct ex-
pressionistic mode involving both the linear and the painterly. Her
focus is harsh and penetrating, the resulting portraits are often
excruciating in their perception. Her copies of subjects has oc-
casionally been innovative--pregnant women or naked men. She
received her formal art education at the Philadelphia School of
Design for Women (now Moore College). She married a Cuban and
moved with him to Cuba to bear her first child and to have her
first exhibit. Upon their return to New York in 1928 their daughter
died of diphtheria. A second daughter was born and was left by her
father in Cuba on his way to Europe. Neel suffered a nervous
breakdown which kept her from working for a year. She and her
daughter were separated for several years. Next followed an inte-
resting succession of lovers and the birth of two sons. Through-
out those years, the 30's, Neel worked for the WPA to support
herself and her children. She continued her "collection of souls,"
as she terms her painting, all through the most critically indiffer-
ent years; and has received recognition late in her life. She con-
tinues to paint today.

Alloway, Lawrence. "Art." The Nation. (March 9, 1974).

Art Digest. (January 1, 1951):17.

Art News. (March 15, 1944):20.

The Art Quarterly. (Summer 1961):129-145.

Berliner, David C. "Women Artists Today." Cosmopolitan.
(October 1973):218.

Berrigan, Ted. "The Portrait and Its Double." Art News.
(January 1966):30-33.

Bochner, Mel. Arts. (March 1966):55.

Bonosky, Phillip. "Alice Neel Exhibits Her Portraits of the
Spirit." Daily World. (Fall 1973):8.

Campbell, Lawrence. Art News. (December 1960):13.

Canaday, John. The New York Times. (January 8, 1966):21.

Cochrane, Diane. "Alice Neel: Collector of Souls." American Artist. 37 (September 1973):32-37, 63-64.
 Neel is also the cover artist.

Crehan, Hubert. "A Different Breed of Portraitist." San Francisco Sunday Examiner and Chronicle. (March 7, 1971): "This World" section.

_____. "Introducing the Portraits of Alice Neel." Art News. (October 1962):44-48.

Elgon, John. "Painting People Finally Won Her Acclaim." East African Standard. (June 21, 1972).
 This paper is located in Nairobi, Kenya.

Gruen, John. Close Up. New York: Viking Press, 1968. pp. 144-146.

Halasz, Piri. "Alice Neel: I Have This Obsession with Life." Art News. (January 1974).

Harris and Nochlin. Women Artists, 1550-1950. pp. 323-24, 360.

Henry, Gerrit. "New York." Art International. (Christmas 1970):77.

Hill. Women. An Historical Survey.... Catalogue. p. 55.

Kramer, Hilton. The New York Times. (October 24, 1970):25.

Krebs, Patricia. "Portrait Painter Tracks Down Her Sitters." Greensboro Daily News. (October 28, 1973):B, 12.

Leslie, Alfred. The Hasty Papers, A One-shot Review. New York, 1960.

Levin, Kim. Art News. (October 1963):11.

Loercher, Diana. "Alice Neel, American Portraitist." The Christian Science Monitor. (March 4, 1974):F6.

_____. "One-Man Shows Liven N.Y. Galleries." The Christian Science Monitor. (October 11, 1973):16.

Mainardi, Patricia. "Alice Neel at the Whitney Museum." Art in America. 62, no. 3 (1974):107-108.

_____, ed. "Talking About Portraits." Feminist Art Journal. III, no. 2 (Summer 1974):13-16, 19.
 A group interview of Marcia Marcus, Patricia Mainardi and Alice Neel conducted by Judith Vivell.

Mellow, James R. "Art: Focusing on Works by Women." The

New York Times. (January 14, 1973).
A review of the "Women Choose Women" show at the New York Cultural Center, see the catalogue section.

Nemser, Cindy. Alice Neel, the Woman and Her Work. Athens, Georgia: Museum of Art, the University of Georgia, September 7-October 19, 1975.
A huge catalogue, unfortunately only printed in black and white. The preface is by William D. Paul, Jr. Nemser's essay is titled, "Alice Neel--Teller of Truth." Her comments are enlivened by her description of Neel persuading her and her husband Chuck to pose for their portrait nude, which they did. Statements by Raphael Soyer, Dorothy Pearlstein and Neel herself are included. There are eighty-three full-page reproductions and a selected chronology and bibliography.

_____. Art Talk. pp. 112-147, 362.
Nemser's in-depth interview supplied most of the specifics in the biographical paragraph.

_____. "Portraits of Four Decades." Ms. (October 1973):48-53.

Newsweek. (January 31, 1966):82.

Nochlin, Linda. "Some Women Realists." Artsmagazine XLVIII, no. 8 (May 1974):29ff.

Perreault, John. Art News. (January 1968):16.

_____. "Art, Alice Neel Show." Village Voice. (February 21, 1974).

_____. "Reading Between the Face's Lines." Village Voice. (September 27, 1973):27.

Petersen and Wilson. Women Artists.... p. 136.

Peterson, Valerie. "U.S. Figure Painting." Art News. (Summer 1962):38.

Raynor, Vivian. Arts. (October 1963):58-59.

Solomon, Elke Morger. Alice Neel. New York: Whitney Museum of American Art, (February-March 1974).
The modest catalogue of her small retrospective exhibit.

Time. (August 31, 1970).
Neel's cover portrait of Kate Millett.

Collections:

New York, Graham Gallery.

Louise Nevelson. <u>End of Day Nightscape IV.</u> 1973. Wood and
black paint. 95" high x 167" wide x 7" deep. Nelson Gallery of
Art-Atkins Museum, Kansas City, Mo. Gift of the Friends of Art.

LOUISE NEVELSON (née BERLIAWSKY). 1899- . American,
 born in Kiev, Russia.

 Possibly the greatest twentieth-century sculptor, certainly
one of the greats. She was raised in Maine and married Charles
Nevelson at the age of twenty-one. They had a son, Mike. She
studied art during her marriage, which ended in divorce in 1931.
She studied both performing and visual arts. From 1929 to 1930
she was at the Art Students League of New York. She studied
with Hoffman in Munich in 1931 and in 1932 at the Art Students
League. Later she was one of Rivera's assistants. She worked
in poverty and isolation throughout the thirties and forties; most of
her early work is lost due to her inability to afford to store it.
Her first one-woman show was held in 1941 by the Nierendorf Gal-
lery in New York. Her early work was in a Cubist vein and grad-
ually developed into her emphasis upon environment, fontality and
a compellingly asserted surface. While her all-white, gold or
black wooden assemblages are most familiár, she also utilizes
Plexiglas, aluminum and steel. She is an active sculptor today.
She was elected President of the New York Artists Equity in 1957
and of the national group in 1963.

Armstrong. Two Hundred Years of American Sculpture. pp. 295-296.

Baro, Gene. Nevelson: The Prints. New York: Pace Editions, 1974.
Discussion of Nevelson's activity as a printmaker.

Bongartz, Roy. "I Don't Want to Waste Time,' Says Louise Nevelson at 70." The New York Times Magazine. (January 24, 1971):Section 6.

Friedman, Martin. Nevelson Wood Sculptures. New York: E. P. Dutton, Inc., 1973.

Glimcher, Arnold B. Louise Nevelson. New York: Praeger Publishers, 1972.
Excellent coverage of her early years and her struggles to become an artist. Many photographs included.

Gordon, John. Louise Nevelson. New York: Whitney Museum of American Art, 1967.

Hill. Women, An Historical Survey.... Catalogue. pl. 57.

Johnson, Una E. Louise Nevelson. New York: Shorewood Publishers, Inc., 1967.

_____. Louise Nevelson: Prints and Drawings 1953-1966. New York: Brooklyn Museum, 1967.
Discusses three phases of printmaking, starting with her 1953 intaglio prints.

Kramer, Hilton. "The Sculpture of Louise Nevelson." Arts. 32 (June 1958):26-29.
Good reproductions of her work.

MacKown, Diana and Nevelson, Louise. Dawns and Dusks. New York: Scribner's, 1976.
Written from tape transcripts made in conversation, by her assistant, MacKown.

Munsterberg. A History of Women Artists. pp. 95-97 and 118.

Nemser. Art Talk. pp. 52-79, 360-361.
The information in the above biographical paragraph and much of the bibliography are from Nemser. Her interview of Nevelson was originally printed in The Feminist Art Journal 1, no. 2 (Fall 1972):1, 14-19.

New York. Martha Jackson Gallery. Nevelson. 1961.
The foreword is by Kenneth Sawyer, a poem by Jean Art and commentary by George Mathieu.

Otterlo, Netherlands. Rijksmuseum Kroller-Muller. Louise Nevel-
son Sculptures, 1959-1969. 1969.
It is introduced by R. Oxenaar.

Petersen and Wilson. Women Artists.... pp. 123-34.

Robert, Collette. Nevelson. Paris: The Pocket Museum, Edi-
tions Georges Fall, 1964.

Seckler, Dorothy Gees. "The Artist Speaks: Louise Nevelson."
Art in America. 55 (January-February 1967):32-43.

Wilson, Laurie. Louise Nevelson's Sculpture: 1929-1959. (Ph.D.
dissertation, in progress, CUNY).

Women's History Research Center, Inc. Female Artists Past and
Present.
Additional bibliography is available on page 93.

Collections:

 Birmingham, Alabama, Art Museum.
 Brooklyn Museum.
 Kansas City, Mo., Atkins Museum-Nelson Gallery.
 New York, Museum of Modern Art.
 New York, Pace Gallery.
 New York, Whitney Museum of American Art.
 Washington, D.C., Hirshhorn Museum and Sculpture Garden.

VIOLET OAKLEY. 1874-1961. American.

 Oakley was one of a trio of women, sharing a home and
studio space with Jessie Willcox Smith and Elizabeth Shippen Green.
From 1893 to 1894 she studied with Carroll Beckwith at the Art
Students League in New York. She then studied abroad, in Paris
at the Académie Montparnasse with Raphael Collin and Aman Jean,
and in England. She returned to study illustration with Howard
Pyle, in Philadelphia. Her career was quite diversified. In 1897
she collaborated with Jessie Willcox Smith on illustrations for
Evangeline, published by Houghton, Mifflin and Co. She designed
stained glass windows for churches in Boston and New York. One
of her most important commissions was the historic murals for
the capital at Harrisburg, Pennsylvania. She finished the forty-
three murals in 1927. She wrote, lettered, and illuminated seve-
ral manuscript books, and briefly taught mural design at the Penn-
sylvania Academy of Fine Arts. For three years, during assem-
blies of the League of Nations in Geneva, she drew portraits of the
delegates and received a commission to do the same at the United
Nations. She was an advocate of world peace, a devout Christian
Scientist, and a follower of Quaker philosophy. All these beliefs
were incorporated into her work. Edith Emerson, a former stu-
dent, was her lifelong companion. The recipient of several awards,

she was the first woman to be presented the medal of honor from the Architectural League of New York.

Biographical Sketches of American Artists. pp. 232-234.
 Lists some of her work.

Clement. Women in the Fine Arts. pp. 254-255.
 Mentions that she also did mosaics and. was a student of Cecilia Beaux's.

Delaware Art Museum. Studios at Cogslea. 1976.

Likos. "The Ladies of the Red Rose."
 Excellent summary of her life and work, stressing her relationship with Green and Smith.

Mason, Clara. "Violet Oakley's Latest Work." American Magazine of Art. 21 (March 1930):130-138.
 Discusses in detail her Geneva portraits and a mural for the Graphic-Sketch Club in Philadelphia. Good black and white reproductions.

Morris, Harrison. "Violet Oakley." The Book Buyer. 24 (May 1903):292-299.
 Summarizes her work and discusses her stained glass designs. Includes a photograph of the Red Rose Inn, the home she shared with her artist friends.

Philadelphia. Philadelphia Museum of Art. Three Centuries of American Art. April 11-Oct. 10, 1976, pp. 511-514.

GEORGIA O'KEEFFE. 1887- . American.

A unique American painter. While still a teenager she studied at the Chicago Art Institute, the Art Students' League and at Columbia University. A few years later she supervised art instruction in Amarillo, Texas, where she stayed four years. An important turning point in her career occurred when a friend of hers showed her drawings to Alfred Stieglitz, the gallery owner and important photographer, who immediately decided to show them. A year later, in 1917, O'Keeffe returned to New York for the second exhibit Stieglitz gave her. In 1924 they were married. Between the years 1923 and 1946 Georgia O'Keeffe had a one-woman show at Stieglitz's gallery each year. 1946 marked the death of Stieglitz and of her retrospective at the Museum of Modern Art. Thereafter she made a new home for herself in the desert of New Mexico where she continues to live and paint today. Her paintings are well known for their stark and economical compositions, defined by lyrical contours. Her subject matter excludes people and has consisted of mountains, architecture, flowers, plants and bones. We like the following O'Keeffe quote: "Well I made you take time to look at what I saw and when you took time to really notice

Georgia O'Keeffe. The White Flower. Whitney Museum of American Art, New York.

my flower you hung all your own associations with flowers on my flower and you write about my flowers as if I see what you think and see of the flower--and I don't. "

Coke, Van Deren. "Nature Presents a New Face Each Moment, Why Artists Came to New Mexico. " Art News. (January 1974).

Eldredge, Charles Child III. "Georgia O'Keeffe: The Development of an American Modern. " (Ph.D. dissertation, University of Minnesota, 1971.)

Goodrich, Lloyd and Bry, Doris. Georgia O'Keeffe. New York: Praeger for the Whitney Museum of American Art, 1970.
 The exhibition catalogue for the retrospective which took place between October 8 and November 20, 1970, and traveled to the Chicago Art Institute and to San Francisco early in 1971. It is a large book that includes bibliography, chronology and full page reproductions, some of which are in color.

Goosen, E. C. "O'Keeffe." Vogue. (March 1, 1967).

Hapgood, Hutchins. A Victorian in the Modern World. New York: Harcourt, Brace and Co., 1939.
This is about her husband.

Harris and Nochlin. Women Artists, 1550-1950. pp. 59, 65, 67, 300-306, 358-59.

Hill. Women, An Historical Survey.... Catalogue. pl. 48.

Kuh, Katherine. The Artist's Voice, Talks with Seventeen Artists. New York: Harper and Row, 1962.
An interview of O'Keeffe is included in this book.

Minneapolis. Walker Art Center. The Precisionist View in American Art. 1960. Catalogue by Martin L. Friedman.

Moss, Irene. "Georgia O'Keeffe and 'these people.'" Feminist Art Journal. 11, no. 2, (Spring 1973):14.

Munsterberg. A History of Women Artists. pp. 71-72.

Neilson. Seven Women, Great Painters. pp. 144-164.

O'Keeffe, Georgia. Georgia O'Keeffe. New York: Viking Press, 1976.
The artist writing about her life and work. Includes large number of reproductions.

Petersen and Wilson. Women Artists.... pp. 121-23, 124.

Plagens, Peter. "A Georgia O'Keeffe Retrospective in Texas." Artforum. 4 (May 1966):27-31.
Chronological analysis of her work. Good color reproductions.

Pollack, Duncan. "Artists of Taos and Santa Fe, from Zane Grey to the Tide of Modernism." Art News. (January 1974).

Pollitzer, Anita. "That's Georgia." Saturday Review. (November 4, 1950).
Pollitzer was one of O'Keeffe's best friends. It was she who took the original roll of drawings to Stieglitz.

Rich, Daniel Catton. Georgia O'Keeffe, Forty Years of Her Art. Worcester, Mass.: Worcester Art Museum, October 4, 1960. Catalogue.

_____. An article about O'Keeffe. Bulletin of the Art Institute of Chicago. (February 1943).

Rose, Barbara. "Georgia O'Keeffe: The Paintings of the Sixties."

Artforum. (November 1970):42-46.

Tompkins, Calvin. "The Rose in the Eye Looked Pretty Fine. "
The New Yorker. (March 4, 1974):40-66.

Wilder, Mitchell, ed. Georgia O'Keeffe. An Exhibition of the
Work of the Artist from 1915 to 1966. Fort Worth: Amon
Carter Museum, 1966.

Women's History Research Center, Inc. Female Artists, Past and
Present.
Much of the preceding bibliography plus additional bibliogra-
phy can be found on page 52.

Collections:

Andover, Mass. , Addison Gallery of American Art, Phillips'
Academy.
Brooklyn Museum.
Chicago Art Institute.
Fort Worth, Amon Carter Museum of Western Art.
Milwaukee Art Center.
Minneapolis, University of Minnesota.
Minneapolis, Walker Art Center.
New York, Metropolitan Museum of Art.
New York, Museum of Modern Art.
New York, Whitney Museum of American Art.
Washington, D.C. , Corcoran Art Gallery.
Washington, D.C. , Phillips Art Gallery.

MERET OPPENHEIM. 1913- . Born in Germany, raised in
Switzerland.

A Surrealist sculptor. Meret Oppenheim arrived in Paris
to study at the Académie de la Grande Chaumier in 1932. Her
work was brought to the attention of André Breton by Arp and Gia-
cometti. She soon began to exhibit with the Surrealists and to at-
tend their meetings. In 1936 she created the famous Fur-Lined
Teacup and Saucer and held her first one-woman show in Basle.
Max Ernst prefaced the catalogue (which we have not been able to
locate). She has also designed fantastic furniture and clothing ac-
cessories. Her production declined from 1944 to 1956. But in
1958 she began to exhibit again. She organized the inaugural feast
at the International Exposition of Surrealism in Paris in December
of 1959. She has continued to work and to exhibit up to the pres-
ent time. Her first one-woman show was not until 1974, in Stutt-
gart. She lives in Paris.

Alexandrian, Sarane. "Sculpture de la Surréaliste," Connaissance
des arts. 245 (July 1972):56.
Excellent summary of her life.

Meret Oppenheim. Object (Le Dejéuner en fourrure). 1936. Fur covered cup, saucer and spoon. 2 7/8" high. Museum of Modern Art, New York.

Ornstein, Gloria. "Women of Surrealism." Feminist Art Journal. 11, no. 2 (Spring 1973):18-19.
 Ornstein's article has supplied the above biographical information.

Petersen and Wilson. Women Artists.... pp. 131, 134.

Phaidon Dictionary of Twentieth Century Art. New York: Phaidon, 1973, p. 287.

Tillman, L. M. "Don't Cry ... Work." Art and Artists. (October 1973):22-27.
 A current interview of Oppenheim.

Collections:

New York, Museum of Modern Art.

I. Rice Pereira. <u>Oblique Progression</u>. Whitney Museum of Amer-
ican Art, New York.

I. RICE PEREIRA. 1907-1971. American.

She was born Irene Rice in Boston. At fifteen she was the
sole support of a sick mother and three younger brothers and sis-
ters. To do this she completed a three-year commercial course
in six months to become a stenographer. While working she at-
tended night school and in 1927 the Art Students' League. She
married Humberto Pereira in 1929. In 1931 she visited Europe
and North Africa. The experience of the Sahara Desert challenged
her thereafter to convey infinite space and illumination. Her first
one-woman show was held in 1933. In these years she was work-
ing toward geometric and non-objective abstraction, which she ar-
rived at in 1937. She pioneered in the use of new materials in
painting. In 1939 she began her first transparent paintings on
layers of corrugated glass to portray a shifting three-dimensional
space. There have been at least fifty one-woman shows since
1933. In the 1950's she published several philosophical works
which are much appreciated in the orient. She had two marriages.

Baur, John I. H. Loren MacIver, I. Rice Pereira. New York:
 Whitney Museum of American Art, 1953.
 Catalogue of the two-woman show.

Hill. Women, An Historical Survey.... Catalogue. pls. 64, 65.

Marxer, Donna. 'I. Rice Pereira: An Eclipse of the Sun. ''
 Women Artists Newsletter. Part II. Vol. 2, no. 8 (May
 1976):1 and 4.

Munsterberg. A History of Women Artists. p. 72, 73.

New York. Amel Gallery. I. Rice Pereira. 1962.

New York. Galerie Internationale. I. Rice Pereira. 1964.

New York. Museum of Modern Art. Fourteen Americans. 1946.
 Her statement is on page 46.

Pereira, I. Rice. The Crystal of the Rose. New York, 1959.

_____. The Finite Versus the Infinite. New York, 1962.

_____. The Lapis. New York, 1957.
 Her theory of imagery; illustrated.

_____. Letter to the editor. Art Voices. IV, no. 2 (1965):80.

_____. Light and the New Reality. New York, 1951.

_____. The Nature of Space: A Metaphysical and Aesthetic In-
 quiry. Washington, D. C. : Corcoran Gallery, 1968.
 Was privately published in 1956.

_____. Roll D222, Archives of American Art, New York.

_____. Roll D223, Archives of American Art, New York.

_____. The Simultaneous Ever Coming "To Be." New York, 1961.

_____. The Transcendental Formal Logic of the Infinite: The Evolution of Cultural Forms. New York, 1966.

_____. The Transformation of "Nothing" and the Paradox of Space. New York, 1953.

Petersen and Wilson. Women Artists.... p. 127.

Phaidon Dictionary of Twentieth Century Art. New York: Phaidon, 1973. p. 294.

Pousette-Dart, Nathanial, ed. American Painting Today. New York, 1962. p. 42.

Tufts. Our Hidden Heritage. pp. 232-242.
Tufts has supplied the information for the biographical paragraph and the bibliography used here.

Collections:

Hartford, Conn. , Wadsworth Atheneum.
New York, Guggenheim Museum.
New York, Metropolitan Museum of Art.
New York, Museum of Modern Art.
New York, Whitney Museum of American Art.
Washington, D.C. , National Collection of Fine Arts.

JEANNE REYNAL. 1903- . American.

Reynal was born in White Plains, New York. From 1930 to 1938 she was an apprentice in the studio of the mosaicist Boris Anrep in Paris. She assisted on some of his large commissions. In 1939 she returned to the United States and lived in California for six years. In 1946 she moved to New York City and in 1953 married the painter Thomas Sills. She credits Seurat and Neo-Impressionism as having influenced her mosaic works.

Ashton, Dore; Campbell, Lawrence; DeKooning, Elaine, et al.
The Mosaics of Jeanne Reynal. New York: George Wittenborn, Inc. , 1964.
Reynal gives a historic and technical analysis of the mosaic medium, followed by an evaluation of her work by five authors.

Campbell, Lawrence. "Jeanne Reynal: The Mosaic as Architecture. " Craft Horizon. 22 (Jan. -Feb. 1962):16-19 and 48-49.

Discusses her stylistic evolution and technical aspects of her work. Relates her work to the historical development of mosaic art. Discusses the use of mosaic in modern architecture and her attempts to develop a form of mosaic which can function independently of the wall, or with it.

DeKooning, Elaine. "Reynal Makes a Mosaic." Art News. 52 (Dec. 1953):34-36 and 51-53.
Photographic study of Reynal at work. Includes good description of the technical aspects of her work.

Kafka, Barbara P. "Art and Architecture: Four Recent Commissions." Craft Horizon. 28 (Jan. 1968):23.
Briefly discusses a free-standing mosaic wall Reynal did for a New York Church.

GERMAINE RICHIER. 1904-1959. French.

A sculptor in lead and bronze of metamorphosized human figures. As a child she was deeply affected by nature, particularly insects; and knew from an early age that she would be a sculptor. She enrolled in Ecole des Beaux-Arts in Montpellier at eighteen against her parents wishes. In 1925 she entered the Paris atelier of Antoine Bourdelle. She married a fellow sculptor, Otto Banninger in 1929. She and her husband fled to his native Switzerland at the outbreak of World War II. There she taught and as a successful woman sculptor inspired many women students. Upon her return to liberated France, Tufts describes her forms as more "brooding and spectral." Insects, too, began to appear in her work. Her best known sculpture is from the early 1950's. In 1955 she married René de Solier. She died of cancer just before her fifty-fifth birthday.

Burr, James. "Toad, Bat, Spider or Man?" Apollo. 98 (July 1973):53-54.
Discussion of the nightmarish quality of her animal shapes.

"Germaine Richier." Werk. 50 (1963):n. p.

Guth, Paul. "Encounter with Germaine Richier." Yale French Studies. 19-20 (Spring 1957-Winter 1958).

Hill. Women, An Historical Survey.... Catalogue. pl. 63.

Jacometti, Nesto. "Germaine Richier." Vie, Art, Cité. 3 (1946): 28.

Liberman, Alexander. The Artist in His Studio. New York, 1960. p. 282.

London. Hannover Gallery. Germaine Richier. 1955. Introduced by David Sylvester.

Germaine Richier. The Batman. 1956. Wadsworth Atheneum, Hartford, Conn. Gift of Susan Morse Hilles.

Munsterberg. A History of Women Artists. p. 94, 95.

New York. Martha Jackson Gallery. Germaine Richier. 1957.
Introduced by Rene de Solier.

Paris. Galérie Creuzebault. Germaine Richier, 1904-1959. 1966.

Paris. Musée National d'Art Moderne. Germaine Richier. Oct.
10-Dec. 9, 1956.

Petersen and Wilson. Women Artists.... pp. 2, 3.

Phaidon Dictionary of Twentieth Century Art. New York: Phaidon,
1973. p. 318.

Collections:

 Hartford, Conn. , Wadsworth Atheneum.
 London, Tate Gallery.
 Minneapolis, Walker Art Center.

New York, Marlborough Gallery.
New York, Museum of Modern Art.
Paris, Musée National d'Art Moderne.
Stockholm, Moderna Museet.

ANNE RYAN. 1889-1954. American.

Ryan, married and the mother of two children, didn't begin her art career until 1938. Previously she had written poetry and short stories. Hans Hoffman encouraged her in painting and she studied printmaking with Stanley William Hayter. Her painting has been described as surrealist-influenced, semi-abstract and biomorphic. Her first one-woman show was in 1941. She is best known for her collage work, which she began after seeing a Kurt Schwitters exhibition in 1948. Her collage work is in a cubist style, utilizing cloth remnants, colored paper and photomontage. Often her collages are in an oval shape. She also designed stage sets and ballet costumes.

Ashbery, John. "A Place for Everything." Art News. 69 (March 1970):32-33 and 73-75.
 Describes and critiques her collage work. Includes several reproductions, one in color, and a photograph of the artist.

Faunce, Sarah. Ann Ryan, Collages. Brooklyn: Brooklyn Museum, 1974.
 Exhibition catalogue.

Frank, Peter. "Anna Ryan at the National Collection of Fine Arts." Art in America. 62 (Sept./Oct. 1974):118.
 Compares her work with Schwitter's and presents a brief chronological analysis of her collages.

Munsterberg. A History of Women Artists. pp. 72-73.

Collections:

New York, Marlborough Gallery.

KAY SAGE. 1898-1963. American.

Sage was born in New York, but lived in Europe (mainly Italy) during her childhood. In 1924 she studied briefly at the Scuola Liberale dell belle Arti in Milan. She exhibited some abstract paintings in Milan in 1936. In 1937 she went to Paris and the following year exhibited at the Salon des Surindependants. Shortly after this she began living with Yves Tanguy. They moved to the United States in 1939. Her surrealist paintings feature infinite perspectives, architectural elements and draped amorphous objects. She also wrote poetry in English, Italian and French.

Kay Sage. No Passing. 1954. Oil on canvas. 51 1/4'' x 38''.
Whitney Museum of American Art, New York.

Bénézit. Dictionnaire. Vol. 7, p. 465.

Breuning, M. "A Kay Sage Retrospective." Arts. 34 (May 1960):54.

Buckley, C. E. "Yves Tanguy and Kay Sage." Wadsworth Athenaeum Bulletin. 49 (May-September 1954):4.
Compares the superficial similarities of the two artists and notes the marked individuality of her work.

Cornell University. Johnson Museum. Kay Sage, Retrospective. January 26-March 13, 1977.

Harris and Nochlin. Women Artists, 1550-1950. pp. 319-20, 338, 360.

Hill. Women, An Historical Survey.... Catalogue, p. xiii.

Jean, Marcel. History of Surrealist Painting. 1959.

Petersen and Wilson. Women Artists.... p. 134.

Sage, Kay. China Eggs. 1955. Unpublished autobiography. The manuscript is in the Archives of American Art, Washington, D.C.

_____. Demain Monsieur Bilber. Paris: Seghers, 1957.

_____. Faut dire c'qui est. Paris: DeBreese, 1959.

_____. The More I Wonder. New York: Bookman Associates,

San Faustino, K. di (pseud. Kay Sage). Piove in Giardino. Italy, c. 1936.
A children's book she wrote and illustrated.

Soby, James Thrall. "A Tribute to Kay Sage." Art in America. 58 (October 1965):83.

University of Maryland. Art Department Gallery. Kay Sage 1898-1963. April, 1977.

Waterbury, Connecticut. Mattatuck Museum of the Mattatuck Historical Society. A Tribute to Kay Sage. 1965.

Collections:

 Hartford, Conn., Wadsworth Atheneum.
 New York, Museum of Modern Art.
 New York, Whitney Museum of American Art.
 Poughkeepsie, Vassar College Art Gallery.
 Washington, D.C., Monagan College.
 Williamstown, Mass., Williams College Museum of Art.

JANET SCUDDER. 1873-1940. American.

Scudder was born in Terre Haute, Indiana. She studied at the Cincinnati Art Academy, at the Art Institute of Chicago with Lorado Taft, and in Paris with Frederic MacMonnies. Her first professional work was some figures for buildings of the 1893 Chicago's World Columbian Exposition. She worked in Paris almost exclusively. She returned to the United States to establish a studio in 1939, after a 45-year residence in France. Although she painted and ventured into architecture once, her work consisted mainly of garden fountains and figures of children. She refused commissions for equestrian and portrait statues, stating, "I won't add to this obsession of male egotism that is ruining every city in the United States with rows of hideous statues of men - men - men ... " [Paris]. She was a member of the National Sculpture Society and a Chevalier of the French Legion of Honor.

Bénézit. Dictionnaire. Vol. 7, p. 687.

Biographical Sketches of American Artists. pp. 282-283.

Clement. Women in the Fine Arts. pp. 311-312.

"Janet Scudder. " Art Digest. 74 (July 1, 1940):24.
 Obituary.

Paris, William F. The Hall of American Artists. New York:
 New York University, 1954, Vol. 9, pp. 77-88.

Payne, Frank. "The Work of Some American Women in Plastic
 Art. " pp. 311 and 313.

Proske. "Part I. American Women Sculptors. " pp. 3-15.

Scudder, Janet. Modeling My Life. New York: Harcourt, Brace,
 and Co. , 1925.
 Autobiography.

SERAPHINE DE SENLIS. 1864-1934. French.

Her paintings dealt exclusively with fantastic plant forms. She was untaught, but has been described as a visionary rather than a primitive artist. She was originally a domestic servant when she was discovered by Uhde. In 1930 she was confined to an insane asylum and died there four years later. She is also known as Séraphine Louis.

Bihalji-Merin, Oto. Masters of Naive Art: A Historical and
 World Survey.

Dorival, Bernard. The School of Paris in the Musée d'Art
 Moderne. New York: Harry N. Abrams, 1962, pp. 190-191.

An excellent color reproduction of her painting, The Tree of Paradise, dated 1929.

_____. Twentieth Century Painters. New York: Universe Books, 1958.

Masters of Modern Painting. New York: Museum of Modern Art, 1938.

Mathey. Six femmes peintres.

Paris. Petit Palais. Catalogue.

Petersen and Wilson. Women Artists.... pp. 103-104.

Uhde, Wilhelm. An article on Senlis. Formes. No. 17 (1931): 115-117.

_____. Fünf primitive Meister.

_____. 'Séraphine ou la peinture révélée." Formes. 12 (September 1931).

Collections:

Paris, Musée de l'Art Moderne.

AMITRA SHER-GILL. 1913-1941. India.

Sher-Gill was the daughter of a Hungarian mother and an Indian aristocrat father. She lived in Budapest until 1921, when the family returned to India. From 1929 to 1934 she lived in Paris and received academic training in art. She studied with Pierre Vaillert and Lucien Simon. She was also exposed to the art of Gaugin and Cézanne, whose influence can be seen in her works. Her family was distressed at the bohemian, promiscuous and bisexual pattern of her life in Paris. She returned to India in 1934. In 1938 she went to Hungary and married her cousin, Dr. Victor Egan. They returned to India the following year and her career ended with her unexpected death at age twenty-eight. Her works were usually figurative, often of women, or Indian village scenes.

"Contemporary Paintings." Marg. 25 (Sept. 1972):70-71.
 Color reproduction and discussion of her 1935 painting, Hillmen.

Goetz, H. "Amitra Sher-Gill." Studio. 150 (Aug. 1955):50-51.

Kapur, Geeta. "The Evolution of Content in Amitra Sher-Gill's Painting." Marg. 25 (March 1972):39-53.
 This whole issue is devoted to the work of Sher-Gill. Many

excellent color reproductions and a helpful chronology are included.

Munsterberg. A History of Women Artists. p. 82.

Raman, A. S. "Present Art of India." Studio. 142 (Oct. 1951): 99-101.

Sheikh, Gulam. "Amitra Sher-Gill--Dialectics of Academicism and Pictorial Situation of Traditional Indian Art." Marg. 24 (March 1972):55-62.

Subramanyan, K. G. "Amitra Sher-Gill and the East-West Dilemma." Marg. 25 (March 1972):63-72.

Sundaram, Vivan. "Amitra Sher-Gill--Life and Work." Marg. 25 (March 1972):4-38.

Collections:

New Delhi, National Gallery of Modern Art.

JESSIE WILLCOX SMITH. 1863-1935. American.

Smith, a Philadelphia native, studied at the Philadelphia School of Design for Women, the Pennsylvania Academy, and the Drexel Institute. She studied with Eakins, Anschutz, and Howard Pyle; Pyle was the strongest influence on her style. She had previously been a kindergarten teacher. She began her art career in the advertising department of the Ladies Home Journal. She shared a studio with Violet Oakley and Elizabeth Shippen Green. They collaborated on a number of books and calendars. She became wealthy as an illustrator, working for many magazines and illustrating many of the classics of children's literature. In her later years she did many portraits of children. She received numerous awards and prizes.

Bénézit. Dictionnaire. Vol. 7, p. 813.

Biographical Sketches of American Artists. p. 293.

"A Child's Artist." Art Digest. 9 (May 15, 1935):12. Obituary.

Clement. Women in the Fine Arts. pp. 319-320.

Delaware Art Museum. Studios at Cogslea. 1976.

Likos. "The Ladies of the Red Rose."

Mahony, Bertha and Whitney, Elinor. Contemporary Illustrators of Children's Books. Boston: Women's Educational and

Industrial Union, 1930, pp. 68-69.

Morris, Harrison. "Jessie Willcox Smith. " The Book Buyer. 24
(April 1902):201-205.
Lists several of her prizes. Good black and white repro-
ductions.

Philadelphia. Philadelphia Museum of Art. Three Centuries of
American Art. April 11-Oct. 10, 1976, pp. 304-306.

FLORINE STETTHEIMER. 1871-1944. American.

Stettheimer was born in Rochester, New York. Although
she is often classified as a "primitive" or naïve painter, she spent
eight years in Europe receiving academic training in art. She was
one of four sisters. She and her sisters presided over an intel-
lectual and artistic salon in New York City. She died virtually un-
recognized by the art world, due to her own indifference. She
didn't try to succeed in the art market. She priced her works out
of range and often gave them away to friends. Her only one-
woman show occurred in 1916 before her work reached its matur-
ity. The Museum of Modern Art had a retrospective in 1946. She
did the set and costume designs for Gertrude Stein's play, "Four
Saints in Three Acts. " Her work is noted for its characterization
of American life in the 1920's--the subject matter frequently in-
cludes friends and family with a strong sense of playfulness.

Bower, Anthony. "Florine Stettheimer. " Art in America. 52
(April 1964):88-93.
Several color and black and white reproductions. Good
analysis of her life style and attitudes.

Columbia University. Florine Stettheimer: An Exhibition of Paint-
ings, Watercolors, Drawings. New York: Columbia Univer-
sity Press, 1973.

"Florine. " New Yorker. 22 (Oct. 5, 1946):26-27.
Humorous description of her home and family. Notes that
she painted from memory, not from models.

Harris and Nochlin. Women Artists, 1550-1950. pp. 58, 64, 94,
266-67, 354.

Hartley, Marsden. "The Paintings of Florine Stettheimer. "
Creative Art. 9 (July 1931):18-23.
Discusses her portrait style. Describes her art as full of
delicate satire and wit. Good black and white reproductions.

McBride, Henry. Florine Stettheimer. New York: Museum of
Modern Art, 1946.
Exhibition catalogue. Discusses technical aspects of her
art. Includes photographs of her stage and costume designs.

Nochlin, Linda. "What Is Female Imagery?" Ms. 3 (May 1975).

Petersen and Wilson. Women Artists. pp. 99, 101-103, 104.

Tyler, Parker. Florine Stettheimer: A Life in Art. New York: Farrar, Struas and Co., 1963.
 In-depth biography with many reproductions and photographs. Unfortunately a bibliography is not included.

Collections:

 Boston, Museum of Fine Arts.
 Hartford, Conn., Wadsworth Atheneum.
 Kansas City, Mo., Atkins Museum-Nelson Gallery.
 Nashville, Fisk University.
 New York, Brooklyn Museum.
 New York, Metropolitan Museum of Art.
 Poughkeepsie, Vassar College Art Gallery.

SOPHIE TAEUBER-ARP. 1889-1943. Swiss.

 She was born in Switzerland. Between 1909 and 1912 she studied art in St. Gall, Munich and Hamburg. She was active in the debut of Dadaism in Zurich. From 1916 to 1929 she was a professor of design and textile arts at the Zurich School of Industrial Arts. She married the sculptor Hans Arp in 1926 and they lived in Paris from 1928 to 1940. She often collaborated with him. She was active in the abstract art movement and was a founder of the magazine Plastique. She was killed in an accident in 1943.

Arp-Taeuber, Sophie and Gauchat, Blanche. Dessin et arts textiles. Zurich, 1927.

Bénézit. Dictionnaire. Vol. 8, p. 211.

Bern. Kunstmuseum. Sophie Taeuber-Arp. 1954.

Brzekowski, Jan. "Les quatre noms." Cahiers d'Art. 9 (1934): 197-200.
 Illustrated review of an exhibition of her work.

Harris and Nochlin. Women Artists, 1550-1950. pp. 60-61, 291, 311-313, 321, 359.

Hill. Women. An Historical Survey.... Catalogue. p. viii.

"Kelly, Collage and Color." Art News. 70 (Dec. 1971):44-46.
 Briefly discusses her influence on the work of Elsworth Kelly.

Krasner, Belle. "Arp and Arp." Art Digest. 24 (Feb. 15, 1950): 15.

Brief review of an exhibition.

Munsterberg. A History of Women Artists. pp. 70-71.

New York. Museum of Modern Art. Extraordinary Women--Drawings. July 22-September 29, 1977.

Paris. Musée National d'Art Moderne. Sophie Taeuber-Arp. 1964.

Schmidt, Georg. Sophie Taeuber-Arp. Basel, 1948.

Stuber, Margit. Sophie Taeuber-Arp. Lausanne, 1970.

Collections:

 Basel, Kunstmuseum.
 Wiesbaden, Museum Lodz.
 Zurich, Musée Decorative Arts.

BESSIE POTTER VONNOH. 1872-1955. American.

 Studied with Lorado Taft at the Chicago Art Institute. Her reputation was established by the work she did with him for the 1893 Columbia Exposition. She married the painter Robert Vonnoh in 1899. Her early work consisted of small genre pieces, usually of women and children in every day activities. She also did portrait busts. In the 1920's and 1930's she began doing life-size figures. She won numerous prizes and became a member of the National Sculpture Society. She ceased working as a sculptor after the 1930's.

Armstrong. 200 Years of American Sculpture. pp. 316-317. Good summary of her life and the source for much of the bibliography.

Bénézit. Dictionnaire. Vol. 6, p. 779.

Clement. Women in the Fine Arts. p. 352.

Hill. Women. An Historical Survey.... Catalogue, pp. xii and 21.

Hoeker, Arthur. "A New Note in American Sculpture: Statuettes by Bessie Potter." Century Magazine. 32 (May/Oct. 1897): 732-35.

Kohlman, Rena Tucker. "America's Women Sculptors." International Studio. 76 (Dec. 1922):227.

"Miss Bessie Potter's Figurines." Scribner's Magazine. 19 (Jan. 1896):126-127.

Payne. "The Work of Some American Women in Plastic Art."
pp. 314-316.

Proske. "American Women Sculptors."

"A Sculptor of Statuettes." Current Literature. 34 (June 1903):
699-702.

Taft. The History of American Sculpture.

SECTION III

NEEDLEWORK

The following is a short, selected bibliography. Books and periodicals are grouped together alphabetically.

Bertrand, Simone. La tapisserie de Bayeux. Paris: Zodiaque, 1966.

Bishop, Robert and Safanda, Elizabeth. America's Quilts and Coverlets. New York: E. P. Dutton, 1976.

_____. A Gallery of Amish Quilts: Design Diversity from a Plain People. New York: E. P. Dutton, 1976.
 Many reproductions with discussion of materials and techniques.

Blum, Clara. Old World Lace. New York: E. P. Dutton, c. 1920.

Bolton, Ethel S. and Coe, Eva J. American Samplers. Boston: Massachusetts Society of the Colonial Dames of America, 1921.

Caulfield, S. F. A. and Saward, Blanche, eds. Directory of Needlework. London: L. Upcott Gill, 1882; reprint, Detroit: Singing Tree Press, 1971.
 Encyclopedia of artistic, plain and fancy needlework.

Center for the History of American Needlework.
 A bibliographical resource. The address is 2216 Murray Ave., Pittsburgh, Pa. 15217.

Christie, A. G. I. English Medieval Embroidery. Oxford, 1938.

Colby, Aberil. Samplers. Newton Center, Mass.: C. T. Branford Co., 1964.

Digby, G. W. The Bayeux Tapestry. London, 1956; reprint, 1967. Edited by F. Stenton.

Dommelen, David van. Decorative Wall Hangings; Art with Fabric. New York: Funk and Wagnalls Co., 1962.

Ebert, John and Ebert, Katherine. American Folk Painters. New York: Charles Scribner's Sons, 1975. p. 37.
 Good summary of importance of needlework as a skill for eighteenth century women. Includes several reproductions.

Finley, Ruth E. Old Patchwork Quilts and the Women Who Made Them. Philadelphia: J. B. Lippincott, 1929.
 Patchwork quilts have only recently begun to be appreciated for their significance to American aesthetic expression. Includes 96 illustrations and 100 diagrams.

Fratto, Toni Flores. "Samplers: One of the Lesser American Arts." Feminist Art Journal. 5 (Winter 1976-77):11-15.

Fry, Gladys W. Embroidery and Needlework. London: Pitman and Sons, Ltd., 1935.
 Textbook on design and technique, illustrated.

Giffen, Jane. "Susanna Rowson and Her Academy." Antiques. 98 (September 1970):436-440.
 Describes a Boston school of the late eighteenth century, that included courses in needlework. Good reproductions.

Haders, Phyllis. Sunshine and Shadow: The Amish and Their Quilts. New York: Universe Books, 1976.
 Discusses the development of patterns and designs.

Hall, Carrie and Kretsinger, Rose, eds. Romance of the Patchwork Quilt in America. Caldwell, Ohio: Caxton Printers, 1936.

Hines, Millie. American Heirloom Bargello: Designs from Patchwork Quilts, Woven Colonial Coverlets, and Navajo Rugs. New York: Crown Publishers, 1976.

Hughes, Therle. English Domestic Needlework: 1660-1860. London: Abbey Fine Arts, n.d.

Huish, Marcus. Samplers and Tapestry Embroiders. New York: Longmans, Green and Co., 1913.

Kahlenberg and Berlant. The Navajo Blanket. Los Angeles: Los Angeles: Los Angeles County Museum, 1972.

Koehler, S. R. "American Embroideries." Magazine of Art. 9 (1886):209.
 Mentions several women designers of tapestry. Three good black and white reproductions.

Kopp, Joel and Kate. American Hooked and Sewn Rugs; Folk Art Underfoot. New York: Dutton, 1975.

Krevitsky, Nik. Stitchery: Art and Craft. New York: Reinhold

Publishing Corp. , 1966.

Lane, Rose Wilder. Book of American Needlework. New York: Simon and Schuster, 1936.

London. Arts Council of Great Britain. Opus Anglicanum; English Medieval Embroidery. 1963.
Catalogue of an exhibit held at the Victoria and Albert Museum.

Lowes, Emily Leigh. Chats on Old Lace and Needlework. London: T. Fisher Unwin, 1908.
A chronological, detailed history; well illustrated.

Mainardi, Patricia. "Quilts: The Great American Art." Feminist Art Journal. 2 (Winter 1973):1, 18-23.
A comprehensive overview of quilt art, its myths and importance in the history of women in art. An extensive bibliography is included.

Maines, Rachel. "Fancywork: The Archaeology of Lives." Feminist Art Journal. 3 (Winter 1974-75):1, 3.
An analysis of needlework as a means by which feminist art history may be traced that is without the usual heavy influence of male cultural definitions and influence. It provided the beginning source for this section of the bibliography.

Norbury, James. Counted-Thread Embroidery on Linens and Canvas. New York: Studio Publications, 1956.

Parker, Rosie. "The Word for Embroidery Was Work." Spare Rib. No. 37 (July 1975):41-45.
Spare Rib is a London feminist publication.

Ring, Betty. "Memorial Embroideries by American Schoolgirls." Antiques. 100 (October 1971):570-575.
Good reproductions of an art form that reached its zenith about 1815.

_____. Needlework: An Historical Survey. New York: Universe Books, 1976.

Roth, Henry Ling. Studies in Primitive Looms. New York: Burt Franklin, Publisher, 1976.

Safford, Carleton and Bishop, Robert. America's Quilts and Coverlets. New York: Dutton, 1972.

Schutte, Marie and Muller-Christensen, Sigrid. The Art of Embroidery. London: Thames and Hudson, 1964.

Siegler, Susan. Needlework Patterns from the Metropolitan Museum of Art. New York: New York Graphic Society, 1976.

Symonds, M. and Preece, L. Needlework Through the Ages.
 London, 1928.

Weiss, Rita, ed. Victorian Alphabets, Monograms, and Names
 for Needleworkers from Godey's Lady's Book and Peterson's
 Magazine. New York: Dover Publications, 1974.

ADDENDA

Section I: General Works

Books

Edwards, Lee R.; Heath, Mary; and Baskin, Lisa, eds. Woman: An Issue. Boston-Toronto: Little, Brown and Co., 1972. Includes reproductions of fifteen self portraits by women.

Fine, Elsa Honig. Women and Art, A History of Women Painters and Sculptors from the Renaissance to the Twentieth Century. Montclair, New Jersey: Allanheld and Schram Ltd., Spring 1978.

The prospectus describes this work as a comprehensive text within a reasonable space; that is approximately 256 pages and 180 reproductions, five in color. Each section begins with a discussion of the conditions prevailing for women artists in that particular era. Over one hundred artists are evaluated and their work illustrated. Supplementary material on many other women artists is included.

_____; Gellman, Lola B.; and Loeb, Judy, eds. Women's Studies and the Arts. Women's Caucus for Art, 1978.

A collection of twenty-nine syllabi by thirty-three authors demonstrating the rich variety of women's studies courses in the field of art history and studio instruction. This 165-page work is actually the third updated edition produced by the WCA. The second edition is listed under Athena Tacha Spear. The new edition is available from Fine at 7008 Sherwood Drive, Knoxville, Tennessee 37919.

Grant, Lynn Chapman. Anger to Action, A Sex Descrimination Guidebook. Women's Caucus for Art-Affirmative Action Committee, 1978.

A concise, thorough and realistic guide for identifying and legally challenging sex descrimination in academia. It is available from Grant at Route 1, Box 295c, Corvallis, Oregon 97330.

National Commission on the Observation of International Women's Year, 1975. The Creative Woman, A Report of the Committee on the Arts and Humanities. Washington, D.C.: U.S. Government Printing Office, April 1976.

Presents a broad perspective on the status of women in the

319

arts and humanities including music, drama, architecture, museums, academia and government, as well as the visual arts.

The Originals: Women in Art. Wilmette, Illinois: Films Incorporated, 1978.
A series of six one-half hour television programs broadcast in early 1978. They were: Georgia O'Keeffe, Mary Cassatt Impressionist from Philadelphia, Louise Nevelson in Process, Helen Frankenthaler, Spirit Catcher--The Art of Betye Saar, and Anonymous Was a Woman. They are available in 16mm or video cassettes from Films Incorporated, 733 Green Bay Road, Wilmette, Illinois 60091, 800-323-4222. We missed the O'Keeffe and Frankenthaler episodes but thoroughly savored the four we did see. Our only criticism is that we wished they were longer!

Rosenthal Art Slides. Vol. II.
This is actually a slide company's catalogue. It is included here because other slide sets have been grouped with books in this bibliography. The Rosenthal company has produced sixty-one slides of works in the Harris and Nochlin curated exhibit Women Artists, 1550-1950, listed in the catalogue on pages 412-414. Forty-two slides of pre-twentieth-century women artists and over two hundred slides of twentieth-century women artists are listed on pages 458-461. There is probably some overlap between the two groups. Rosenthal's address is 5456 South Ridgewood Court, Chicago, Illinois 60615.

Véquaud, Yves. The Women Painters of Mithila. New York: Thames and Hudson, Inc., W. W. Norton and Co., Inc., 1977.
A large paperback with eighty-eight illustrations of which sixty are in color. Mithila is a province in northern India in which all the women are painters. In 1970 Véquaud "discovered" them. See the Paris entry in the catalogue section of this Addenda for an exhibition and the Ward entry under periodicals (also in this Addenda) for a review of that show.

Periodicals

Calyx, A Journal of Art and Literature by Women.
This journal is published three times a year. It is available at Route 2, Box 118, Corvallis, Oregon 97330.

Glueck, Grace. "The Woman as Artist." New York Times Magazine. (September 25, 1977): Section 6, pp. 48-68.
A lavish review of Women Artists: 1550-1950 containing numerous colored and black and white reproductions.

Ward, Ruth V. "Mithila: The Women, Their Paintings, and the Favors of the Gods." Womansphere, the Journal of the Washington Women's Arts Center. (September 1975):4-7.

Ward reviews and illustrates the Paris exhibit (see below in the catalogue section) of Véquaud's collection (above in the book section).

Women in the Arts Bulletin.
The newsletter of Women in Art (WIA) that has been published since 1972. Ten issues are produced each year by Women in the Arts Foundation, Inc. at 435 Broome Street, New York, N.Y. 10013. Subscriptions are available.

Women's Studies Newsletter.
A quarterly begun in 1972 published by the Feminist Press and the National Women's Studies Association. Subscriptions are available from The Feminist Press's Clearinghouse on Women's Studies, Box 334, Old Westbury, New York, 11568.

Catalogues

New York. Women's Caucus for Art and the Bronx Museum of the Arts. Clay, Fiber, Metal: Women Artists. January 25-February 24, 1978.
The second annual national invitational exhibition sponsored by the WCA. This crafts show represents an important effort on the part of the Caucus to challenge the validity of the old barriers between art and craft, barriers that have particularly been used against women. The first exhibit, Contemporary Issues, Works on Paper is listed under Los Angeles in the catalogue section. The catalogue is in the form of a poster.

New York. Women's Caucus for Art, New York, New Jersey and Connecticut Chapters; and Graduate Center of the City University of New York. Women Artists '78. January 26-February 23, 1978.
A regional juried show selected from among area Caucus members. It has a particularly handsome catalogue.

Paris. Musée des Arts Decoratifs. Mithila--Les Femmes, Leurs Peintures, et la Faveur des Dieux. 1975.
The exhibition of Véquaud's collection. See Véquaud in the book section above and Ward in the periodical section above.

Sister Chapel. Long Island City, New York: P.S. 1 (Institute for Art and Urban Resources), January 15-February 19, 1978.
A collectively painted environment that should travel. The chapel consists of eleven life size, full length standing portraits of heroines and goddesses in a circular environment with a circular ceiling painting. The catalogue consists of a poster which reproduces the twelve images in black and white in a mandala format. The twelve individual paintings and their respective artists are: God-Cynthia Mailman, Bella Abzug-Alice Neel, Womanhero-Martha Edelheit, Joan of Arc-Elsa Goldsmith, Lilith-Sylvia Sleigh, Frida Kahlo-Shirley Gorelick, Durga-Diane

Kurz, Marianne Moore-Betty Holliday, Self Portrait as Super-
woman-Sharon Wybrants, Betty Friedan as the Prophet-June
Blum, Artemisia Gentileschi-May Stevens, and the Ceiling,
which is abstract-Ilise Greenstein who coordinated the entire
project.

Section II: Individual Artists

MARY CASSATT

Breeskin, Adelyn D. Mary Cassatt, Pastels and Color Prints.
Washington, D.C.: National Collection of Fine Arts,
Smithsonian Institution Press, Feb. 24-April 30, 1978.
An illustrated catalogue.

EMILY CARR

Shadbolt, Doris. Emily Carr. Seattle: University of Wash-
ington Press, 1977.
"... Carr's best paintings are illustrated here and sup-
plemented with a text and extensive notes...."

IMOGEN CUNNINGHAM

Cunningham, Imogen. After Ninety. Seattle: University of
Washington Press, 1977.
Introduction by Margaretta Mitchell. Includes eighty of
her late portraits.

_____. Imogen Cunningham: Photographs. Seattle: Uni-
versity of Washington Press, 1970.
A survey of seventy years of her career.

SONIA DELAUNAY

Hoog, Michel. Robert et Sonia Delaunay. New York: Hacker
Art Books (to be published Winter, 1978). reprint of Paris:
Musee National D'Art Moderne, 1967.
Text is in French. Includes 135 plates in color and
black and white, introductory essay, short bibliography,
list of exhibitions.

LEONOR FINI

Leonor Fini au Chauteau de Vascoeuil. May 28-Oct. 2, 1977.
An exhibition catalogue with a number of fine black and
white and color reproductions. Included are short essays

by Constantin Jelenski and Jean Bouret, plus a short biography of the artist.

Leonor Fini: Miroir des Chats. New York: Hacker Art
Books (to be published Winter, 1978). originally published
in Paris, 1977.
Study of the feline species, one of her favorite subjects.
Photographs by Richard Overstreet. Text is in French.
Includes both paintings and drawings.

GEORGIA O'KEEFFE

Hoffman, Katherine Ann. A Study of the Art of Georgia
O'Keeffe from 1916-1974. Ph.D. dissertation from New
York University, 1976.

JESSIE WILLCOX SMITH

Schnessel, S. Michael. Jessie Willcox Smith. New York:
Thomas Y. Crowell, 1977.
Includes many color illustrations, biography, chronology,
bibliography and a near catalogue of her work which lists
her magazine covers, book illustrations, etc.